Nikon
SYSTEM HANDBOOK
6th Edition

B. MOOSE PETERSON

SILVER PIXEL PRESS®

Rochester, NY

Nikon System Handbook
6th Edition

Published by
Silver Pixel Press®
A Tiffen® Company
21 Jet View Drive
Rochester, NY 14624
Fax: (716) 328-5078
www.saundersphoto.com

ISBN 1-883403-64-2

Design: Buch & Grafik Design, Günter Herdin, Munich
Printed in Germany by Kösel GmbH, Kempten

Photographs supplied by the author © B. Moose Peterson/WRP

All the information provided in this book including specifications, release dates, nomenclature, and promotions relates to the U.S. marketplace. Since Nikon, Inc., U.S.A. has different model names and marketing strategies from the rest of Nikon's worldwide distributors, some release dates, specifications, and nomenclature vary (this does not apply to serial numbers, which hold true worldwide). This is not necessarily an indication of a different product being sent to the U.S., only marketing preferences. This is why some Nikon products are never seen in the U.S. market. All information in this, the sixth edition, supersedes all other editions.

This book is not sponsored by Nikon, Inc. Information, data, and procedures are correct to the best of the publisher's knowledge; all other liability is expressly disclaimed. Because specifications may be changed by the manufacturer without notice, the contents of this book may not necessarily agree with changes made after publication. We would like to thank Laterna magica and Nikon GmbH for the use of some product photographs.

Library of Congress Cataloging-in-Publication Data

Peterson, B. (Bruce), 1959-
 Nikon system handbook / B. Moose Peterson. -- 6th ed.
 p. cm.
 Includes index.
 ISBN 1-883403-64-2
 1. Nikon camera--Handbooks, manuals, etc. 2. Nikon camera-
-History. I. Title.
TR263.N5P49 2000
771.3'1--dc21
 99-26695
 CIP

Acknowledgments
This book would not have been possible without the help of many in its preparation. I want to especially thank the folks at Nikon, Inc.: Victor Borod for his endless support; Steve Jarmon, Sharon Lebowitz, and Richard LoPinto for their technical expertise; Maurice Benchimol for his help and friendship; and Mr. K. Shioiri of Nikon, Japan, for his information and support. My technical advisors, Michael Pliskin and Geoff Keller, have provided great insight and been of great assistance through the years. Thanks to Chuck Kober at Russ' Camera and Video in Santa Barbara for loaning me his extensive collection of Nikon equipment. And finally, to Steve Hess and Marti Saltzman at Saunders for standing behind me and all my projects. To all of you, a heartfelt special thanks!

Dedication

To Pop: For opening up the experiences of a lifetime.

Contents

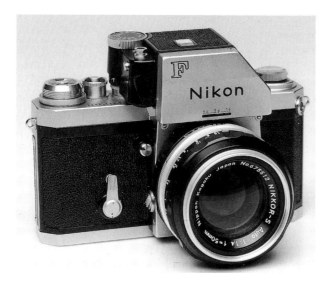

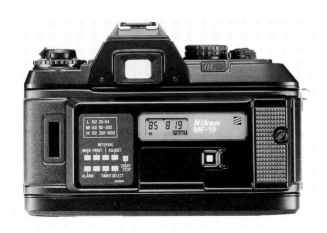

Introduction

The Nikon we know today started as an optical company almost a century ago. The Japan Optical Company (English for Nippon Kogaku, K.K.) was formed on July 25, 1917, by the merger of three small optical firms, the oldest one dating back to the 1880s. They started with just 200 employees and were later strengthened by German technicians who became part of the company by invitation in 1919 (but arrived in 1921). It's important to understand that they produced only optics for other camera manufacturers, manufacturing no camera bodies of their own in the beginning. They began by producing microscopes, transits, surveying equipment, optical measuring devices, and telescopes (and are still a leader in this field today). These early optics paralleled those of Leitz and Zeiss, companies that also started as optical firms.

Because of the type of optical products they were manufacturing, Nikon became well known in the scientific and industrial communities but not by the general consumer. By the thirties, they were manufacturing a series of photographic lenses from 50mm to 700mm, mostly for plate back cameras. With these lenses came a new name for their optics "NIKKOR," which was derived from "NIKKO," a name used on their early microscopes.

In the summer of 1937, they completed the design of three 50mm lenses, the f/4.5, f/3.5, and f/2, as original equipment on the famous Hansa Canon camera introduced that same year. Nippon Kogaku actually manufactured all of Canon's lenses for their rangefinder models up to mid-1947. These lenses first incorporated the Canon bayonet mount and were later switched to the Leica screw mount. All prewar and early postwar Canons came with NIKKOR lenses. With World War II, Nikon was selected by the government to be the largest supplier of optical ordnance and grew to 23,000 employees and 19 factories. All that Nikon produced during this period is rare to find and is highly sought after by today's collectors.

At the end of the war the company was reorganized for civilian production under the occupational forces. Nikon was left with only 1,400 employees and one factory. They went back to optical production, but their legendary status was limited to Japan as the world had yet to hear of their products. Sometime in 1945–46, it was decided that they should produce a camera body of their own with interchangeable lenses and coupled rangefinder. A Twin Lens Reflex (TLR) and a 35mm design were considered but the TLR was soon dropped. On April 15, 1946, a production order was issued for 20 experimental "miniature cameras." Some time after that the name "NIKON," short for **NI**ppon **KO**gaku, first appeared on a body. The first rangefinder came out in 1948. And the rest, well, is history still being written.

Note: All references made to the position (top, bottom, left, and right, etc.) of the camera's various buttons, symbols, and controls refer to the camera when held in the shooting position.

Nikon Bodies—The Evolution

Nikon bodies have led the way over the decades. They have constantly evolved with new technological advances, raising the standards of the entire photographic industry. From the original all-metal, mechanical body to today's all-electronic models, Nikon has been the main system for pros since the beginning. Many of the design features utilized in today's cameras have their origins in those early mechanical models. By knowing how Nikon's 35mm SLR (single-lens-reflex) cameras developed, we can better understand current cameras and future camera technology. We'll delve into the evolution of Nikon bodies, highlighting the major technological innovations that make each one unique.

For those of you who own older camera bodies but have lost the instruction manual, this chapter aids in learning more about your camera. For those who own modern camera bodies and have read their instruction book but are still confused, this chapter clears the way. And for those connoisseurs of Nikon equipment who just want to lap up every little juicy tidbit about the system, this chapter is ideal! Some of the basics and some of the very complicated technical explanations, though, are not covered here. That information is available in the expanded *Magic Lantern Guides* on specific Nikon equipment published by Silver Pixel Press.

The information I bring to light comes from my personal experience with Nikon's SLR system. Nikon's first bodies were rangefinders, discovered by the first photojournalists and soldiers involved in the Korean conflict. The history of the different models is extremely well illustrated in Hove Book's *Nikon Rangefinder Camera* by Robert Rotoloni, which I highly recommend to rangefinder lovers. In my *Nikon System Handbook,* I start at the end of the rangefinder era with Nikon's introduction of their first SLR camera—the start of something really big!

The revolution and evolution of the Nikon SLR that we know today started with the "F" body. It established the standards still followed by the company today, the most important of which is the deliberate absence of "planned obsolescence." That is to say, what Nikon made yesterday still must work with what is made today. The most important design feature to be developed for the Nikon F was the Nikon F bayonet lens mount. This same mount is still incorporated into every camera body today, even with the introduction of autofocus (a feat many said could not be accomplished).

Nikon F

The **Nikon F** was the first "professional" camera model. Its basic construction and design can be traced back directly to Nikon's rangefinder cameras. The interchangeability of lenses, titanium foil focal plane shutter curtain, slip-down camera back, ability to be converted to motorized operation, shutter speed dial, and shutter release are all descendants of the rangefinder. The F went farther with innovations of its own, being the first body to incorporate interchangeable prisms and screens into its design. It also had many other new accessories and features, which made it the most advanced SLR of the day (and helps account for its popularity to the present).

Users of the Nikon F soon became accustomed to its durability and dependability. The F did not change significantly over the years of its manufacture (one million cameras were manufactured between 1959 and 1972) other than changes in internal parts. These

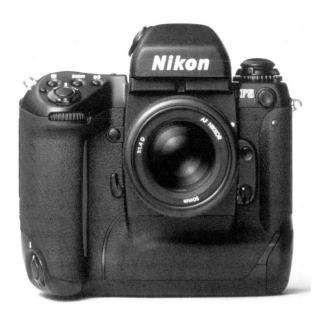

Nikon F5

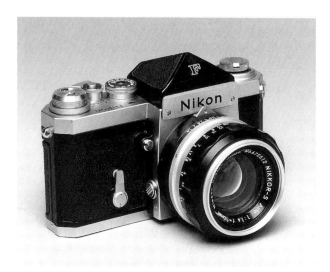

Nikon F

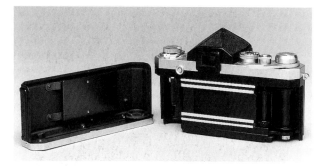

The back of the Nikon F slides off rather than swinging open as with later models.

were improved with the advance of new materials and technologies that came from constant research and a desire to improve the product. The main features of the F are:

❏ A 35mm SLR rendering a full-frame 24 mm x 36 mm on-film image
❏ Interchangeable prism finders
❏ Interchangeable viewing screens
❏ Automatic lens diaphragm operation for maximum aperture viewing while the lens is pre-set to any f/stop
❏ Standardized lens bayonet mounting flange
❏ Standardized shutter speed settings
❏ Titanium foil shutter curtain, focal plane type
❏ Vibration-free mirror and mirror box with mirror lock-up capability ("vibration-free" for the time)
❏ Built-in self-timer—3 to 10 seconds
❏ Flash sync up to 1/1000 second with flashbulbs, 1/60 second with electronic flash
❏ Depth-of-field preview button
❏ Self-resetting film counter
❏ Single-stroke film advance in a 136° stroke

❏ Removable film back for easy access to film
❏ Acceptance of metered prism
❏ Virtually 100% coverage of the picture field
❏ Film transport and pressure-plate design ensuring that the film is absolutely flat

These are the features of the basic F without any prism attached. The first F came with a standard eye-level prism finder (but understand, that's all that was available). The **Eyelevel Prism Finder** has no metered components but provides corrected viewing, permitting the photographer to view the scene through the lens exactly as it appears. The eyelevel finder originally came with a square viewing port. This requires an adapter (**Eyecup Adapter for Nikon F**) for eyecups or other prism finder accessories to be attached. Late in the production of the F when the F2 was about to appear on the market, the viewing port was changed from square to round, making an adapter no longer necessary.

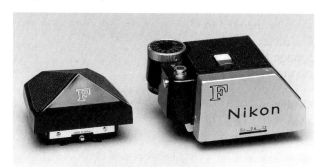

The Nikon F featured interchangeable prism finders. Pictured here are the F Eyelevel Prism Finder and the Photomic FTn Finder.

The original eyelevel finder, with its mirrored prism, developed a problem over time. At times, a complete or partial black band can be seen running through the viewfinder. This is caused by the silver coming off the center seam of the prism mirror. When the prism is removed from the camera, one can see the missing silver. Solving this problem is no easy matter. Most either buy a new prism or try to have the prism mirror re-silvered. My advice is to live with it or buy a DE-1 finder (the eyelevel finder for the Nikon F2). If the nameplate is removed, the DE-1 fits the F.

The finder is removed by depressing the small button on the back top left of the body (the same button is used for changing the screens). Metering is only possible with a clip-on external meter (**Model 3** came with a booster and incident light opal plate). It

couples with both the camera's shutter speed dial and lens aperture. The top of the meter provides exposure information. To determine the correct exposure, you must match the two needles by turning the shutter speed dial or aperture ring. It wasn't until 1962 that the first metered prism was introduced for the F.

The first Nikon F metered prism was the **Photomic Prism.** It combined the basics of the eyelevel prism with an external meter using a CdS (Cadmium Sulfide) cell. This metered prism is coupled to the shutter speed dial and aperture ring (it does not have through-the-lens metering). Correct exposure is set by centering the meter needle that appears in the viewfinder. This is accomplished by turning either the shutter speed dial or aperture ring. This information is also provided on the back topside of the prism.

The light meter readings are obtained from small interchangeable attachments on the side of the meter. A **Light Acceptance Converter Tube** and **Incident Light Opal Plate** were provided with the prism and, depending on the lens in use and/or lighting present, must be changed to obtain the correct meter reading. The meter worked with ASA 12 to 1600 films—quite a range for its day (ASA is now designated ISO, but the numbering has not changed).

This prism was replaced with the **Photomic T Finder** in 1965, which provided TTL (through-the-lens) metering. The TTL prism could now take into account any exposure variables such as filters, etc., which previously had to be calculated manually. Built-in condenser lenses in front of the two CdS cells in the prism minimize the influence of backlight entering from the eyepiece. It uses a match-needle system requiring the photographer to turn either the shutter speed dial or lens aperture ring to determine

exposure. All of this information is provided while viewing through the prism. Its ASA rating is 12 to 1600.

This finder was improved in 1967 and introduced as the **Photomic Tn,** the first Nikon metered prism to have center-weighted exposure metering. This finder, like the rest, is removed by depressing the release button on the back top left of the body. The meter is turned on by pressing a button on the right front side of the prism. It is turned off by pressing a button on top, next to the ON button.

Up to this point, all of the Photomic finders required that the maximum lens aperture be manually matched to the ASA dial on the prism to obtain the correct exposure. To maintain proper indexing, this must be changed each time a lens is attached.

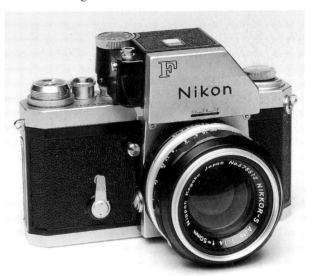

Nikon F Photomic FTn

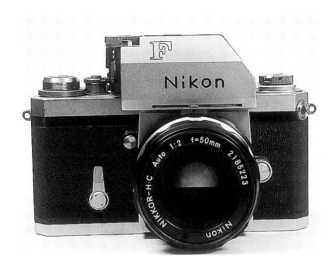

Nikon F Photomic T

In 1968, the Photomic Tn was replaced with the **Photomic FTn.** It provides semi-automatic maximum aperture indexing. This is accomplished when the lens is mounted to the body. First, set the lens' aperture ring to f/5.6, then mount the lens onto the body. Once it is attached, turn the lens to the minimum aperture, then back to the maximum, which indexes the meter to the aperture. The ASA range of the FTn was boosted to work with films rated from ASA 6 to 6400.

An exposure compensation dial surrounds the ASA dial on this finder. This was the first meter compensation setting to be designed into a camera meter, not physically related to just changing the ASA dial. The FTn was also the first metered finder to display the shutter speed setting inside the viewfinder.

To change the FTn finder on the F, depress the button on the back top left of the camera body while pressing in the lever on the right front of the finder. For older F bodies (serial number 6900001 or below), a small modification needs to be made to attach this finder to the body correctly. The Nikon nameplate on the body must be filed slightly. Turn the meter on by pressing the ON button on the right front of the meter. This pops the OFF button up and exposes a red line indicating the meter is on. Turn the meter off by pressing the OFF button on the top of the meter, directly above the ON button. To check the battery, press down on the OFF button when the meter is off. A good battery is indicated by the meter needle pointing in the center of the meter display (on top of the prism).

For their day, the F's shutter and mirror box were quite advanced. Its available shutter speeds are: 1 second, 1/2, 1/4, 1/8, 1/15, 1/30, 1/60, 1/125, 1/250, 1/500, and 1/1000 second, B (bulb), and T (time). When the shutter release button is depressed, a moment before the exposure is made, the mirror lifts up and the lens diaphragm (coupled to the mirror's action) closes down to the predetermined f/stop. Immediately after the shutter fires, the mirror comes back into place for instant viewing through the finder. These integrated actions are performed in approximately 71 milliseconds when the shutter speed is set at 1/1000. (To advance or rewind the film, there is a ring around the shutter release that must be turned to the appropriate setting—"A" for advance and "R" for rewind.)

The F was in production in the days of the flash bulb. Electronic flash was just starting to be developed and used commercially near the end of its production. The F was designed to synchronize with flash bulbs completely at all shutter speeds by changing the synchro-selector ring surrounding the shutter speed dial. The shutter speed can be adjusted to the particular type of flash bulb in use. The four settings for focal plane (FP) bulbs are: green dot = 1/125 to 1/1000 second, red dot = 1/60 second, white dot = 1/30 second, white dot with red F = 1/15 second or slower. The FX setting is for electronic flash. The F has a PC socket located on the upper left front corner of the camera body. Either flash bulb or electronic flash units can be connected to the camera through this socket and fire as the shutter releases.

The F has a mechanism that locks the mirror up during an exposure. The mirror lock-up button is at the lower right of the lens mounting assembly on the front of the body. Turn this button (it has a ridge in the center to facilitate operation) toward the red dot

to activate. To return the mirror to its original position, turn the button downward until the black dot on the button meets the black dot on the body. This should be done after the shutter is released or the mirror will not return to its original position to allow viewing until the next exposure is made. Losing one exposure of film during this process cannot be prevented. There were many special-production F bodies, one of which had a red dot on the back of the top plate. It was unique in that it could lock up the mirror and not lose a frame of film. It is believed to have been made for astronomers for use on large telescopes.

The F had optional finders designed for special applications. This was a first. These finders replaced the metered finder, but had no metering capability. The **Waist-Level Finder** permits direct viewing from the top of the camera. The principal reasons behind its manufacture were to aid in photographing subjects at ground level and for use on copy stands or microscopes. Both models of waist-level finders have a built-in magnifier (3x) that pops up when a button on the top of the finder is depressed. The first waist-level finder was a three-sided model. The last model made has four sides (made during the period the **DW-1** was being produced for the F2) and is the rarest and most sought-after model. The original waist-level finder, when purchased new, came with a small leather case and was wrapped in a small piece of green material, a special touch that Nikon added but soon abandoned.

The **Prism Reflex Action Finder** (commonly called the **Sportfinder F**) was an innovation designed for photographers who wear safety glasses or goggles, permitting greater viewing distance. The standard pentaprism finder (an eyelevel finder) requires a normal eyepoint of 15 mm to 18 mm (about two-thirds of an inch) to view the entire screen, whereas the Sportfinder permits viewing from as far away as 60 mm (2.4 inches), with complete screen viewing at 20 mm (0.8 inch). For many decades, the F-Sportfinder combination was extremely popular with underwater photographers because it could be used inside an underwater housing and provide complete screen viewing.

The one other finder for the F is the **6x Magnifier.** This ghost of a finder is extremely rare; it looks just like the **DW-2** finder for the F2. The 6x finder has a built-in diopter, which must be customized by focusing on the rangefinder split on the ground glass of the viewing screen before it is used to focus on a subject. This finder has the same angle of view as the waist-level finder, but provides critical focus, especially for

high-magnification work. Like the four-sided waist-level finder, the F 6x finder came out near the end of the F production line when the F2 and its accessories were beginning to be manufactured.

The F's interchangeable viewing screens were another major innovation of the day, which photographers found to be indispensable. The F came with the A screen as standard equipment. The "A" has a split-prism rangefinder (3 mm [0.1 inch] in size) that is dead-center in the screen. It is surrounded by an all-matte Fresnel field. A 12 mm (0.5 inch) concentric circle surrounds the split to delineate the weighted metering area of the metered finder. Twenty-one other screens were developed for the F, many with very specific purposes; others were more generic. (General descriptions and applications for each screen can be found in the *Accessories* chapter.)

The F went through some cosmetic changes near the end of its production as the F2 came on line. Some of the F2 parts were adapted for the F. The most obvious change was in the film advance lever, which was originally all metal. The F was later equipped with the plastic-tip style lever adopted for the F2.

Many believe that the serial number of an F indicates the year of manufacture. This is not true. The first two digits of the serial number do not correspond directly to the date of manufacture, but this numbering system is widely used to no harm. For example, the F camera was introduced in 1959, but the earliest serial number recorded is 6400001. The serial number of the last Fs manufactured started with "74," though they were actually manufactured only until the end of 1972.

There were many special versions of the F, many known only to Nikon. The **F HighSpeed** line was made for a limited time. One was the **F HighSpeed Sapporo,** firing 7 fps (frames per second), and another was the **F HighSpeed Montreal,** firing 9 fps. Another F was the **F Motor Pellicle** with a pellicle mirror. Two other known versions were a NATO green version, believed to have been made for NATO forces, and an all-white version (for what purpose, unknown). Many Fs had other modifications, special symbols, and notations that now make them quite collectible. There is enough material to write an entire book just on the history of the F, which this book in no way attempts to do.

Nikkormat FT and FS

In 1965 when Nikon introduced the F Photomic T, they also introduced their first Nikkormat. A less sophisticated line of camera bodies, the Nikkormats were the first in a long line of bodies with non-interchangeable prisms and which lacked certain features and accessories found in the "professional" bodies.

Two Nikkormats were brought on the market in 1965, the first being the **Nikkormat FT.** The FT was a moderately priced SLR with a fixed pentaprism. It accepted all Nikkor lenses and some Nikon system accessories. Later in 1965, Nikon introduced the **Nikkormat FS,** a simplified version of the FT without the exposure meter and mirror lock-up. This model was not very popular and production lasted only six years.

The metering in the FT is biased evenly over the entire image area. Two regular condenser lenses in front of the two cells (on either side of the viewfinder eyepiece) project an image of the entire screen onto the surface of the CdS cells. The meter is activated when the film advance lever is moved out from the body 35° (there is a detent to hold it there). It remains on as long as the lever is out.

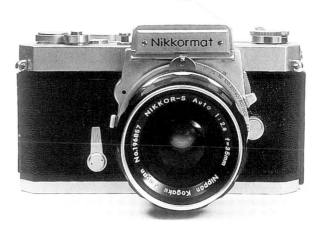

Nikkormat FT

The Nikkormats' finder coverage is only 92% of the picture field (whereas the F has virtually 100% coverage). The Nikkormats also have the faster "swing-open" film back (not the slip-down model of the F), a style change inherent in all future models of Nikon cameras. Opening the back is done by pulling down on a small tab on the left at the base of the body, below the flash sync socket.

Shutter speeds are set by turning a ring that encircles the lens mount. The shutter speed selected can be seen within the viewfinder. Three white numbers appear on the lower edge of the viewfinder; the selected shutter speed is in the middle. It is also indicated on the outside of the body at the top right of the lens mount. Correct exposure is determined by centering the needle between the brackets inside the viewfinder or by centering it in the circle on top of the prism. The same ring that sets the shutter speed also sets the ASA setting. It has an ASA range of 12 to 1600.

Like with the Photomic T and Tn finders, the lens' maximum aperture needs to be indexed to the film's ASA for correct exposure readings with the FT. This must be reset every time a lens with different maximum f/stop is attached. The viewing screen, an all-matte Fresnel with a 12 mm central microprism circle, is not interchangeable. The FT has depth-of-field preview capability, which is accomplished by pressing a button on top of the body, to the right of the pentaprism.

The Nikkormats (with the exception of the FS) also have a mirror that can be locked up. This is done via a flat sliding tang to the left of the lens mount (just above the lens release button). Though hard to push, this feature is useful. It permits the use of lenses, such as the 21mm f/4, that require the mirror to be locked up. The cameras also have a self-timer with a duration of ten seconds, however they are missing a flash mounting shoe. Attaching a flash is accomplished with the **Nikkormat Accessory Shoe.** This attaches to the prism and is held into place by an eyecup retaining ring. Connections are made by plugging a PC cord into either the M or X socket on the left side of the body.

The film advance (on the top right of the body) is a single-stroke, 120° advance. The film advance lever needs to be away from the body 35° to activate the meter (it has a detent for this). The meter remains on as long as the lever is left out. The shutter release button and frame counter are also located adjacent to the advance lever.

Nikkormat FTn

The big breakthrough in the Nikkormat line came in 1967 with the **Nikkormat FTn.** The reception of this camera was so great that one photo magazine of the day said, "The danger of building a better and more economical mousetrap is that it can be too successful, thereby making [it] a liability [to] your more expensive models....this may appear to be the case with the Nikkormat camera vs. the Nikon F." What made the FTn so hot? The FTn, with so many new improvements, was priced the same as the FT. This is probably the only time in photographic history that this has happened. (Keep in perspective that things like pocket calculators and other electronics we take for granted today were not even on the market yet.)

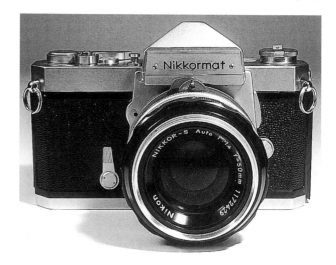

Nikkormat FTn

Housed in the same body as the FT, the FTn's big new feature was its center-weighted meter. The CdS meter behind the lens reads the finder screen at full aperture with an emphasis on the central area. This minimizes exposure errors caused by backlight, long lenses, and extraneous light surrounding the subject. The FTn's meter has plastic, aspherically convex, and Fresnel grooved lenses that form an image from the central 12 mm diameter circle of the viewing screen to achieve center-weighted metering.

The new ASA indexing system on the Nikkormat FTn was also revolutionary. Lenses mounted on the FT, or even the Nikon FTn (the Nikon F with a Photomic FTn metered prism), are indexed by setting the maximum aperture opposite the ASA of the film. This is a time-consuming procedure when trying to photograph action. Other manufacturers made their lenses obsolete in adopting a system of semi-automatic indexing. Nikon's commitment to planned non-obsolescence held true with the FTn's new, semi-automatic system. The ASA is indexed by a unique, spring-loaded connecting ring on the lens mount. It has a sliding metal indicator that is aligned with the appropriate ASA number. When the lens is mounted on the body, the aperture should be set at f/5.6. By turning the aperture ring to the lens' smallest

aperture then back to the largest, aperture indexing is completed.

Other improvements on the FTn are found inside the viewfinder. The brackets for the match-needle metering have been given a minus sign at the top and a plus sign at the bottom. This is an easier system to read quickly and to adjust for correct exposure (by centering the needle). One drawback, however, is that the movement of the needle is nonlinear. The same amount of movement up does not equal a comparable movement downward. The shutter speed readout at the bottom of the screen on the FTn was changed from that of the FT. Of the three shutter speeds displayed, the selected shutter speed is white while the other two are yellow. The Copal Square-S vertical shutter provides the FTn with a 1/125 second flash sync.

The FTn has the same screen as the FT, except that the outside Fresnel rings are slightly closer together (50 mm lines per compared to the original 25 mm) to enhance picture brightness. Later, an FTn came out with the option of a rangefinder screen that has a split-image rangefinder (4 mm in diameter) in the center of screen surrounded by a matte Fresnel field. All of these improvements added only 1 ounce to the overall weight of the FTn (39 oz.) versus the FT (38 oz.).

Nikkormat EL

The next change in the Nikkormat line did not come until 1972 when the **Nikkormat EL** was introduced. Its contributions to today's Nikons are Aperture-Priority automation plus the option of full manual control, and exposure memory lock.

Though the EL contained many components of the FTn, it was given completely new cosmetics. The shutter speed dial no longer surrounded the lens mount, but was brought topside to the right of the prism (the prism is not interchangeable). It has 15 shutter speeds ranging from 4 seconds to 1/1000 second, plus a "B" for bulb and an "A" for Aperture-Priority. By pulling up on the outer ring of the shutter speed dial, flash sync can be changed to work with either electronic flash or flash bulbs. The difficult FTn mirror lock-up latch was also changed to an easy throw switch located on the lens mount. The EL came with the same style viewing screen as the FTn, but can often be found with a split rangefinder screen, which can be a factory- or custom-installed feature.

The meter has CdS cells concentrating 60% of their reading on the center of the "bright matte" (not the same as the future bright matte) Fresnel screen. This is center-weighted metering. The meter readings are displayed on the inside of the viewfinder along the left edge of the display. They start at 4 seconds on the bottom and go up to 1/1000 second. A solid green bar moves as the shutter speed is changed, indicating the manually selected speed. In Manual, the black needle moves in reaction to the light. This must be matched to the green bar by adjusting either the shutter speed or aperture to obtain the correct exposure.

When the camera is set to Aperture-Priority mode, the green bar covers the "A" (at the top of the scale) and the black needle moves, indicating the shutter speed the camera has chosen. Based on the meter reading, the camera sets the shutter speed to correspond to the aperture the photographer has selected. In Aperture-Priority mode, the shutter speeds are stepless. The camera can pick a shutter speed such as 1/67 second, 1/467 second, or hundreds of other speeds not listed on the shutter speed dial. The camera indicates only those speeds that are on the scale, even when a stepless shutter speed has been selected. This aids the photographer in comparing the camera's meter setting against his or her mental calculations.

The ASA setting on the EL was moved to the far left topside of the camera. It is set by turning a ring located under the film rewind lever. The semi-automatic indexing of the FTn is still employed on the EL, but the maximum aperture is displayed on the left of the lens mounting ring. Mounting a lens onto the EL still requires setting the lens at f/5.6. After mounting the lens, index the meter, rotating the aperture ring to the minimum aperture then back to the maximum. The traditional F bayonet lens mount is still employed as on all previous Nikon bodies.

When turned counterclockwise, the EL's self-timer provides up to a ten-second delay. When pushed in towards the lens mount ring, the self-timer lever becomes the memory lock (when the camera is in Aperture-Priority). The EL has a depth-of-field button, found on the right, above the self-timer lever.

The camera's 6v battery, which runs the meter and the electronic circuitry of the shutter, is located under the mirror inside the mirror box. Use the mirror lock-up lever to lock the mirror up in order to gain entry to the battery box (a small tab at the base of the mirror box). The EL has a battery check system. Depress the battery check button located on the top left of the back cover. This will light up an LED to its left if the battery is good.

The EL camera back opens by pulling up on the film rewind knob. This was a new feature that has since been retained in Nikon bodies for two decades.

Nikkormat FT2, ELw, and FT3

The Nikkormats did not change radically after the introduction of the EL. In 1975 the **Nikkormat FT2,** a modified FTn, came on the market. The FT2's biggest change was its built-in hot shoe for mounting a flash directly onto the body. In conjunction with this, the FT2 has an automatic M/X switchover determined by shutter speed selection. This works with either an electronic flash or flash bulb. For bigger flash units, there is a standard PC plug on the top left side of the body. All other features and operating procedures remain the same as those of the FTn.

In 1976 came the introduction of the **Nikkormat ELw** ("w" standing for winder-compatible). Other than a modification made to accept the winder, there were no other changes to the EL's body design or its features. The **AW-1,** a very simple film winder, attaches to the bottom of the ELw and advances the film when the shutter release button is pushed. The AW-1 is extremely noisy and prone to breakdown because of a nylon gear that is easily stripped on one of the main drive shafts. A gear from the MD-3 can replace the stripped gear, but it is difficult to obtain anymore.

In 1977, the next camera in the Nikkormat line was introduced, the **Nikkormat FT3.** The FT3 is a direct copy of the FT2 with one exception, it works with the then newly introduced "AI" (Automatic Indexing) system.

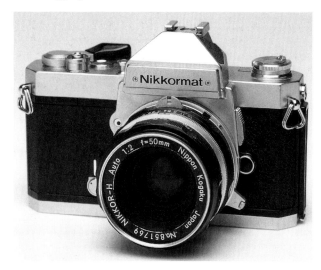

Nikkormat FT3

Nikon EL2

Later that same year, the **Nikon EL2** came on the market. It is an exact copy of the ELw except that it works with the "AI" indexing system. These last Nikkormats were produced for a brief period (production numbers were never released). Few ever reached the U.S. market. The FT3 and EL2 are still in use today by many photographers and are, mechanically, extremely reliable. With the passing of the EL2 went the era of the Nikkormats.

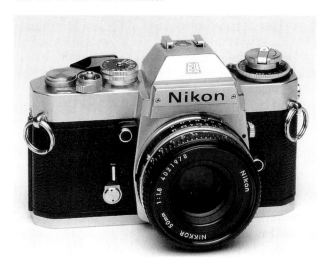

Nikkormat EL2

Nikkormat cameras with a "Nikomat" nameplate were originally sold in foreign markets. The "Nikkormat" nameplate was on cameras imported into the U.S. In the same way, the N90s is the same as the F90x, which is sold in markets outside the U.S.

Nikkorex F

There was one camera that Nikon brought on the market for a brief time, which should be mentioned. In 1961 Nikon introduced the **Nikkorex F,** a medium-priced SLR that would accept the Nikkor F lenses. It had an accessory shoe located in the front for an external meter, but otherwise it was pretty barren of features. Not many were manufactured, so it was not on the market long. Occasionally these cameras come on the used market and are mistakenly purchased as collectibles, but their real value is actually less than $100.

Nikon F2

In the fall of 1971, Nikon introduced their first change to the pro series Nikon bodies. The **F2** was a big departure from the F. It was given a cold reception at first by the thousands of loyal, diehard F owners (which happens any time a new pro body is introduced). But in a seemingly short time, the F2 became the workhorse of photographers around the world. Some of the concepts of the F were carried through to the F2. Features such as interchangeable prisms, screens (the F2 utilizes the exact same screens as the F), and the bayonet F lens mount remained the same. The F2 was also the beneficiary of many of the Nikkormat's innovative designs. Features such as a hinged film back and other cosmetic features were incorporated into the F2's design. But the F2 brought many of its own innovations to the Nikon line.

The basic F2 controls were designed and placed for optimum ease of operation. On the top right is the film advance lever (with plastic tip) that has a short, single-stroke action of 120°. Film advance can also be performed by a number of shorter strokes. Pulling the film advance lever out from the body 30° activates the power for the meter. The meter remains powered as long as the advance lever is left out in this position. Directly above the film advance lever is an additive frame counter. This indicates how many frames have been fired. The shutter release, next to the advance lever, is protected by the T/L ring. The ring has two functions, setting the camera for time exposure ("T") and preventing the camera from accidentally firing ("L," for lock). To use those functions, lift up the ring and turn it until the notch is either set to "T" or "L." Leave the notch in the center for general shooting. The **AR-2** cable release screws around the shutter release button for hands-off firing.

The shutter speed dial is adjacent to the prism. Its settings are Bulb ("B") and 1 second through 1/2000 second. The F2 was the first Nikon with a top shutter speed of 1/2000 second. The red line on the shutter speed dial between 60 and 125 indicates the top flash sync of 1/80 (though 80 is not imprinted), and the dial can be set at that line for flash sync.

The F2 provides stepless shutter speeds when working between 1/80 and 1/2000 second. It is possible to fine-tune the exposure using the shutter speed dial (as opposed to using the aperture ring) when a metered prism is attached to the body. Controls for turning the shutter speed dial are different depending upon whether a metered prism is attached or not. With a metered prism, the shutter speed dial is turned via a knob atop the prism.

Without a metered prism, you can just turn the shutter speed dial on the body.

In the center of the shutter speed dial on the body is a small line that rotates as the film is wound through the camera. This is a visual indicator for the film advance. It cannot be seen if a metered prism is attached to the camera.

The film rewind knob and accessory shoe are the only features on the top left side of the F2. To rewind the film manually, first depress the small button located on the base of the body. Next turn the rewind knob in the direction the arrow points until the film is back in the cassette. The accessory shoe that surrounds the rewind knob accepts only a special Nikon flash shoe, which is not a standard ISO flash shoe. The **AS-1 Accessory Shoe Attachment** is required to attach a standard ISO-foot flash unit, and provides a hot-shoe connection. There is a standard PC plug on the front of the camera (in front of the accessory shoe), if required.

The button on the back of the camera (directly behind the film rewind knob) allows you to remove viewfinders and screens. Removing a viewfinder requires that you depress that button (a strong, pointed object is recommended unless you have mega fingernails) and then press in and turn the lever on the viewfinder. Removing the DE-1 viewfinder requires just depressing the button. This same button is used to remove the screen from the body (when no viewfinder is attached). This is performed by continuously pressing the button while carefully turning the body on its side until the screen drops free. When a viewfinder is not attached to the F2, you'll notice two posts on either side of the viewfinder mount. The post on the left side (when viewed from the back) is surrounded in plastic, the other is bare. These posts channel the power up from the battery box to power the meter.

The depth-of-field preview (DOF) button, mirror lock-up lever, and the self-timer are on the right front of the F2. The depth-of-field button and mirror lock-up lever are part of the same assembly (at the top, near the shutter release button). Depressing the DOF button closes the automatic diaphragm down to the set aperture. This causes the viewfinder image to become very dark. Turning the ring around the DOF button locks the mirror up. Below this is the self-timer, which, when activated, delays firing for up to ten seconds.

Note: The depth-of-field preview button on camera bodies doesn't perform some magical voodoo. Lenses come with an automatic diaphragm, a spring-loaded affair that holds the aperture blades open to

permit bright viewing. Without this spring, we'd always be looking through the set aperture, making viewing and focusing extremely difficult. The DOF button merely lets the lens close down to the selected aperture. It then takes a talented and good eye to see the resulting depth of field.

On the base of the camera is the O/C Key (Open/ Close). It folds out and, when turned in the direction of the arrow, pops open the camera back (it must be manually reset after closing the back to its original position). Next to this is the battery chamber, which holds the two 1.55v (MS76) batteries that power the meter. To the right (below the sprocket roller) is the film rewind release button. Two motor drive connecting sockets are on the base as well.

The finders first released with the F2 in 1972 were a standard pentaprism, the **DE-1,** and a metered prism, the **DP-1 Photomic**. (The combination of the F2 with the DP-1 is referred to as the **F2 Photomic.** There is no name for F2 with the DE-1 attached.) The F2 body always remains an F2 no matter what finder is attached (though there were hundreds of internal changes over the many years of production). The DE-1 and all other finders for the F2 provide virtually 100% viewing, so what you see is what you get. This is aided by a newly designed mirror in the F2, which is physically larger to prevent image cutoff, especially when using a telephoto lens. The compact DE-1 was designed with photojournalists in mind. At the time, they relied more on the handheld meter than the newer TTL meters. The DE-1 has an electrical post on the back left side that, when connected with a dedicated flash (SB-2 or 7E, for example) or accessory, lights up a flash-ready signal at the top of the prism finder's eyepiece.

In its day, the DP-1 Photomic finder was quite a mechanism. It employs high-quality CdS cells. As a testament to its durability, many are still in use today. Improvements in its design let the meter function from EV 1 to EV 17 at ASA 100. The center-weighted metering system concentrates 60% of its reading from the 12 mm circle on the screen (app. 1/8 of the total area of the screen) and becomes gradually less sensitive towards the edges.

The ASA setting range is an amazing 6 to 6400! The meter couples with the lens for semi-automatic indexing (as on the Nikkormats). To index the lens to the meter, mount the lens with the aperture set at f/5.6, then rotate the aperture ring from its minimum back to its maximum aperture. A window on the front of the prism displays the maximum indexed aperture. For example, with an f/2 lens and a properly indexed meter, f/2 appears in the window. The information inside the viewfinder provides the photographer with the shutter speed and aperture in use. It also provides a match-needle meter readout.

On the top of the DP-1 is a window that's split in half. The top half is a plastic light diffuser that illuminates the meter needle inside the prism. The bottom half displays the same match-needle meter reading found inside the prism. For correct exposure, the needle must be centered in the empty space between the squared-off box. When the needle touches the right point of this box, the meter is reading that the scene is approximately 1/3 stop underexposed. When it touches the left point, the meter is reading that the scene is approximately 1/3 stop overexposed. If the needle is anywhere past these points, exposure is more then 1/3 stop over- or underexposed.

When viewed through the finder, the shutter speed readout is to the right of the needle, the aperture is to the left. Both numbers are on a wheel that turns inside the prism when either the shutter speed dial or aperture ring are adjusted. These can sometimes get out of alignment or stuck between numbers, but that can be easily repaired.

On the right front of the DP-1 is a silver battery check button. Depress it and the needle should center in the meter readout, indicating a good battery. The lever right beside the battery check button is used to remove the finder. To do so, press in and turn the lever while pressing in the finder release button on the back of the body. To remount it, press the finder back onto the body, spinning the shutter speed dial to make sure it aligns with the dial on the body.

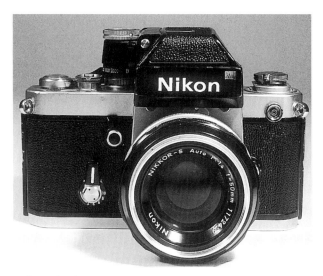

Nikon F2 Photomic

The serial number located on the top left of the body has been mistakenly believed to indicate the year of camera manufacture. For example, a camera with serial number 7100001 is called a "71" body and is assumed to have been manufactured in 1971. This does not hold true at all, but does help identify the earlier models with problems. Some early model F2s with serial numbers beginning with "71" and "72" had a problem with the film transport system. The drive cam on the take-up spool has a slight kickback to it when advancing the film, which can give a ghosting effect to the photograph. This problem is most obvious when a motor drive is used. There is no easy or inexpensive fix. Throughout the years of F2 production, many internal changes were made to perfect the camera's operation, and this was one of the first.

Nikon introduced its first new metered prism for the F2 in 1973, the **DP-2.** The combination of the F2 body and the DP-2 finder is referred to as the **F2S** (the long version is F2S Photomic). The DP-2's main new feature is in the way it relays the exposure information to the photographer. Instead of having a needle to center, it has diodes that display over- or underexposure in the viewfinder display. These diodes are also visible in the window on the top of the prism. The arrow on the right indicates underexposure; an arrow on the left, overexposure. When both are lit simultaneously, exposure is correct. The DP-2 with its CdS cells is more sensitive than the DP-1 (but CdS cells are still not very sensitive), having a range of EV -2 to EV 17. It still employs the same meter coupling system as the DP-1.

The DP-2 can meter down to 8 seconds. This was a new feature. First, turn the shutter speed dial to "B" (bulb). Then press the button in the center of the ASA dial. The ASA dial can now spin, showing 2, 4, 6, and 8-second markings directly above the "B" setting. The number set above the "B" is the shutter speed for which metering will be set.

A window on the front of the DP-2 indicates the maximum aperture setting. The lens must be properly mounted and indexed for correct operation. There is a new set of contacts under a ledge near the left front of the finder. These hook the DP-2 up to the **DS-1 EE Aperture Control Unit.** This attachment provides Shutter-Priority operation. Working off its own separate battery (the **DN-1 NiCd** charged with the **DH-1 Charger**), it is mounted by first removing the lens and PC cap from the body. The DS-1 has a ring that fits around the lens mount. This ring has a squared-off tang on a track that connects to a small tang on the lens' aperture ring. This ring slips over the lens mount as the locking knob on the DS-1 is

turned and screwed into the PC socket. This permits the DS-1 to change the aperture for correct exposure. The chosen shutter speed causes either the plus or minus diodes to light up in the viewfinder, indicating exposure. At the same time the DS-1 receives the information, it receives impulses that turn the aperture ring until both diodes light up indicating correct exposure. With any lighting changes, the DP-2 sends a signal to automatically change the DS-1, which sets the correct exposure. Though extremely accurate, the DS-1 is very, very slow in operation. A later introduction, the **DS-2** is the same as the DS-1, except that it has a PC socket.

The F2 accepts updated special-application finders. The **DA-1 Action Finder** (also called Sportfinder) is an updated version of the F Sportfinder. It has the same specs as the F Sportfinder, with minor cosmetic changes. The **DW-1 Waist-Level Finder** has a four-sided folding hood with a pop-up magnifier (as released at the end of the F era). The **DW-2 6x Focusing Finder** is the critical focusing finder. It has an enlarged eyecup that is removable. These finders do not have a prism to correct the image, so everything is seen in reverse. These finders can work on the F if modified, normally by removing the nameplate and filing some. The metered prisms for the F2, though, do not fit the Nikon F, mainly because the F has no battery posts to deliver the power to the top of the body.

In 1976, Nikon introduced another new finder, the **DP-3.** When attached to the F2, this combo is referred to as the **F2SB.** The DP-3 is a fantastic finder! It was the first to come out with a very sensitive light-gathering system: Silicon Blue Cells (which have withstood the test of time). (These are also called Silicon Photo Diode, or SPD, cells.) The cells are coupled with a five-stage LED display to indicate correct exposure.

Inside the finder there is a plus, a circle, and a minus sign (from left to right). The circle is lit by itself when the exposure is correct. A lighted circle with the plus sign denotes overexposure by 1/3 stop. A circle with a minus sign means 1/3-stop underexposure. If only the plus or minus sign is lit up, exposure is off by one or more stops.

The DP-3 has an eyepiece curtain which should be closed when firing the camera remotely. This prevents extraneous light from entering the prism and causing errors in exposure readings. The DP-3 works with either the DS-1 or DS-2 for Shutter-Priority photography.

The F2 system continued on for three years without any major changes until 1977. That is when AI

Nikon F2AS

Nikon F2H with the MD-100 Motor Drive

coupling was introduced to the system in the production of the **DP-11** and **DP-12** metered finders. The F2 camera and DP-11 combo is referred to as the **F2A,** and the F2 with the DP-12 as the **F2AS.** The DP-11 is an exact copy of the DP-1 but with AI meter coupling added. The DP-12 is an updated DP-3 with AI coupling. Both metered finders lost the maximum aperture window in the front. It was no longer needed since that meter coupling system was no longer in use.

The DP-12 had a new EE aperture control unit, the **DS-12.** It works the same as the DS-2 but has slightly different couplings for the lens' aperture ring (because of its being AI coupled). The AI metering prong can be locked up on both the DP-11 and DP-12 so that non-AI lenses can be mounted to the body. Meter coupling is lost, though. Just press the metering prong on the front of the meter up, and it snaps up out of the way. Pressing the button located above the letters "A" or "AS" on the front of the finder releases the prong back to AI meter coupling.

Other F2 models were introduced in limited quantity in 1976. The first was the **F2T,** identical to the F2 except its back, top, and bottom plate were made of titanium, a very strong, yet lightweight metal. The body came with the **DE-1T,** a DE-1 finder with a titanium top. The F2Ts were distinguished from other F2s by a textured finish. Those with a serial number starting with "79" have the word "Titan" written on them. A chrome version also came out with this inscription. Those with serial numbers starting with "92" were missing the word and were a flat black color. The F2T accepts all accessories available for the F2 without modification. This includes metered prisms and motor drives. Nikon also made special F2Ts for the space program. Appropriate monikers (NASA, Titan, etc.) were inscribed on these cameras' faces, and they are now *very* rare.

The **F2H** came out the same year with a titanium body and a special pellicle mirror. The pellicle mirror does not flip up like a normal mirror when an exposure is made. It stays in place, permitting the photographer to view through the lens while a picture is taken. The photograph itself is taken right through the mirror.

Screens cannot be interchanged in the F2H; a B screen is permanently mounted. The body has been stripped of the self-timer as well as the "T," "B," and 1/2000 second shutter speed settings.

Connected to the motor drive **MD-100,** the F2H can fire up to ten frames per second. The MD-100 is powered by a permanently attached, double-stacked **MB-1 Battery Pack** that is loaded with four **MN-1**

NiCds. It comes with a special charger that charges all four NiCds at once. The F2H was produced in very limited numbers and is collectible, as well as being extremely sought after for active shooting.

Nikon FM

In 1977, Nikon embarked on a whole new line of compact bodies. The **FM** was the first to be introduced with basic, functional features. This soon made it quite popular (and it is still in wide use today). It is significantly smaller and lighter than the Nikkormat or EL series, however it maintains full-sized operating controls. Like all Nikons to come, the FM meter couples with the AI system.

The FM had completely new metering cells, radically different from all previous models. Gallium Photo Diodes (GPD) respond to light changes with incredible speed, especially at low light levels. This increased sensitivity (EV 1 to 18) quickly caught on with users. The center-weighted TTL meter has the standard 60% bias in the 12 mm circle centered on the screen. The FM has a fixed Nikon type K screen—a split rangefinder 3 mm in diameter surrounded by a microprism circle, which is, in turn, surrounded by an overall matte Fresnel.

The viewfinder readout is clean and simple. On the right is the meter display with a plus, a circle, and a minus sign. Next to them, a red LED communicates exposure like other LED or diode systems found in previous Nikon bodies. The shutter speed is on the left-hand side. The selected aperture can be seen on the top of the display, in the center. This appears via the new Aperture Direct Readout (ADR) system in conjunction with the new AI lenses. The aperture ring has two sets of numbers, the smaller set being read by the ADR. A mirror on the top inside of the prism reflects them into the finder. Like most Nikons, the finder has a built-in -1 diopter correction.

The FM finder coverage is only 93% of the picture field. This means that a portion of the image is not seen through the finder but is captured on the film. (This is supposed to correspond to the amount of image lost when the transparency is mounted in a slide mount.) The FM does have an oversized instant-return mirror. This prevents image cut-off when shooting with telephotos, bellows, or other high-magnification gear. It also has a special mirror-dampening mechanism and other construction characteristics based on those proven in the F2. Unlike the Nikkormat, the FM has no mirror lock-up capability. Mirror lock-up utilizes quite a bit of space inside the mirror box as well as adding weight. This feature would have increased production costs, price point, and size, all of which defeat the purpose of a compact camera.

The FM's unique shutter travels vertically rather than horizontally as in previous Nikon bodies. This minimizes noise and vibration during exposure while increasing durability. The shutter speeds on the FM range from 1 second to 1/1000 second plus "B," with a flash sync of 1/125 second. A simple multiple exposure control is available by pushing the small lever located next to the film advance lever. This permits the shutter to be cocked without advancing the film. After the camera is fired, advancing the film restores normal operation. This function works with a motor drive attached as well.

The FM accepts all Nikon lenses (except those requiring mirror-up operation like the 10mm f/5.6 OP). Its meter couples with the newer AI lenses. For mounting non-AI lenses, the AI meter prong on the FM folds back out of the way. This is accomplished by pressing the button next to the AI prong on the meter coupling ring and then pushing back on the prong. Once done, stop-down metering is required to obtain the correct exposure. The FM has a depth-of-field feature, which is activated by pressing the lever to the right of the lens mount in towards the body. The FM also has a 10-second, cancelable self-timer.

A state-of-the-art film transport system is also featured in the FM. Typical of the current designs, the FM has an oversized pressure plate, extra-long film rails, cassette stabilizer, a film roller to prevent bowing, plus emulsion-side-out winding on the take-up spool. All this combined assures superior film flatness for optimum edge-to-edge sharpness. The single-stroke film advance is 135°. When the film advance lever is at 30°, the meter is activated. There is also a hinged film back that has become standard equipment on Nikon bodies. The FM has a hot shoe that is attached to the prism. An automatic safety switch built into the shoe prevents a voltage spike from damaging the camera contacts. A standard PC socket on the body permits a flash unit to be attached with a PC cord.

The FM has a standard threaded cable release socket surrounded by a rotating collar. This collar must be properly set to sync the FM with the optional motor drive, MD-11. With a black FM, turn the collar so its mark aligns with the red dot for use with a motor drive or with the white dot for manual film advance. With a chrome FM, turn the ring to the red dot to sync with a motor drive and to the black dot for manual advance. In later models this feature was

dropped in favor of a system that did not need to be set manually.

The **MD-11 Motor Drive** was the motor drive originally designed for use with the FM. It connects to the base of the FM with a turn of the thumb wheels. And it can provide up to 3.5 frames per second film advance. It has a socket for remote firing using the **MC-10 Cord** or **MR-1 Button.**

Nikon FE

In 1978, the **FE** was introduced to the line (the "E" stands for electronic). Though its body looks exactly like the FM, the FE is different in that its shutter and meter are completely powered by batteries. The FE offers an Aperture-Priority mode as well as complete manual exposure control with match-needle metering.

Nikon FE

The FE has three interchangeable screens: the K (standard), which has a split rangefinder; B (plain matte) with 12 mm circle; and E, known as the architectural screen, which is the same as the B but with three horizontal and five vertical lines. It has dual SPD cells with a monolithic integrated circuit for 60% center-weighted metering (what a mouthful). Exposure information inside the viewfinder is similar to that in the EL series (which was still on the market at this time). The shutter speeds are displayed on the left—a green bar indicating the chosen shutter speed and a black bar indicating correct exposure. The Aperture Direct Readout is employed, displaying at the top of the viewfinder the aperture set on the lens.

When Nikon system flash units are used, a ready light appears in the viewfinder when the flash is powered up. If the shutter speed is faster than 1/125 second when the flash is attached, the ready light flashes a warning.

The shutter speeds range from 8 seconds to 1/1000 second, plus "B" and "Auto" (for automatic shutter speed selection, a.k.a. Aperture-Priority mode). A new setting appeared on the FE, the "M90" setting. In case dead batteries cause a shutter speed shutdown, turn the shutter speed dial to M90. This provides a mechanical 1/90 second shutter speed. Metering functions are still inactive, but you can at least limp by with one speed. On the back top left of the FE is a battery check LED. Utilizing this feature prevents your being stuck by battery failure and having to use the M90 feature.

The FE has no mirror lock-up. It does have the FM-style depth-of-field lever for DOF preview. This also makes possible stop-down metering with non-AI lenses. The FE also features a lock-up AI prong on the aperture ring. The ASA dial and a new exposure compensation dial surround the film rewind knob. Exposure compensation can be biased by +/- 2 stops in 1/2-stop increments.

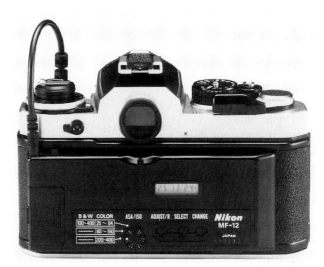

MF-12 Data Back

The camera has a detachable hinged film back that can be replaced with an **MF-12 Data Back.** This back can imprint simple numbers such as year/month/day on the lower right corner of the image. It is connected to the camera via a cord (Replacement Cord, product #4418) to the PC socket. The back is triggered just the same as a flash would be,

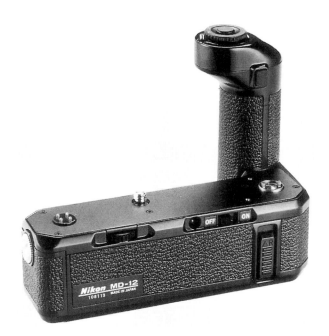

MD-12 Motor Drive

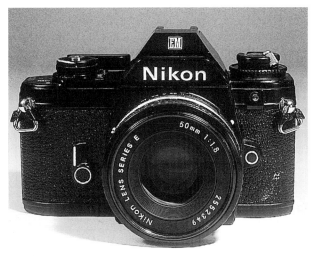

Nikon EM

imprinting at that instant. The FE can also use the newer **MD-12** or older MD-11 motor drive.

Nikon EM

In 1979, a year after the introduction of the FE, Nikon entered the consumer market with the **EM.** This ultra-compact camera was stripped of most of the basic features desired by "serious" photographers. It does not have a depth-of-field button, PC terminal, interchangeable screens, or shutter speed control. The EM is a fully automatic camera with Aperture-Priority, automatically picking the correct shutter speed according to the chosen f/stop.

The EM was the first of many Nikons to come with an all-plastic aperture ring. Only AI and AIS lenses can be attached. Non-AI lenses cannot be mounted to the body without damaging the body's meter coupling ring. The viewfinder's shutter speed readout is a needle that indicates the selected shutter speed. The shutter speeds are stepless. The integral shutter speed closest to that selected by the camera is indicated by the needle. If the shutter speed should fall below 1/30 second, a "sonic" warning (an annoying beep) signals a speed too slow for handholding the camera. If the batteries fail, all shutter and meter operation is lost (the battery check is right next to the film advance lever). Like the FE, the EM has an M90 setting for a mechanical 1/90 second shutter speed.

The EM also has an electronic "B" setting. Using this setting requires battery power, which is used for the entire exposure.

Even the flash is semi-automatic on the EM (a first). When used with the **SB-E Flash,** the camera's hot shoe transmits ASA and aperture information from the camera to the flash. When switched on, the flash sets the camera's shutter speed to 1/90 second for proper flash sync and activates the LED in the viewfinder. The LED blinks when an incorrect f/stop is used.

Another advanced feature on this economical camera is backlight control. A button located on the left front of the body near the film rewind knob activates this. When this button is pressed, the camera automatically increases exposure by two stops. This is unique, since the EM lacks an exposure compensation dial. The meter is center-weighted, using one SPD cell with a sensitivity range of EV 2 to 18. The EM's finder coverage is only 92% of the picture field.

The EM has no mirror-up mechanism or depth-of-field button. On this or any such camera lacking a manual DOF button, depth of field can be seen through the lens by partially dismounting the lens. Press the lens release button and turn the lens as if removing it from the body. As the lens is turned, at one point the aperture disconnects from the automatic lens diaphragm lever that keeps the aperture opened to its maximum. Once disengaged, the lens stops down, and depth of field can be seen. Be careful not to forget the lens is only partially engaged to the lens mount when doing this!

The EM has become a curious camera. In its day, it was popular briefly for its "15 minutes of fame," then faded away. In the past few years though, its very compact and reliable design has made it a very sought-after camera. With its little winder, the **MD-E,** the EM is still widely used by many. And some pros still enjoy its lightweight, easy operation.

Nikon F3

1980 was a very exciting year. True to its tradition of introducing a new "pro" model every ten years, Nikon introduced its third addition to the pro camera line, the **F3.** Like the F2, the fully electronic F3 was at first given the cold shoulder. This reluctance lasted for over a year, but slowly the F3 gained acceptance. It turned out to be one of Nikon's best-selling cameras, with strong sales for nearly two decades! The F3 was the first truly all-electronic pro camera for Nikon. It served as a test for many new features and innovations that Nikon developed with an eye toward the future.

Nikon F3

Incorporating these new features gave the F3 a totally new look. The first is the shutter speed dial (still located to the right of the prism). It has a rubber ring wrapped around it for ease of turning (even in cold weather). Shutter speeds range from 8 seconds to 1/2000 second, with 1/60 in red to indicate the flash sync speed. A button in the center unlocks the shutter speed dial, which locks when set to the "A" (Aperture-Priority), "T", or "X" positions. The "T" is a time feature for taking long exposures without draining the batteries. Turning to "X" provides a 1/80 second sync speed (the F3's top flash sync speed), but the metering is lost.

The shutter release button is located in the middle of the film advance lever. It is an electromagnetically

activated release (requiring battery power) rather than a mechanical one. The shutter release button also activates the meter. The meter turns off 16 seconds after the shutter release is no longer depressed. The small lever below the film advance lever (toward the front) must be turned and the red dot exposed to turn on the camera's power. If the MD-4 Motor Drive is attached, its batteries power the F3, and the switch on the body does not need to be utilized. A very convenient double exposure lever is also located here. It is shaped like a crescent moon and, once swung out, allows the shutter to be cocked without advancing the film.

On the front of the camera, right below the shutter release is the molded handgrip. Permanently fixed, this rubber-coated grip is well designed and placed for maximum comfort and security. Next to the handgrip near the top is the self-timer light. When the self-timer is activated, it flashes at an even pace (2 Hz) except for the last two seconds before the exposure. It then increases its flashing rate (8 Hz), indicating the picture is about to be taken. The self-timer is activated by the lever surrounding the front of the shutter speed dial. Pushing the lever and exposing the red dot activates it, and pressing the shutter release starts it. It can be terminated during the countdown by simply pushing the lever to cover the red dot.

Next to the lens mount are the depth-of-field button and mirror-up lever. These work just like those on the F2. Below these and next to the lens mounting ring is the memory lock button. (It is in the center of the manual shutter release lever.) Depressing the button and holding it in during the exposure locks the shutter speed at the speed displayed. The shutter speed selected by the camera (while in Aperture-Priority mode) is derived from what the camera is seeing through the lens. Normally this feature is used when the shutter speed selected by the camera is not what is desired by the photographer. Turning the camera, locking in a new shutter speed, and reframing is faster than switching to Manual to change the shutter speed. Once the exposure is taken and the memory lock button is released, all operations return to normal.

The F3 is all electronic. If the batteries go dead, the whole camera is inoperable except for the film advance and the camera's mechanical shutter release. The mechanical shutter release lever provides a 1/60 second shutter speed as a back-up if the batteries die. Also, the time exposure feature does not require battery power to operate. Whenever the time exposure is used, the manual shutter release is the recommended method of firing the camera.

On the top left side of the camera are three features housed in the same unit: the film rewind knob, ASA dial, and exposure compensation dial. The film rewind knob, when lifted up, is the means to opening the camera back. (The release lever at its base must first be pressed in the direction of the arrow, allowing the knob to be pulled up.) Film is rewound the same as with previous models. The chrome lever running through the center of the film rewind knob is flipped up and then turned in the direction of the arrow. (The release button on the base of the camera must be pressed prior to rewinding.)

The ASA dial offers a range of film speeds from 12 to 6400. The ridged ASA ring is lifted and then turned until the desired ASA appears in the window. The exposure compensation dial overrides the exposure meter by +/- 2 stops in 1/3-stop increments (resulting in the same effect as changing the ASA by single increments).

The F3 has TTL flash capability when using dedicated Nikon system flash units (other brand flash units with the F3 TTL contacts work as well). The F3 does not have a standard ISO hot shoe. Instead, the flash contacts are a part of the rewind knob assembly and a flash unit fitted with an accessory shoe must be used. The **Flash Adapter AS-4** permits the F3 to accept any standard-footed flash, but provides no TTL connections. The **Flash Coupler AS-8** adapts the SB-16 Speedlight to the F3 contacts. If a flash is attached to the foot, it covers the film rewind knob, making access impossible. The flash must be removed before the film back can be opened or the film can be rewound (unless a motor drive is attached). The **Flash Coupler AS-7** permits the use of flash while maintaining access to the film rewind knob. The system frustrates photographers still, as it is not a clean and simple way of taking flash photos. (All three "professional" cameras, the F, F2, and F3, have removable prisms. This has required them to incorporate a special flash shoe on the body instead of on the prism. The strain of a top-mounted flash on the prisms and prism mounts is too much for their designs.)

When the F3 was originally introduced it came with the **DE-2 Finder.** In 1982 it was replaced by the **DE-3 High-Eyepoint Finder.** The F3 was from then on known as the **F3HP** (or **F3 High-Eyepoint**). The DE-3 has a larger diameter eyepiece. This enables those wearing eyeglasses to see the whole screen. The high-eyepoint feature also provides greater eye relief for those who do not wear glasses. This feature became so popular it was incorporated in nearly all Nikon bodies to come.

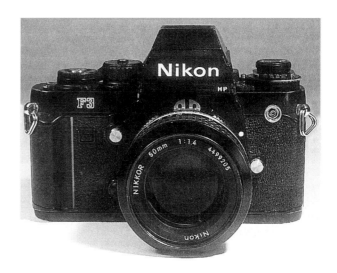

Nikon F3HP

The information in the finder is simple and provides 100% viewing of the picture field. Dead-center at the top of the viewfinder is the Aperture Direct Readout window displaying the f/stop in use. Next to it on the right is the flash diode for the TTL exposure/ready light indicator. To the left is the LCD (Liquid Crystal Display) window, which displays the shutter speed when in Aperture-Priority ("A" mode). In A mode, the camera displays the shutter speed closest to the one selected by the camera (remember it is a stepless system).

The LCD window displays metering information when in Manual mode. Correct exposure is indicated when a plus and minus sign are displayed simultaneously. When one or the other is lit, over- or underexposure is indicated (+ is over, - is under). An "M" is displayed in the window when in Manual mode. The meter coupling is AI, but the AI prong folds back permitting non-AI lenses to be mounted to the body. This does require stopped-down metering though. The displays do not change when this is done.

The F3 has interchangeable finders along the same lines as the F and F2: the **DW-3 Waist-Level,** the **DW-4 6x Magnifier, DA-2 Sportfinder,** and the **DX-1 AF Finder** (providing focus assist when mounted to a normal F3). Metering is maintained when these finders are attached, since the meter is in the body. The DW-3, DW-4, and DA-2 function exactly the same as the older finders for the F and F2 except they have been updated cosmetically. There are two levers on the side of each finder. These must be pushed forward to remove the finder from the body. When reattaching it to the body, press until a click is heard, signaling that the finder is securely attached.

Interchangeable viewfinders for the Nikon F3

The F3 meter is unlike any that Nikon had previously manufactured for a pro body. The meter is in the camera body, a first for a pro camera. Any prism used on the F3 utilizes the same metering functions. The SPD cell is located at the bottom of the mirror box and works in two modes, both separate from one another. When working with ambient light, the SPD cell takes a reading off a four-piece secondary mirror. The cell receives its light through the mirror used to focus. Very close inspection of the mirror reveals a rectangle in the center made up of thousands of tiny holes (a pinhole mirror). The light passes through the lens, aperture, and pinhole mirror, and strikes a second mirror (attached to the rear of the main mirror), which bounces the light to the cell at the bottom of the mirror box.

The same cell operates the TTL flash exposure. Through-the-lens flash exposure functions in this way: The flash goes off and lights the subject. That light reflects off the subject and comes back through the lens, through the aperture, and hits the film (the mirror and secondary mirror have swung up for the exposure). It is then bounced off the film and onto the cell. Once the film has been correctly exposed, the cell tells the camera's computer to shut the flash off. All of these calculations happen at the speed of light and with incredible accuracy. This system provides the F3 with a very sensitive center-weighted flash meter. Added to these capabilities, the mirror box has air-dampened shock absorbers. These reduce mirror vibration during the first phase of exposure.

Among the many innovations of the F3, the completely quartz-timed shutter speeds are the most radical. Whether the camera is in Manual or Aperture-Priority mode, the quartz timing mechanism is in use. The mirror box combination magnet and the sequential operation of the shutter release are also quartz-timed. Over time this system has proved to be extremely accurate, providing the user true shutter speeds for years without loss of timing. The F3 retains the same style titanium horizontal shutter curtain as the F and F2, precluding any high sync speeds for flash.

The F3 has what were at the time state-of-the-art microelectronics. These included six integrated circuits, an SPD metering cell, quartz oscillator, and LCD block (what a mouthful of goober, especially then). There is also a Functional Resistance Element (FRE) integrated on a rigid substrate and then bonded to a Flexible Printed Circuit (FPC) board. The F3 with an MD-4 attached was cold-tested to -20°F to assure all these electronics live up to the Nikon name.

The F3 had many different "marketed" versions.

The F3 has interchangeable screens. They are not the same screens used with the F and F2, but they do share the same nomenclature.

One feature of the F3 that constantly confuses photographers is revealed when the camera back is opened (by lifting up the film rewind knob). The film counter automatically resets to -2 frames at this time. Until the film is advanced to frame 1, the meter is not operable. To prevent long exposure times for "shots" taken while the film is being advanced to frame 1, the camera automatically sets the shutter speed to 1/80 second. When you look inside the viewfinder before the counter has reached frame 1, you will see "80" (representing 1/80 second) displayed on the LCD. The counter must be on frame 1 before any metering can be read.

The first was the **F3HP** in 1982. That same year the **F3T** came on the market. The first model of the "T" was finished in natural titanium color and referred to by many as the "champagne" version. Later this was replaced with a black F3T, which is still available. It is exactly the same camera as the basic F3, except that it has a titanium top, bottom, back, and prism cover (though the nameplate on the prism is plastic). The F3T also has a sealed main circuit board to protect it from moisture. This chrome F3T did not sell well originally and was discontinued in favor of the black-finish model in 1984.

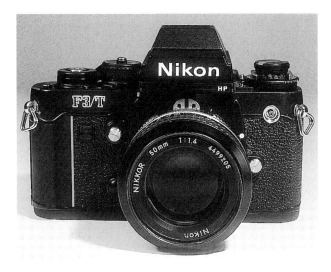

Nikon F3T

In 1983, Nikon took a very daring leap into the world of autofocus with the introduction of the **F3AF.** An extremely fine-working camera system, the F3AF did not last long, simply because it was ahead of its time (and now looking back, its autofocus system is judged as a very slow system, though it was fast for its day).

The F3AF is the basic F3 body combined with the **DX-1 AF Finder.** The screen is built into the DX-1, so no screen is needed in the body. (This body can be used as a regular F3 by removing the DX-1 and adding a prism and screen.) To autofocus, the DX-1 reads the right and left halves of the image-forming light rays reflected by the subject. These pass through the lens and converge at the finder screen, located at the geometric equivalent of the focal plane distance. The direction in which the two halves travel is reversed as the light rays pass through the finder screen. Those halves are then split by a half-mirror beam divider that transmits a portion of the image-forming light rays towards two relay lenses (isn't that a bunch of hooey?).

The internal relay lenses redirect each half to its respective SPD sensor. The sensors electronically detect the degree of focus shift and its direction from the optical axis. Focus detection is virtually instantaneous, within 0.5 millisecond. With this information the finder tells the lens (80mm f/2.8 AF or 200mm f/3.5 EDIF AF—the only lenses designed for the system) which way to focus. The motor that does this is in the lens itself. It is a good and accurate system, but it never caught on with the public, so more lenses were never developed and Nikon soon dropped the camera.

In 1983 an F3 was secretly introduced. The **F3P** was not released to the general public at first, but was offered only to Nikon Professional Services (NPS) members. An NPS member could order the camera through a dealer, but otherwise the dealer could not obtain it for general sales. In 1987, it became open stock for dealers. The sluggish sales of the F3P probably reflected the need of professionals for a high flash sync speed, which none of the F3 models offered. On the general market though, the F3P sold very well and was quickly gobbled up.

The F3P is a stripped-down F3 with an ISO non-TTL hot shoe on top of the prism. The F3P lacks the film back opening lock, self-timer, and double exposure lever. It does have a taller shutter speed dial, a battery switch (with special pin), and a gasket-fitted shutter release button. These improvements were designed to facilitate one's use of the camera while wearing gloves. The F3P also comes with an **MF-6B** back (which leaves the film leader out after rewinding the film with the MD-4) and a B screen. The literature that came with a new F3P claims that the camera may be better sealed against moisture than a normal F3, but this doesn't mean it is waterproof!

The **DE-4** is a special finder packaged with the F3P. It has an ISO hot shoe on the top. Another distinguishing characteristic can be seen when it is removed from the camera. A number of contacts on the base of the prism are exposed. This finder works only on the F3P body and cannot be attached to any other F3. The F3P accepts all F3 system finders with no problem (but you lose that expensive hot shoe).

Nikon FM2

In 1982 came the introduction of what was at the time the "World's Fastest 35mm SLR," the **FM2.** At the center of this claim lies its completely new shutter. It is a vertically traveling, mechanical, focal plane shutter made of titanium curtains. This delivers an

incredible 1/4000 second top speed and a flash sync of 1/200! Housed in the same basic body as the FM and FE, the FM2 has a number of new features. The ASA setting is located in the shutter speed dial at the top of the body. It is set by lifting up the outer dial and turning it to the appropriate number. The FM2 is also the first in the series with an energy-saving switch. Once the shutter release button is touched, the camera automatically turns off the meter within 30 seconds.

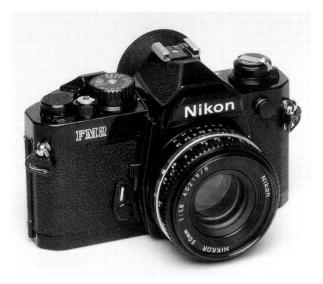

Nikon FM2

The shutter speeds range from "B" to 1/4000 second, with a special 1/200 second setting. The 1/125 setting is labeled in red to indicate the top speed for flash sync within the standard shutter speed range. Outside the standard range of shutter speeds past the 1/4000 setting on the shutter speed dial is 1/200 printed in red. One problem with setting the 1/200 sync speed is that metering capability is lost. If 1/125 is used for flash sync (which is within the standard sequence of speeds), metering is maintained. But with the 1/200 setting, metering must be done either prior to switching to that speed or with an external, handheld meter.

The viewfinder information is the same in the FM2 as in the FM, with one exception—a ready light that works in conjunction with Nikon system Speedlights. Other FM features retained in the FM2 are: depth-of-field preview, self-timer, multiple exposure, single-stroke film advance, oversized mirror, motor drive capability, and interchangeable screens. It incorporates the AI coupling feature, but the AI prong on the body aperture ring does not fold back.

Nikon FG

Nikon had a good year in 1982 with the announcement of another new body. Not only did they introduce the new FM2, but also the FG. The **FG** is the next step in the EM line, but with vast improvements and some incredible new features that would be used throughout the next decade. The revolutionary new features of the FG were TTL flash exposure with Program, Aperture-Priority, and Manual settings. All these new features were compacted into the small FG body!

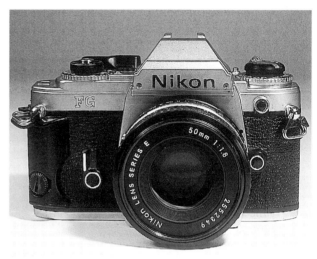

Nikon FG

The meter in the FG is a single SPD cell. It provides the FG with 60% center-weighted metering. The metering range is from EV 1 to 18, offering exposure compensation of +/- 2 stops. The FG also has the same backlighting button found on the EM. This creates an instant 2-stop overexposure override.

When in Program mode, set the lens' aperture ring to the minimum aperture setting and the shutter speed dial to "P." The camera selects the correct shutter speed-aperture combination in this mode. In Aperture-Priority mode, the shutter speed dial must be set to "A." In this mode the camera selects the correct, stepless shutter speed according to the aperture you've selected. In Manual mode, both the shutter speed and aperture setting are selected by the photographer. The FG's aperture ring is AI coupled, but its AI prong does not fold up, so non-AI lenses cannot be mounted to the body.

The viewfinder information in the FG was changed radically from previous Nikon bodies. The

shutter speeds are displayed vertically on the right, 1 second on the bottom and 1/1000 second at the top of the scale. Directly to the right of the scale is a red LED column that provides exposure information. When film is first loaded, both the 60 and 125 lights blink to indicate 1/90 second has been selected. The speed stays set until frame 1 has been reached.

In Program mode (the lens' aperture ring is set to its minimum f/stop and the camera selects the aperture), the LED opposite the shutter speed the camera has selected lights up. When two LEDs are present, it means the camera has selected an intermediate shutter speed (remember it is a stepless system). In Aperture-Priority, as in Program mode, the LED lights opposite the shutter speed the camera has selected. In Manual mode the LED lights up at the set shutter speed. The shutter speed recommended by the camera's meter is indicated by a blinking LED. The aperture is not displayed in the finder in any of these modes.

Directly below the shutter speed numbers is a lightning bolt. This symbol indicates correct exposure for the flash when in TTL mode. If underexposure occurs, it blinks rapidly, indicating a need to either get closer to the subject or open up the aperture. If the bolt goes off and then comes back on a few seconds after the exposure, this indicates a correct exposure has been made. (When using flash, the Program mode loses its ability to set a correct aperture. The photographer must always set the f/stop manually when using a flash with the FG.) To determine when flash is required, the FG has a "sonic" alarm. It sounds when the shutter speed falls below 1/30 second. The meter is activated by touching the shutter release button. It turns itself off 16 seconds after the shutter release is no longer depressed. The screen in the camera is the standard K screen and is non-removable.

The FG is the first "non-pro" Nikon that has a small handgrip on the right front of the camera. This provides extra security when holding the camera, and it must be removed when the **MD-14 Motor Drive** is attached. The MD-14 mounts directly to the base of the camera via a simple thumb screw. It is powered by eight AA batteries and is capable of shooting 3.2 fps set on High and 2 fps on Low. Though not a fancy unit, the MD-14 is small and compact, fitting quite well with the FG. It provides outstanding service.

The FG also has a data back available, the **MF-15,** which imprints the date/time/year on the lower right-hand corner of the frame. Though the FG was considered an amateur camera body, many of the technological designs used in current cameras were put into practice with its introduction. Like the EM, the FG continues to be a very popular camera long after its discontinuation.

Nikon FE2

In 1983 the best in the FE/FM series was introduced, the **FE2.** The FE2 has the same basic body as the FE and many of the same features. The main new feature of the FE2 was the electronically controlled, vertical-traveling focal plane shutter with titanium curtains (like that in the FM2). This affords the FE2 shutter speeds from 8 seconds to 1/4000 second with a flash sync of 1/250 (the fastest around at the time). Nikon coupled this fast flash sync with TTL flash capability, thus making the camera an instant hit with most photographers. The FE2 has a standard ISO hot shoe on the prism and accepts Nikon system TTL Speedlights as well as many off-brand units (not recommended by Nikon). The shutter speed dial has a new setting: "M250." This is a mechanical 1/250 second setting that can be used if the batteries go dead. The red "250" on the dial indicates the flash sync speed (1/250 second). The meter is fully operational at this setting (unlike the 1/200 flash sync setting on the FM2). The FE2 meter couples to the AI system, but the AI prong does not fold up, so non-AI lenses cannot be mounted.

FE2 metering is 60% center-weighted, controlled by a pair of silicon diodes. They provide a metering range of EV 1 to 18. The viewfinder information is the same as that on the FE with the addition of a lightning bolt for the flash ready light. This ready light operates identically to that on the FG for TTL exposure indication.

The FE2 offers exposure compensation of +/- 2 stops in 1/3-stop increments. This control is located around the film rewind knob along with the ASA dial (which has an ASA range of 12 to 4000). If the exposure compensation is turned to a number other than zero, a "+/-" LED appears in the viewfinder as a reminder. The meter is activated by depressing the shutter release button and turns itself off 16 seconds after the shutter release is no longer depressed. The film advance lever has a single-stroke action, standing out at 30°. When fully pushed into the body, it locks the shutter release button.

The FE2 has a fixed prism with 93% coverage of the picture field. It has three interchangeable screens of the new bright screen type. The standard screen is the K2 matte with a center-split rangefinder surrounded by a microprism collar. In addition, the B2

(plain matte with a 12 mm center circle) and the E2 screen (the same as B2 but with three horizontal lines and five vertical lines) are also available. The FE2 also has a memory lock button like that in the EL series. Push the self-timer/memory lock lever in towards the lens mount to activate memory lock, and hold it until the exposure is completed. (The self-timer is activated by pushing the lever away from the lens mount.) It also has the same depth-of-field lever as the FM and FE. The FE2 uses the same MD-12 motor drive, but does have a new data back, the **MF-16.** It does not require being connected to the PC socket with a cord.

Nikon FA

The year 1983 also saw the introduction of the **FA.** Though cosmetically different from the FE2, the FA shares many of the same features: 1/250 second flash sync, TTL flash metering, three bright screens, M250 manual shutter, exposure compensation dial, memory lock, depth-of-field lever, self-timer, 93% viewing of the picture field, and shutter release-meter activation with automatic 16-second shut-off. But the FA brought to Nikon bodies a whole new metering system, Automatic Multi-Pattern (AMP) metering. (This is the basis of Nikon's matrix metering.)

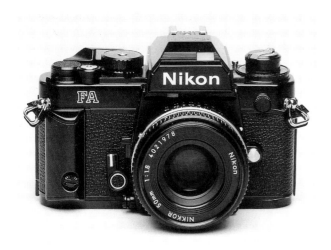

Nikon FA

In simple terms, AMP metering makes five readings off the screen (three SPDs are in use), and these values are computed to arrive at a correct exposure. In drawn-out terms, five sensors corresponding to the five segments individually sense the light coming through the lens. These analog values

are compressed logarithmically. Then a high-speed sequential comparison A/D (analog to digital) converts these to digital values. The computer in the camera then takes into account the lens' focal length, aperture, shutter speed, and other basic exposure needs. Finally, the computer calculates these values against pre-programmed scene values (said to be over 100,000) to compare and provide a final number. This explanation is oversimplified, however the astonishing part is the speed at which this whole procedure is done. This meter has an exposure range of EV 1 to 20!

There is a button located on the base of the lens mount ring. When turned and depressed, it switches the metering from AMP to 60% center-weighted. The AMP mode requires AIS lenses in order to take advantage of all exposure modes. The FA has Program mode (P), Shutter-Priority (S), Aperture-Priority (A), and Manual (M) mode incorporated into it, all working with the AMP system. Program mode has P-HI bias built in, switching automatically to a faster shutter speed if a lens longer than 135mm is attached.

The FA has a plastic aperture coupling ring, so non-AI lenses cannot be mounted. An AI or AI'd (AI modified) lens can be mounted to the FA. AI lenses can be used in P, but P-HI will not be selected with long lenses. AI'd lenses work with center-weighted metering but not with AMP. The camera works with AI'd lenses in P and S, though. Information provided in the viewfinder depends on the mode selected.

In P mode, the LCD at the top of the viewfinder displays the speed closest to the automatically selected speed (in stepless shutter speeds). The aperture must be set by the photographer at the lens' minimum aperture. But the camera does not display the aperture it has selected, which can vary from any within the lens' range. "HI" or "LO" on the display warns that over- or underexposure may occur. An LCD displaying "FEE" indicates that the aperture, which must be set at its minimum f/stop, has not been set properly.

In S mode, the photographer selects the desired shutter speed, and the camera matches it with the aperture setting for the exposure recommended by the meter. The set shutter speed is displayed in a window at the top right side of the viewfinder. The camera uses stepless aperture settings and the LCD displays the integral aperture number closest to the f/stop selected by the camera. If the chosen shutter speed cannot be matched with an aperture for correct exposure, the camera reverts to Program mode and sets both the shutter speed and aperture. If this happens, the shutter speed chosen by the photographer

still appears in the viewfinder window, but the LCD displays the shutter speed actually being used.

In the A mode, the LCD displays the shutter speed that matches the chosen f/stop to produce the correct exposure. A warning of "HI" or "LO" will be displayed by the LCD if the correct exposure cannot be made with the selected aperture. The aperture is displayed via the ADR system.

In M mode, the LCD displays the manually selected shutter speed preceded by "M" (for Manual). A plus or minus sign indicates exposure problems. Correct exposure occurs when the plus and minus signs are both lit at the same time. Either one or the other lit by itself shows over- or underexposure accordingly. The f/stop chosen is always displayed by the ADR dead center at the top of the viewfinder.

The FA has a unique motor drive, the **MD-15.** The FA can use the MD-12, but certain special features are possible only with the MD-15. The MD-15 battery compartment is slightly slanted forward, towards the lens, providing better balance and handling when handheld. The drive uses eight AA batteries. When connected to the FA, they power both the camera and the motor drive (not so with the MD-12). When attaching the MD-15 to the FA, both the small cap (to the right of the battery cap) and the handgrip on the front of the camera must be removed. (Remember, the FA does not need batteries when the MD-15 is attached.)

On the rear of the camera on the top right is a button, which must be depressed to set the camera's shutter speed to M250 (providing a mechanical 1/250 second speed in case of power failure) or "B." To the left of this button is a lever that operates the eyepiece curtain. This must be closed when taking photographs when the eyepiece is not covered by the photographer's eye. If the eyepiece is not covered, the exposure can be miscued. The meter cells are housed here and the extra light coming in can change the meter reading by as much as three stops!

Nikon FM2N

The FM2 was updated in 1983 with the introduction of the **FM2N.** With the majority of the features remaining exactly the same as the FM2, the FM2N's big change was in the shutter. The FM2N has a flash sync of 1/250 second. This setting falls within the standard range of speeds, and hence metering capabilities are maintained. All other features remain the same, including the all-mechanical shutter. The FM2N can also use the "bright view" screens of the FE2 and FA. The FM2N does not operate TTL with flash.

For a time, the FM2N, FE2, and FA shared the same basic shutter curtain design with the special, honeycombed titanium blades. But in 1989, the honeycombed shutter blades of the FM2N seem to have been replaced by the same, completely smooth blades found in the N8008. The improved design and the strength of the new blades in the N8008 warranted this design change. This leads one to believe that Nikon plans to have the FM2N around for some time.

Nikon FG-20

In 1984, Nikon continued the EM and FG line with the introduction of the **FG-20.** This is a scaled-down FG, both in physical size and features. The FG-20 retained all the features of the FG except Program mode and TTL flash metering. It did keep the warning beep for slow shutter speeds and the 2-stop exposure compensation button for backlit shots. This simplified camera did not go over well with the public and was discontinued shortly after its introduction.

U.S.A. and International Designations for Nikon Cameras

Certain Nikon camera models are designated differently in the U.S. than in other parts of the world. Below is a list of those cameras.

U.S.A.	International
N2000	F-301
N2020	F-501
N4004	F-401
N4004s	F-401s
N5005	F-401x
N6000	F-601M
N6006	F-601
N8008	F-801
N8008s	F-801s
N50	F50
N60	F60
N70	F70
N90	F90
N90s	F90X

Nikon N2000 (F-301 outside the U.S.A.)

Nikon N2000

Nikon moved more aggressively into the consumer market in 1985 with its N-Series cameras. The first to be introduced was the **N2000.** This mechanically outstanding little camera was packed with new features that made it quite exciting. One of the most remarkable features is its built-in motor drive, Nikon's first. It fires off 2.5 fps (2.0 fps when using autoexposure lock). The motor drive has three settings. "C" is for "continuous," firing repeatedly as long as the shutter release button is depressed. "S" is for "single," firing one frame each time the shutter release is depressed. "L" locks the shutter release. Lifting up and turning the ring around the shutter release button is required to select a mode. The motor drive only advances the film; rewinding is still a manual operation.

Pressing the shutter release button halfway down engages metering operations. Metering shuts off after 16 seconds if the shutter release is not depressed. Right below the shutter release button is a lever with a wave symbol and a dot. Switching to the wave symbol activates an optional warning beep that warns of a shutter speed too slow for handheld shooting, as on the FG.

Film loading was made easier in the N2000. Load the film cassette into the back of the camera (which is opened by pulling up on the film rewind knob) and pull the film leader over to the red square. Now close the back. Press the shutter release, and the camera automatically advances the film to frame number 1. On the left side of the camera back is a window. The film cassette can be seen through it, and the type of film loaded, its ISO rating, and the number of exposures on the roll is displayed. There is also a film advance confirmation indicator on the back. It rotates when the film is advanced if the film has been loaded correctly.

The shutter speed range is 1 second to 1/2000 second plus a "B" and 1/125 second flash sync with full TTL flash exposure. The N2000 has four other settings on the shutter speed dial: "A," "P DUAL," "P," and "P HI." Aperture-Priority (A) is similar to that on all Nikons. The High-Speed Program (P HI) mode is designed to utilize the fastest shutter speed possible. P HI always selects a shutter speed of 1/200 second or faster to eliminate camera shake when using a 135mm or longer telephoto lens. It sets the aperture based on the shutter speed. In Program (P) mode, the camera selects a middle-of-the-road combination of shutter speed and aperture. It provides a shutter speed fast enough to permit handholding and selects the appropriate aperture for the meter reading. Dual Program (P DUAL) is a new mode. It selects the fastest possible shutter speed when a 135mm or longer lens is in use (same as P HI), and then switches to P mode when a lens shorter then 135mm is used (the lens must be set at its minimum f/stop in any of the Program modes). This feature prevents the photographer from having to switch between modes when shooting with a variety of lenses.

In addition to these modes, the N2000 also provides the option of complete manual operation. As with the FA, AIS lenses are required with this camera in order to take full advantage of all these features. It can accept only AI, AI'd, or AIS lenses since the AI prong on the aperture ring cannot lock up.

The new metering in the N2000 uses Nikon's Light Intensity Feedback Exposure Measurement System. This system is used when the camera is in Program or Aperture-Priority mode. It is engaged the moment the lens is stopped down after the shutter release has been pressed to take a picture. The system measures the exposure again, and in response to the computed value (based on the reading taken prior to firing the camera), the shutter speed is precisely adjusted to reduce the chance of exposure error. This system is not engaged in Manual mode because it is pointless to remeasure the exposure and alter the photographer's manually selected aperture and shutter speed settings.

The viewfinder, with a 93% view of the picture field, provides exposure information in a new way. The shutter speeds are arranged in a line and displayed on the far right with 1/2000 at the top, 1 at the

bottom, and a triangle at either end. These LEDs light differently depending on the information being relayed. In P, P HI, and A modes, the shutter speed lights up. If two speeds light up, it means that an intermediate (stepless) shutter speed is in use. In Manual mode, the correct shutter speed blinks. When only the blinking shutter speed is lit up, exposure is correct. If either triangle lights up, an incorrect exposure is indicated—the top triangle for overexposure, the bottom for underexposure. The flash TTL lightning bolt is located under the bottom triangle and works like the TTL light of the FG and FE2. No ADR exists, so it is necessary to examine the lens to determine the aperture in use.

Another new feature on the N2000 is DX coding. Film cassettes have a black and silver bar code. The DX coding in the N2000 reads this bar code and can set the ISO automatically. Set the ISO dial to the DX notch for this feature or set it manually to a desired ISO. Film ISO settings go from 12 to 3200 when set manually and 25 to 5000 in the DX mode. When the camera is set to DX but is loaded with a non-DX coded film cassette, the camera locks up after the film has advanced to frame 1. There is a red indicator lamp next to the ISO dial on the back that alerts the photographer to a problem. A warning beep also goes off at the same time. A +/- 2-stop exposure compensation can be set in 1/3-stop increments by using the exposure compensation dial (located on the ISO dial).

The N2000 does not have a standard cable release socket, however it does have a terminal on the front of the camera above the lens lock button that accepts the **MC-12A** remote cord. This same socket allows the use of Nikon's other remote triggering devices. The N2000 comes with the **MB-4** AAA battery holder (built into the base of the camera), which holds the batteries that power the camera. This can be removed and replaced with the **MB-3** to allow the use of AA batteries. The MB-3 tray is slightly deeper to make room for the batteries, which adds a slight bit of height to the camera.

The N2000 was Nikon's first camera with a fully automatic programmed TTL flash mode. It can set an aperture and shutter speed automatically when a properly dedicated TTL flash is used. The aperture setting in the programmed flash mode is determined by the speed of the film in use. With ISO 100 film, it sets an aperture of f/5.6. With ISO 200 film, the automatic aperture setting is f/8. If ISO 400 film is used, the aperture setting is f/16. The shutter speed is set automatically to 1/125 second. This programmed flash mode works only with AIS, AF, and Series E lenses.

The tripod socket on the N2000 is off-center. Nikon makes the **AH-3** accessory, a 1/2-inch thick plate that recenters the hole. The AH-3 provides additional (and necessary) protection for the camera base. If the socket had been constructed in the center, it would leave no room for the batteries or the socket would have gone right though them.

Nikon N2020

The N2000 was selling very well when a newer version of the camera was introduced just one year later. In 1986 the **N2020,** a dual autofocus camera, made its grand appearance on the market. The N2020 is identical to the N2000 in nearly every way except the addition of a few features, principally the autofocus.

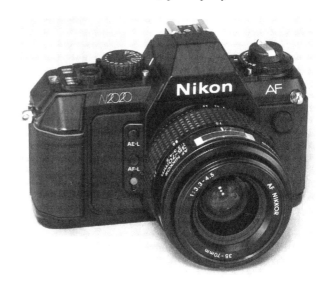

Nikon N2020

Nikon must have felt that having the autofocus motor in the camera body was a superior design to the motorized lenses of the ill-fated F3AF. With the introduction of the N2020 came its own special complement of new autofocus lenses. These lenses do not have internal motors. The N2020 can also accept all previously made Nikon lenses. It meter couples with AI lenses but works in P Dual and programmed flash modes only with AIS lenses. The N2020 carries out Nikon's main design directive of planned non-obsolescence. It retains the bayonet F lens mount even with autofocus technology!

The autofocus motor is housed in the camera body under the shutter release button. Its power is transferred to the lens mount via a gear train. It connects to

the lens via a small shaft on the lower left of the lens mount ring. The autofocus sensor is located in the bottom of the mirror box. By placing the detector there, it can read the light off the focal plane, know the amount of deviation, and whether the incoming light portions have changed places on the detector or not.

Nikon's original algorithmic principles can detect the defocus amount (the distance between the focal point and the focal plane). This is processed electronically. The direction (whether the focal point is in front of or in back of the focal plane) is easily detected and commands the camera to focus the lens to align the actual focal point with the detector. The detector incorporates 24 pairs of CCDs (Charge-Coupled Devices) in two arrays (a total of 96 CCDs) mounted to a ceramic plate. (How far autofocus technology has advanced in a short time; the N90s has 246 CCDs!)

The total analog output of each CCD is converted into a digital signal via an autofocus interface IC for relay to a host CPU (Central Processing Unit). The host CPU processes the data by using Nikon-developed software, then outputs it to focus. Below the infrared cut filter are two CCD detectors. The larger CCD is called the f/2.8 detector, the smaller is the f/4.5 detector. Depending on the speed of the lens in use, the camera automatically selects the correct detector. This weighty but brief explanation is an overview of the autofocus system in the N2020. When compared to the F3AF, we can see that Nikon completely changed its thinking about autofocus operation. (This system would be changed again in later autofocus designs.)

The term "dual autofocus" is derived from the option of Single Servo (S) or Continuous Servo (C) modes. Single Servo works by lightly pressing the shutter release button, which activates the metering and autofocus (flip the switchover lever on the top of the camera body to "S"). Once the camera focuses on the object in the sensor, the focus will not change until the shutter release button is released and then depressed again. Continuous Servo works when the shutter release button is depressed and the camera is pointed at the subject (the lever is set to "C"). In Continuous mode, the camera constantly refocuses as long as the shutter release is depressed.

Focusing information is provided in the viewfinder. A green dot appears when the camera is in focus. A red X lights up when focus detection is not possible (there are a number of parameters under which the camera cannot focus). There are also two arrows that provide focus assist when focusing manually. Turning the lens in the direction indicated by the arrow lights the green dot, indicating the subject is in focus.

The N2020 has three interchangeable screens. None of these have the split rangefinder, which was made unnecessary by the autofocus assist. The E and J screens have the same design as other E and J screens but are of the BrightView system. N2020 screens work only in the N2020 (the N2000 does not have interchangeable screens).

One problem that occurs with the N2020 and N2000 involves the use of long focal length lenses. When longer focal length lenses (300mm or longer) are left connected to the body, the weight of the lens hanging on the lens mount ring causes the lens mount to get pulled out from the body just a fraction. This contributes to focusing problems, such as the camera front focusing or a corner being out of focus when the rest of the image is sharp. A little extra care when using heavier lenses is all that is needed to curtail any such problems.

Nikon N4004

The age of the pocket camera capable of doing everything prevailed in the mid-1980s, and Nikon made a number of "pocket cameras" to meet the demand. In 1987, Nikon upped the ante on that market by introducing the **N4004.** Though not really a pocket camera, the features of the N4004 are largely based on the pocket camera idea. The N4004 advanced autofocus technology with Nikon's exclusive **AM200** module. Unlike the N2020 with 96 CCDs, the N4004's autofocus detector contains 200 CCDs! This optical module, unique among autofocus cameras of the time, features one-piece construction for reliability and efficiency.

The N4004 uses the same autofocus lenses available for the N2020 (and all AF lenses later introduced). Manual lenses can be mounted, but all metering and program modes will be lost. The N4004 operates differently than prior Nikons in that the f/stop is selected by a dial on the body and not the lens' aperture ring. When a lens is mounted on the N4004, the lens must be set to its minimum f/stop and left there. Found on the top right side of the camera are the majority of the operational controls.

The camera has a built-in motor winder and molded handgrip. The shutter release is at the top of the handgrip. Like all other Nikons of the day, this release turns the camera's functions on (shutting off 16 seconds after last being touched). Next to the prism are two dials. The shutter speed dial has a range of

1 to 1/2000 second, and the letters "B" (Bulb), "A" (Aperture-Priority), and "L." (When the "L" is in the window on the dial, the camera is in the lock position and will not fire.) The aperture dial has a range of f/1.2 to f/32 and the letter "S" (Shutter-Priority).

When the "A" appears in the window, Aperture-Priority mode is set. Select the desired aperture by turning the aperture dial until the f/number appears in the dial's window. Do not turn the aperture ring on the lens! Dialing the "S" in the aperture dial window sets the camera to Shutter-Priority mode. Select the shutter speed via the shutter speed dial. The camera is set to Program mode when there is an "S" in the window on the aperture dial and an "A" displayed in the shutter speed dial. Manual mode is selected by independently selecting an f/stop on the aperture dial and the shutter speed on the other dial. Right next to these dials is a button that, when pushed, rewinds the film. Coupled to the metering system is an exposure lock button that is located on the right front of the camera, near the handgrip.

In the autofocus and autoexposure modes, if the camera cannot focus on the chosen subject, the exposure is not correct, or if any combination of these two (including pilot error) occurs, the camera will not fire. Nikon calls this the automatic fail-safe operation, which is part of the Decision Master System. To continue shooting, it is necessary to find the error and correct it. The N4004 has manual focus as well as autofocus, permitting complete manual control, if desired. The N4004 is powered by AA batteries (a nice feature) housed in the handgrip of the camera.

The N4004 recognizes DX coding but has no ISO selection dial or exposure compensation. It does have a self-timer and a very new feature—built-in flash. When viewed though the viewfinder (93% viewing of the picture field), the exposure indicators are at the bottom as in the FM. There is a plus, a zero, and a minus sign to indicate exposure. The lightning bolt appears when the camera recommends the use of flash, especially for backlit subjects. The lightning bolt also illuminates after firing the flash to indicate correct flash exposure as with previous systems. When the exposure is too low, the flash can be popped up and full TTL flash comes into operation. The N4004 is the first Nikon to offer balanced fill flash for just such problem exposures, incorporating its triple-sensor metering system. On the left of the viewfinder display is the focus indicator, which lights when the camera is in focus.

Nikon N8008

Up to this time, autofocus systems by Nikon (as well as those of most manufacturers) were not holding their own, with most photographers not taking them very seriously. In the spring of 1988, this all came to a halt with the introduction of the N8008. The **N8008** was so well designed and feature-packed that many said it would make an average photographer good and a good photographer great. Never before had a camera received such high acclaim as fast as the N8008, which quickly earned its reputation.

The exciting feature of the N8008 is its matrix metering (a much improved version of the AMP metering of the FA). This evaluates light in its entirety as the camera lens sees it. The improvements on the AMP metering are: the one-component SPD sensor module with five segments, the use of a more powerful computer for faster and more comprehensive calculations, and advanced Nikon software to enable operation under more varied conditions.

The matrix metering works by dividing the picture-taking scene into five segments. Each segment's output is compared and two basic parameters, brightness value and degree of contrast, are established. The scene is segmented into classifications of brightness and contrast that together comprise a 5 x 5 matrix (hence the name for the system). Upon reading additional data (such as which segment is brighter and by how much), matrix metering appropriates the suitable algorithm pattern from four computation methods: low-brightness weighted, high-brightness weighted, average, and center-segment. The output values from the five segments are included in the computation and considered in accordance with the automatically determined computation method. Optimum brightness value is then determined.

Another part of the matrix system is exposure screening. When comparing the exposure information from each of the five segments, the system is programmed to factor out extremes of brightness and darkness. Using special algorithms, the matrix metering can recognize scenes that include such extremes as snow, sand, or the sun in the picture. (Don't conclude that the meter can't be fooled by bright elements such as snow, because it can!) The N8008's matrix metering works as described whether the camera is held horizontally or vertically.

A 75% center-weighted meter is the other metering alternative in the N8008. On the top left of the camera (next to the prism) is a button labeled with the symbol for matrix metering. Depress this and turn the thumb wheel (its proper name is the Command Input

Control Dial) until the center-weighted symbol is displayed in the LCD. If a manual focus lens, extension tube (even connected to an AF lens), teleconverter (even connected to an AF lens), or any other accessory without a CPU is attached to the N8008, even with the camera set to matrix metering, center-weighted metering is automatically set by the camera.

Coupled to this amazingly accurate metering is Cybernetic Flash TTL Sync. A cyber is an electronic device that performs automatically. In the N8008, the computer is the cyber, automatically adjusting the shutter speed in accordance with the f/stop and TTL flash for correct flash and ambient light exposure. In other words, the camera can set exposure to balance ambient light and flash. The N8008 provides four different flash metering options: matrix balanced fill flash, center-weighted fill flash, matrix TTL flash control, and center-weighted TTL flash control. This amazing technology takes a little to understand. (Please don't get confused and think the flash is metered by the matrix system. The flash metering is center-weighted!)

TTL flash metering technology determines flash exposure by reading light reflected off the film plane. Proper flash exposure is controlled by altering the flash-to-subject distance and/or f/stop (working manually). But in TTL, the duration that the flash tube burns is governed by the camera's computer (normally flash just blasts away on each exposure). It is like having a switch that simply turns the flash on and off for as long as it is needed. This means that a photographer can use the desired f/stop to control depth of field rather than having it determined by the laws of physics. Within the limits of the flash's output, TTL controls proper exposure.

How does the cyber come into play in all of this? Remember that the shutter speed affects only the ambient light, not the flash exposure. It is not part of the TTL metering system. But the camera can properly expose and balance the combination of ambient and flash light. This is accomplished by the camera's computer, which is able to determine the correct shutter speed to properly expose the ambient light based on what aperture has been selected. (Without TTL, creative choice is limited to f/stop and flash-to-subject distance. With TTL, you can use whatever f/stop works to produce the desired photograph. These computations are typically too much for most photographers to handle, but not for the N8008.)

In matrix balanced fill flash, the camera's computer balances the exposure for the ambient light (typically the background) with the exposure by the flash via matrix metering. Cutting to the chase, the ambient light is metered via the matrix metering system. The camera is simply set to matrix metering (using a lens with a CPU), the flash is attached, and away you go.

Getting down to nut and bolts, the camera automatically selects a stepless shutter speed (1/60 to 1/250 second in normal sync, 30 seconds to 1/250 second in rear curtain sync; review the *Flash* chapter for more details) in conjunction with the manually selected f/stop for proper exposure. This is done using the basic matrix metering pattern previously described. (The metering for the flash, though, is center-weighted.) Depending on how the camera and flash are programmed, the camera's computer matches the light reading of the ambient source with the light emitted by the flash. The computer can provide a flash exposure equal to 1:1 (light emitted by the flash is equal to the ambient light), or incrementally reduce the flash to 1-1/3 stops less than ambient light (minus compensation), depending on how the computer reads the scene. (This is when the flash is in the automatic control mode. For control of this ratio, see the *Flash* chapter).

Center-weighted fill flash shifts the metering to emphasize the background scene while the cybernetic system fixes the TTL flash output to 2/3 stop below standard output level (-2/3 stop). This occurs when the value measured by the center segment is within the controlled shutter speed or aperture range. The result is a flash fill that is 2/3 stop less than the ambient light whenever shooting in this mode. In this mode (set the camera to center-weighted or use a lens without a CPU), both the ambient light and flash are metered via the center-weighted meter.

A big part of this whole process is the new shutter in the N8008. With a top shutter speed of 1/8000 second and a bottom end of 30 seconds, the N8008 has a wider range than ever before available. The vertically traveling aluminum alloy (no longer titanium) shutter curtains are used because of their rugged, reliable operation throughout the shutter speed range. The same shutter, because of its reliable performance, was installed in the FM2N in 1989. This Nikon technological advance also gives the N8008 its surefire 1/250 second flash sync.

The N8008 has the same three Program modes as the N2020 and N2000: Program Dual (P_D), Program High (P^H), and Program (P). It also has Shutter-Priority (S), Aperture-Priority (A), and Manual (M). An AF lens or a lens with a CPU must be mounted to take advantage of these Program modes or Shutter-Priority mode. If a lens is attached without a CPU and the camera is set to one of these modes, the camera automatically switches to Aperture-Priority mode

and center-weighted metering. To switch modes, first depress the Mode button on the top left of the camera, then turn the thumb wheel until the correct mode is displayed in the LCD on the top of the camera. The mode is also displayed in the viewfinder.

There are three other buttons located along with the Mode button on the top left of the camera. All are activated by pressing down on the button while turning the thumb wheel to dial in the desired setting. The ISO button is used to set the film speed. You can set the desired ISO manually or set the camera to DX coding. The DX setting has an ISO range of 25 to 5000, and when set manually the ISO range is 6 to 6400. When the camera is set to DX and a film cassette is loaded that the camera cannot read, it flashes the ISO in the LCD panel, beeps if the camera is set to beep mode, and the shutter locks up, disabling the camera from firing. The Drive button controls the built-in motor drive. When set to "C^H" (Continuous High-Speed), the camera can fire up to 3.3 fps. In "C_L" (Continuous Low-Speed) mode it fires 2.0 fps, and in "S" (Single) it fires once each time the shutter release button is depressed.

The last button, "ME," has two functions—multiple exposure and film rewind. When this button is depressed and the thumb wheel is turned, the camera's multiple exposure function is activated. This permits up to nine exposures to be made on one frame of film. The frame counter disappears and is replaced by the number of frames set for multiple exposure. This stays in the display until all the shots have been fired. The counter counts down the number of exposures left in the multiple sequence starting at a maximum of nine and counting down to one. (This can be extended if reprogrammed before reaching frame 1, which can be done as many times as desired.) Note that any exposure computations for these multiple exposures must be done by the photographer.

Pressing the ME button and depressing the film rewind button above the LCD display on the camera's right shoulder rewinds the film. Both buttons have the same symbol for easy recognition. This is the same symbol that appears in the LCD display to indicate the film is loaded correctly. In the lower right corner of the LCD the current frame number is displayed.

On the top left of the camera, below the four-section buttons, is the self-timer button. Activate it by depressing it and then turning the thumb wheel. It can be set for up to 30 seconds. It can also be set to take two exposures (the first after ten seconds and the second, five seconds later) with one push of the shutter release button.

Above the LCD panel on the top right is a button with a "+/-" symbol on it. This is the meter exposure compensation. By depressing the button and then turning the thumb wheel, compensation of as much as +/- 5 stops can be dialed in. (An analog display appears in the LCD panel, but it only displays a range of +/- 2 stops.) The same analog display is used to adjust the exposure settings when in Manual exposure mode.

The power switch is on the top right with the shutter release button just above it on the handgrip. With the power switch set to "ON," the warning beep system will not sound. To listen to the melody of the beeper (as lovely as it is), set the power switch all the way to the right to the ")))" symbol. When the camera is activated, the LCD displays on top and inside the viewfinder report all current camera settings. After 16 seconds the camera automatically shuts down, leaving only the basic info displayed—frame number, metering mode, etc.

The viewfinder on the N8008 is a high-eyepoint finder with the same eyepiece diameter as that of the F3HP with all the same advantages. The finder coverage is only 92% of the picture field. The information display is very clean and simple, a great help with so many camera options. When in one of the Program modes, Aperture-Priority, or Shutter-Priority mode, a "P," "A," or "S" appears in the display. In these modes, the corresponding shutter speed and aperture in use are also displayed. In Manual mode, an analog display appears. The scale displays changes in exposure in 1/3-stop increments. Correct exposure is achieved when the bar on the analog display is at "0." The shutter speed and aperture are displayed as well. There is no ADR window, so with a manual focus lens the f/stop is not displayed and "F - -" appears in the LCD where the f/stop is normally shown.

The focus indicator is on the far left of the viewfinder display. It is the same as that on the N2020, and relays the same information. The N8008 has interchangeable screens, but these are new, brighter screens never before available. For autofocusing assist, the screens have a small bracket dead center. This bracket must cover the subject in order for the camera to focus on it. (There is an autofocus lock, which allows you to focus and then recompose a photo if so desired.) The TTL lightning bolt is also in the display on the far right, working as in previous models. The display inside the viewfinder automatically lights up in lower light levels. To switch this on manually, there is a button on the back to the right of the eyepiece with a little burst symbol on it. When

pushed, it lights up only the internal display. The LCD panel on top of the camera cannot light up. Working at night with this display lighted can be difficult and takes some getting used to. Since it is brighter than the darkness, the illumination can overpower one's eye and impair one's ability to see and focus on the subject.

The N8008 has the **Advanced AM200** autofocus module. It is basically the same as the AM200 in the N4004, but with some minor electronic additions. It has a built-in 8-bit microcomputer unit using special autofocus software in the N8008. It can quickly process focus information obtained by the 200 CCDs. There are three computers in the N8008 and one in the AF lens. They all work together using Nikon software. The motor that is operating and focusing the lens is coreless and is located in the body. This is more efficient than the older cored motor of the F3AF, using less power and space. This enables the N8008 to work off four AA batteries and maintain its small size. There are three such motors in the N8008, one for autofocusing the lens, one for motor drive functions, and one for such basic mechanical operations as opening and closing the aperture, raising and lowering the mirror, and cocking the shutter.

The N8008 has a depth-of-field button that is located on the front of the camera to the left of the lens mounting ring. Below this is the AF-L button, which locks the autofocus. The autoexposure lock (AE-L) button is on the back of the camera next to the button that lights up the viewfinder display. To override the metering, depress the AE-L button and hold it until the exposure is made. On the other side of the lens mount is the lens release button, which must be depressed to remove the lens from the body. Below that is the autofocus selector switch, which works the same as that on the N2020.

The N8008 has automatic film loading as well as rewinding capability. If the camera is set to the beep warning, it beeps and the film indicator on the top of the camera flashes to signal the end of a roll of film. Rewinding is accomplished as described on the previous page.

The interesting thing about all this incredible photographic technology is that it is all housed in a polycarbonate housing. The front of the camera, including the handgrip, has a nice rubberized coating for a good, solid grip. The back of the camera (which can be replaced with a data back) is a buffed plastic. The body aperture ring is also plastic and accepts only AI or AIS lenses.

Nikon F4

The fall of 1988 was an exciting one with the introduction of a Nikon pro camera, the **F4.** The F4 is the culmination of all Nikon bodies up to that point, plus a whole lot more! It is no surprise that it received the European Camera-of-the-Year and Camera Grand Prix awards in 1989. The F4 is fully loaded with technological features that can easily scare new buyers away. In practice, it is the most user-friendly camera Nikon has ever manufactured. The engineers at Nikon crammed 1,750 parts, four coreless motors, and batteries into a small package, making the F4 an incredible machine.

Nikon F4, F4s, and F4e (front to back)

First let's understand its name. The term F4 comes from being the fourth in the line of Nikon pro F bodies. The F4 is packaged with the **MB-20** battery pack and sold in markets outside the U.S. The MB-20 holds four AA batteries and provides a firing rate of 4.0 fps.

The **F4s** is the U.S. model. It is an F4 body (without an MB-20) combined with an **MB-21** battery pack. The MB-21 holds six AA batteries providing a firing rate of 5.7 fps. The MB-21 adds seven ounces of weight to the basic F4. Incorporated in the MB-21 is a vertical firing button plus an outstanding molded handgrip for vertical firing.

In 1991, Nikon, Japan, released the **F4e** for the international market (not including the U.S.). This is the basic F4 body packaged with the **MB-23** battery pack and an **MS-23** AA battery tray. The MB-23 provides a firing rate of 5.7 fps, a vertical firing button,

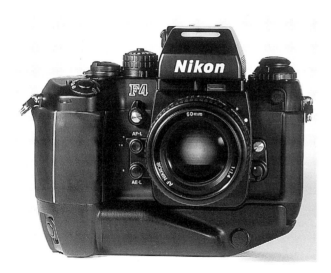

Nikon F4s

and the option of using NiCds. The F4e was later available in the U.S., but not packaged as a single unit. The components had to be purchased separately. But no matter what the combination of body and battery pack, an F4 body is an F4, with all the same functions and features.

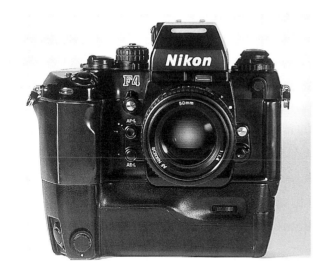

Nikon F4e

Note: Many photographers use AA lithium batteries in their F4. This is not recommended by the factory because the original voltage of these batteries when new and their tendency toward voltage fluctuations can hurt the camera. It is believed that this greatly shortens the life of the camera!

The F4's autofocus capability is quite good, though not remarkable by today's standards. (This is important to note as many today expect the F4 to have fast autofocus.) It features the same Advanced AM200 module as the N8008. It has continuous, single, and manual focus modes just as the N8008. However, the F4's autofocus capability is faster than the N8008's. The body was redesigned with more space to incorporate new features that contribute to the F4's increased AF speed. One is a new coreless motor that produces 15% more torque and rotation speed than the N8008.

Another new feature incorporated in the F4's autofocus is that it has two switchable filters. These two filters are incorporated into the base of the mirror box. They switch into use depending on the shooting situation. One filter screens out infrared light to prevent erroneous focus detection resulting from the chromatic aberrations of the lens in use. The other transmits infrared light and is used with a flash that has an infrared AF illuminator. The filters have a dust remover that keeps dust off their surface. The F4 even has little windshield-style wipers that clean the autofocus sensors inside the body. These clean the sensors each time the camera is turned on.

When the firing rate button is set to the C_L mode and the autofocus mode selector is set to C, the camera's computer can track focus. While focusing on a moving subject, the camera's computer calculates the speed and movement of the subject. While the mirror is up and the exposure is about to occur, the computer calculates the distance traveled by the subject during the short time prior to the exposure and refocuses the lens accordingly.

Like all other pro models, the F4 has interchangeable finders. But unlike previous models, the F4's finders are mounted to the camera via a rail system. By pressing in the small lever at the top left of the camera next to the finder, the finder slides toward the back of the camera. This very important new design allows the **Multi-Meter Finder DP-20** (the standard finder on the F4) to have an ISO TTL hot shoe on top of it (incorporating a semiconductor switch to prevent damage by flash units with high-sync voltages). This is the first pro model to standardize its hot shoe with other current Nikon camera bodies, enabling complete compatibility of TTL flash and flash accessories.

All F4 finders have 100% viewing of the picture field. They also have a new "stylized" look to them rather than the old squared-off mold. Some have limited metering capabilities. The DP-20 is the only finder that offers matrix, center-weighted, and spot

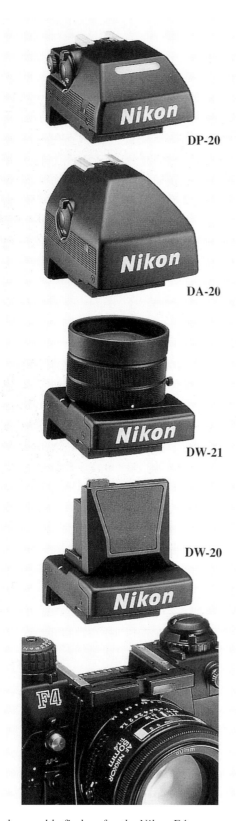

DP-20

DA-20

DW-21

DW-20

Interchangeable finders for the Nikon F4

metering. The DP-20 has four ICs, including one 8-bit microcomputer. The metering pattern switch on the side of the finder simply turns to select the desired metering pattern. Within a year of the F4's introduction, the cosmetics and detent of the metering pattern switch were changed. The tab to move the switch was enlarged both in width and height. The spring, or detent, on the switch was made stiffer (for lack of a better word), so the switch cannot be easily knocked out of a selected metering mode. The finder release lever was also changed in later versions of the F4, giving it a two-stroke release action to prevent one from accidentally hitting it and causing the finder to drop off.

Right in front of the metering pattern selector is a window with a "0" showing. This indicates exposure compensation dialed into the prism, compensating for a bright screen that was installed. Take the finder off the camera to access this control and use the special tool supplied with the F4 to make the necessary adjustment. For the majority of the screens, this value will not require changing. The DP-20 also has built-in diopter (-3 to +1) correction for those who need prescription lenses and want to use the F4 without having to wear glasses.

The **DA-20 AE Action Finder** is referred to by most as the Sportfinder. This large finder provides center-weighted and spot metering which is set with a switch on the side of the prism. It also provides an ISO TTL hot shoe on top of the finder. The major feature of the DA-20 is its TV-like eyepiece. The idea behind the large eyepiece is to enable viewing of the entire screen (which is still 100%) without having the eye right next to the finder. When using goggles, an underwater housing, or when shooting from a blind, this can be very handy for quick reference. The DA-20 comes with a large eyecup that extends out quite a ways, making it difficult to hold the camera up against your eye. But the eyecup is important because the center-weighted metering cells are located in the prism itself and can be affected by light coming in from the finder's large eyepiece. The eyecup provides a rubber eyepiece shield for remote work.

The **DW-21 High-Magnification Finder** is often referred to as a chimney finder. It permits viewing straight down from above the F4. The finder provides 6x magnification of the image (which is still 100%) with a -5 to +3 diopter correction. This is important for getting a sharp image at high magnification. This finder is often used with the special M screen, which cannot function without a finder that has built-in diopter correction. To set the diopter correction properly, focus on the *screen*. Turn the diopter correction

until the lines etched in the screen become dark. When not in focus, the lines will appear to be either doubled or fuzzy. Since the DW-21 doesn't have a pentaprism incorporated into its design, the image is reversed. This can take some getting used to and confuses many first-time users.

The DW-21 does not have an ISO hot shoe for TTL connection. Instead it has a locking socket on the back of the finder to accept the TTL cord **SC-24.** It shares the same coiled cord, TTL foot configuration, and length as the SC-17. Only the spot metering system built into the F4 is available to the DW-21.

The **DW-20 Waist-Level Finder** provides the same vantage point as the DW-21. It is a folding finder—the hood folds down into the finder for easy storage. The DW-20 permits one to view the entire screen from some distance away, but again, the image is reversed (as with the DW-21). The DW-20 provides 5x magnification via a pop-up loupe that is part of the hood. And like the DW-21, the DW-20 does not have a TTL hot shoe, but a socket that accepts the SC-24 cord. The DW-20 has no metering system built in, so only spot metering is available with this finder.

Opening the DW-20's hood can be a mystery. The trick is to push on the left rear edge of the hood, pushing it toward the shutter speed dial. That makes popping it up easy. Closing it is accomplished simply by pushing it down, and if the magnifier is up, it automatically closes with the hood.

When these finders are attached to the F4, the information display in the viewfinder changes. The readout at the base of the screen is lost, as are the frame counter and exposure compensation displays at the top left corner. These are replaced with a two-sided readout. On the right is the shutter speed in use, an error message, etc., and on the left is the exposure mode in which the camera is set. The autofocus indicator and flash indicator are still in their normal locations. In Manual mode, the number of stops the exposure is off from the meter's recommendation is displayed. When the correct exposure is set, the readout says "0.0" with a +/- symbol and two triangles lit.

Metering with the DP-20 on the F4 provides all three metering options. Matrix metering on the F4 works the same as that on the N8008. One big difference is that the F4 does not require a lens with a CPU to work in the matrix mode (this is still the only camera for which this is true). This allows full use of all AI, AIS, and AF lenses. The center-weighted metering is the traditional 60%. Spot metering reads 2.5% of the finder area in the center of the screen for its

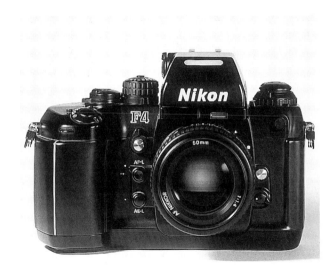

Nikon F4

exposure reading. This area is magnified and the spot becomes narrower with longer focal length lenses, but the area metered is still 2.5% of the screen.

Contrary to popular belief, there is no matrix flash metering. The sensor for the flash is at the base of the mirror box and operates center-weighted. The term "Matrix Fill Flash" refers to the ambient light being metered by the matrix meter when working with flash.

The placement of controls on the F4 is slightly different from other pro models. It does carry through though, the same basic design concepts of the F, F2, and F3. Integrated with the old standard large shutter speed dial are streamlined innovations, for example, the shutter release button on top of the handgrip. Hidden below the button is a rubber bellows designed to resist dust and moisture from entering the camera's electrical system.

Surrounding the shutter release button is the film advance mode ring. "C_H" (Continuous High) delivers 5.7 fps with the MB-21 or MB-23 and 4.0 fps with the MB-20. "C_L" (Continuous Low) delivers 3.4 fps with the MB-21 or MB-23 and 3.3 fps with the MB-20. In C_L mode, setting the AF to "C" activates focus tracking, which slows down these rates. "Cs" (Continuous Silent) delivers 1 fps with the MB-21 or MB-23 and 0.8 fps with the MB-20. (All speeds in the above examples apply when a 35-70mm f/3.3-4.5 autofocus lens is attached and the camera is in Continuous Servo mode. Firing rates can be faster in manual focus mode, or slower if a slow shutter speed is in use.)

The "silent" in Cs mode does not mean the camera cannot be heard when fired. Rather, it is the mode used in situations when the camera's noise needs to be less obtrusive (i.e., on a sound stage or in a courtroom). This mode is also excellent when shooting in cold conditions when static electricity or film breakage is a concern.

The clock symbol on the film advance mode ring is the self-timer, which provides a 10-second delay. "L" stands for lock, which shuts the camera system off. It is the only way to completely shut the power off (the 16-second shut-off still draws a small amount of power). If the ring is left at any setting other than L, the batteries will slowly be drained.

Behind the exposure compensation dial is the multiple exposure lever. Commonly referred to as the double exposure lever, this feature allows multiple exposures to be made on a single frame of film. When you want a multiple exposure, just take the first exposure and then pull this lever out from the body before advancing the film. The film will not advance until the shutter has been released again. If you want more than two exposures on the same frame, pull out the lever before each additional shot is taken. To cancel multiple exposure, simply push the lever back into the body. The film registration in the F4's film transport has the close tolerance of a pin-registered camera. This is great for multiple exposure or sequence shooting.

Next to this lever is the exposure compensation dial offering +/- 2-stop compensation in 1/3-stop increments. If compensation has been set, a +/- sign lights up in the top right corner of the viewfinder as a reminder (this also appears if using a flash that has compensation dialed in).

Under the exposure compensation dial is the lever for changing exposure modes. There is "M" for Manual, "A" for Aperture-Priority, "S" for Shutter-Priority, "P" for Program mode, and "P_H" for Program High. The viewfinder display inside the camera displays the currently selected mode. Operational procedures for the F4 in these modes is the same as those for the FA, N2000, N2020, and N8008.

The shutter that is coupled to all these firing rates and mode buttons is revolutionary. Because of this shutter's design, the F4 has a 1/250 second flash sync and 1/8000 second top-end speed. This is the first camera to deliver 6 fps with all other features engaged. Four of the shutter blades are made from special epoxy plates with carbon fibers to maximize strength while reducing weight. The others are made of a tough aluminum alloy. The shutter is a dual-curtain, multi-bladed, vertical shutter. This assures that light does not leak past the thin curtain blades, which could fog the film. (In the FE2, FM2, and FA, the concern of light leaking past the ultra-thin shutter blades on their fast shutters prevented them from having a mirror lock-up function.) The dual curtain, multi-bladed shutter of the F4 allows it to have a fast sync and mirror lock-up.

To make all this work smoothly every time and to eliminate all vibrations, the F4's shutter has a tungsten alloy shutter balancer. The balancer rises slightly when the shutter curtains operate. The anti-directional movement of the balancer absorbs vibration caused by shutter curtain travel. The balancer does not need much power; it is designed for high density and minimum drive. Combined with an efficient shutter braking system, the balancer protects against shutter bounce. It is not needed when using high shutter speeds of 1/500 second or faster, but can make a big difference with shutter speeds from 1/15 to 1/250 second. This balancer makes vibration-free photography a reality.

The all-electronic F4 (there are no mechanical overrides if the batteries go dead) has four coreless motors powering all the functions. The shutter charging motor is located beside the sprocket and takes care of bringing the mirror back down into place after the exposure has been made. Approximately 20% of the motor rotation takes care of mirror placement, aperture, shutter magnet resetting, and release magnet resetting. The rest of the rotation charges the shutter curtain (setting it to fire). The spool motor advances the film and is located inside the film take-up spool. The sprocket functions as a film perforation counter and not a film advancer as in conventional cameras. (An exception to this applies to the MF-24 back in which the sprockets do help drive the film.)

The rewind motor located at the lower side of the film cartridge chamber rewinds the film. It also changes the filters of the Advanced AM200 autofocus

module. The autofocus motor takes care of moving the mechanisms necessary to focus the lens.

There is also a two-motor partnership between the shutter charging motor and the spool motor. They work simultaneously (parallel control) to achieve high-speed film advance. When such high speed is not required, the shutter charging and spool (film advance) motors are driven sequentially (series control). When the firing rate is set to the Cs mode, the power repeats the ON-OFF operation, making the motor repeat the sequence of fast to slow movement.

The F4 is packed with other features we have yet to discuss, but it is the microelectronics inside the camera that make them all possible. The F4 has the largest computer system ever built into a 35mm SLR camera. There are nine ICs, including two eight-bit microcomputers and one four-bit microcomputer. The DP-20 has four ICs including one eight-bit microcomputer. As the camera's computer cannot be grounded, this static electricity can wreak havoc leading to occasional failure in powering up. On the last page of the F4 instruction book there is a small box with a solution for this static electricity block: simply take the batteries out of the camera and then reinsert them.

Other electronic "goodies" include the Advanced AM200 module with 200 CCDs and a special spot meter sensor incorporated adjacent to the AM200. A TTL sensor monitors the flash light exposure on the film and the flash/matrix-balanced fill flash. Multimeter SPD sensors located beside the eyepiece detect the scene's brightness and combine that information with the matrix metering system. Hybrid, multi-layer, printed circuit boards under the mirror box consist of several layers of epoxy glass. These printed circuits are sandwiched between these layers. They are commonly used in computers, but those in the F4 mark the first time this technology has been incorporated into a 35mm camera.

There are two film rewind modes on the F4. One is manual film rewind, which is accomplished by first depressing the button in the middle of the lever labeled "R_1." This is located between the shutter speed and exposure compensation dials. Once the button is pressed, pull the lever away from the body. Next flip out the lever running through the center of the film rewind knob. Turn the lever in the direction of the arrow to rewind the film. The R_1 lever stays out without being held during the time the film is being rewound. This can be used in conjunction with the Cs firing mode when "silent" operation is required.

The second and main film rewind system is motorized. It is activated by depressing the button on the R_1

lever and pulling it out from the body. Next, depress the button right next to the label "R_2" (by the film rewind) and push the lever adjacent to it to the left. Let go of the R_1 lever as soon as the R_2 button is depressed and the R_2 lever is pushed. The red light above the R_2 label lights as the film is being automatically rewound and stops blinking when rewinding is complete. This same red light also blinks rapidly if the film has not been loaded correctly (the shutter also locks up to prevent firing).

The R_2 lever can accidentally be knocked into the position for rewinding film. When this happens, the camera sounds as if it is in silent (Cs) mode. The camera fires normally, but does not advance faster than 1 fps. To remedy the situation, just push the R_2 lever back to its normal position.

The film rewind knob also opens the camera back. This is done by pressing the tab (with an arrow) at the front of the knob in the direction of the arrow, and then pulling up on the rewind knob. Below the knob is the ISO dial where the film speed can be manually set from 6 to 6400 or to DX coding. To override the DX coding, the ISO must be set manually. Right below this on the front of the camera is a standard PC socket for PC connections (this is not a TTL socket). Beneath the PC socket next to the lens mounting ring is the lens release button. Below this is the autofocus selector switch for choosing the C, S, and M modes. These operate the same as those on all autofocus Nikons. The F4 is the first Nikon body since the F3 to have a fold-back AI coupling pin on the aperture ring, which allows non-AI lenses to be mounted to the camera. Folding back the AI prong is the same as with the FE.

On the other side of the lens mounting ring are the autofocus lock (AF-L), the autoexposure lock (AE-L), depth-of-field preview, and mirror lock-up buttons. Depress the lower button marked "AE-L" to activate that function. "E L" will be displayed in the center of the bottom viewfinder display. To lock the exposure value, the button must remain depressed even during the exposure.

Using the AE-L button when in Aperture-Priority mode provides complete "manual" control over the exposure. This is true even when the camera is selecting the shutter speed. The camera displays the shutter speed it has selected based on the aperture the photographer has selected. If this shutter speed is not acceptable to the photographer, he or she has two choices: either take time to switch to Manual mode, or override the camera's selection. The fastest method of gaining manual control is to utilize the autoexposure lock button. Point the camera towards

different lighting until the desired shutter speed appears in the window. Then press in on the AE-L button to lock in the shutter speed. Reframe the shot and shoot (after exposure, release the AE-L button). This provides immediate control over the shutter speed without taking time to switch in and out of modes and manually set the shutter speed. This method allows you to maintain the use of stepless shutter speeds while being in control.

The AE-L button is convex, which distinguishes it by touch from the concave AF-L button (the next button up). The AF-L button is a great feature when using the C autofocus mode. The AF-L button has a small lever connected to it, which permits it to perform two functions at once, AF-L and AE-L. Set the lever to the single white dot for AF-L and to the white and red dot for dual AF-L and AE-L operation. Above this is the mirror lock-up lever and depth-of-field preview button, which work just like those on the F2 and F3.

Nikon released all new screens for the F4, the BrightView screens (yes, you've seen this term used before). The screen designations used for the F, F2, and F3 screens are the same for the F4 screens. But the F4 accepts only F4 screens. The standard screen that comes with the F4 is the B, not the A as with most previous Nikons (the F2H came with a B screen and the FM came with a K screen). This is because the F4 has a built-in electronic rangefinder and does not require the focusing aid of the A screen. The F4 screens have a small, rectangular AF bracket in their center. This is the visual reference point for the autofocus' electronic rangefinder.

The autofocus indicator lights are inside the viewfinder, at top right. The red triangles point in the direction the lens needs to be turned if focusing manually. The green dot appears when focus has been achieved either manually or automatically. A red X notifies the photographer that the AF system cannot focus on the subject. The exposure compensation indicator is directly to the right of the focus indicators. It alerts you that exposure compensation is in use.

In the top left corner of the viewfinder is one of the best features of the F4, the frame counter. It is no longer necessary to look on top of the camera to confirm the film's frame number. To the left of the frame counter is a window that displays the amount of exposure compensation dialed in via the exposure compensation dial, which is located next to the shutter speed dial. (This display changes with other finders.)

The display at the bottom of the viewfinder indicates other features and modes that are in use. On the far left is the metering pattern selected, and next to it,

the shutter speed. Next to that is the f/stop if in Shutter-Priority or one of the Program modes. Here the camera displays "FEE," "HI," or "Lo" if the camera is not set correctly. "FEE" indicates that the lens is not set to its minimum aperture when in these modes. "HI" or "Lo" refers to the exposure, which can be corrected by opening or closing the aperture or shutter speed as desired.

On the far right, the F4 display indicates the mode that is in use. An "A," "S," or "P" appears when any of those modes are in use. In Manual mode, the analog display appears with a range of +/- 2 stops in 1/3-stop increments. When the single dot is placed dead center on the analog display, correct exposure has been achieved.

In dark or dim situations, turn the switch on the front of the camera under the shutter speed dial until the red dot appears. This activates a light that illuminates the display information for as long as the meter is on. This also lights up a small light above the aperture value, which enables the use of the ADR readout dead center at the top of the viewfinder. It is visible in any and all modes. For working at night, this is a great system, since the photographer has control over whether the light is on.

Most owners of the F4 do a lot of vertical shooting because of its molded handgrip. This is especially true because of the very convenient vertical firing button on the end of the MB-21 and MB-23. It offers easy access and more stable handheld shooting. Nikon anticipated this popularity by incorporating a matrix metering switching system for vertical shooting. The matrix vertical sensor in the F4 is different from that in the N8008 in the way that it knows it is turned vertically. A matrix vertical sensor is incorporated into the DP-20 on either side of the eyepiece lens. When the camera is turned vertically, a mercury switch enclosed in each of the two sensors is automatically activated. These switches change the metering output assignment for the five segments, assigning appropriate readings for vertical shooting.

Whether the F4 is vertical or horizontal, the eyepiece shutter is necessary to keep out extraneous light when the photographer's eye is not pressed against it. Otherwise, extraneous light changes the meter reading and the exposure.

The F4 like the N8008, has cybernetic flash sync, matrix balanced fill flash, center-weighted fill flash, and TTL flash. These all work the same as in the N8008 and provide the same features. The F4 also utilizes these features when the camera is in the vertical position. There are many other features avail-able when using the F4 with the SB-24, 25, 26,

or 28 flash. (These are discussed in depth in the *Flash* chapter.)

When working with black-and-white film and using dark red or deep orange filters, you run the possibility that the electronic rangefinder and autofocus will not function properly. Nikon recommends manual focus when using these filters. With a film such as Polapan, which has a very dark film backing, TTL flash will not work properly without some type of exposure compensation. The meter sees the dark film and keeps the flash on longer than required for correct exposure because it is so dark.

When using teleconverters that are AI, even connected to a lens with a CPU, matrix metering is lost. An AIS teleconverter must be used to maintain matrix metering, those being the TC-14A, TC-14B, TC-201, and TC-301. Many photographers are still using the older TC-14 and wonder why the exposure does not come out correctly. When an AI teleconverter is attached to the F4 and the F4 is in matrix mode, the camera automatically changes to center-weighted metering, though the selector switch still says matrix. The viewfinder communicates the change to center-weighted metering.

Every body and lens ever made by Nikon has been updated during its production. The engineers at Nikon are constantly trying to make a good thing great, and the F4 is no exception. None of these updates make any new technology available, but just refine the operation of the F4. Many are cosmetic changes. Most are never divulged by Nikon as they are internal in nature.

The changes include clearer lettering on the shutter speed dial, a taller unlocking button, and greater tension was added to turning the shutter speed dial. The exposure compensation dial was made bigger. The metering mode switch tab was made larger and its detent stronger to prevent it from being moved accidentally. The spring on the release lever for opening the back was made stronger, and the battery warning LEDs respond at a lower voltage. These changes were phased into new bodies with serial numbers between 2100000 and 2180000. Other more recent changes are a thicker, rubberized back, a double detent on the finder release lever, and an ISO hot shoe with a lock pin hole.

Nikon N4004s

In 1989 the N4004 was slightly revised and introduced as the **N4004s**. It was upgraded with the Advanced AM200 module of the N8008 and a lock for

Nikon N4004s

the shutter speed and aperture dials to prevent the camera from being accidentally knocked out of Program mode. Otherwise it is exactly the same camera as the N4004.

Nikon N6006 and N6000

In the summer of 1990 Nikon introduced two new cameras to replace the N2020 and N2000—the N6006 and N6000. Although they offer similar features, the **N6006** has additional major features not incorporated in the N6000. The N6006 was an extremely popular camera. And it did not just appeal to the general public, photojournalists also latched onto this unique package of technical wizardry.

Nikon N6006 and N8008s

However one drawback to the N6006 is its power source, a 6v lithium battery. Under normal conditions, it can expose a maximum of 75 rolls of film, but at 14°F, only 3! Use of the built-in flash knocks these numbers down even further. (This did not seem to slow down sales of the camera, but did increase sales of 6v batteries!)

The N6006 has superior autofocus capability featuring focus tracking. Focus tracking is operational in any film advance or autofocus mode combination. If the subject is moving, focus tracking analyzes the speed of the subject and activates the autofocus to anticipate the subject's position at the exact moment of exposure. Focus detection is possible as low as EV -1 (with ISO 100 film) while providing CF, S, and M focus modes (with the switch located under the lens lock button). It utilizes the AM200 module of the N8008 and F4. As a result, the autofocus in the N6006 is faster than that in the N8008 (but not N8008s).

Its metering options include matrix, center-weighted, and spot, with an AE-lock increasing its flexibility. To set a particular mode, depress the SLW button located to the left of the prism on top of the camera. Then turn the command dial until the symbol for the desired metering pattern appears in the LCD panel.

The AE-L lever operates either the AE-L function alone or AE-L and AF-L combined. Changing this function requires depressing the shift button (directly to the right of the prism) first and then the Drive/AF-L button (to the left of the prism). Pressing the Drive/AF-L button while holding down the shift button changes the message in the LCD panel to say "AF-L" or "- - - - -," the latter indicating that just AE-L is in use. If "AF-L" appears, the combined AE-L and AF-L functions are in effect when the lever is depressed.

Coupled with these are S, A, M, and P modes (as in the N8008) as well as a new "Pm" (Auto-Multi Program) mode. The Auto-Multi Program Exposure Control mode is designed to take control in low lighting (when using a lens with a CPU). It will not use a shutter speed slower than the reciprocal of the focal length of the lens in use without warning the photographer. Changing the exposure mode requires you to press down the MODE button while turning the command dial until the desired symbol is displayed on the LCD panel.

A new feature of the P and Pm modes is called "Flexible Program" (Flexible Program was first introduced in the original N8008). When in these modes, lightly press the shutter release button and the exposure info appears. If a different aperture or shutter speed is desired, turn the command dial until the desired combination is displayed. When this is done correctly, the exposure mode indicator will blink in the LCD panel and viewfinder display. This is canceled when the camera is turned off or the camera automatically shuts down after eight seconds.

The N6006 has built-in autoexposure bracketing providing three- or five-frame bracketed exposures. This operates only with P, Pm, S, or A modes. In P or Pm modes the shutter speed and aperture automatically change during bracketing. In S mode the aperture changes, and in A mode the shutter speed changes.

To set the camera to autoexposure bracketing, first make sure it is set to the desired exposure mode. Next, press and hold in the shift button, then push the BKT/SET/R button (located to the left of the prism). The "+/-" and blinking "BKT" symbols on the LCD panel and the "+/-" blinking in the viewfinder remind you that auto bracketing is operational. After the camera's auto shut-off, the "BKT" on the LCD panel no longer blinks.

Setting the degree of bracketing and the number of frames requires pressing the BKT button. Next turn the command dial until the desired combination appears in the LCD panel. Bracketing is in 0.3, 0.7, and 1.0-stop increments. With "3F" selected, the camera automatically exposes one frame under the meter reading, one right on, and one over. With "5F," the camera exposes two frames under, one right on, and two over. In the S (Single Servo) advance mode, the camera takes one shot each time the shutter release is depressed (counting down the number of exposures each time). In C (Continuous Servo) advance mode, the camera fires off all frames with just one press of the shutter release button.

The N6006 has a built-in, pop-up flash that's just a hint of the camera's flash technology. The built-in flash provides a guide number of 43 with ISO 100. It is powered by the camera's 6v battery. The flash is not heavy duty. It is not recommended that it be flashed more than 20 times with a 5-second or shorter interval between flashes. If this occurs, let the flash rest for at least ten minutes before firing again.

Note: The usable film speeds for TTL flash photography are ISO 25 to 1000.

The built-in flash can function with matrix or center-weighted balanced fill flash. The built-in flash is incompatible with a number of lenses, primarily long telephotos and zooms. There is a complete list on pages 78 and 79 in the N6006 instruction book. It is

also recommended that lens hoods not be used when using the built-in flash to prevent vignetting. If the flash is popped up, an auxiliary Speedlight (if attached) cannot be fired.

The N6006 has matrix balanced fill flash, center-weighted fill flash, spot fill flash, and standard fill flash built into its system. These provide automatic balanced fill flash, manual flash output level adjustment (a complicated way of saying flash exposure compensation), slow sync, and rear-curtain sync. At one time, these features were available only with the F4 and N8008. In fact, it is important to note that functions on the flash are overridden by the flash functions incorporated in the N6006. The lens aperture, ISO, and angle of coverage settings must be input manually, just as if a non-CPU lens were in use. Depressing the M or SEL buttons on a Nikon flash has no effect—no message appears on its LCD panel. Slow sync and rear-curtain sync settings are made on the N6006 itself.

With automatic balanced fill flash, the flash output is automatically compensated to balance the foreground subject (lit by the flash) and the background (ambient light). This is achieved by first depressing and holding down the shift button and then depressing the MODE/man-and-sun button. This has been done correctly when the man-and-sun symbol appears in the LCD panel. Select the desired metering pattern as usual to utilize matrix (requires use of a lens with a CPU), center-weighted, or spot fill flash. Note the TTL flash exposure is still only center-weighted. Matrix, center-weighted, and spot metering apply strictly to metering ambient light.

Operating the N6006 with flash when in Program mode is unique in the Nikon system. With the exposure mode set to "P" or "Pm," turn on the flash unit making sure it's switched to TTL. If the flash is not set to TTL, the mode indicator and man-and-sun symbol blink for a few seconds to warn of a mis-setting. With a lens 60mm or shorter mounted, the shutter speed can range from 1/focal length to 1/125 second. For example 1/focal length for a 20mm lens would be 1/20 second. With a lens that is 60mm or longer, 1/60 or 1/125 second are the only possible speeds. Switching the camera to slow sync provides a shutter speed range of 30 seconds to 1/125 second.

There are a number of warnings the camera's LCD can flash when controls are improperly set. "FEE" blinks when the aperture is not set to its minimum f/stop. The analog display appears when ambient light is causing either over- or underexposure. The lightning bolt in the viewfinder indicates proper or improper flash exposure as with previous Nikons. If underexposure occurs, it blinks rapidly, indicating a need to either get closer to the subject or open up the aperture. If the bolt goes off and then comes back on a few seconds after the exposure, this indicates a correct exposure has been made.

Operation in S and A modes is basically the same as in P or Pm modes. The same warnings appear if the flash is not set to TTL. In S, the camera defaults to 1/250 second if the camera is set to a faster shutter speed. In A, control of depth of field is back with the photographer and the camera provides the correct flash exposure automatically.

Exposure compensation in TTL is where most get lost in the instruction book. The N6006 provides three methods of making exposure compensations; manually adjusting flash output, using the camera's EV compensation, and auto bracketing. These can be used separately or in combination.

Manual flash output level compensation is the most commonly desired but misunderstood function. Depress and hold in the shift button and press the MODE/man-and-sun button to call up the man-and-sun symbol in the LCD panel. Next, press the shift button calling up the "lightning bolt, +/-" flash output level symbol. While holding down the shift button, turn the command dial to set the desired flash exposure compensation. Compensation from EV +1 to EV -3 is available. Remove your finger from the shift button and the analog display will disappear, leaving the "lightning bolt, -/+" symbol to indicate flash compensation has been dialed in. This probably sounds like you need four hands, but it is easy if done slowly and practiced before it is actually needed.

Slow sync flash works with a slow shutter speed. This permits correct, low ambient light exposure when working with shutter speeds from 30 seconds to 1/125 second. When the camera is in slow sync, it automatically exposes the ambient light correctly, even in low light levels, while providing correct TTL flash exposure. When in normal sync, the shutter speed can range from 1/focal length (as long as it is 60mm or shorter) to 1/125 second.

When using slow sync, the camera must be used in exposure modes P, Pm, or A. To select slow sync, press and hold in the shift button, then press the Matrix/SLW button to the left of the prism. The "SLOW/lightning bolt" symbol appears in the LCD panel when slow sync is activated. In this mode, the flash is taken at the beginning of the exposure. This function is most effective when used in concert with exposure compensation as previously described.

In rear-curtain sync and rear-curtain slow sync, the flash fires at the end of the exposure. It is activated by

depressing and holding the shift button while pressing the self-timer/RE button. When rear-curtain sync is activated, the "REAR/lightning bolt" symbol appears in the LCD panel. In S or M mode, only rear-curtain sync is available. In PM or A modes, both rear-curtain and slow sync can be used in concert.

Like the N8008, the N6006 works with a thumb wheel control dial. Because the camera has a built-in flash, there is no port to light up the internal viewfinder display, so a light illuminates the display constantly. The camera also has a high-eyepoint finder, but with a square eyepiece. The finder coverage is only 92% of the picture field. It also has a built-in motor drive providing up to 2 fps, which is powered by the 6v lithium battery. It accepts a standard cable release but does not have a port for an electrical cable release.

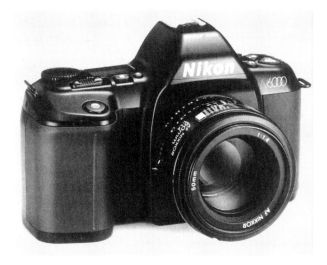

Nikon N6000

The **N6000** does not have a built-in flash or autofocus capability. It is a manual focus camera. However it does have all the TTL flash capabilities and features of the N6006. Neither camera has interchangeable screens—the N6006 offers an electronic rangefinder, while the N6000 offers a split range finder screen. All other features, design, and the basic camera chassis are the same. Neither camera accepts a multi-function back or the MC-12a cord, only an **AR-3** cable release. The backs on both cameras are solid plastic, the bodies are polycarbonate like that of the N8008.

While the N6000 has all of the sophisticated flash capability of the N6006, its LCD panel displays some of the error messages differently. Refer to the N6006 section for an explanation of flash use and the

N6006/N6000 flash photography instruction manual for specifics on error messages.

Nikon N8008s

In the spring of 1991 Nikon introduced an updated N8008, the **N8008s.** The "s" either stands for "spot" or "speed," because those are the only new features in this updated version.

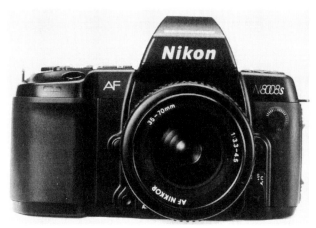

Nikon N8008s

The N8008s has a spot meter incorporated with its matrix and center-weighted metering systems. As with the other metering systems, AF lenses or lenses with CPUs are required to take advantage of the spot metering. The area metered by the spot meter is a circle approximately 3.5 mm in diameter in the center of the viewing screen. It is activated the same way the other metering patterns in the N8008 are.

The autofocus coreless motor in the N8008s is the same charging motor as the F4's. This update increased the speed of the autofocus in the N8008s by 15% over that of the N8008. This is a noticeable and vast improvement. The momentary whir of the motor when the shutter release is first pressed on the N8008 is not present with the N8008s. The N8008s also has focus tracking capability.

All other features, functions, and operations of the N8008s are the same as on the N8008. Those doing home electronic modifications, be forewarned that the electronics for firing the N8008s are different from the N8008. To customize an electronic release that activates autofocusing, metering, and shutter release on this camera, a different resistor from the one used to activate the same function in the N8008 needs to be installed.

Nikon N5005

In the fall of 1991, Nikon came out with a state-of-the-art version of the N4004, the **N5005.** It incorporated the latest editions of the Nikon arsenal of electronics into the same frame as the N4004s. These include independent shutter speed and aperture dials, dial lock release, and the AM200 module. There are only four basic new features that make the N5005 stand out: full matrix metering, predictive autofocus, "T" (time exposure), and a pop-up flash with 28mm lens coverage.

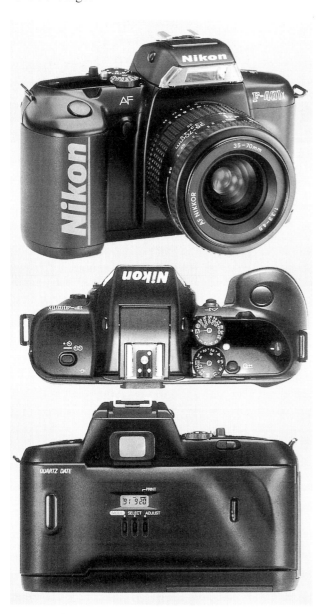

Nikon N5005 (F-401x outside the U.S.A.)

Matrix metering works in Program, Shutter-Priority, and Aperture-Priority modes. This is done without requiring any action by the camera operator. In Manual mode or when the AEL button is used, the camera automatically switches to center-weighted metering. It is a traditional center-weighted meter with its bias on the 12 mm center spot.

Predictive focus operates automatically when the autofocus is set to "A." It is based on the same principles as that of the F4 and N8008s.

The T setting is unique in that it does not require a cable release to be activated. First, set the camera's shutter speed dial to "T." Next fully depress the shutter release button, remove your finger, and then wait 0.5 second for exposure to begin. During the exposure the self-timer LED blinks every second. To stop the exposure, press the shutter release button lightly. When the exposure is finished in this mode, it is best to place the lens cap over the lens before pressing the shutter release button to end the exposure. This prevents the photograph from blurring.

The pop-up flash of the N5005 can cover the range of a 28mm lens whereas the N4004s has only the coverage of a 35mm lens. The N5005's flash range coincides with what was then a new little lens, the 28-70mm f/3.5-4.5 AF. Combined, this lens, the N5005 body, and its built-in flash make an excellent traveling camera rig. The N5005 instruction book comes with a separate, thorough flash instruction book, which allows you to take full advantage of Nikon's TTL flash system.

Nikon N90

The increased use of flash in mainstream photography comes out loud and clear in the **N90.** Introduced in September 1992, this technological workhorse took flash, autofocus, and photography a leap forward. Boasting new wonders such as 3D matrix metering, five-segment TTL multi-sensor flash control, wide-area high-speed autofocus, Vari-Program, and Data Link system compatibility, the N90 truly heralds the next evolution in camera body technology!

Though housed in a body similar in appearance to the N8008s, the interior workings of the N90 have something special. This is best seen on the exterior where the coupling for the cable release now requires a ten-pin jack (the F4 and N8008s use two pins). This jack makes the N90 unique because it hooks up to and talks with the Sharp® Wizard Electronic Organizer, linking up the camera's advanced computer array to an outside source.

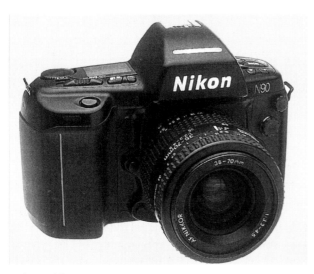

Nikon N90

The basics of the N90 include many features most commonly in demand. Depth-of-field preview button, a DX range of ISO 25 to 5000 and manual range of ISO 6 to 6400, autofocus lock, autoexposure lock, matrix metering, automatic film loading, and continuous motor drive with two settings (2.0 fps and 3.6 fps operation) are all standard equipment. The wider girth of the body, the placement of the buttons and controls, and its rubberized camera back give the N90 a much better feel than the N8008.

The power source for the N90 is four AA batteries (lithium AA batteries are not recommended). The camera has a battery condition alert that signals battery status. It is shaped in the form of a battery, and when fully darkened with bars, this symbol indicates that the batteries are in new condition. The bars disappear as the batteries are drained until finally the battery symbol blinks, indicating that new batteries are required. If no symbol appears, then either the batteries have been loaded incorrectly or the batteries are completely dead.

The N90 encompasses an entirely new autofocus system. The advance can be credited to the new CAM 246 Wide-Area Cross-Type Focus Detection Sensor. This relates to a 7 mm horizontal and 3 mm vertical detection zone for the autofocus sensor. Subjects that might be off-center, for example, will now be detected by the sensor and locked on to. When the camera is turned vertically, the AF sensor is more sensitive than in past models, making response faster and surer. This, coupled with new software and overlap servo, meant that at the time of its release, the N90 had the fastest AF operation of any Nikon. This, even in low-light conditions (EV -1).

The N90 has the standard three modes of focus, M, S, and C. The cosmetics of the focus mode selector (located under the lens release button) have been updated. The mode switch, when set to M, sticks out from the mount. This makes switching to the AF mode easy, if desired.

The Nikon N90 still incorporates an electronic rangefinder for manual focus. It has the same focus indicators—two triangles and a dot—as in previous models. In either of the AF modes though, these familiar symbols take on a whole new set of meanings.

If you are focusing on a stationary subject, just the dot appears in the viewfinder when the subject is in focus. If the subject should move, the camera automatically switches to focus tracking. This is indicated by the double triangles lighting. As soon as the subject is expected to be in focus, all three symbols appear. And if the double triangles should blink, the system cannot focus on the subject. If using Single Servo ("S") mode in focus priority, the shutter will not fire until either the dot or all three symbols are lit indicating the subject is in focus.

The autofocus brackets are larger than those in any previous AF camera. It has an expanded 7 mm bracket of horizontal coverage (the circle inside the bracket is the spot focus zone of coverage). There are two autofocus modes, Single Servo AF ("S") with focus priority and Continuous Servo AF ("C") with release priority. In either mode (at 3 fps), focus tracking automatically tracks a moving subject or a subject that starts moving.

Single Servo is usually reserved for stationary subjects but can take on moving targets. Focus tracking is automatically activated by lightly depressing the shutter release button. When the subject moves and is expected to be in focus, the in-focus symbol appears, indicating it is time for you to take the picture. In this mode, the camera will not fire until the subject is in focus, whether it is moving or stationary.

In Continuous Servo AF mode with release priority, the camera fires whether the subject is in focus or not. Focus tracking is automatically in operation, tracking the moving subject. But the camera can be fired any time, whether the camera says the subject is sharp or not. As with the Single Servo mode, the triangles indicate when the subject is expected to be in focus. Since the focus is not locked in this mode, an off-center subject requires you to use the AF-L button. For this situation, the S mode is probably a more effective mode of operation. Either mode is greatly affected by either wide-area or spot AF detection. For example, in C wide-area detection mode, the camera

searches when two subjects of different distances are detected within the zone.

The owner's manual goes into great depth concerning when to use either wide-area or spot AF mode. Subjects that are extremely bright, for example, require spot. The use of a circular polarizer, rather than a linear one, is still required with this system. If a situation comes up in which neither AF mode works, manual focusing is still an option with the electronic rangefinder assist (as long as a lens with a CPU is used).

The N90 comes with a high-eyepoint finder with a built-in shutter for the eyepiece. To the left of the eyepiece is a small button that, when depressed, illuminates the viewfinder and the LCD panel on the top of the camera. This light stays on for approximately eight seconds. The N90 finder coverage is only 92% of the picture field, but the image is exceptionally bright. It comes with the B BriteView screen, and the E screen is the only screen available as an option. It takes the **DK-6** eyecup and uses all other additional viewfinder accessories of the F4 and N8008.

The information inside the finder is placed as in the N8008 and N8008s. From left to right it has: AF detection mode, focus indicators, exposure mode, shutter speed, aperture, electronic analog display, frame counter/Vari-Program/compensation value, exposure compensation indicator, and flash recommend/ready light. The B screen has an inner circle, which is the 3 mm spot area AF detection zone; a 7 mm horizontal bracket indicating the wide-area detection zone; and the 12 mm reference circle for center-weighted metering.

The N90 offers two types of programmed autoexposure modes, Auto-Multi Program (P) and the new Vari-Program (Ps); and the old standards, Shutter-Priority (S), Aperture-Priority (A), and Manual (M). S, A, and P modes are the same operating modes as in previous models and operate in the same manner. It is the Ps with its seven different variable programs that is quite exciting and new to the Nikon system.

In Vari-Program mode, the camera's computer takes the information from the meter and predetermines the best shutter speed and aperture combination for the situation. Though these Vari-Programs can be accomplished via conventional modes and methods, they allow the photographer greater creative freedom by taking care of what could be complex exposure decisions. The seven programs are Portrait (Po), Portrait with Red-Eye Reduction (rE), Hyperfocal (HF), Landscape (LR), Silhouette (SL), Sport (SP), and Close-Up (CU).

The Ps modes are activated by depressing the Ps button located on the top left side of the camera while simultaneously turning the command dial. Once that is accomplished "Ps" appears in the mode window on the display panel. To activate a particular Ps mode, again press the Ps button while turning the command dial until the desired program is displayed.

The Po mode selects the widest aperture, creating portraits with shallow depth of field. The rE mode activates the SB-25, 26, and 28's red-eye reduction feature, which emits four bursts of the flash prior to exposure to reduce red-eye. HF mode provides for the greatest depth of field (though not truly calculating hyperfocal distance). LR is designed for scenics in which greater depth of field is desired. An additional feature of this program is that it takes the relative brightness of the top half of the image (the sky) into account when it calculates the exposure. SL underexposes the subject for a dramatic silhouette against a bright background. SP is for capturing fast movement by freezing the action. CU is designed for general close-ups that require a blurred background.

When in the Ps mode, the camera automatically resets certain camera functions. The flexible program is canceled, metering is set to matrix (though you can reset this function), exposure compensation goes to 0, focus area is set at wide, and other functions are reset when a flash is attached. The instruction book goes into this in great depth. The N90 instruction book has excellent, detailed, step-by-step instructions for making the best use of each Vari-Program. It discusses metering, focus area, focus mode, film advance, and flash sync. It goes a step beyond that by providing greater in-depth tips for creating the perfect photographs, illustrating possible problems that the photographer might encounter.

Changing functions or modes is done by the same method as on the N8008 and N8008s. The mode, metering pattern, drive, ISO, and film rewind controls are on the left. They are changed by depressing the appropriate button and then turning the command dial on the right. New is a lightning bolt to the left of the mode button. This is for the N90's controlled-by-the-camera flash operation. Depressing it while turning the command dial activates either slow sync, rear sync, or red-eye reduction. Also new are two green dots, one on a button to the left of the prism and the other on the exposure compensation button. When the two buttons are depressed simultaneously, the camera settings are reset to the basic factory default settings (factory settings are: single-frame advance, matrix metering, Auto-Multi Program exposure mode, wide-area AF, canceled flexible program, 0 compensation, and normal flash sync).

The LCD panel on the top right of the camera is packed with information. The mode that is in use determines what is displayed. The familiar shutter speed, f/stop, ISO/DX indicator, self-timer, exposure compensation, exposure mode, and frame counter of the N8008 and N8008s are still in place. New additions are abbreviations for the new modes and programs—AF-R for "C" AF mode, AF-F for "S" AF mode, MF for manual focus mode, H for continuous high-speed motor drive operation, L for continuous low-speed motor drive operation—and a battery condition indicator.

The shutter release button is in its familiar locale as is the ON/OFF switch with its familiar beeper symbol. On the N90, the beeper sounds twice if activated when a subject is in focus. It also has a number of other signals to let the photographer know if things have gone haywire.

All these seemingly new improvements really dance around the great advances the N90 offers the photographer. At the top of the list of advances has to be the metering system, both for ambient and flash light (see the SB-25 instruction book for flash information). 3D matrix metering links the eight-segment matrix metering pattern to the distance information from the CAM 246 to perform complex exposure analysis. This is only possible when "D" technology lenses are employed, which at the time the N90 was released included the 28-70mm f/3.5-4.5D, 35-70mm f/2.8D, 80-200mm f/2.8D ED, 300mm f/2.8 AF-I, and 600mm f/4 AF-I. The process can be broken down into four steps. First, the brightness data from each of the eight segments is read and analyzed. Second, the contrast of each segment is compared with that of the other segments. Third, the distance information from the D lenses is calculated. And for the fourth step, data regarding the defocus amount from the camera's AF system is added in. This information builds the 3D matrix box, which comes up with the best exposure. (It is good that we just know that it works and don't have to understand thoroughly how its works!)

True, the 3D matrix metering works only with D lenses, but the eight-segment matrix metering works with any lens with a CPU. Step three is left out during the calculation process when non-D lenses are in use. If a non-CPU lens or accessory is used on the N90, the camera automatically switches to center-weighted metering. The N90 also has 75/25 center-weighted metering and spot metering. The spot metering is approximately 1% of the total viewing area and is indicated by the small 3 mm circle in the middle of the screen.

The N90's flash metering was the most advanced of the Nikon arsenal at the time of its release. 3D multi-sensor balanced fill flash is possible when the N90 is used in conjunction with the SB-25, 26, or 28 flash and a D lens. With this combination, the N90's five-segment TTL multi-sensor is being used to its fullest.

The meter calculates the information in the following manner. Remember, it is doing it at the speed of light! 1) The D lens sends camera-to-subject distance to the N90 computer. 2) The flash unit fires a series of weak flashes (up to 16) just after the mirror goes up but before the shutter moves. This monitor pre-flash is for the TTL multi-sensor. At the same time, the ISO, subject distance, lens aperture in use, and brightness value for the center subject are all read and registered. 3) The TTL multi-sensor reads the light from the monitor pre-flash as it is reflected off the special, gray painted shutter curtain. In this step the reflectance value of the subject is taken into account and compensation is made if required. 4) The camera's computer takes those readings and compares the amount of light that actually reaches each of the five segments with the theoretical amount required calculated from the distance information. 5) The computer then analyzes and decides which segment of the TTL multi-sensor to use for flash exposure according to the reflected light reading and the amount of flash output required to balance with the ambient light exposure. 6) The shutter opens, the flash fires, and the camera's computer shuts down the flash output determined by step 5.

When using the N90 and SB-25, 26, or 28 without a D lens, distance information is not available, so exposure might not be as well defined. When this is the case, the N90 delivers the same results as the TTL flash system in the F4 and N8008. Using the N90 with other flash units, such as the SB-24, monitor pre-flash is not available, but the matrix multi-sensor is still employed. When any lens that doesn't contain a CPU is used, matrix flash operation is lost. Center-weighted and spot-metered fill flash are used for automatic balanced fill flash. (And will this system deliver radically better exposures than the F4? If there is a four-stop or greater range in exposure, yes. Otherwise, it delivers the same excellent results as the F4.)

TTL flash operation starts with setting the preferred metering system and exposure mode on the N90. Turn on the flash. If wide-area AF is set on the camera, the camera automatically switches to spot area and the indicator on the camera's LCD panel blinks indicating this has occurred. Depressing the

shutter release button brings up an array of info indicating whether the subject is in focus, flash is being used properly, etc. With basic TTL balanced fill-flash operation, this is all that is required of the photographer for proper exposure.

The N90 has slow sync operation built into the body. Depressing the large button with the lightning bolt symbol (on the top left of the camera) and turning the command dial until the word "SLOW" appears on the LCD are all that is required to activate slow sync. Using the SB-25 and SB-26 flash units is not required for this function to work. Slow sync allows the camera to set the shutter speed as low as 30 seconds automatically to properly expose the ambient light. Matrix flash metering is still in use with slow sync.

The N90 also has rear-curtain sync built into the body and it, too, works with any flash. If the SB-24, SB-25, or SB-26 is being used, the rear-curtain sync on the body is ignored and must be activated by the switch on the flash unit. When rear-curtain sync is activated, slow sync is also activated automatically. The message in the camera's LCD reads "SLOW/ REAR" (once the lightning bolt is no longer depressed). In this mode, the first shutter curtain goes up and the flash fires only when the second (and last) shutter curtain begins to close. (This mode cannot be used with any of the Vari-Program modes.)

The last of the N90's built-in flash features is red-eye reduction. This is activated the same as slow and rear-curtain sync, and the LCD shows two lightning bolts to indicate operation. Red-eye reduction can be used in any exposure mode, and in "rE" mode it is set automatically.

The instruction manuals for the N90 and SB-25 represent a huge advancement in how Nikon treats flash. Explanations, uses, problems, and possibilities are thoroughly discussed in Nikon's latest instruction books, which are vastly superior to previous manuals. The camera and flash have an array of symbols that appear and disappear when certain functions are activated. Many of those are explained in depth in the SB-25 write-up. Careful reading of the instruction books clearly defines and illustrates any symbols.

The introduction of the N90, more than anything else, heralded the beginning of a more high-tech era of photography. N90's ten-pin coupling permits the camera to be connected to an outside data base computer, the **Sharp® Wizard Electronic Organizer OZ-8000** and **OZ-9000** series. This powerful accessory wasn't released until 1993, but the options it offers the photographer are staggering.

The **AC-1E Nikon Data Link Card** and **MC-27**

Connecting Cord link the camera to the Wizard. Two modes are available, On-Line and Off-Line. The On-Line options are amazing. They include but are not limited to: remote camera control and operation with display of camera functions, customized settings that allow factory settings to be changed, a "Memo Holder" that memorizes shooting data for later downloading, photo technique selection, control of the MF-26 Multi-Control Back, and a variety of other custom features. It even enables you to modify exposure curves for programmed exposure modes!

The Off-Line features a photographic manual for the N90, the Photographic Hand-Book, which is the basic Nikon guide to photography, and would later include other features to be announced by Nikon. The uniting of such technology is exciting when considered with what we know of the N90. But what this said of things to come from Nikon and where it would take camera technology in the future is amazing! Photo Secretary came next.

Nikon FM2/T

The FM2N received a facelift in 1993, becoming the **FM2/T.** It has all the same specs of the FM2N and accepts the same accessories. The difference is that the FM2/T has a titanium outer shell. The top and bottom plates and back are made of titanium, which provides superior strength. This is the only all-mechanical camera in the Nikon line with a strong and loyal following. This T version gives those all-manual fans a camera that is highly shock- and corrosion-resistant.

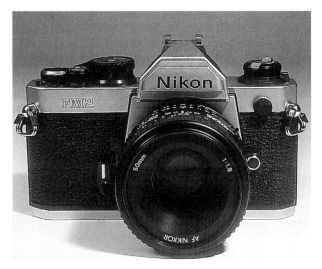

Nikon FM2/T

Nikon N50

In 1994, Nikon introduced "powerful technology, yet simple operation" with the **N50.** Nikon's literature states, "Want a portrait? Push a button. Want a close-up? Push a button." The N50 is heralded as the "Shortcut to Great Pictures." In an age of Windows® and user-friendly software for computers, the N50 offers the same basic philosophy to the world of picture-taking.

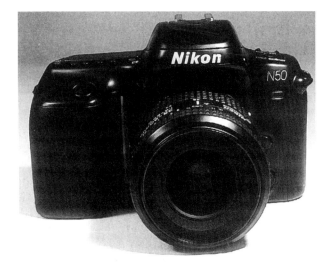

Nikon N50

The key to this "shortcut" is the camera's eight program modes. There are four Simple mode programs and four Advanced mode programs. The Simple modes are General Purpose (camera icon), Landscape (mountain icon), Portrait (profile icon), and Close-Up (tulip icon). The Advanced modes are Sport (runner icon), Silhouette (palm tree icon), Night Scene (building and moon icon), and Motion Effect (runner icon with streaks). These, along with the other features and functions of the camera, are easily programmed via the camera's icon-rich LCD panel. And if none of these programmed modes fits the moment, the N50 offers Shutter-Priority, Aperture-Priority, and Manual modes. (All icons appear via a dot matrix LCD, the first incorporated in an SLR.)

The instruction books for the N50's body and flash are a little out of the ordinary because of the N50's simplicity. Old-time Nikon users might find this approach a little confusing, so let's clear up some of the points. Some of the basics not obvious in the manual are that the N50's picture area is viewed at only 90%.

The N50 has a built-in flash providing coverage for a 35mm lens with a guide number of 42.7 in feet, 13 in meters (ISO 100). It has the Advanced AM200 auto-focus module with detection from EV -1 to 19. It also has focus tracking, which automatically switches on when the subject is moving. It does not have a socket for remote firing, either with an electronic or manual cable release.

Film loading and advance are automatic. It has a set speed of just 1 fps. The film is automatically rewound at the end of the roll. During rewind, the film cassette symbol and double triangles blink indicating the film is being rewound. It stops automatically and an "E" appears in the frame counter. (If the battery is weak or cold, the film might not rewind completely. An "Err" message might appear, which is resolved by replacing the batteries with new ones.) Depressing the button on the base of the camera permits rewinding in mid-roll if desired. The ISO range for DX coded film is 25 to 5000 and for non-DX coded film, 6 to 6400.

The viewfinder illuminator activates automatically when the exposure meter is engaged. The viewfinder information display is quite different from that on the top LCD panel. The familiar "HI" or "Lo" appear when either over- or underexposure are possible. The lightning bolt comes on when flash is recommended by the camera. It also indicates when the flash exposure is inadequate or incorrect. A blinking shutter speed indicates a shutter speed that is too slow for the camera to be handheld securely with the lens attached (this is only the camera's opinion). It is simply a reminder and a hint for you to use a flash or tripod. The autofocus dot can also blink, indicating that the camera cannot focus on the subject. Other information displayed relates directly to the Simple and Advanced modes. But there are so many viewfinder and LCD indicators on the N50 that three pages of the instruction book are dedicated to explaining their meanings.

Selecting a Program mode first requires selecting either the Simple or Advanced mode. This is accomplished by first switching on the camera. The ON/OFF switch on the N50 is on the top far left, a totally new place for the switch on a Nikon. Above it is the mode switch, which is simply turned to the desired program series. Switch to "SIMPLE" to access the four Simple modes or "ADVANCED" to access the four Advanced modes. The last mode selected then appears in the LCD (factory set to General Purpose Program). Now if the desired program comes up, there is no need to change it. But if another is desired, depressing a few buttons has you up and shooting.

Depress the menu button (to the right of the prism) and four symbols appear: "P," "S," "A," and "M." Above each one of these symbols is a button. Depress the one above the P to access the Program modes. Two or three icons now appear along with arrows pointing left and right. Depress the button above its respective symbol to activate that program. If an icon does not appear for a program that is desired, depress the button above one of the arrows to find the desired program's icon. There are only three screens, so finding the desired program icon is quick and simple.

In keeping with the uncomplicated nature of the N50, definitions and parameters of the eight Program modes are simplistic. The four Simple modes are defined as follows: The Landscape program provides you with greater depth of field. It does this while providing a fast enough shutter speed to prevent the subject from blurring. The exposure metering makes the assumption that sky is present and shifts its metering accordingly. The Portrait program limits the depth of field to blur the background and make the subject pop. It is suggested that lenses between 85mm and 135mm make the most of this program. The Close-Up program really isn't different from the Portrait program in that it provides a shallow depth of field. This is actually backwards, as the biggest obstacle with close-up photography is the lack of depth of field. The General Purpose program is a good generic program providing good depth of field and a fast shutter speed.

The General Purpose program is a flexible program. The shutter speed and aperture combination can be changed as desired. When the camera is in this mode, two arrows appear on the far right in the LCD. By pressing the buttons above the up or down arrows, the shutter speed-aperture combo can be altered. The selected combo in the flexible program disappears when the camera automatically turns off, the camera is manually turned off, or the mode is switched. A "P*" appears on the LCD and a triangle-dot combo appears in the viewfinder to indicate that this flexible program has been activated and is in use.

The four Advanced programs shake down to this. The Night Scene program attempts to balance flash, illuminating the foreground subject with available background light. This set of exposure calculations is made automatically by the camera. The Motion Effect program selects a slow shutter speed to help blur a moving subject. It does this by closing down the f/stop, which provides greater depth of field. This effect can be increased by panning or following the action of the subject with the camera. The Silhouette program works with bright backgrounds, properly metering and biasing the exposure for the bright scene. This in turn makes the silhouetted subject appear black. The Sport program is biased to provide faster shutter speeds.

The N50 comes with the standard set of exposure modes. Shutter-Priority, Aperture-Priority, and Manual are available and selected just like a Program mode. In Shutter-Priority, the shutter speed appears in the LCD. Two arrows, one up and one down, appear above the shutter speed readout, and the buttons above the arrows are depressed to change the shutter speed. In Aperture-Priority the aperture appears and two arrows are displayed above it. Press the buttons above the arrows to select the desired aperture. And in Manual mode the entire LCD is used, displaying both aperture and shutter speed. Arrows appear above the readouts and the corresponding buttons are used to select the desired exposure. An analog display (a scale) appears in the LCD in M mode to aid in obtaining the correct exposure. Correct exposure has been obtained when only a single square appears below the 0. In all modes, Simple, Advanced, and others, the lens must be set to its smallest aperture. In all modes, the aperture is electronically set and *not* manually via the aperture ring.

All of these systems depend on matrix metering. With D lenses, the N50 has the new 3D matrix, six-segment metering. This is available in all Program modes, as well as in Shutter-Priority and Aperture-Priority. The metering takes advantage of the information provided by D technology. If a non-D lens is used on the N50, its advanced matrix metering takes over. The D technology obviously wouldn't be used in this situation. And if these don't work for you, the N50 has 60% center-weighted metering.

So what else can this puppy do? Well, it has a self-timer. It is activated by depressing the button near the self-timer symbol on the top right and depressing the shutter release. The N50 has a "TIME" setting in Advanced mode only. In Manual mode, you can select "TIME," which allows an exposure time as long as desired. The battery is tapped during the entire length of the exposure. The N50 also has an AE-L.

The Advanced mode offers a memory function. This lets you pre-set the combination you desire and access it simply by pressing the menu button for two seconds. But in keeping with the simplicity of this camera, that sums up the basics of its operation. For those desiring the simplicity of a pocket camera but with greater flexibility, this is the perfect camera for you. It is a logical progression from the N4004 and N5005, and for the position it holds, it performs very well.

Nikon N70

The "replacement" for the N8008s was introduced in fall 1994. The **N70** didn't light the skies with rockets, but that is no reflection on the camera. The N8008s was a very popular camera with many loyal users who at first were not tempted by the advanced features of the N70. But like all new Nikons, the N70 has its place and is slowly developing its own loyal following.

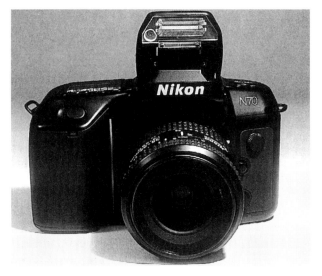
Nikon N70

appears depends on what button you press. In normal operation, just the frame count appears. In the "rays" of the sun reside the various functions and features of the N70. Depressing the FUNCTION and SET buttons and turning the command dial is how these features and functions are set. The area that these rays comprise is called the Function Zone (not to be confused with the Twilight Zone. Get it? Sun rays, twilight...). There are eight functions in the Function Zone: Film Speed Setting Mode Area, Film Advance Mode Area, Focus Mode Area, Exposure Mode Area, Metering System Area, Flash Sync Mode Area, and Exposure.

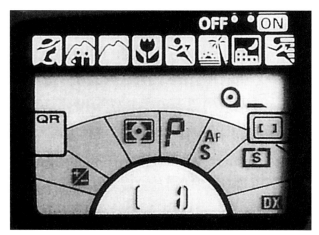
Nikon N70's LCD panel

The slogan for the N70 is, "The N70 is a camera that can turn your vision into reality." The N70's new multi-windowed LCD panel is what makes that happen. It is a newly designed, large, brightly colored LCD that, along with the command dial, permits any of the N70's features to be selected quickly. Also, the N70 boasts the world's first built-in 3D multi-sensor balanced fill flash. The N70 incorporates a new CAM 274 for fast autofocus speed. To complement these high-tech advances, the N70 has an assortment of Nikon's fine touches in its design. These include a built-in pop-up flash (GN 46 with 28 mm coverage) with slow and rear-curtain sync, red-eye reduction, flash exposure bracketing, a remote socket, a built-in motor drive (3.7 fps maximum) and eight Program modes with Flexible Program.

The most radical of the new features is the camera's programming. The LCD's layout includes a small half-circle with rays that extend outwards, resembling a sunrise. This is where information such as frame number, self-timer, ISO film speed, and exposure compensation value reside. The information that

The basics of this are rather simple. First, turn the camera on and then depress and hold the FUNCTION button (to the left of the prism). When this is done, the symbol of the function last selected starts blinking in a function area. Still holding the FUNCTION button, rotate the command dial as the function indicator (a pointer) moves to the desired function or feature you want to select. You will know when you have arrived because the selected function's symbol starts blinking. Some of the function areas contain multiple functions, one of which you might want to select. Let go of the FUNCTION button, depress the SET button (found right below the FUNCTION button), and rotate the command dial until the desired icon appears in the function area. Remove your finger from the button and the mode, feature, or function is set.

Let's dive right into the Function Zone to understand just what each area has to offer. The very far right band is where the ISO/DX setting is made. When selected as described above, "ISO" starts to

blink. To set it to DX mode, depress the SET button and turn the command dial until "DX" appears. In the DX mode, the usable film speed range is 25 to 5000. To manually set the ISO, depress the SET button and turn the command dial until "ISO" appears. The N70 has a manual ISO range of 6 to 6400. In either case, the ISO number appears in the center of the half-circle.

Next to the ISO/DX window is the film advance mode function area. Four film advance modes are available. They are accessed via the SET button. Single-frame advance (S), silent rewind (SL), continuous low-speed (L), and continuous high-speed (H) are your options. The only new one in the group is the silent rewind. This feature is tied in with single-frame advance mode and does not function with the continuous modes. The SL mode offers a quieter rewind when quiet is called for (it is not silent though). Continuous high provides a firing rate of up to 3.7 fps and continuous low provides 2 fps (with fresh lithium batteries). If the built-in flash is used and the camera is set to either continuous rate, the camera automatically switches to "S," preventing the flash from becoming overheated. When this happens, the continuous symbol blinks to warn of the change.

Nipping the corner of the film advance mode area is the focus area window. The N70 offers wide-area focus and spot focus detection. The wide-area symbol is two brackets, "[]", and the spot focus symbol is a dot, "•". This is selected and set slightly differently than the others. Depress the "[o]" button next to the ON/OFF switch while turning the command dial. Rotate the dial until the desired symbol appears, then let go of the button to set the desired focusing area. If flash is used and the camera is set to the wide-area focus detection, the camera automatically sets the focus to spot. If this happens, the wide-area symbol blinks to warn of the change.

The next function area is for focus mode. This is selected by a combination of the focus mode switch (the bottom-most button on the left front of the body) and the FUNCTION button. If the focus switch is set to Manual (M), an "MF" will appear in the function area. In this instance, the camera can be focused manually using the electronic rangefinder, if desired.

If the focus mode switch is set to "AF," the camera is set to autofocus, and two options are available (either "AF-S" or "AF-C" blinks when this is done). Set these functions via the SET button and the command dial. In the AF-S mode, the camera is set for Single Servo. This means the camera locks onto the subject and will not refocus until the shutter release button is released and depressed again. The N70 has

focus tracking, so if the subject moves, the AF system tracks and focuses on the subject. In this mode, the camera will not fire unless the subject is sharp. Otherwise it locks up, preventing the camera from firing. In AF-C mode, the camera continuously focuses while the shutter release is depressed, and the camera will fire even if the subject is not in focus. Focus tracking is available in this mode as well. If a non-AF lens is attached and the camera is set to an AF mode, the AF symbol in the function area will tell you to set the camera to manual (M). (Operation of the AF system is the same as described previously for other AF bodies. Refer to them for dos and don'ts.)

Next on the Function Zone, to the left is the exposure mode function area. The N70 has Auto-Multi Program (P), Vari-Program's eight program modes (PS), Shutter-Priority (S), Aperture-Priority (A), and Manual (M). To take advantage of all these modes (except A and M), a lens with a CPU must be used. The S, A, and M modes operate and function as in any other Nikon. It is the two Program modes that take on a new look and set of meanings.

To select an exposure mode, first, press the FUNCTION button and turn the command dial until "P," "S," "A," or "M" blinks in the function area. Depress the SET button and turn the command dial until "P" appears, indicating that the Program modes are activated. Straight P mode provides a good f/stop and shutter speed for basic photographs (remember the lens must be set to its smallest aperture). This shutter speed-aperture combo can be shifted via the Flexible Program (in the Vari-Program as well). This permits you to fine-tune the combo in 1/3-stop increments temporarily, reverting back to the default settings when the camera goes off. Simply turn the command dial until the desired shutter speed-aperture combo appears. When in the Flexible Program, an asterisk appears next to the P (P*). (This appears as a reminder in the top LCD as well as in the viewfinder.)

The Vari-Program is very similar to that on the N50 and N90. The eight Vari-Program symbols are visible on top of the LCD at all times to remind you that they are available. They are: Portrait Program (profile icon), Hyperfocal Program (mountain and people icon), Landscape Program (mountain icon), Close-Up Program (tulip), Sport Program (runner icon), Silhouette Program (palm tree and sun icon), Night Scene Program (moon over city icon), and Motion Effect Program (runner icon with streaks).

To select one of these you must first call up the "Ps" in the exposure mode function area (as described above). Next depress the Ps button to the right of the prism. While depressing this, turn the

command dial until a small black triangle appears under the desired program icon. When in the Vari-Program, the camera settings are automatically set to matrix metering, wide-area focus detection, Flexible Program, sync mode, and exposure compensation. The matrix metering, focus area detection, and exposure compensation can be altered. The sync mode changes according to the Vari-Program in use—slow sync in Night Scene Program and Motion Effect Program, or normal sync for all others. (To cancel Vari-Program, depress the Ps button and rotate the command dial until the Vari-Program indicator disappears. The previously set exposure mode then appears in the function area.)

What do these Vari-Programs offer you? Creative techniques that might otherwise be difficult to achieve. The Portrait Program selects a large aperture for narrow depth of field. The Hyperfocal Program selects a small aperture for a great depth of field. This program does not actually use the hyperfocal distance theorem. The Landscape Program is not much different from the Hyperfocal Program, selecting a small aperture for a great depth of field. The Close-Up Program tends to select a large aperture, creating narrow depth of field. This is to provide a faster shutter speed to help eliminate blurry photographs. The Sport Program tries to provide the fastest possible shutter speed. The Silhouette Program is used only when the background is bright and a dark subject is desired. The Motion Effect Program provides a slow sync shutter speed to capture a sense of motion. The Night Scene Program is...? This program is a mystery to me as the same results can be obtained with equal ease in any other mode.

In Shutter-Priority mode, the lens must be set to its smallest aperture. The camera automatically and electronically selects the correct aperture based on the selected shutter speed. The shutter speed is selected by rotating the command dial (make sure you are not holding down any buttons during this process). The shutter speeds that are displayed are in 1/3-stop increments. This might take some time to get used to, so be forewarned and don't freak out when "1/13" appears! If the lens is not set to its minimum aperture in this setting, "FEE" appears and blinks in the LCD and viewfinder displays. If the camera is set to "buLb" in this mode, "buLb" blinks as a warning because the camera cannot operate at this setting in Shutter-Priority mode. The familiar "HI" and "Lo" can also appear, indicating over- or underexposure.

In Aperture-Priority mode, the lens is manually selected by turning the lens' aperture ring. The selected aperture is displayed electronically (not via an ADR) in the LCD and viewfinder displays. The f/stop displayed is limited to the conventional range listed on the lens. But there are a few exceptions. For example, intermediate f/stops such as f/1.8 or f/3.3 can be displayed when lenses with those maximum apertures are set at those f/stops. A nice feature comes with zooms. The maximum aperture for different focal lengths are displayed in 1/6 stops. The camera selects the correct shutter speed based on the aperture in use. In this mode, when a lens or accessory without a CPU is attached, "F - -" appears. This just indicates that the f/stop cannot be read (due to the lack of a CPU). The shutter speeds are displayed in 1/3-stop increments.

The Manual mode is basically the same as in other Nikons. The aperture is set manually on the lens. The shutter speed is set via the command dial. An analog display appears in the LCD in this mode with the bar under the "0" indicating correct exposure. The analog display blinks when the set shutter speed-aperture combo is beyond the exposure value range of the N70's meter. The aperture can be read in the LCD or viewfinder only when lenses with CPUs are used.

The next function area to the left displays the metering system. The N70 offers three basic metering systems, matrix, center-weighted, and spot. Matrix metering offers 3D matrix metering with D lenses and only advanced matrix is available when non-D lenses are used. Matrix metering is available only to lenses with a CPU. If a lens without a CPU is attached and the camera is in the matrix mode, the matrix symbol blinks and the metering is switched to center-weighted. (At the same time, if in a Program mode, the camera switches to Aperture-Priority, "F - -" appears, and the program's icon blinks.) Center-weighted metering is a 75/25% system with 75% of the sensitivity based on the 12 mm center spot (the larger circle). The spot meter bases nearly 100% of its reading on the smaller 3 mm center spot. All three of these are selected via the FUNCTION and SET buttons as previously described.

Note: What's the difference between 3D matrix metering and advanced matrix metering? 3D matrix metering uses three types of data to make its calculations: scene brightness, scene contrast, and the distance of the camera to the focused subject (this is the factor that requires a D lens). The scene's brightness and contrast are read by the camera's eight-segment advanced matrix sensor. This data is then bounced off and compared to the subject's distance. Advanced matrix metering uses the same eight-segment matrix

meter to analyze the scene's brightness and contrast, but does not compute that data with subject distance since a non-D lens is in use.

The next function area to the left is the flash sync mode. The N70 offers four flash sync modes with its built-in, pop-up flash. These are activated via the FUNCTION button and selected by the SET button. Available are normal sync (lightning bolt symbol), red-eye reduction (lightning bolt and eye symbol), slow sync (lightning bolt plus "SLOW"), and rear-curtain sync (lightning bolt plus "REAR"). All these symbols appear in the LCD except in normal sync when the lightning bolt disappears once the SET button is no longer depressed. (More on flash photography with N70 follows later in this chapter.)

Nipping the corner of the flash sync function area is the yellow Quick Recall (QR) box. The Quick Recall feature allows the film advance mode, focus area, focus mode, metering system, exposure mode (including Vari-Program), flash sync mode, and exposure compensation value to be memorized for instant recall. Four files can be memorized and recalled, with "0" holding the factory default settings and files 1, 2, and 3 available for the photographer to program.

To "memorize" (record) a custom file setting, set all the functions of the N70 as you want them. Next, depress the "IN" button (located on the top left of the camera) and confirm that a "-" appears in the QR window. While depressing the "IN" button, rotate the command dial until the number you want as the memorized file number (1, 2, or 3) appears in the window. With this done, remove your finger from the "IN" button and all the set functions will be memorized. To recall the settings, simply press the "OUT" button and rotate the command dial until the desired file number appears in the window. When you let go of the "OUT" button, the functions are set. Changing any of the functions manually on the N70 will automatically cancel the QR setting.

To the left of the flash sync function area is the exposure compensation function area. This relates to the exposure compensation for the ambient light meter and is accessed and set via the FUNCTION and SET buttons. This provides a ten-stop exposure range of compensation in 1/3-stop increments from -5 to +5 EV. Once the compensation value is set, the "+/-" symbol appears in the LCD and in the viewfinder. Exposure compensation must be reset in the same manner as it was set. The only quick method of doing this is by using the QR feature. But of course, setting the QR feature takes time too.

The N70 has an AE-L (autoexposure lock) button located to the right of the command dial. Pressing this in temporarily "memorizes" the meter's settings. To use the "memorized" setting, you must depress the button until the exposure has been completed. Releasing the AE-L button returns the camera metering back to normal. This is a quick and easy way of exposure compensation when you just want to take one or two frames at a different exposure.

This same function area is the home of the "flash output level compensation" (flash exposure compensation in simpler terms). You can bracket the flash exposure -3 to +1 stops via this function. This function can affect either the built-in flash or an attached flash unit. You can tell that flash compensation has been activated by the "+/-" appearing in the top corner of the function area (the ambient light bracketing is in the lower corner). Setting the flash compensation is accomplished using the same procedures as exposure compensation and is turned off only once it is deprogrammed.

The last function area on the far left is the all-mode exposure bracketing area. (Flash exposure bracketing is also in this area but will be discussed later.) All-mode exposure bracketing affects just the ambient light with all of the N70 exposure modes. Access this function area in the same manner as the others and "AE BKT" (autoexposure bracketing) appears. The amount of bracketing is set by depressing the SET button and turning the command dial. You can bracket the exposure of three different frames in increments of 0.3, 0.5, 0.7, or 1.0 stop. For example, if you set the compensation value at 0.5, the first frame is underexposed by 1/2 stop, the next frame is shot at the meter's recommended setting, and the last frame is overexposed by 1/2 stop (0.5 = 1/2 stop).

With the bracketing set, all that is left to do is fire the shutter. With the camera set to Single Servo (S) advance, one frame is taken each time the shutter release is depressed. With the camera set to one of the continuous modes, all three are taken with one press of the shutter release. Once all three frames have been taken, the all-mode bracketing function is canceled. If in continuous advance and one continues to shoot after the three bracketed frames have been made, the camera goes back to exposing normally. Now if flash exposure bracketing has been set (see below), setting the all-mode exposure bracketing cancels its setting. If the camera is set to bulb and all-mode exposure bracketing is set, the shutter locks and the bulb indictor blinks.

Flash exposure bracketing is also in this function area. It can be used with either the built-in flash or

one attached via the hot shoe. The bracketing range is the same as that for ambient light. The bracketed exposures are taken in the same sequence as those for ambient light. Setting, canceling, and firing the flash exposure bracketing frames are the same as for ambient light. The only difference is that a lightning bolt appears next to "BKT" in the function area.

Within the half-circle at the bottom of the LCD is the setting for the self-timer. This is activated by pressing the SET button (which has a clock symbol on it) and turning the command dial. Rotate the command dial until the self-timer clock symbol stops blinking and then remove your finger from the SET button. The 10-second self-timer is then activated by fully depressing the shutter release button. Canceling the self-timer is as easy as turning the camera off. Remember, when doing remote photography with the N70 (which often involves self-timer exposing), to cover the eyepiece with its shield. This prevents light from entering the eyepiece and causing false meter readings.

Using flash with the N70 is slightly simpler than with the N8008s. The major difference between the two is the onboard programming available on the N70. With most of the Nikon dedicated Speedlights, matrix flash metering is possible. Only with the SB-26 is every function possible. With the SB-24, 25, and 28 most functions are available. The possibilities are slow sync, rear-curtain sync, repeating flash, flash exposure compensation, flash bracketing, and red-eye reduction. Functions such as slow sync and flash bracketing are set via the camera for these units. Refer to the flash chapter to understand the flash's LCD symbols for the various functions when set.

The N70's viewfinder suggests when flash might help the exposure. On the middle far left of the viewfinder, a green lightning bolt lights up when the camera thinks the subject needs flash. If you don't act on its advice, it will still let you take the picture except that the subject might be underexposed or blurred. Above the green lightning bolt a red lightning bolt might appear. The red lightning bolt is the ready light indicator for the flash as well as being the correct exposure indicator. It works the same as on all other Nikon bodies.

What other wonders are held in the N70? In the top right corner of the LCD panel is the battery condition indicator. It looks like a battery, and when it's completely darkened, the batteries are in "new" condition (two CR123 A-type lithium batteries are recommended). The darkness of the battery slowly fades as the condition of the batteries goes down. The final indications of battery life are when the battery symbol is 1/4 darkened and then just appears as a blinking outline.

Right below the battery condition indicator is the film indicator. When a fresh roll of film has been loaded, a film cassette with a leader symbol will appear in the LCD. If the film has been loaded incorrectly, the cassette blinks and an "E" appears in the LCD (the shutter also locks up). When the film is at its end, the word "End" appears in both the LCD and viewfinder, the shutter locks, and "End" and the film cassette symbol start to blink. To rewind the film, depress the IN and Ps buttons at the same time. (This is the first N-Series Nikon on which the buttons for rewinding are not marked with red cassette symbols.) While the film is rewinding, the film cassette indicator blinks.

Other points of trivia. The N70's back is not removable, so it has no multi-function or data backs. (There is an F70D available in markets outside the U.S., which offers Date/Time imprinting. This same camera has a mystery "PANORAMA" switch on the bottom of the camera back.) The N70's viewfinder covers 92% of the picture area. Its LCD panel is automatically illuminated when the metering is activated. The screen is the new, advanced B-type BriteView Screen II, which is not interchangeable.

The instruction book for the SB-26 states on one page that the N70 works with its FP (high-speed sync) mode. This is not correct. The N70 cannot sync with the flash at 1/4000 second (however the N90 and N90s can).

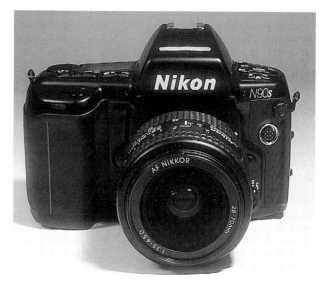

Nikon N90s

Nikon N90s

The fall of 1994 saw the release of the updated N90, the **N90s.** This vastly improved version may seem to have only a few updates, but they make the camera an incredible and indispensable tool (something that can't be said of the N90). Now, the fact that it's missing that annoying beeper alone does not make the N90s better (but it helps). But tangible improvements make it stand out among camera bodies, its 1/3-stop shutter speeds and 25% faster autofocus system probably being the most significant.

Nikon F5

In June of 1996, the long wait (and the rumor mill) came to an end with the announcement of the **F5.** The latest in a distinguished line of pro model camera bodies, the F5 exceeded even the wildest expectations for Nikon's flagship. The names given the features on this new camera were entirely new: RGB sensor, 3D color matrix meter, Lock-On™ focus tracking, Multi-CAM1300, and wide-cross array to name just a few. I can honestly say that all the innovations in the F5 have radically changed my photography—something no other body has ever done!

Typical of the changes made to most of Nikon's previous pro body designs, the F5 looks nothing like its predecessors. It features the Nikon F bayonet lens mount, but past that, its similarities end. There are two major innovations in the F5 to which all else pales, the 3D color matrix meter and the autofocus system. I'll cover them first.

The most revolutionary development to occur in camera technology in three decades is the F5's 3D color matrix meter, the world's first! In a nutshell, a color meter coupled with an advanced matrix system provides information that's analyzed by a sophisticated computer program, in order to determine the final correct exposure (it does this perfectly for me 99.9% of the time—faster than I can begin to calculate correct exposure manually). While Nikon's manual focus lenses are physically compatible with the F5, they do not allow you to take full advantage of all the camera's metering wizardry. For the most complete compatibility and information exchange, D lenses are recommended. Other perfectly acceptable, compatible lenses include AF, AF-I, or AF-S lenses (they just lack the distance information that the D lenses offer).

How does the 3D color matrix meter work? The F5 has a 1,005-pixel CCD (Charge-Coupled Device),

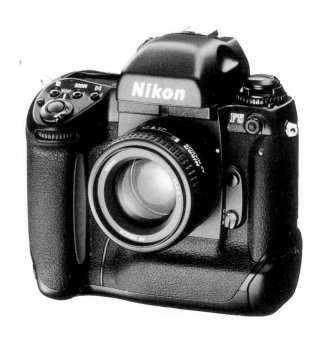

Nikon F5

which is what actually reads the light. The amazing thing to me is not that it has 1,005 pixels, but the fact that each pixel has incorporated in it either a red (R), a green (G), or a blue (B) filter! Each pixel not only evaluates the scene's brightness and contrast, but also the scene's color! Why is this important?

Basic matrix or center-weighted metering systems read the scene and compare the brightness of the scene to a basic, 18% gray. This is how they provide an exposure recommendation. Now as we all know, these meters with their 18% dependencies can be fooled, causing some photographers great heartache. Dialing in compensation is a traumatic experience for some, and for others, it means taking their attention away from the action in the viewfinder, which could possibly cause them to miss the image. With 3D color matrix metering, Nikon has delivered us from this dread and transported us into photography heaven! Now back to how the color matrix meter works.

The information received from the 1,005 pixels— scene brightness, contrast, selected focus, distance information, and the scene's color characteristics—is analyzed and then processed by a powerful microcomputer whose database is said to hold information from at least 30,000 different exposures. With this input, the F5's meter instantly provides a reading, which I have found to be dead-on. How dead-on? Since the first shot I ever took with an F5, I have never, repeat, *never* had to dial in exposure compensation to accommodate a fooled meter!

The RGB sensor can actually detect different light sources. It can differentiate between tungsten, fluorescent, bright yellow, and tender green light. Not only can the F5 "see" these light sources, but it knows how to meter for them by biasing the exposure to the specific light source. And it goes farther! The F5's meter features high sensitivity, offering an EV range of EV 0 to EV 20 (at ISO 100 with a 50mm f/1.4 lens) with 3D color matrix and center-weighted matrix metering, and EV 2 to EV 20 with spot. It is also highly resistant to electrical "noise" (static electricity doesn't drive it nuts). Though it has no vertical sensors, the F5 meters vertical compositions accurately by sourcing the vertical scene data stored in its database. The RGB sensor's 1,005 pixels also provide accurate metering in poor light, and backlit subjects are correctly exposed no matter where they are placed in the frame. In addition, brightly colored subjects no longer fool the meter. WOW!

The F5 also offers center-weighted and spot metering. The center-weighted meter's concentration can be customized to your own preferences. It comes factory set with a 75% concentration on the 12 mm circle in the center of the viewfinder. By using Custom Setting 14 you can redefine the metering concentration within different sized circles—8 mm, 12 mm, 15 mm, 20 mm in diameter—or you can select full average metering. You can also adjust this area further using Nikon Photo Secretary.

The spot meter is pretty novel as well. It is linked to the active AF area (any of the five can be selected by you). To select the 4 mm spot you want to meter, just select the corresponding AF sensor. Another way to use the spot meter is to obtain a mental average of the exposure range of the scene. To do this, simply take five spot meter readings, changing the active AF sensor with each reading (but the 3D color matrix meter does this faster and more accurately).

The second most important innovation is the F5's autofocus technology. Simply stated, it has changed the way I take photographs! Up until the release of the F5, I did not use AF; it was slow, and it simply didn't work for my style of photography. But the F5 changed all of that, literally causing my photography to become better (and my wallet smaller!). The F5's autofocus system permits the photographer to concentrate on the subject rather than on the mechanics of taking a picture, and that puts you way ahead!

What is so special about the F5's AF system? First and foremost for me are its five autofocus areas that form what Nikon calls a wide-cross array. This AF system allows you to activate just one or all five sensors at a time, providing the badly needed ability to

compose creatively while the camera's focus still tracks moving subjects. I've found that it does this with subjects moving in any direction in the frame, so you can easily photograph flying birds in a vertical format! The bottom line is, even though we might not fully understand how it works, this system does work. Let me explain what I know of it.

Nikon started by creating a new sensor module called the Multi-CAM1300. There are five CCD sensors incorporated into the module, one sensor on the left, one on the right, and three in the center. They provide coverage on the left, right, top, center, and bottom of the frame. These AF sensors not only "see" more of the frame than previous models, but have a much greater ability to see in lower light (EV -1 to 19) and to relay their information faster to the computer driving the system. In "normal" (Single-Area) AF shooting, a focus area is selected by the photographer (the corresponding bracket appears on the viewfinder screen) and aligned with a still subject. In Dynamic Autofocus mode, part of the focusing area is automatically expanded to keep moving subjects in sharp focus (an area greater than the AF bracket seen on the viewfinder screen). Amazing!

Dynamic Autofocus is really the big ticket on the F5, permitting photographers to effortlessly photograph moving subjects. Dynamic Autofocus is selected by depressing and holding down the [+] button behind the shutter release while turning the main command dial until all five "+" signs appear in the LCD. Without all five, you are not in Dynamic Autofocus mode. In this mode, all five AF sensors track the movement of the subject in the frame. The process starts with the photographer selecting the primary active sensor using the focus area selector. By aiming the active focus area at the subject and pressing the shutter release partway, the F5 locks onto it and maintains focus. If the subject should move, the F5 automatically tracks its movement and maintains focus by changing to another sensor.

The brackets surrounding the primary focus area sensor are darker than the rest (with the EC-B screen in use). In Dynamic AF mode, although the active sensor might change with the movement of the subject, the F5 does not communicate this change to you. The sensor that was originally selected remains dark during the entire tracking process until you take your finger off the shutter release or select a different primary AF sensor. Telling you which sensor is currently active in Dynamic AF mode would slow down the entire system, something not desired when faster AF speed is the goal. The system can be programmed through the Photo Secretary to speed up its search by

limiting which sensors are being used in Dynamic AF mode.

Incorporated into this whole thing is Nikon's new Lock-On™ software. In a nutshell, when you've locked onto a subject, you've locked onto a subject. If something should come between the camera and the subject and you're still depressing the shutter release, focus on the subject is not lost; the interfering object is ignored by the system. This amazing feature works incredibly well. I've had everything from blades of grass to a ranger's truck come between me and my subject, but the F5 held focus the entire time. The F5's focus tracking is like that in the N90s, and it works with the Lock-On™ even at the F5's blistering firing rate of 8 fps.

The F5 has the two basic AF modes, Single Servo (S) and Continuous Servo (C). The Single Servo mode comes from the factory set with focus priority. This means the camera will not fire until the subject is in focus, and if it is not in focus, the camera won't fire. Continuous Servo comes set with release priority. In this mode, the F5 fires whether the subject is in focus or not. In either of these modes, focus tracking and Lock-On™ are automatically working. The priorities of these AF modes can be changed using Custom Settings 1 (C mode) and 2 (S mode) or via the Photo Secretary software. I shoot in the C mode with focus priority. You select the desired mode by using the switch on the left front of the lens mount just as with previous AF bodies. Manual focus (M) can be selected with this switch as well.

The F5 has an electronic rangefinder with arrows and dots indicating focus as in previous AF bodies. If the arrows bother you, you can turn them off using Custom Setting 23. With the assistance of the AF illuminator on an AF flash unit such as the SB-28, the F5 can autofocus in darkness. However for the AF illuminator to function, the center AF sensor must be selected and Single Servo activated.

The active sensor can be selected quickly using the focus area selector on the back of the F5. This large thumb pad is easy to press and manipulate, so easy in fact, that some folks with "bigger" noses need to be careful that they don't unintentionally change the active AF sensor!

The F5 has two AF-ON buttons, which are placed for horizontal and vertical shooting. They allow you to focus on the subject without pressing the shutter release button or, when used with Custom Setting 4, they can be used to autofocus without activating the F5's metering system.

The one thing that everybody probably wants to know about more than anything else is focusing speed. I don't have a way of testing AF speed from one camera to the next, but I can tell you when it comes to the F5's autofocus speed, there are two scenarios: the speed when using a lens with an internal motor, and the speed when using a lens without one. When the F5 is attached to an AF-I or AF-S lens, to say that it flies is an understatement. The system works and often focuses faster than my eye can. Nikon states that the F5 autofocuses at least 15% faster than any other Nikon body. When using the F5 with an AF lens without an internal motor, it's still fast, but not as fast as with a lens that has its own motor. However, I can tell you that the system has never let me down, so it's fast enough for my photography.

One side note: This system works only with lenses that have an aperture of f/5.6 or faster. While this covers every single Nikon AF lens, it doesn't include all the long glass used with teleconverters. For example, the 600mm f/4 AF-S with a TC-14E works great, but not so hot with the TC-20E, which turns the 600mm f/4 into a 1200mm f/8. On the other hand, the 500mm f/4 AF-S with a TC-14E or TC-20E works very well in most light (in darker scenes the TC-20E is not as reliable), even with an effective f/stop of f/8. Go figure!

After its metering and autofocus systems, the rest of the F5's features seem rather tame. We have the design genius of Giorgio Giugiaro to thank for the smart, convenient styling and functionality of the F5's controls. Looking at the top panel, you'll find some of the F5's basic controls. To turn the F5 on or off, depress the small button located just to the right of and behind the shutter release, and turn the dial surrounding the shutter release. (This button must be pressed to unlock the on/off switch. The camera was designed this way to prevent turning the camera on or off accidentally.) Rotating the dial to the right with the camera turned on illuminates the top and rear LCD panels. (The light inside the viewfinder comes on automatically with camera activation.) Repeating this step turns the lights off. The lights also turn off after a picture is taken or when the camera automatically turns itself off (the duration before the camera automatically shuts off can be set with Custom Setting 15).

There is a hidden magic about the F5's shutter mechanism, which you should be aware of. The F5 incorporates a double-bladed shutter assembly with Nikon's patented shutter monitor system. The shutter monitor system is pretty cool as it maintains consistently accurate shutter performance. Every time the shutter fires, the system monitors the shutter speed. If speeds begin to shift from the calibrated speed, the camera automatically compensates to maintain an

accurate exposure. The F5 does not tell you when this happens unless the deviation is extreme. If a malfunction should occur, like the shutter curtain fails to operate altogether, the alert LED and an Err message blink in the viewfinder and top LCD. The shutter curtain blades are unique as well; six are constructed of special epoxy and are carbon fiber reinforced, and the two other blades are made with aluminum alloy.

All this high-tech stuff, as well as the shutter and mirror movement, is incorporated into a floating mechanism for silent operation. Once you hold and fire the F5, you'll find out just how quiet it really is. It is not only quiet, but I find it to be the smoothest firing camera I've ever shot with. This is partly because of the exclusive Nikon mirror balancer. This balancer is important to the AF system and when tracking focus at 8 fps because it delivers the smooth performance required during those operations. It even stays steady at 2 stops slower than the F4!

Directly behind and to the right of the shutter release is the +/- exposure compensation button. By depressing the button and turning the main command dial, you can dial in compensation of +/-5 stops in 1/3-stop increments. The center button behind the shutter release is the mode button. By depressing this button and turning the main command dial, you can select P (Program), S (Shutter-Priority), A (Aperture-Priority), or M (Manual) mode. These modes function in the same fashion as in previous Nikon bodies. In A mode, change the aperture via the sub-command dial (the direction in which you turn the dial to increase or decrease aperture values can be changed via Custom Setting 6; the rotation can be made continuous via the Photo Secretary software). In S mode, change shutter speeds via the main command dial.

The button to the left of the other two is the AF area button, as previously discussed. Behind these buttons and to the left is the multiple exposure button. To take a multiple exposure, depress this button while turning the main command dial until the multiple exposure symbol appears in the LCD. Using this procedure, you can take just two exposures on one frame. You can add more exposures to the one frame by going through the whole process again before taking the second exposure. You can also use Custom Setting 13 to extend the number of exposures per frame without going through this process.

The F5's large LCD panel is found here as well. This panel communicates: shutter speed lock, shutter speed, multiple exposure, autoexposure bracketing or flash exposure bracketing, exposure mode, exposure compensation, aperture lock, aperture, focus area lock, battery level, frame counter, focus area or AF

area mode, exposure compensation value, and if flexible Program (Program shift) has been selected. This panel can be illuminated using the power switch as previously mentioned. I'm happy to report that the material covering the LCD panel seems to be extremely scratch-resistant because mine, after years of use, still looks like new!

The **DP-30 Multi-Meter Finder** is the finder that comes with the F5, however there are three other compatible viewfinders. The **DA-30 Action Finder** is just like the DA-20, providing 5-segment matrix, center-weighted, and spot metering. The **DW-31 6x High-Magnification Finder** is just like the DW-21, and the **DW-30 Waist-Level Finder** is like the DW-20; both provide only spot metering capabilities. All four finders provide virtually 100% viewing.

On the right side of the DP-30 finder is the large metering mode selector. By depressing the large button in the center and turning the switch, you can select either matrix, spot, or center-weighted metering. Behind this dial on the DP-30 is a small knob for adjusting the internal diopter. By pulling the knob out and turning it, shooters can adjust it to five different eyesight correction settings from -3 to +1. When at zero correction, the + and – sign are perfectly horizontal. On the back of the DP-30 is the eyepiece curtain, which needs to be closed if shooting remotely so light cannot get in and fool the meter. Just below this is a small button that when depressed, permits the DP-30 to be removed from the body. The DP-30 slides into place by the same dual-rail system first introduced on the F4s. On top of the DP-30 is a standard TTL hot shoe.

Looking through the DP-30 you see the typical display of information on the bottom of the frame. On the right side and across the top are arrows (or orangish triangles). They are indicators to show you which AF sensor is active (or in Dynamic AF, which sensor has been selected as the primary one). One of these arrows will always be lit. They are not really needed with the standard EC-B screen because the selected AF sensor appears darker on the screen than the others. With any other screen this is not the case, so these arrows are your only means of knowing which sensor is active when viewing through the viewfinder (the top LCD still indicates which sensor is active). The electronic rangefinder is in the top right corner (the red arrows can be turned off via the Photo Secretary). The ADR is at the top, dead-center as always. And when any other finder is used on the F5, an exposure level appears in the top left corner.

On the far left of the F5 is the motor drive and film rewind knob. Depressing the small button on the top

Nikon F5's viewfinder screen

left corner allows you to rotate the film advance mode dial (surrounding the film rewind knob) and select Single (S), Continuous Low (CL), Continuous High (CH), Continuous Silent-Low Speed (Cs), or Self-Timer. Single takes one frame per depression of the shutter release. Continuous Low delivers 3 fps, which can be changed to either 4 fps or 5 fps with Custom Setting 10. Continuous High delivers 8 fps (when using the MN-30 battery unit, otherwise 7.4 fps) and can be set to 6 fps using Custom Setting 9 (for those not able to control their firing finger). Continuous Silent delivers 1 fps and nearly silent operation, which makes the F5 the quietest camera to date. The self-timer is set to a default of 10 seconds. With Custom Setting 16, this time can be set to any time between 2 to 60 seconds.

Automatic film rewind with the F5 is a blistering 4 seconds (with the MN-30; 6 seconds with AA batteries)! Motorized film rewind is accomplished by first opening the small door labeled "1" on the back right of the camera. The door covers a small button that must be depressed (you must push on this button hard to make it stay engaged; a light touch will not engage it for hands-free operation). Then depress the rewind button labeled "2" on the top left of the camera back, and simultaneously push the lever next to it up. The film starts rewinding. Manual film rewind is accomplished by depressing the rewind "1" button and turning the crank on the film rewind knob.

There is no way of setting the F5 to automatically rewind the film when the end of the roll is reached. You can set the F5 to automatically advance a newly loaded roll of film to frame 1 via Custom Setting 8. You can also set the F5 to automatically stop firing on either frame 35 or 36 via Custom Setting 12. This is for folks who develop their own film and want to put their strips in a negative page without having one or two frames left over. The only way to get your F5 to leave the film leader sticking out after rewinding is to take it to an authorized Nikon repair facility. They have to do it for you.

Once your film is rewound, open the camera back by pushing the small lever, next to the film rewind knob, in the direction of the arrow. This permits you to pull up on the knob, and the back pops open.

On the top right corner of the F5's back is the main command dial. It is used to dial in various camera functions, features, and settings as described in the text. To the left of the dial are the AF-ON (previously described) and AE-L/AF-L buttons. The AE-L/AF-L button can serve several functions. Depressing the button locks both exposure and focus simultaneously, working with any system in the F5. But in Aperture- and Shutter-Priority mode, aperture and shutter speed (respectively) can be changed even while this button is depressed. You can also set this button to lock either focus or exposure using Custom Setting 21. You can also set the AE-lock to lock shutter speed or aperture via Custom Setting 5.

On the lower back of the F5 is the second LCD panel and five buttons covered by a small door. This LCD panel displays film speed, bracketing information, or Custom Setting number; film speed setting mode; autoexposure bracketing or flash exposure bracketing; bracketing information; flash sync mode; PC Link connection; and if a Custom Setting has been set. Select one of the features by depressing the appropriate button located to the left of the LCD, and turn the main command dial to change settings.

The ISO button permits you to set the F5 to either DX coding (with a range of ISO 25 to 5000) or manual setting with a range of ISO 6 to 6400. This information appears only in the rear LCD.

Depressing the lightning bolt button allows you to access the various flash options in the F5: front-curtain sync (flash fires at the beginning of the exposure—a lightning bolt symbol appears in the rear LCD), slow sync (permits a slower shutter speed to be used to properly expose the ambient light; the flash fires at the beginning of the shutter cycle—turn the main command dial until the word "SLOW" appears with the lightning bolt symbol in the rear LCD), and rear-curtain sync (permits slow sync operation and flash fires at the end of the exposure—the word "REAR" and a lightning bolt symbol appear in the LCD while the button is depressed, but after the button is let go, both "SLOW" and "REAR" appear with the lightning bolt).

In front-curtain sync, shutter speeds ranging from 1/60 to 1/250 second are available. In slow sync and rear-curtain sync, shutter speeds range from 30 seconds to 1/250 second. Sync ranges can be changed via Photo Secretary. You can also alter the fastest TTL flash sync speed via Custom Setting 20. The fastest sync speed with the F5 is 1/300 second (set with CS 20), but that is possible only in Shutter-Priority and Manual modes. FP high-speed sync is possible with the SB-26 and SB-28.

By depressing the BKT button and rotating the main command dial, you can activate the bracketing function (why you would with RGB metering is beyond me, I think it's a waste of chip space). You can set the bracketing sequence to expose a maximum three frames in increments of 1/3 to 1 full stop. This is done in an order of zero compensation, minus compensation, and then plus compensation. This can be altered via the Photo Secretary software or Custom Settings. Custom Setting 3 lets you change the order of exposure to minus, zero, and plus. Custom Setting 17 alters bracketing in Manual exposure mode from shifting shutter speed (default) to shutter speed-aperture combination, just shutter speed, just aperture, or flash output level. Now these are truly fancy controls for bracketing in a camera that already has the most sophisticated meter in the world.

The center button is labeled L, for lock. With it you can lock in a shutter speed, aperture, or focus area setting (this prevents the setting from being changed accidentally). To lock the focus area, select the desired AF sensor then depress the lock button (repeat these steps to unlock the setting). To lock shutter speed, rotate the main command dial to select the desired shutter speed and depress the lock button (repeat to unlock). To lock aperture, rotate the sub-command dial to the desired aperture and depress the lock button (repeat to unlock). The lock function works only with lenses containing a CPU. When a setting is locked, the word "LOCK" in a black box appears above the appropriate symbol in the top LCD panel.

The last button in this set is the CSM, Custom Setting Menu, button. By depressing it and turning the main command dial you access the F5's Custom Settings. You can also save two sets of customized settings, labeled A or B, programmed into the F5. This permits you to quickly access two sets of Custom Settings for special or frequently used shooting situations.

The battery compartment on the F5 is incorporated into its body design. On the left side of the F5 is a small key that, when lifted and turned, permits you to remove the battery tray. The **MS-30 Battery Holder** accepts 8 AA batteries. Alkaline batteries are acceptable, but do not deliver the best performance; lithiums deliver much better performance.

The best power source is the **MN-30 Ni-MH (Nickel-Metal Hydride) Battery Unit,** which gives you the most power for running the motor drive. This type of battery does not have the memory problems sometimes associated with NiCds. The battery consumption levels published in the instruction book are not accurate, and Nikon quickly amended this. You should expect to take 10 to 12 rolls with alkaline batteries, 40 to 42 rolls with lithiums, and 60 to 62 rolls with the Ni-MH MN-30. The MN-30 is charged with the **MH-30 Charger**. This is a standard charger like the MH-20, but with one improvement. Prior to charging the MN-30, the MH-30 discharges it basically down to nothing. This procedure is recommended at every fifth charge.

The battery indicator on the F5 is very touchy. When the battery symbol is fully black, there is no problem, but when the indicator becomes only half black, run for batteries, because you might not finish the roll!

The F5's TTL flash system works on the same principle as that of the N70 and N90s. The 3D multi-sensor balanced fill flash is a marvel and works with all functions. In addition to working with the basic TTL formula, this system goes further, incorporating such information as subject distance and reflective values. All this, combined with the incredible speed of the F5, makes for great flash photography. By the way, whereas with the F4s and N90s when I want to use fill flash I dial in minus 2/3 stop flash compensation, I have found that with the F5, minus 1/3 does the same job. I believe this is because the advanced 3D color matrix metering system takes better care of the ambient light exposure.

There's a heck of a lot here in terms of operating power. The F5 incorporates no fewer than four coreless motors in its body. The shutter charge, film winding, rewinding, and lens drive motors are all coreless, providing the smooth operation the F5 is so well known for. The F5 has a powerful computer network (yes network) that runs all of these operations. The network is a hybrid circuit construction that includes three 16-bit, one 8-bit, and one 4-bit CPU. Some of the other goodies inside the F5 are proprietary, which just makes you wonder what all is crammed into its elegant design. But without a doubt, the F5, more than any other Nikon body, truly deserves the title Flagship!

Nikon FM10

In the spring of 1998, the Nikon **FM10** was announced. This is a basic, uncomplicated, fully manual camera. It has only one metering system, center-weighted, and one exposure mode, Manual. Its shutter speeds range from 1 to 1/2000 second, plus B. Its EV range is 2 to 19 at ISO 100. Film advance and rewind are both manual as well.

Although the FM10 has an ISO hot shoe, it has no TTL flash meter, limiting flash operation to manual or non-TTL auto modes. Flash sync is 1/125 second or slower. At only 14.8 oz. (420 g) the camera is very lightweight, and its viewfinder provides only about a 92% view of the picture field.

The camera was originally sold with the 35-70mm f/3.5-4.8 manual zoom lens, and even with that, it could be purchased new for under $300.

This basic little camera is not meant to compete with the F5. Instead, it is a great entry-level camera for a student taking photography classes or someone who wants a 35mm camera but doesn't want to break their budget. Because it doesn't have any autoexposure modes, the user has to understand or learn the basics of exposure. It accepts all Nikkor AI and AF lenses, so there's no limitation there. It's just a simple, straightforward, manual camera.

Nikon F5AE

In the summer of 1998, Nikon introduced the **F5AE** (Anniversary Edition) in celebration of the company's fiftieth anniversary. What makes it so special is that it is an F5 designed with a few cosmetic alterations: It has a titanium top cover, the word "Nikon" on the prism in the old-style logotype, and "Nippon Kogaku" printed on the back panel. The grip is dark gray, without the red stripe of the F5, but otherwise it's a Nikon F5 through and through. It was sold with a commemorative strap and box, and a limited edition of approximately 3,000 was manufactured.

Nikon N60

In the late summer of 1998, Nikon released the **N60.** While considered an entry-level camera, for the price, this is a great little item! First and foremost what struck me about the camera was its styling. The old-style "chrome" top, the curves, and the placement of the controls make it a sleek and highly functional camera for the beginning photographer, which

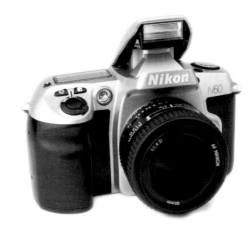

Nikon N60

is exactly the market it is designed for. As Nikon states, "advanced simplicity" is the cornerstone to what makes this a really great camera.

The N60 has autofocus and manual focus capabilities. It incorporates the AM200 AF module, an update of the module first used in the N4004, which is capable of detecting if the subject is stationary or moving. If the subject is moving, the module can detect the direction it is traveling. If the subject is stationary, the module's software switches automatically to focus lock; if it is moving, it switches to focus tracking. This is a great feature for the newcomer, and all you have to do to take advantage of this is to activate the autofocus system by switching the focus mode selector lever found below the lens release button to AF. The N60 can be used in manual focus mode by flipping the focus mode selector to the M position.

Setting exposure with the N60 is simple and intuitive. I like that! Located on the body's top left is a simple exposure mode dial. There you'll find ten exposure modes: Manual (M), Aperture-Priority (A), Shutter-Priority (S), and Program (P), General-Purpose Program (AUTO), Portrait (lady's profile), Landscape (mountain), Close-up (tulip), Sport (runner), and Night Scene (moon and building). All of these modes are identical to those in previous models, with the exception of AUTO. The AUTO mode in this camera turns the camera into a true point-and-shoot, taking care of everything for you, providing you with a basic, foolproof camera. Program mode provides the Flexible Program (P*) feature, which permits you to change the shutter speed-aperture combination while maintaining equivalent exposure.

The abilities of the N60 are extended with its built-in flash. Whereas many other manufacturers' pop-up flash units have a guide number of 39 in feet

(12 in meters), the N60's pop-up flash has a guide number of 49 in feet (15 in meters). This provides a flash range of 2 to 35 feet (0.6 to 10.6 meters), depending on the lens and film speed in use. That's nice, because while the N60 has a standard ISO TTL hot shoe that can accept any Nikon Speedlight, this camera is really meant for folks who don't need too much flash power. Having a slightly more powerful built-in flash unit definitely makes this a great camera for the world traveler!

One other cool feature on the N60 is its built-in AF illuminator. Located on the body's right front, this little port emits a simple beam that allows the camera to focus in dark situations. This same little port serves as the red-eye reduction and self-timer count-down indicator. Nice touch!

The shutter release, located on the camera's top right, is surrounded with an unlockable on/off dial. Behind this is an exposure compensation button (+/-). Pressing it while turning the command dial permits you to set +/-3 stops of compensation in 1/2-stop increments. Exposure compensation can be entered only in the four standard exposure modes: P, A, S, or M.

The large command dial on the camera's back top right is also used to set the aperture in A mode and the shutter speed in S or M mode. Changing the aperture in Manual mode with an AF Nikkor mounted is done slightly differently than with previous camera models. The lens' aperture ring must first be locked to the minimum aperture (largest f/number). Then depress the aperture button located to the right of the exposure compensation button. With this depressed, turn the command dial to select the desired aperture, which is displayed in the viewfinder and LCD panel. The shutter speed is set by turning the command dial without pressing the aperture button.

The N60 comes with a high-eyepoint finder, which makes viewing easier for folks who wear glasses. It also has a built-in diopter adjustment control. A small sliding lever on the right side of the viewfinder allows you to adjust the diopter from -1.5 to +1.

To the left of the prism and in front of the exposure mode dial is the self-timer button. Just push the button to activate the 10-second self-timer; to deactivate it before the exposure is made, depress the button again.

The N60 is powered by two 3v, CR123A-type lithium batteries.

The N60's quartz data version, the **N60QD,** is powered by one 3v CR2025 or equivalent lithium battery. The N60QD permits the printing of such things as time and date on the negative.

The N60 is a cool little camera, better than some of Nikon's previous "beginner" cameras.

Nikon F100

In the fall of 1998, Nikon released the long-rumored **F100.** Speculation about this camera started almost a year before its introduction, yet even the best rumors didn't live up to the camera that was released. In some ways, the F100 is a better camera than the F5. It has features that I'm sure were derived from lessons learned from the F5. These feature "upgrades" are delivered in a smaller package and at a lower price than the F5, which makes the F100 an incredibly popular and outstanding camera.

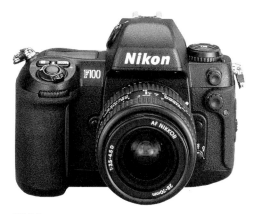

Nikon F100

The very first things you'll notice about the F100 are its size and finish. Somehow the engineers at Nikon managed to cram one heck of a lot of great stuff into this small body. The same size as the N90 and weighing only 27.7 oz. (785 g) without batteries, the F100 is easy to hold. The armor-like top and bottom covers made of magnesium alloy ensure the ruggedness of the Nikon F series while keeping the camera lightweight. The engineers at Nikon even went so far as to design the camera with strategically placed O-rings to provide resistance against moisture and dust.

The F100's mirror box features a new quick-return mirror assembly. This design reduces mirror bounce and vibration, however the F100 does not have a mirror lock-up feature. (Mirror lock-up is one of the most expensive features to incorporate into a camera body.) Even so, with this new mirror transport system, the movement caused by the mirror is minimal, if non-existent!

Surrounding the shutter release on the top right of the F100 is the power switch. There is no lock on this collar; a simple turn switches the camera's power on or off. It also turns on the LCD illuminator.

Right behind this collar are two buttons, one is the exposure mode button (MODE) and the other is for exposure compensation (+/-). By depressing the MODE button and rotating the main command dial on the back right of the camera, you can access the F100's various exposure modes. It has the four basic modes found in previous Nikon bodies, Shutter-Priority (S), Aperture-Priority (A), Program (P), and Manual (M). There is nothing new about these modes; they operate and perform just like those on the F5.

The exposure compensation button (+/-) allows you to override the meter and dial in the desired amount of compensation. By depressing this button and rotating the main command dial, you can compensate exposure by +/-5 stops. This method of changing exposure might be too awkward for some, so there is a Custom Setting that does it more easily. By selecting Custom Setting 13, exposure compensation can be set by simply rotating the main command dial when you're in A mode or the sub-command dial on the front of the camera in P or S mode. This is very fast and convenient!

The metering system in the F100 is excellent, but not as foolproof as the F5's. But I'm splitting hairs here, folks! I have found that the meter in the F100 is fooled only when shooting white on white. In other words, in 99.9% of the shooting situations you might come across, the F100 delivers the correct exposure. Nikon accomplished this without incorporating the RGB metering technology of the F5, instead, they reinvented their matrix metering system.

The F100 uses a ten-segment, 3D matrix meter. The metering pattern in which this system works is beyond description. It is designed to work with a new, sophisticated computer program. Besides looking at highlights, shadows, and contrast range and computing what part of the scene is the subject from the autofocus sensor that's been selected, the metering program compiles this info and compares it to 30,000 preprogrammed exposure solutions. This very advanced system is why such a high percentage of correct exposures is delivered without the use of an RGB color meter.

Of course the F100 also has the basic 75% center-weighted meter and a 1% spot meter. The metering pattern is selected just as on the F5. A dial on the right side of the prism is printed with the three metering pattern symbols. Turn the dial to the desired metering system, and you're set to operate.

The F100 has autoexposure and flash exposure bracketing. Depressing the BKT button on the top left of the camera body and turning the main command dial until "BKT" appears on the LCD activates the bracketing feature. Then, by depressing the BKT button and turning the sub-command dial, you can select either a two- or a three-frame bracket that varies by +/-1 stop in 1/3-stop increments. The bracketing works in all four exposure modes: P, A, S, and M. Custom Setting 11 permits exposure bracketing for either the ambient or flash exposure. This feature is unique to the F100. Pretty cool!

Unlike the F5, the F100 has only one LCD panel located on the top deck of the camera. It is here that you can see everything you have programmed into the camera, all functions, bracketing, Custom Settings, and the like. You will notice that the characters in the LCD are slightly different from those on previous Nikons. While this has absolutely nothing to do with the camera's performance, I just think it's interesting to note that Nikon has "updated" their look a little.

Below the LCD panel and power switch is the depth-of-field preview (DOF) button. Depressing and holding in this button closes down the lens aperture to the one selected so the user can visualize the depth of field. This button is the same as that on the F5. It is a magnetically operated device. I also use this feature to check the status of my batteries. I have found that depressing the button five times really quickly takes the surface charge off the batteries. If the batteries are about to die, I'll know it before heading out into the field.

The F100 runs on four AA batteries. I prefer to use lithium cells, which give me outstanding performance even in cold weather. I'm averaging about 60 rolls of film per set, using the camera's autofocus function.

The F100, in my opinion, has a slightly faster focusing speed than the F5. I'm splitting hairs, but there is a slight speed difference, which might be due to the camera's software. The F100 has Dynamic Autofocus and Single Area Autofocus, just like the F5. The F100 also has Lock-On™ focus tracking, which comes on automatically no matter what mode you're in. Its high-speed focus tracking permits AF operation even at 5 fps.

Activating Dynamic Focus is slightly different on the F100 than on the F5. On the back of the camera to the left of the focus area selector is a small dial, the AF area mode selector. Turn this dial with your finger to either the Single Area ([]) or Dynamic ([+]) Autofocus symbol. You can look in the LCD panel and see that Dynamic Autofocus has been selected when + signs appears in each of the AF sensor areas.

Dynamic Autofocus in the F100 operates just like that of the F5. If the subject moves, the camera's computer passes the active sensor off to the next one. The camera does not tell you it has done this or which sensor has been newly activated. What most folks don't realize about Dynamic Autofocus is that the AF sensors actually will cover more area than what the little brackets on the viewfinder indicate. The active region enlarges with Dynamic Autofocus, which is a giant benefit for shooting any type of action. This is true for both the F100 and the F5.

An AF sensor is selected by depressing the focus area selector on the back of the camera. The lever located at the base of the selector permits you to lock the selected sensor. Many photographers didn't like the fact that the active focusing sensor was black on the F5, so the F100 has redesigned the viewfinder so the selected sensor glows red. While this is great for shooting in daylight when viewing through the viewfinder is bright, it is not as successful at lower light levels as it is hard to see past the red glow.

The F100 incorporates some classic features such as a diopter adjustment knob on the camera's back, to the right of the prism (however there is no built-in eyepiece shutter). On the back right of the F100 is an AE-L/AF-L button and AF-ON button that operate similarly to those on the F5.

Film rewind is accomplished by simultaneously depressing the exposure compensation button and the BKT button, both of which are designated with a rewind symbol. The film rewind is slow by F5 standards, an agonizing 11 seconds. You can also set the camera to rewind automatically at the end of a roll by using Custom Setting 1. This is another improvement over the F5.

The F100 has three film advance modes, S, C, and Cs. Single frame advance (S) mode advances the film one frame after the shutter is released. The continuous advance (C) mode permits the F100 to take pictures as fast as it can as long as you keep the shutter release pressed. The F100 advances film at a speed of 4.5 fps, and with the MD-15 Motor Drive attached, 5 fps. The continuous silent low-speed (Cs) mode slows down the continuous advance to about 3 fps, and somewhat quiets down the firing noise of the camera, but not by very much. The F100 also has a self-timer and a multiple exposure function. All of these functions are accessed by the film advance mode selector dial on the top left of the camera. Depress the small button located by the dial at ten o'clock, and turn the dial to the desired mode.

The F100 has an interesting array of 22 built-in Custom Settings. In addition to those already mentioned, there are a couple others that bear talking about. Custom Setting 2 permits one to set the increments for exposure control by 1/3, 1/2, or 1 full stop. Custom Setting 8 automatically advances the film to frame 1 when the film back is closed. Custom Setting 18 permits data to be imprinted on frame 0 when the **MF-29 Data Back** is in use. Custom Setting 22 permits aperture selection via either the sub-command dial or the lens' aperture ring.

As far as I'm concerned, the TTL flash function in the F100 is identical to that in the F5. The one noticeable addition is the F100 has a red-eye reduction feature, and the F5 does not.

I am impressed with the F100 and its performance. I really like having a small camera body that's lightweight and easy to carry while it still maintains the same performance of the F5. I don't like the slower firing rate and film rewind time, but you can't expect that in a small body. However, when it comes to a lightweight, fast-focusing camera with accurate metering, I honestly don't think you'll find anything better anywhere!

Nikon Body Production Dates

Model	Introduced	Discontinued	Model	Introduced	Discontinued
Pro Models			**FM/FE Series**		
F	1959	1972	Nikon FM	1977	1982
F Photomic	1962	1966	Nikon FE	1978	1982
F Photomic T	1965	1966	Nikon EM	1979	1984
F Photomic Tn	1967	1968	Nikon FM2	1982	1984
F Photomic FTn	1968	1972	Nikon FG	1982	1986
F2 body	1971	1980	Nikon FE2	1983	1987
F2 Photomic	1971	1977	Nikon FA	1983	1987
F2S	1973	1976	Nikon FM2N	1983	S.I.P.
F2SB	1976	1977	Nikon FG-20	1984	1986
F2T	1976	1980	Nikon FM2/T	1994	S.I.P.
F2H	1976	1980	Nikon FM10	1998	S.I.P.
F2A	1977	1980			
F2AS	1977	1980	**N Series**		
F3	1980	1983	Nikon N2000	1985	1990
F3HP	1982	1999	Nikon N2020	1986	1990
F3T	1982	1999	Nikon N4004	1987	1989
F3AF	1983	1988	Nikon N8008	1988	1991
F3P	1983	1988	Nikon N4004s	1989	1991
F4s	1988	S.I.P.	Nikon N6006	1990	1998
F5	1996	S.I.P.	Nikon N6000	1990	1994
F100	1999	S.I.P.	Nikon N8008s	1991	1994
			N5005	1991	1994
Nikkormat Series			N90	1992	1994
Nikkormat FT	1965	1967	N50	1994	1999
Nikkormat FS	1965	1971	N70	1994	S.I.P.
Nikkormat FTn	1967	1975	N90s	1994	S.I.P.
Nikkormat EL	1972	1977	N60	1998	S.I.P.
Nikkormat FT2	1975	1977			
Nikkormat ELw	1976	1977			
Nikkormat FT3	1977	1978			
Nikon EL2	1977	1978	S.I.P.: Still in Production		

Nikon Lenses—The Evolution

In 1959 when Nikon introduced the Nikon F, they also introduced their first SLR lenses. This was the start of a long legacy that would come to be known as Nikkor Optics. There are two main reasons Nikon sets the industry standard for quality in lens production and has since the beginning: their superior optical design with constant innovations, and a complete line of lenses to solve any photographic problem. This has kept them the industry leader.

Every Nikon enthusiast is sure to light up with stories of his or her favorite lens. They are more than happy to say why it is the sharpest lens Nikon ever made. Actually, most of the rave reviews are justified. Nikon optics are the best around (remember, we are splitting hairs many times with this statement). Only a few of their lenses are described by Nikon as "good" (their term for "less than satisfactory"). Some lenses have well-established reputations, whether good or bad, deserved or undeserved. There are lenses out there that do not meet with the established norms and might contradict the lens' track record. And some folks may have a different opinion about a lens. The information I put forth here is not carved in granite but reflects my personal results with the lenses I have shot with. I do not shoot with hand-picked lenses, but with those found on the shelves of

camera stores and in the bags of other photographers. The majority of the time the lenses are not even new. Keep this in mind when digesting the information I present here.

The evolution of Nikkor lenses is not as radical or dramatic as that of the bodies, but their designs run parallel with the bodies' and their changes in technology. Nikkor lenses are manufactured by Nikon (Nippon Kogaku), who started manufacturing optics in 1925. The optical engineers at Nikon start with the most basic element of photography in their lens design—light. They manufacture their own optical glass and completely assemble the entire lens in its mount. Rare earth elements are used to their fullest in glass manufacture. Even the crucibles with their platinum liners are made by Nikon. Once the glass is ground, polished, coated, and finished for mounting, the mechanical procedure for manufacturing the lens barrel and helicoid that houses the glass is just as precise.

Lens barrels are made of special aluminum alloys, with phosphor bronze at points of wear to maintain their precise alignment. The seating of the elements in the lens barrel and lens mount must be milled so that the lens fits precisely into the camera mount to assure accurate alignment of the aerial image with the film plane. The result of this combination of optical and mechanical precision delivers maximum distortion-free performance. Lenses provide maximum corner-to-corner sharpness without vignetting at full aperture.

This is Nikon's description of their 1960s lens manufacturing process. This has changed as new technology in lens design, especially computers, started to become an important factor in lens manufacture. This is particularly true of autofocus lenses, which use new technologies in design, manufacture, and function.

Optical Glass Manufacturing Process

In the 1960s, the process of manufacturing Nikkor optical glass was described thus: first, raw materials are heated to 1500° C and melted in a crucible. The mixture is then either cooled in the crucible until it hardens or cast according to its intended use. Once

cooled, the mixture in the crucible is removed and broken into lumps. These lumps are carefully inspected for bubbles, stria, and non-transparent elements. After inspection, the glass is reheated until it is soft enough to be molded into rough blocks. It is then cut or pressed and annealed by cooling slowly for up to two weeks. This yields rough discs sized for a particular lens element. The glass is then inspected again before the grinding-polishing stage. The lens surface is ground by fine-meshed abrasive (i.e., Carborundum or corundum) to rough out the element to the requisite curvature.

The surface is then polished with cerium oxide to obtain the final lens curvature, texture, and clarity. The extraneous marginal edges are ground off to make sure the polished lens will have its optical axis in the center. Next, a thin, low-reflective layer of coating is applied to the glass surface by a vacuum depositing method to minimize surface reflections. This produces optical glass that is virtually bubble-free (completely bubble-free glass is an impossibility). The elements are now precisely seated in element groups that are fitted into lens mounts and then seated in the lens barrel at extreme tolerances.

The glass is coated during this manufacturing process. The surface of elements that are in contact with air reflects as much as 4 to 5% of the light striking it. When light enters a lens with a number of element surfaces (the more surfaces, the greater the potential problem), a significant amount of the light is lost through reflection before it reaches the film plane. Reflection can also cause flare, reducing the contrast of the picture. Lens coatings are designed to reduce this loss from reflection, to an amount as little as less than 1%. Lens surfaces are coated with a thin layer or multiple layers with varied refractive indexes. The thickness of one layer of coating is equal to one-fourth the wavelength of light and varies according to the type or usage of the lens.

A Nikkor lens with a single coating may be recognized by a blue, magenta, or amber tinted reflection of light in the front element. The stable chemical properties of these coatings not only prevent surface reflections but help protect the surface of the lens. The main coating in a single layer is magnesium fluoride. This procedure started to change in 1969 as newer multicoated lens designs were introduced.

In the Beginning

When the Nikon F first came on the market, there were a few rangefinder lenses that could be mounted on it. They required the aid of one of two special adapters, the **BR-1** and **N-F.** The **135mm f/4 Short Mount** lens requires the **BR-1,** while the others require the **N-F** adapter. The rangefinder Short Mount lenses, introduced in **1955** and **1958,** were:

135mm f/4 Short Mount
180mm f/2.5 Short Mount
250mm f/4 Short Mount
350mm f/4.5 Short Mount
500mm f/5 Short Mount
1000mm f/6.3 Short Mount

These lenses were designed primarily for the Nikon S series rangefinders, with a reflex housing attached. They can also be used with a Nikon F-mount camera, but the N-F adapter must be used, taking the place of the reflex housing. This adapter provides the correct amount of extension when mounted on the F that the reflex focusing housing provides on the rangefinder. These adapters permit the camera to work either horizontally or vertically, but there are no linkages for automatic diaphragm or meter coupling (which didn't exist when these lenses were manufactured).

The lenses are called "Short Mount" because without the adapter their barrel lengths are shorter than standard lenses of equivalent focal lengths. They are very heavy and bulky. These lenses do not have an automatic lens diaphragm. They cannot link with the lever in the F body that keeps the lens aperture open at its maximum aperture (for bright viewing and focusing). Nor can it then close down the aperture to the selected f/stop at the time of exposure. For this reason they are also known as "pre-set" lenses.

With the Short Mounts, a two-ring affair works the aperture. The first ring actually operates the aperture. The second ring is the "pre-set" ring. It is turned and left locked in the position where the aperture should be set for the exposure. In operation, the pre-set ring is set to the desired aperture. The aperture ring is then opened up to its maximum aperture, permitting focusing. Once the lens is focused, the aperture ring

is turned until it is stopped by a stop on the pre-set ring. The photograph is then taken. This is by no means a quick process!

Lens	Aperture Range	Weight	Attachment Size
180mm f/2.5	2.5–32	60 oz. (1,701 g)	82mm
250mm f/4	4–32	32 oz. (907 g)	68mm
350mm f/4.5	4.5–22	59 oz. (1,673 g)	82mm
500mm f/5	5–45	324 oz. (9,185 g)	108mm
1000mm f/6.3	6.3	21.9 lbs. (10 kg)	52mm in filter ring

The **1000mm f/6.3** is the first mirror lens that Nikon produced and is the odd man out in this lineup. It is not much smaller than the current 2000mm mirror lens, and in its day it was considered a monster. It is amazing. Its design consists of only three elements in two groups, that's all! Its minimum focusing distance is 100 feet (30.5 m), so its final image size is small. It has a filter ring that uses 52mm filters, but will not accept any other additions.

These lenses were not enough to make a viable working camera system, so Nikon introduced all new lenses designed for the SLR F. (It would be 25 years before Nikon introduced a new line of lenses for a new body.) All of the lenses manufactured by Nikon until 1977 had the non-automatic indexing coupling (this is the little "rabbit ears" on top of the aperture ring) that engages the metering prong on the body's meter (see the *Bodies* chapter for more information).

The first lenses introduced with the Nikon F in **1959** and **1960** were:

21mm f/4
28mm f/3.5
35mm f/2.8
50mm f/2
58mm f/1.4
105mm f/2.5
105mm f/4 Pre-set
135mm f/3.5
85-250mm f/4-4.5

These original lenses are unique for a couple of reasons. First, some were designated in centimeters rather than millimeters, for example, the 50mm f/2 was the 5cm f/2. Second, some of the original lens designations included a letter indicating the number of elements in their design. These letters are the first letter of the Latin (or sometimes Greek) word for that number:

U (Unus) *one element*
B (Bini) *two elements*
T (Tres) *three elements*
Q (Quattuor) *four elements*
P (Pente) *five elements*
H (Hex) *six elements*
S (Septem) *seven elements*
O (Octo) *eight elements*
N (Novem) *nine elements*
D (Decem) *ten elements*

These letters occur after the word "NIKKOR" on the serial number ring on the front of the lens (for example, "NIKKOR-H"). This system was completely dropped from Nikkor lenses by 1974. Most people never understood what it meant or really cared how many elements were in the lens design.

All of the new lenses for the F capitalized on the camera's SLR design except the 21mm f/4. SLR stands for Single Lens Reflex—viewing through the lens that takes the picture. It must be remembered that in 1959 35mm photography for the masses was in its infancy, and this was a radical concept.

The **21mm f/4** is a throwback to the rangefinder days. The rear element on the 21mm extends out past the lens mount. The mirror of a camera must be locked up to mount the lens, preventing SLR viewing. The 21mm comes with a finder that attaches on the accessory shoe of the F. This permits the photograph to be roughly framed. It has a length of 1 inch (2.54 cm), an aperture range from f/4 to f/16, no meter coupling, a filter size of 52mm, an angle of view of 81°, and a weight of 4.75 oz. (135 g). The 21mm is very compact. Serial numbers 225001 or higher fit all Nikkormats, those below that number do not. All 21mm lenses fit the F, F2, etc.

The **28mm f/3.5** first came out designated as 2.8cm on the barrel, but it was later changed to 28mm f/3.5. The 28mm f/3.5 is a very compact lens. It has a length of 2 inches (5 cm), an aperture range from f/3.5 to f/16, meter coupling, a filter size of 52mm, an angle of view of 64°, and a weight of 7.75 oz. (220 g). The 28mm f/3.5 was never thought of as an outstanding lens. It sold rather well, though it was never

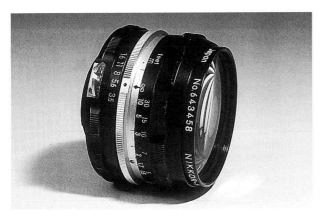

Nikkor 28mm f/3.5 (Non-AI)

highly regarded. Its optical formula did not change much over the years, though its cosmetics did.

The **35mm f/2.8** is similar to the 28mm f/3.5 with the original lens being designated 3.5cm. It has a length of 2 inches (5 cm), an aperture range from f/2.8 to f/16, meter coupling, a filter size of 52mm, an angle of view of 62°, and a weight of 7 oz. (198 g). It never enjoyed a reputation of being a great lens but sold well because of the focal length. Like the 28mm f/3.5, it did not change much optically over the years, but did undergo cosmetic changes.

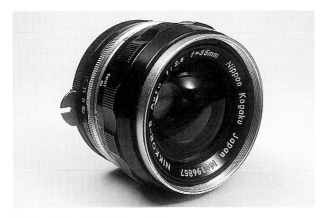

Nikkor 35mm f/2.8 (Non-AI)

The **50mm f/2** was the first "normal" SLR lens manufactured by Nikon. It is relatively slow at f/2. It has a length of 1.5 inches (3.8 cm), an aperture range from f/2 to f/16, meter coupling, a filter size of 52mm, an angle of view of 39°, and a weight of 7.2 oz. (204 g). This little lens, though not suited for low-light photography, works great for general and close-up photography. This is especially true on a bellows. Even at f/2 it delivers outstanding resolution

and color rendition. Closed down to f/5.6 it is excellent. When working with the lens reversed, the corner sharpness suffers slightly, and it is best closed down to f/8. This lens sold by the thousands, going through few changes over the years. Multicoating, an all-black barrel and rubber focusing ring (non-AI) are the extent of the changes that have been made.

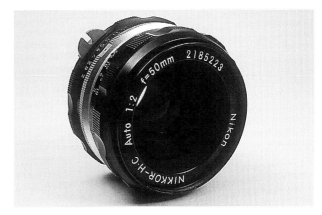

Nikkor 50mm f/2 (Non-AI)

The **58mm f/1.4** is a unique lens that was made for only one year. This lens covers a slightly wider angle than "normal." It has a length of 2.5 inches (6.4 cm), an aperture range from f/1.4 to f/16, meter coupling, a filter size of 52mm, an angle of view of 34°, and a weight of 12.8 oz. (363 g). The lens was always designated 5.8cm on the barrel, never acquiring millimeter markings. It is excellent at f/1.4; closing down is not required for better results. It is still sought out by old-time photographers who use the FM and F2, but it is not capable of being converted by Nikon to AI coupling.

The **105mm f/2.5** quickly caught on with photojournalists stationed in Japan after the Korean conflict in 1959. It was considered by many as the best lens on the market at the time (many still swear by it). The 105mm f/2.5 is a lens that has become the standard for portrait work. A very simple design, the lens is compact. It has a length of 3 inches (7.6 cm), an aperture range from f/2.5 to f/22, meter coupling, a filter size of 52mm, an angle of view of 19°, and a weight of 13 oz. (369 g). It has gone through many cosmetic changes since its release. The first version had a chrome lens barrel and filter ring. That was changed to a chrome lens barrel with a black filter ring. Then it became all black with a larger focusing ring and a minimum f/stop of f/32. It then went to a rubber focusing ring and back to f/22. It maintained that design until 1977.

It was said that its optimum performance was at f/5.6, but when used at f/2.5 it produces equally outstanding results. In advertisements of the day, the hexagonal form of the aperture blades was emphasized because of the clean, out-of-focus highlights they produced. When the lens was purchased, it came with a shade. It can be reversed over the lens for storage and turned around when in use. This lens gave Nikon the kick-start to becoming legendary in lens design!

The **105mm f/4 Pre-set** is a rangefinder lens that Nikon retrofitted to work with the bayonet F mount. On an F, this rather odd looking lens (marked 10.5cm rather than 105mm) is extremely light. It has a length of 3.75 inches (9.5 cm), an aperture range of f/4 to f/22, stop-down metering, a filter size of 34.5, an angle of view of 19°, and a weight of 9 oz. (255 g). There is no automatic diaphragm operation, but it has TTL viewing. It is a pre-set lens, operating the same as the Short Mount lenses. Its days were numbered even before the F was introduced, and it was discontinued not too long after. It became a rare, forgotten, and not much sought-after lens.

The **135mm f/3.5** was Nikon's second "portrait" lens. It is short for its focal length. It has a length of 3.5 inches (8.9 cm), an aperture range of f/3.5 to f/22, meter coupling, a filter size of 52mm, an angle of view of 15°, and a weight of 13 oz. (369 g). It was popular for only a short while. Like the 105mm f/2.5, it changed cosmetically over the years, but not as much nor as often. It ended up with a minimum aperture of f/32, which helped its popularity briefly, but it has never been known as a "killer" lens.

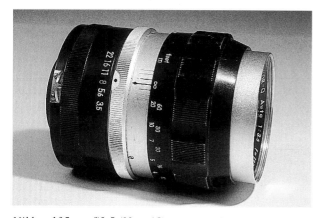

Nikkor 135mm f/3.5 (Non-AI)

The **85-250mm f/4-4.5** was Nikon's first zoom design. It incorporates an internal zoom mechanism that is operated by pushing and pulling a ridge around the lens barrel. This is a big lens with lots of glass. It

has a length of 20 inches (50.8 cm), an aperture range from f/4 to f/16, meter coupling, a filter size of 95mm (Series 9), an angle of view of 24° to 8°, and a weight of 70 oz. (1,984 g). As it is zoomed, it is necessary to keep track of the focal length because it requires aperture compensation. At the 180mm focal length it loses light until the 250mm mark, where it is at f/4.5.

The **35-85mm f/2.8** came and went between 1959 and 1960. This fast zoom had a filter size of 82mm and was a heavyweight. Very few are known to exist—I've never seen one. I have no firsthand knowledge of this lens or its fate.

The Nikon lenses offered did not change much over the next two years other than the discontinuation of the 58mm f/1.4 in 1960 and the 105mm f/4 Pre-set in 1961. Discontinuation of a lens does not necessarily mean immediate unavailability of new stock for purchase, rather, that it is no longer manufactured. Many photographers, when looking back at the variety of lenses originally available, wonder how Nikon ever made it this far. It should be remembered that photography was enjoyed by a limited number of "weekend" photographers back then in comparison to the hundreds of thousands of "weekend" photographers in the field today.

A unique lens sneaked into the lens lineup in **1962**, the **55mm f/3.5 Micro Pre-set.** This extremely rare lens was on the market for less than a year. It has an aperture value range from f/3.4 to f/22, no meter coupling, a filter size of 52mm, an angle of view of 43°, and a weight of 11.5 oz. (326 g). Its length is unknown. What makes this lens so unique is it focuses down to 1:1 with 8.14 inches (20.7 cm) of working distance. I have never shot with this lens and have never heard of its optical reputation. It is one of the true ghosts of the Nikon lens line and eludes many a collector.

The next group of lenses to help fill out the Nikon lens line was introduced in **1963.** They were:

8mm f/8 Fisheye
35mm f/3.5 PC
50mm f/1.4
55mm f/3.5 Micro Compensating
200mm f/4
43-86mm f/3.5
200-600mm f/9.5-10.5
200mm f/5.6 Medical
500mm f/5 Mirror

The **8mm f/8 Fisheye** was a very exciting lens when it was introduced. The 8mm has an angle of view of 180° and is a fixed-focus fisheye (everything

is in focus, so there is no focusing ring). The 8mm takes a circular image, not filling the frame but leaving black in the corners of the photograph. Up until this time, there had been no other lens like it. Hundreds of photographs taken with this lens soon appeared in print heralding the age of the "Fisheye." The demand for this type of lens made the 8mm the first of many fisheyes to come.

This lens can be mounted only on cameras with a mirror lock-up. Its rear element protrudes into the camera body, resting only millimeters away from the film plane. With the mirror locked up, there is no viewing through the lens. An auxiliary viewfinder, which attaches to the camera's accessory shoe, is used to frame the picture. However, this finder has only 160° of coverage, 20° less than the lens. Photographers can get their feet or the tripod legs in the picture if they're not careful. The finder has its own small lens cap for protection when not in use.

The 8mm has a variable f/stop, going down to f/22. However the depth of field is so immense, the only advantage in closing down the aperture is when focusing on an extremely close subject (as in, touching the front element!). Because the angle of view is so extensive, front filtration is impossible. Even the slightest extension past the front element will enter the picture frame. Nikon provides built-in filters in a turret, the L1A, Y48, Y52, O57, R60, and X0. These are mostly for black-and-white work. The L1A, a skylight filter, can be used for color photography. A unique feature of the 8mm is its rear lens cap, which fits over the long rear element. It also provides an accessory shoe to which the finder can be attached during storage.

The **35mm f/3.5 PC** (Perspective Control) was a first in its day. The front element assembly can shift on its optical axis, moving the image at the film plane. This allows the camera to stay parallel to the subject, normally a building, and the front element shifts to bring the subject into the frame. (Use of this lens is discussed in greater detail in the description of the 28mm f/3.5 PC.)

The **50mm f/1.4** is physically larger than the 50mm f/2 to accommodate its larger glass elements. The "normal" lens was improved with a faster maximum aperture. As normals go, the Nikon 50mm f/1.4 is very good, rendering sharpness even when shot wide open. In write-ups at the time of its introduction, claims were made that the flare potential had been eliminated because of the use of integrated multi-layer coatings on all air surfaces of individual elements. The description does suggest more than one layer. But this is not the same as being multicoated.

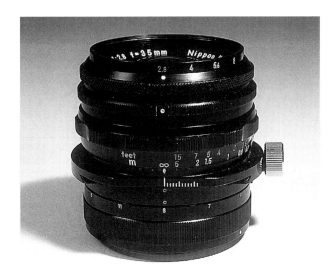

Nikkor 35mm f/3.5 PC

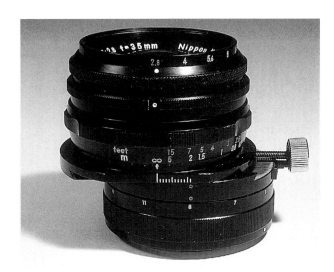

Nikkor 35mm f/3.5 PC, shifted

Light reflecting off the front element (which has a blue, purple, or green hue) makes this lens look like all other lenses with a single coating.

The 50mm f/1.4 went through many updates and cosmetic changes over the years. The non-AI version with an all-black barrel and rubber focusing ring was multicoated. The 50mm f/1.4 has good sharpness when used normally. Reversing it is not recommended, as the image suffers at the corners, and it is not recommended for copy work.

The **55mm f/3.5 Micro Compensating** is a unique lens whose myth lives on long after its production ceased. The 55mm f/3.5 is a compact design. It has a length of 2.5 inches (6.4 cm), an aperture range of f/3.5 to f/22, meter coupling, a filter size of 52mm, an

angle of view of 36°, and a weight of 8.8 oz. (249 g). Nikon has always called their close-focusing lenses "Micro." This term does not fit this lens, as "micro" actually means greater than 1:1 magnification. The 55mm f/3.5 by itself can focus only to 1:2 (1/2 life size) and with the **M Ring** (included with the lens when purchased) to 1:1 (life size). So it is really a "macro" lens. The term "micro" is a carryover from the first 55mm micro, which could go 1:1. From then the term would be used for all micro lenses to come. The 55mm f/3.5 can also focus to infinity (when the M Ring is not attached).

The 55mm f/3.5 Compensating lens couples with the meter for fully automatic diaphragm linkage. It also has "automatic aperture compensation," which provides an image of constant brightness regardless of the focused distance or magnification. "Compensating" is a nickname the lens earned because of this feature. No recalculation of exposure or exposure factor needs to be made when doing close-up photography. When focusing at greater magnifications, the aperture automatically opens up. At 1:2 the lens opens up one full stop. If using the M Ring, you can open up one stop manually to compensate for the light loss from the increased magnification. One interesting note: the 55mm f/3.5 aperture closes down to f/32, but meters only couple to f/22. You must disengage the coupling to close all the way down to f/32.

The **200mm f/4** design is not particularly special or radical. It has a length of 8 inches (20.3 cm), an aperture range from f/4 to f/22, meter coupling, a filter size of 52mm, an angle of view of 10°, and a weight of 19.25 oz. (546 g). It has a built-in lens hood that pulls out for use. The original design stayed the same until 1977, with only minor cosmetic changes. The ring on the barrel between the hood and the focusing collar changed from having a chrome finish to black, and the last version is multicoated. It was a very popular lens in its day. It is still in use and readily available. A respectable lens, it is a good, inexpensive way to get into telephoto work. This is a popular lens to mount a reversed wide-angle to for close-up work. It functions very well in this mode.

The **43-86mm f/3.5** is a design that lasted until 1981, going through many cosmetic changes and one optical change. It has a length of 5 inches (12.7 cm), an aperture range from f/3.5 to f/22, meter coupling, a filter size of 52mm, an angle of view of 45° to 22°, and a weight of 14 oz. (397 g). It is a small zoom and had a popular focal length range in its day. By Nikon standards, the early version was not sharp, but this changed when it became multicoated. The serial

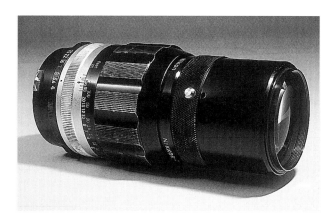

Nikkor 200mm f/4 (Non-AI)

numbers on Nikon lenses are normally six digits, but the later versions of the 43-86mm have seven digits (a testimony to how many were manufactured). The later models are the sharpest of all 43-86s, but they are not up to the same quality that many photographers are used to today.

The **200-600mm f/9.5-10.5** was something of an enigma—a big lens in size and a rather strong seller in the stores. It has a length of 27 inches (68.6 cm), an aperture range from f/9.5 to f/22, stop-down metering, a Series 9 (82mm) filter size, an angle of view of 10° to 3°, and a weight of 85.5 oz. (2,424 g). It has a tripod collar permitting rotation of the lens for vertical and horizontal shooting, with click-stops at every 90°. It is not handholdable. The lens comes with a hood and a close-up lens. An orange distance scale engraved on the barrel is for "close-up" work and relates to the orange ring on the filter.

The 200-600 was actually a variable f/stop zoom, going to f/10.5 when zoomed out to 600mm (variable f/stop zooms are not that new an idea). Like the 43-86, the early version (which has a chrome ring on the end of the lens) is not a fantastic lens. However, a shorter (by 2 inches, or 5.1 cm), sharper version introduced later is quite a nice lens. In 1977, it came out in an ED (Extra-low Dispersion) version, a rare and *very* sharp lens. Its aperture then became a constant f/9.5. One measure of the lens' popularity is that it rarely appears on the used market. Those who purchased it new got a good thing, and they know it! Production numbers of the ED model are believed to be few since its f/stop was so slow, and recent trends have favored faster lenses.

An extremely curious lens, the **200mm f/5.6 Medical** was designed for the medical field. It has a length of 7.75 inches (19.7 cm), an aperture range from f/5.6 to f/45, stop-down metering, a filter size of 38mm, an

angle of view of 10°, and a weight of 23.6 oz. (669 g). In its early days, Nikon specifically designed many lenses for the scientific community, probably because of the overwhelming demand to document scientific innovations photographically. It was designed for close-up photography, when a good working distance as well as superb illumination of the subject are required.

The Medical can focus to 11 feet (3.3 m) at its maximum with an image ratio of 1:15. With a close-up lens attached to it, 3:1 magnification can be attained. Focusing of the subject is accomplished by moving the camera-lens combination closer or farther away from the subject until it is in focus. Changing the combinations of any of the six close-up filters changes the magnification. The Medical is powered by either the **LA-1** (AC) or **LD-1** (DC). It has four focusing bulbs to illuminate the subject during focusing as well as a built-in ring-flash for exposure. It self-compensates for exposure (no aperture ring) by matching up the film's ISO to the image ratio on the barrel of the lens. The magnification ratio from 1/15x to 3x or a numeral from 1 to 39 can be imprinted, if desired, on the lower corner of the final picture. The 200mm f/5.6 Medical was in production until the early eighties. (There are two versions of this lens with differences in the electrical power source and leads.)

The **500mm f/5** was the first catadioptric (mirror) 500mm lens for Nikon, and it was popular at the time. Catadioptric is the technical name for the optical design of the mirror lens. "Catoptric" means reflecting light, and "dioptric" means transmitting light. A mirror lens uses both of these systems to get the image to the film. The first element focuses the image on the back mirror, which then reflects that image onto a second mirror attached to the center of the front element. This sends the image back through a different lens near the back of the lens that focuses the image on the film plane.

This lens has a length of 13 inches (33.0 cm), a fixed aperture, no meter coupling, a front filter size of 122mm and a rear filter size of 39mm, an angle of view of 4°, and a weight of 59 oz. (1,673 g). The 500mm f/5 is not easily handheld because of its size. It has a built-in tripod mount allowing the camera to be turned 90° for vertical shooting. A 39mm filter must be attached on the back of the lens at all times to have accurate focus. Usually this would be an L39 UV filter, but the lens also came with Y52, O56, R60, and ND filters. Because of the fixed aperture, the exposure is changed by altering the shutter speed or by adding ND filters. With a minimum focusing distance of 50 feet (15.2 m), the lens did not sell well. It

was, however, a nice lens as far as sharpness goes.

The 500mm f/5 introduced photographers to the "doughnut" highlights that were to become synonymous with mirror lenses. The highlights are caused by the mirror attached to the front element. As light enters the lens, it is bent around that mirror, causing the black hole or doughnut-shaped highlights. There is nothing that can be done to eliminate the highlights other than for you to be aware of the background, and use it to hide them.

Nikon did not rest on its laurels for long, coming out with more lenses in **1964** to help round out the lens line. The new additions were:

55mm f/3.5 Micro
85mm f/1.8
300mm f/4.5
600mm f/5.6
800mm f/8
1200mm f/11

The **55mm f/3.5 Micro** is only slightly different from the earlier compensating model. The 55mm f/3.5 Micro Compensating lens was discontinued with the introduction of this 55mm Micro. This 55 does not compensate for the focusing distance or magnification (it must be done manually), although the lens does have magnification and exposure compensations etched on the barrel for ease of operation. The optical formula was changed from that of the 55mm f/3.5 Compensating as well. The new 55 has a slight modification in the gap between element groups. All measurements and dimensions are otherwise the same. There is one cosmetic change in the new model—a rubber focusing ring.

The lens attains a 1:2 ratio by itself. An **M2 Ring** is required to achieve 1:1 magnification. At the time of introduction, it was proclaimed to be the sharpest lens for general photography available, not losing any sharpness when focused down to 1:1. It was said to have better resolving power across the whole plane of focus than the finest-grain film could hold. This is a claim that was pretty well justified, as the lens is still in wide use even today because it is so sharp. This model 55mm would soon receive multicoating on the lens elements, though the cosmetics remained the same.

From the first, the **85mm f/1.8** was widely accepted as a great lens. It was bought for its focal length and speed and is still widely sought after today. It has a length of 4 inches (10.2 cm), an aperture range from f/1.8 to f/22, meter coupling, a filter size of 52mm, an angle of view of 23°, and a weight of

15 oz. (425 g). It is an extremely sharp lens with excellent edge-to-edge quality in a small package (this is one of Nikon's silent sleepers). It can easily be handheld even at relatively slow shutter speeds because of its compact size. It went through only one major cosmetic change when the chrome barrel was made all black and the metal focus ring became rubber. Sadly it was discontinued in 1977 and was never manufactured and sold as an original AI. Thousands of 85mm f/1.8s have been converted to AI, a testament to its popularity.

The first **300mm f/4.5** started the long succession of Nikon 300mm lenses. It has a length of 8 inches (20.3 cm), an aperture range from f/4.5 to f/22, meter coupling, a filter size of 72mm, an angle of view of 6°, and a weight of 35 oz. (992 g). It can be handheld, even at slower shutter speeds, because it is so well balanced. It does not have a moveable tripod collar, but rather two tripod 1/4"-20 sockets permanently attached to the barrel for vertical or horizontal shooting. It has a built-in shade, which slides out, providing adequate flare protection. The design had only minor cosmetic changes until 1977 when the AI version was released.

The **600mm f/5.6, 800mm f/8,** and **1200mm f/11** were the beginnings of today's dynasty of telephotos. These "Super Telephotos" were unique in design and application, making them very popular. The three focal-element units are attached to a focusing unit, the original being the **CU-1.** The three separate front-element units screw in and out of the CU-1, enabling the body to remain attached to the CU-1 while changing the focal length.

The CU-1 has an automatic diaphragm with an aperture range of f/4.5 to f/22. It can be closed down manually to f/64 with the 800 and 1200, but in either case, stopped-down metering must be employed. These lenses are approximately as long as their focal length, so they are by no means handholdable. A special attachment, the Cradle, later came with the CU-1 to facilitate use on a tripod. The lenses are sharp, with

excellent color and contrast. But their physical size makes them very hard to manipulate. Another disadvantage is their lack of meter coupling. The CU-1 was later discontinued and the **AU-1** introduced. It does the same job but has a more modern cosmetic design and a 52mm built-in filter drawer.

In 1966, a **400mm f/4.5** was added to complete the line. All these lenses can easily be used at their maximum aperture with excellent results, though closing them one to two stops delivers maximum sharpness. In 1975, the 600mm, 800mm, and 1200mm were updated to an ED edition. The ED versions were quickly snatched up because they are absolutely outstanding optically! With the advent of EDIF (Extra-low Dispersion, Internal Focusing) lenses in 1978, the ED lenses were discontinued. Today the ED versions are very hard to find, while the non-ED lenses still show up in used lens ads.

In **1965,** Nikon introduced five new lenses to round out their original lens line. They were:

35mm f/2
55mm f/1.2
135mm f/2.8
50-300mm f/4.5
1000mm f/11 Mirror

The 35, 135, and 50-300 saw action instantly, as photojournalists assigned to the Vietnam conflict found them uniquely suited for their work.

The **35mm f/2** was the fastest wide-angle lens offered by Nikon at the time and was quickly adopted by photojournalists. Its compact design greatly helped its popularity. It has a length of 2.5 inches (6.4 cm), an aperture range from f/2 to f/16, meter coupling, a filter size of 52mm, an angle of view of 62°, and a weight of 10 oz. (284 g). Its sharp picture quality and solid contrast made it a hit. Its angle of view of 62° was preferred so often for journalistic photography that many PJs called the 35mm f/2 their "normal" lens.

Early Super Telephoto Lens Specs

Lens	Filter Size	Angle of View	Weight (w/o CU-1)	Length (w/ CU-1)
400mm f/4.5	122mm	6.1°	66.8 oz. (1,894 g)	18.3" (46.5 cm)
600mm f/5.6	122mm	4.1°	84 oz. (2,381 g)	20.6" (52.3 cm)
800mm f/8	122mm	3°	80.8 oz. (2,291 g)	28.4" (72.1 cm)
1200mm f/11	122mm	2°	123 oz. (3,487 g)	36.5" (92.7 cm)

Nikkor 35mm f/2 (Non-AI)

The **55mm f/1.2** was the fastest Nikkor around, with a maximum aperture of f/1.2. Its optical quality permits shooting wide open without any loss in image quality. It was well accepted by photographers, especially with the fast f/stop. But its quality is what kept it popular. It has a length of 2.5 inches (6.4 cm), an aperture range from f/1.2 to f/16, meter coupling, a filter size of 52mm, an angle of view of 36°, and a weight of 14.8 oz. (420 g). This lens is known to be sharper in the center than at the edges, so it is not recommended for use reversed on a bellows or in copy work. It went through a couple of cosmetic changes; the last models having a rubber focusing ring. It is the last of these models that is the most popular and sought after today.

The **135mm f/2.8** made quite an impact. It was a fast telephoto in 1965, making it very popular. It has a length of 4.25 inches (10.8 cm), an aperture range from f/2.8 to f/22, meter coupling, a filter size of 52mm, an angle of view of 15°, and a weight of 21.9 oz. (621 g). Closing down just one f/stop to f/4 delivers its best performance, but it isn't a lens noted for picture quality. It has a built-in lens shade that locks into place by twisting, for use or storage. An interesting thing about this lens is that it did not change cosmetically until immediately before a whole new model came out in 1977. In a very limited run, the 135mm f/2.8 came out all black, with a rubber focusing ring, and multicoated elements. This is a very rare version. This lens is not recommended for any type of close-up work because the image quality suffers at the corners with close focusing.

The **50-300mm f/4.5** is a big lens that had its 15 minutes of fame when it was first introduced because it was the only 6x zoom on the market. Making a lens containing normal to telephoto focal lengths produced a large package. It has a length of 12.5 inches

(31.8 cm), an aperture range from f/4.5 to f/22, meter coupling, a filter size of 95mm, an angle of view of 25° to 4°, and a weight of 5.1 lbs. (2.3 kg)! Of the original model it was said that at the 300mm end of the zoom, chromatic aberrations (a problem many worried about then) were virtually eliminated, giving excellent resolution and contrast.

The 50-300 is a two-ring zoom, one ring focuses, one ring zooms. It is a true zoom and can be focused on a subject and zoomed back and forth without losing focus. It can focus down to 8.5 feet (2.6 m), which was good in its day. It has a built-in tripod collar that allows for 360° rotation. It also has two strap lugs. This permits you to carry it by the lens rather than the camera body to avoid stressing the body's lens mount. It went through a few cosmetic changes over the years, being refined each time. There are many photographers still using this old lens and getting respectable results!

The **1000mm f/11** is Nikon's second mirror lens, optically constructed just as the 500mm f/5. It has a length of 9.75 inches (24.8 cm), a front element of 108mm (no threads for a filter), a fixed aperture of f/11 (stop-down metering is required), an angle of view of 2.3°, and a weight of 4.2 lbs. (1.9 kg). Some say they can hand-hold this lens, but it is best to put it on a tripod.

Its optical performance is improved compared to the 500mm f/5, focusing down to 26 feet (7.9 m) and delivering a sharper image. It has a filter turret in the rear like that of the 8mm fisheye, which contains four filters, L39, Y48, O56, and R60. It has a tripod collar allowing for either vertical or horizontal photography and a reversible front lens shade. The lens is well corrected for all aberrations giving good resolution and contrast with minimized "doughnut" highlights because of the small aperture. Depth of field is good because of its small f/stop. Popular even today, this lens has been changed only once, and that was the replacement of the filter turret with the 39mm rear screw-in filter system.

It wasn't until **1967** that any new lenses were seen from Nikon, and then there were only two. They were:

7.5mm f/5.6 Fisheye
24mm f/2.8

The **7.5mm f/5.6 Fisheye** is similar to the 8mm f/8 Fisheye. Like the 8mm, it requires a camera with a mirror lock-up function and utilizes an auxiliary finder to frame the photograph. It has the same built-in filters in a turret as the 8mm and the same angle of

view, 180°. Nikon discontinued the 8mm f/8 in 1966, and this lens served as its replacement.

Nikon's **24mm f/2.8** became a staple for photographers from the moment it was introduced. It is a very compact lens, which adds greatly to its popularity. It has a length of 2.75 inches (7.0 cm), an aperture range of f/2.8 to f/16, meter coupling, a filter size of 52mm, an angle of view of 84°, and a weight of 10.2 oz. (289 g). This was the first lens to incorporate **Close Range Correction** (CRC). This floating-element design is coupled to the focusing ring and provides automatic realignment of elements as the lens is focused at its minimum distance. This results in outstanding corner-to-corner image quality (at all points in the focusing range, in my opinion).

The 24mm f/2.8 is excellent wide open, with its optical quality barely changing when closed down. This is a popular lens to use on a bellows or reversing ring. When reversed, it is best at f/8. The 24mm f/2.8 went through many cosmetic changes through the years. From its original chrome barrel to the newer rubber focusing ring design, the optics remained the same. The 24mm f/2.8 is probably one of the biggest selling lenses Nikon has ever designed and one that every Nikon owner has had at least once.

It was not until **1969** that Nikon released new lens designs, but what a new group it was! These lenses could be categorized as "specialized" because of their applications. They were:

6mm f/2.8 Fisheye
10mm f/5.6 OP Fisheye
20mm f/3.5
45mm f/2.8 GN
105mm f/4 Bellows
500mm f/8 Mirror
2000mm f/11 Mirror

The **6mm f/2.8 Fisheye:** there has never been any lens like it, before, or since. Still in production (special order only), it is truly a remarkable achievement in optical design. It has a length of 6.75 inches (17.1 cm), an aperture range from f/2.8 to f/22, meter coupling, a weight of 11.5 lbs. (5.2 kg), and a front element that's 9.3 inches (235 mm) across! To give you a better idea of its size, the front element completely hides any camera attached behind it. Not only is the size of this lens huge, but so is its coverage—220°! The lens was originally developed for special applications in meteorological and astronomical research (as were most fisheyes). It also served environmental and architectural design applications. A further use is in quality control for such things as

Nikkor 6mm f/2.8 Fisheye

pipes, boilers, nuclear reactors, and other constricted areas where no other lens could be employed.

Because of the 220° coverage, it can see literally behind the photographer, thus creating the danger of accidentally getting one's feet in the picture. It comes with a special lens cap made of leather that fits around the element and then snaps into place (with two snaps on the back of the element barrel). It has filters (L1A, Y48, Y52, O56, R60, and X0) built into a turret, with no means of front element filtration. It also comes with a special wooden lens case. This is the only fisheye at this time that meter couples or that is SLR. The first photograph I ever saw taken with this lens was at a Nikon School of Photography class. They had a grasshopper resting on the front element. It and everything else in the picture was totally sharp—this is an amazing lens! The 6mm f/2.8 has not gone through any changes and is still available from Nikon, but it is not cheap!

The **10mm f/5.6 OP Fisheye** is another fisheye lens designed with the scientific community in mind. It is not an SLR lens, being along the same lines as the 7.5mm and 8mm (the rear element sticking into the camera body). It has the same accessory finder with 160° coverage and built-in filters in a turret as the 7.5 and 8mm lenses have. It is just a little bigger than the other two fisheyes. It has a length of 4.25 inches (10.8 cm), an aperture range from f/5.6 to f/22, stop-down metering, no front filter, and a weight of 14.1 oz. (400 g).

What makes the 10mm f/5.6 OP special is the Orthographic Projection (OP) or aspherical element formula. Orthographic Projection means that the lens gives even exposure throughout the image, including

any point light source. In comparing photographs taken with the 10mm OP versus the 7.5mm or the 8mm, the 10mm OP delivers an even, blue sky, whereas the other lenses produce a light band of blue above the rest of the blue sky. All three of these fisheyes have a coverage of 180°. But the 10 OP is the nicest of the three, being sharper and cleaner in the final image.

The **20mm f/3.5,** the widest non-fisheye lens, got the photographic world very excited. It provided a whole new perspective in picture-taking while providing through-the-lens viewing. The 20mm f/3.5 is a largish lens, bigger than any other wide-angle at the time. It has a length of 2.75 inches (7.0 cm), an aperture range from f/3.5 to f/22, meter coupling, a filter size of 72mm, an angle of view of 83°, and a weight of 13.8 oz. (391 g).

What's interesting about the 20mm f/3.5 is that it has 2° wider coverage than the 21mm f/4. This is because the 20mm f/3.5's rear element is flush at the lens' mounting flange. The 21mm f/4 is only 5 mm away from the film plane, causing less coverage. This belies the standard rule-of-thumb of "the smaller the focal length, the greater the angle of view." The 20mm f/3.5's design was called "retrofocus" because it did not need the mirror to be locked up in order to mount the lens. The term is not commonly used anymore because no lens has since been manufactured that needed the mirror to be locked up.

The **45mm f/2.8 GN** (Guide Number) was an ingenious lens—incredibly sharp and amazingly small. It has a length of less than an inch (0.79 inch [2.0 cm] to be exact), an aperture range from f/2.8 to f/32, meter coupling, a filter size of 52mm, an angle of view of 42°, and a weight of only 5 oz. (142 g). The 45 GN was designed to make flash photography easy and quick, solving the problem of correct automatic exposure. It was designed before flashes had the ability to take care of exposure via their own sensors or that in the camera.

The way the lens works is so simple, it is surprising that more models were not manufactured. Activating the 45 GN requires matching up the guide number of the flash (printed on the aperture ring 180° opposite from the aperture numbers) with the coupler attached to the focusing ring, then pushing the coupler into place. This coupler locks the focusing ring to the aperture ring. When the lens is focused, the aperture turns in concert, changing the f/stop of the lens to match the focus distance for correct flash exposure. It is so simple and so accurate! This was particularly popular with wedding photographers because it allowed accurate exposures to be made quickly and easily.

The 45 GN works great on a bellows! Its four-element design, though not technically flat field, provides the quality of a flat-field lens. It is an excellent lens for close-up photography when attached to a bellows, and has a decent working distance. It also has a minimum f/stop of f/32 for excellent depth of field (not recommended past f/22 though). The 45 GN is still used by photographers today for slide copying, even though it has been discontinued since 1977. It never came out in an AI version, but many have been converted to AI. The shade for the 45 GN (no number was ever given to it) is one of the oddest shades Nikon ever made. The shade is 52mm across, but has an extending lip jutting over the front of the lens. It has a small hole in the center for the lens to peer out. A unique style of shade!

The **105mm f/4 Bellows** lens is still popular. It appeals to many photographers although it has long been discontinued. This lens (often incorrectly called the Short Mount 105) was designed specifically for use on the PB-4 and PB-5 Bellows but works on any bellows. It focuses from infinity to 1.3x. The lens has no focusing helicoid of its own, relying on the extension or contraction of the bellows to focus. It has a length of 2 inches (5.1 cm), an aperture range from f/4 to f/32, stop-down metering, a filter size of 52mm, an angle of view of 19°, and a weight of 8.1 oz. (230 g). It is a pre-set lens, having no automatic diaphragm linkage. The aperture does have aperture click-stops every 1/3 stop (the only Nikkor that does) for pre-setting exposure.

The 105 Bellows lens is extremely sharp, and though not a flat-field design, it does render outstanding sharpness from corner to corner. (In case you are wondering, the design of the 105mm f/4 Micro was based on this lens.) On the bellows, it has an excellent minimum focusing distance of 6 inches

Nikkor 45mm f/2.8 GN

(15.2 cm) at maximum magnification. Another very popular use of the 105 Bellows is attaching it reversed to a 200mm f/4 via an aftermarket 52-52 thread adapter. This combination produces a 7x magnification with a working distance of 4 inches (10.2 cm). For optimum results, set the aperture on the 105mm Bellows wide open, and do not close down the 200mm f/4 past f/16.

The **500mm f/8 Mirror** is a completely new design from the 500mm f/5. It has been slimmed way down in size from the 500mm f/5. It has a length of 5.6 inches (14.2 cm), an aperture fixed at f/8, stop-down metering, a front attachment size of 88mm, an angle of view of 4°, and a weight of 2.2 lbs. (1 kg). Besides the lens being much smaller, the minimum focusing distance is considerably less at 13 feet (4 m) compared to 50 feet (15 m) with the 500mm f/5. The 500mm f/8 maintains the same filter system (rear-mounted 39mm screw-in filters), one having to be in place to complete the optical formula. This lens can be handheld and has a tripod collar with a click-stop for vertical or horizontal shooting. Like the 500mm f/5, the 500mm f/8 still has the drawback of "doughnut" highlights. When purchased new, it came with a case. In the lid of the case are the four filters for the rear mount.

The **2000mm f/11** can best be described as a car! This is the biggest lens ever manufactured by Nikon. Its power is equivalent to that of a 40x telescope, or 40 times the power of a 50mm lens. It has a length of 24 inches (61.0 cm), an aperture fixed at f/11, stop-down metering, a front element that's approximately 250mm, an angle of view of 1°, and a weight of 16.5 lbs. (7.5 kg)! Filtration is achieved by four filters in a turret that require turning a knob to change. L39, Y48, O56, and R60 filters are supplied with the lens. It comes in a cradle/turret that looks like a machine gun mount, which adds another 7 lbs. (3.2 kg) to the lens and mounts onto a tripod (this is not handholdable). The lens also has a built-in, stationary handgrip on top of the lens barrel. The lens mount rotates with click-stops for vertical and horizontal shooting and is well suited for astronomical photography. This is a rare lens.

Four lenses were introduced in **1970,** three of which would become the mainstay of camera bags for years to come. They were:

8mm f/2.8 Fisheye
35mm f/1.4
180mm f/2.8
80-200mm f/4.5

Riding the wake of a seven-year fascination with the "Fisheye" look, Nikon introduced the **8mm f/2.8 Fisheye.** Of all Nikkor fisheye lenses, this is the only one that is really practical in the field. Its size is easily handholdable. It has a length of 5 inches (12.7 cm), an aperture range from f/2.8 to f/22, meter coupling, a 122mm front attachment (no filtration is possible), an angle of view of 180°, and a weight of 2.2 lbs. (1 kg). Not only is it three or four stops faster than the 7.5mm, 8mm, or 10mm OP, but it permits through-the-lens viewing when shooting.

This is very important with a lens this wide. Non-SLR fisheye photographs usually contain unwanted elements in the picture. This becomes easier to monitor with the introduction of through-the-lens viewing. The 8mm f/2.8 has a built-in filter turret with L1A, Y48, Y52, O56, and R60 filtration and comes with a metal lens cap. The lens focuses to 1 foot (0.3 m), which makes emphasizing the foreground extremely easy. It also has an equidistant projection formula for even exposure and excellent sharpness. It still produces a circular image, but straight-line rendition can be achieved in the center of the picture if care is taken in placing the horizon.

The introduction of the **35mm f/1.4** made photojournalists ecstatic. It would become "the" lens for them! It was the first Nikkor lens to originally be introduced with multicoating. It has a length of 2.75 inches (7.0 cm), an aperture range from f/1.4 to f/22, meter coupling, a filter size of 52mm, an angle of view of 62°, and a weight of 14.6 oz. (414 g). For most PJs it ended up replacing the 50mm f/1.4 as their standard lens because of its compact size, speed, and sharpness. Another great feature of the 35mm f/1.4 is the floating element design (CRC) for extreme sharpness from corner to corner, even when focused down to 1 foot (30.5 cm) (its closest focusing distance). The first design had an all-metal focusing ring; later it was produced with a rubber focusing ring.

The **180mm f/2.8**—few lenses have been as popular as this! This incredibly sharp lens earned its reputation right from the start. Because of the optics required to make a fast telephoto, the 180mm f/2.8 is not a lightweight lens. It has a weight of 29.3 oz. (831 g), length of 5.6 inches (14.2 cm), an aperture range from f/2.8 to f/32, meter coupling, a filter size of 72mm, and an angle of view of 11°. It also has a built-in shade that pulls out for use. The original model has the five-element design that was continued over the entire production life of the 180mm manual focus lenses, including the later ED version. It is believed that this early version of the 180mm had a

front element of ED glass not announced by Nikon. This is possible, since it has the same quality as the ED version. I have yet to see a 180mm f/2.8 lens that is not tack sharp!

The **80-200mm f/4.5** is the zoom that set the mark for all zooms to come! It is very easily hand-held, with zooming and focusing just as easy. It has a length of 6.4 inches (16.3 cm), an aperture range from f/4.5 to f/32, meter coupling, a filter size of 52mm, an angle of view of 25° to 10°, and a weight of 29.3 oz. (831 g). It is a push-pull zoom, 200mm at the rear pushing out to 80mm. It is a true zoom, holding its focus while being zoomed (as long as the focus ring isn't moved when zooming). It maintains a constant f/stop at all focal lengths. The sharpness of the 80-200mm f/4.5, even wide open, is excellent for every version. It is not recommended with a teleconverter, the edges especially have a loss of sharpness. The original non-multicoated version was later replaced with a multicoated one. Both are beautifully sharp, the multicoated version rendering better color. The zooming action becomes looser with use, but can be tightened by a repairman.

In **1971** Nikon continued their line of "fast" wide-angles. They introduced only one lens this year. It was:

28mm f/2

The **28mm f/2** never achieved the fame of other fast wide-angles. As with the 35mm f/1.4 and 24mm f/2.8, the 28mm f/2 has the floating rear element (CRC) for superior sharpness even when focused at close distances. The 28mm f/2 was the second lens to be introduced originally with multicoating, giving the lens its great contrast and color rendition. It has a length of 2.7 inches (6.9 cm), an aperture range from f/2 to f/22, meter coupling, a filter size of 52mm, an angle of view of 74°, and a weight of 12.2 oz. (346 g). While popular at first, the 28mm f/2 never attained the reputation it deserves. An excellent lens, its ability to focus down to 1 foot (30.5 cm), shallow depth of field, and wide angle of coverage made it a natural for most PJs. But it never caught on with the general public. Originally it came with a metal focusing ring, which was replaced with a rubber one prior to the introduction of the AI version.

In **1972** Nikon introduced only one lens and it was to be the last new circular-image fisheye. It was:

6mm f/5.6 Fisheye

The **6mm f/5.6** is the pudgiest model of all the fisheyes. It has the same design as the 7.5mm, 8mm, and 10mm OP, with its rear element extending into the camera body. It differs from the others in that it has a coverage of 220° (but still uses the 160° finder) as opposed to 180°. It is a very short lens. It has a length of 1.7 inches (4.3 cm), an aperture range from f/5.6 to f/22, stop-down metering, an attachment size of 89mm (with built-in filters), an angle of view of 220°, and a weight of 15.2 oz. (431 g). It also employs the equidistant projection formula for even exposure over the entire 220° picture. This is one of the rarer lenses and is not found often on the used market. It delivers excellent quality. Its biggest drawback is its wide coverage with no way of viewing the final picture. The auxiliary finder is 60° less than the lens' angle of view, making accurate composition impossible.

The Ball Is Rolling

In the early 70s, Nikon began to release all their new lenses and update existing lenses with multicoating. How the multicoating is applied and the mineral elements used in these coatings are a trade secret. Nikon gave this process a new name: **Nikon Integrated Coating (NIC).** This means the coatings are part of the optical design. The coating(s) are integrated as part of the optical formula so that the lens is constructed as a whole unit, glass, grinding, and coatings combined. When a particular lens is designed, all air surfaces are examined and analyzed. A coating is chosen for each element. This can be the same for all elements or different, depending on the lens design.

The NIC system is very important for color photography. The major benefit in using Nikon lenses is that no matter which lens is in use, they all deliver the same color rendition of the scene. Being able to change lenses and maintain such standards is a mark of quality. All Nikkor lenses manufactured after this time have the NIC coatings, which have made many of the later "radical," otherwise impossible designs possible.

Three exciting lenses were added to the inventory in **1973** by Nikon, they were:

15mm f/5.6 Ultra-Wide
16mm f/3.5 Fisheye
400mm f/5.6

The **15mm f/5.6** is Nikon's first ultra-wide, with the widest angle of view (other than fisheyes) to be manufactured up to this date. It is a special lens packed with formula technology that makes it a

legend in lens design. It has a length of 2.7 inches (6.9 cm), an aperture range from f/5.6 to f/22, meter coupling, an angle of view of 110°, no filter attachment (it has a filter turret), and a weight of 19.8 oz. (561 g). This is a particularly sharp lens with its linear dimension the same as that of a 50mm lens. That means it has straight line rendition. Horizontal and vertical lines stay straight in relation to each other without curving or distorting.

The lens has been a favorite of many magazine photographers since its introduction. It can be used to photograph a subject in the foreground and maintain a focused background while preserving linear relationships. The lens uses a filter turret with L1A, Y48, O56, and R60 installed. These are in a ring that encompasses the entire lens. A lock must be depressed to turn the turret. One bothersome feature of the 15mm f/5.6 is the focusing ring. It is around the large portion of the lens barrel. Its narrow width makes it difficult to use. It can be slow and awkward to use, especially when working fast or wearing gloves. Because of the lens' angle of view, no shade can be attached, but there is a built-in, scalloped lens shade that provides some shading. The photographer's hand can be used for extra shading if the camera body has 100% viewing. This is the best method of eliminating flare, which is a problem with ultra-wides.

It has long been thought that the f/5.6 has fewer ghosting and flare problems than later versions of the 15mm. I've found that both lenses, with their 110° coverage, can flare just as easily from any light source, direct or indirect. Constantly looking for the "purple ghosts" is necessary when shooting with these lenses.

The **16mm f/3.5 Fisheye** is a wonderful lens! It has 170° full-frame coverage. This means that the lens provides picture coverage for the entire 24 mm x 36 mm image. It has a length of 2.5 inches (6.4 cm), an aperture range from f/3.5 to f/22, meter coupling, an angle of view of 170°, no filter threads, and a weight of 11.6 oz. (329 g). The 16mm f/3.5 accepts no front shade or filter, so a built-in, scalloped shade and a filter turret are incorporated. The filter turret is a new design, similar to the 15mm f/5.6's design. The filters in the turret are L1A, Y48, O56, and R60. It is not uncommon to find this lens fitted with filters other than those indicated. Many of these lens filters were modified by photographers for their particular needs. The most common modification is the installation of a color-correction filter for photographing interiors.

The **16mm f/3.5**, though full frame, distorts the image. It is a fisheye and curves horizontal and vertical lines, especially those at the edges of the frame and close to the lens. Tilt the lens slightly up or down and the horizon curves up or down. This can almost be neutralized for horizontal lines by running them through the center of the picture. This technique can be used to render figures almost normal-looking, thus making the 16mm f/3.5 excellent for photographs relating foreground to background.

The **400mm f/5.6** telephoto has outstanding optics! Handholdable for some, it is best when attached to a pistol grip or gunstock. It is not a small lens but is well balanced. It has a length of 10.5 inches (26.7 cm), an aperture range from f/5.6 to f/32, meter coupling, a filter size of 72mm, an angle of view of 5°, and a weight of 3.1 lbs. (1.4 kg). It has a built-in lens shade and a tripod collar with 360° rotation for vertical and horizontal shooting. The focus throw (the amount the lens barrel has to be turned to focus from infinity to the minimum focusing distance) of the 400mm f/5.6 is quite long. This can cause problems when photographing any sort of fast-moving subject going from near to far or vice versa.

A later version of the 400mm f/5.6 would be an ED model. It has a front element of ED glass and the distinctive gold band around the lens barrel. The original version was more than likely ED but lacked the gold band to acknowledge it. The 400mm f/5.6's correction of chromatic and other optical aberrations gives it outstandingly high resolution. It maintains excellent image contrast and sharpness even wide open, all of which are attributes of an ED lens. For those wanting an excellent telephoto but who are unable to pay the high price of new glass, finding this lens used is an excellent option.

The factory doors blew open in **1974** with the introduction of nine new lens designs. To date it was one of the widest spectrums of lenses to be introduced at one time. The lenses were:

18mm f/4
20mm f/4
28mm f/2.8
28mm f/4 PC
35mm f/2.8 PC
105mm f/4 Micro
28-45mm f/4.5
180-600mm f/8 ED
360-1200mm f/11 ED

The **18mm f/4** added to Nikon's growing collection of ultra-wides. It was good timing, since fisheyes were starting to lose their popularity, leaving a gap for the ultra-wides to fill. The lens has a length of

2.3 inches (5.8 cm), an aperture range from f/4 to f/22, meter coupling, a Series 9 (86mm) filter size (held in place by the HN-15 shade), an angle of view of 100°, and a weight of 11.1 oz. (315 g). An excellent lens, its principle drawback is its corners. They are not as tack sharp when the center is in focus (we're splitting hairs here). It lacks CRC for close-up work. It is able to focus down to only 11.8 inches (30.0 cm), which is a disappointment. It is a good lens for getting into the world of ultra-wides if found on the used market where it sells for a fraction of its original cost.

The **20mm f/4** was an entirely new design. It's much smaller than the f/3.5 version it replaced. It has a length of 1.9 inches (4.8 cm), an aperture range from f/4 to f/22, meter coupling, a filter size of 52mm, an angle of view of 94°, and a weight of 7.4 oz. (210 g). This compact wide-angle was very popular when first introduced because of its small size and relatively low price. Its sharpness seems about the same as that of the 20mm f/3.5, though some felt the lens lost more than just 1/3 stop in the update. The 20mm f/4 is excellent reversed, either on a bellows or attached to a 105mm lens.

The **28mm f/2.8** was an intermediate design. It falls between the fast and more expensive f/2 and the slower, less expensive f/3.5. This happy middle ground proved to be a popular design and was well received by most photographers. It has a length of 2.1 inches (5.3 cm), an aperture range from f/2.8 to f/22, meter coupling, a filter size of 52mm, an angle of view of 74°, and a weight of a scant 8.5 oz. (241 g). It can focus down to 11.8 inches (30.0 cm), but it does not employ CRC (the AIS version does), so the edges and corners are not as crisp as the center. Though not blisteringly sharp, the 28mm f/2.8 does render an excellent quality good enough for reproduction. Cosmetic changes were few throughout its entire production.

The **28mm f/4 PC** (Perspective Control) is a notable new lens design with a exciting "twist." The 28mm f/4 PC lens barrel actually shifts—the front element moving up to 11° away from the film axis. Rather than the camera being tilted, the camera can stay parallel to the subject while the lens is shifted to keep the subject in the picture. This minimizes distortion and convergence of parallel lines. The lens has a length of 2.7 inches (6.9 cm), an aperture range from f/4 to f/22, pre-set meter coupling, a filter size of 72mm, an angle of view of 74°, and a weight of 14.1 oz. (400 g). It can close focus to 11.8 inches (30.0 cm), making it wonderful for photographing miniatures.

Operating the 28 PC is quite simple. Set the camera up on a tripod, then focus on the subject. Next, tilt the camera body until the back of the camera (same as the film plane) is parallel to the subject. Using a level on the camera back assures proper alignment. If the subject is cut off within the frame, this is when the shift knob comes into play. Turn the shift knob on the lens. As it is turned, the subject starts to come back into alignment in the frame. Stop shifting when the subject is properly framed. The subject is now perceptively correct in relation to the film plane, and any keystoning has been eliminated.

Due to limitations of the 35mm film format, only 11° of correction is possible when the camera is vertical and 8° when horizontal. Shifting the lens 10° actually adds 10° to the angle of view, so the 28mm f/4 PC will have 84° coverage, making it equal to a 24mm lens. In addition to having these features, the lens is very sharp and is a real asset to any photographer desiring corrections of a large-format camera in a small package.

Note: If using the camera's meter, it is necessary to meter via stopped-down metering before shifting. After metering, set the pre-set ring at the desired f/stop, and open the manual diaphragm all the way so you can focus during shift correction. When it is time to take the picture, close the manual diaphragm down to the pre-set setting.

The **35mm f/2.8 PC** works on the exact same principle as the 28 PC. It has a length of 2.5 inches (6.4 cm), an aperture range from f/2.8 to f/32, pre-set aperture, a filter size of 52mm, an angle of view of 62°, and a weight of 9.8 oz. (278 g). When the lens is shifted, its angle of view increases to 74°. Its operation is the same as the 28 PC; refer to the section on this lens for instructions.

The **105mm f/4 Micro** is an excellent, all-purpose micro. It is the culmination of design work begun with the 55mm f/3.5 Micro and the 105mm f/4 Bellows lens. The 105mm f/4 Micro can focus 1:2 to infinity without a bellows or any other accessory. Handholdable, the 105mm f/4 is a medium-sized lens. It has a length of 4.1 inches (10.4 cm), an aperture range from f/4 to f/32, meter coupling, a filter size of 52mm, an angle of view of 23°, and a weight of 17.6 oz. (499 g). The 105mm f/4 has a built-in shade and, when focused out to 1:2, the lens is 6.7 inches (17.0 cm) long.

The 105mm f/4 has a greater subject-to-lens working distance than the 55mm f/3.5 when at 1:2, 9 inches (22.9 cm) compared to 3 inches (7.6 cm). Like the 55mm, it has color-coded depth of field and magnification scales on the barrel for normal application or

use with an extension tube. The extension tube PN-1 (2.1 inches, 52.5mm) is required to go to 1:1 magnification. With wear the focusing ring can loosen, causing slippage when working at a specific magnification ratio. To avoid the expense of a relube, the use of tape or a rubber band may sometimes solve this problem. This lens changed only once during its production, but it never became extremely popular.

The very nice **28-45mm f/4.5** was the first "wide-angle" zoom for Nikon. Though its range is short (not even 2x), its size and quality made it very popular. It has a length of 3.6 inches (9.1 cm), an aperture range from f/4.5 to f/22, meter coupling, a filter size of 72mm, an angle of view of 74° to 50°, and a weight of 15.5 oz. (439 g). This is a two-ring zoom, one ring for focusing, the other for zooming. The lens is quite sharp throughout its entire zoom range. It is a somewhat hard lens to find in today's used market, probably because it tends to be a "keeper."

A beautiful lens, the **180-600mm f/8 ED** has never been very common and remains hard to find, new or used. Hampered by its high cost and large size, it has regrettably not been used by many photographers. It is incredibly sharp! It has a length of 15.9 inches (40.4 cm), an aperture range from f/8 to f/32, meter coupling, a filter size of 95mm, an angle of view of 13° to 4°, and a weight of 7.6 lbs. (3.5 kg). The second and fourteenth elements are ED glass. In 1974, the f/8 speed was not a factor in its slow sales. But today with speed so important, it has kept this magnificent lens from common use.

The 180-600mm f/8 was the first lens to be released originally as ED. This lens marked the inauguration of a special, new optical glass invented and manufactured just by Nikon. **Extra-low Dispersion (ED) glass** revolutionized optical technology by combining glass and coating. Telephoto lenses (300mm and longer) were said not to have the same crisp snap to their images as did the shorter focal lengths. The ED glass brought the "snap" to telephotos for the first time.

What does ED glass do and why do we need it? The white light that our eyes perceive is made up of a spectrum of colors. White light is split by the lens elements on its journey through the barrel and is put back to its constituent colors as it hits the film plane. This is called dispersion. In optical design, one element compensates for the dispersion caused by another element as light passes through it. This is usually done for just blue and red (the high and low end of the spectrum). With shorter focal length lenses, dispersion is not a readily noticeable problem, and there is no need for correction.

With conventional lenses of 300mm or greater, element relationships cannot be arranged to correct for dispersion. When the red and green wavelengths of light are focused on the film plane, the blue band of light focuses past it. This results in a lack of critical sharpness. Some manufacturers have solved this problem by making lens elements from artificially grown calcium fluorite crystals. But lenses made from these crystals have the drawback that they are sensitive to heat and humidity, which can change the focus and/or sharpness of the lens.

ED glass, with its special make-up and coatings, bends all bands of white light so they focus at the same point on the film plane. This not only improves focus but also color rendition. Traditionally with non-ED telephotos, closing the lens' aperture was required to obtain the sharpness and color of the ED glass. But with the invention and introduction of ED glass to lenses, fast telephotos could be manufactured and shot wide open delivering blistering sharpness!

The actual formula for ED glass is a guarded secret, but it is a specially manufactured glass with coatings that make long lenses with fast maximum apertures possible. The ED glass is physically very hard, so it can be used as a front element. It is not sensitive to heat and humidity like calcium fluorite and can be used in severe environments with few problems. Lenses with ED glass have a gold band around the barrel to signify the ED glass, usually on or near the focusing ring. These lenses are expensive, but their quality is unparalleled!

The **360-1200mm f/11 ED** is a behemoth! It is the longest push-pull zoom in 35mm photography. It has a length of 27.7 inches (70.4 cm), an aperture range from f/11 to f/32, meter coupling, a filter size of 122mm, an angle of view of 6.5° to 2°, and a weight of 15.7 lbs. (7.1 kg). It is a monster lens, exceeded only by the 2000mm, at 38 lbs. (17.3 kg). It has ED glass (the second and fifteenth elements), which contributes both to the incredible image quality and to its high price tag (suggested list in 1984 was $7,800 when the yen and the dollar were getting along). It also has a special tripod collar design (cantilevered) for superior balance, accommodating vertical and horizontal framing. The lens has four handles for quick focus and zooming. A unique feature of this lens is that it can focus down to 20 feet (6.1 m)! That's an outstanding distance, making the lens a great tool. The total number of owners of this lens could probably fill a small room, but those privileged individuals have one hell of a lens, and they know it.

Nikon introduced only six new lenses in **1975**—only one really new design, the other five being revisions. They were:

300mm f/2.8 ED
300mm f/4.5 ED
400mm f/5.6 ED
600mm f/5.6 ED
800mm f/8 ED
1200mm f/11 ED

From its introduction, the **300mm f/2.8 ED** became one of the lenses most sought after by the photographic community. The speed of this lens came at a time when photographers were demanding faster lenses to better accommodate available-light photography as well as isolate a limited depth of field. It has a length of 9.9 inches (25.1 cm), an aperture range from f/2.8 to f/32, manual meter coupling, a filter size of 122mm, an angle of view of 8.1°, and a weight of 5.7 lbs. (2.6 kg). The weight of this lens is amazing considering it has only six elements! It has a built-in lens shade that pulls out and a tripod collar for vertical and horizontal shooting. The aperture is a pre-set design, which makes for very slow operation. It requires stop-down metering or the use of a handheld meter. With ED glass, the 300mm f/2.8 is tack sharp even with the aperture wide open, which makes it a standout for press photographers. This is one of Nikon's rarer lenses, seldom seen on the used market.

The **300mm f/4.5 ED** is an ED version of the 300mm f/4.5. The front element is ED glass, which adds 2 oz. (57 g) to the original version. In all other aspects, the 300mm f/4.5 ED has the same specs as those of the 300mm f/4.5 but a higher price tag. This lens was produced for just one year. Some can be found on the used market, but for the money the non-ED version is a better buy.

The **400mm f/5.6 ED** is the same as the 400mm f/5.6, released a year before, except it now has a front element of ED glass and a few minor cosmetic changes. If photographs from the two 400mm f/5.6s were to be compared, little difference would be found, which leads many to believe that it was an ED lens from the start. Nikon has never confirmed this conclusion, but both versions are outstanding whether marked with the gold band or not.

The **600mm f/5.6 ED, 800mm f/8 ED,** and **1200mm f/11 ED** have revised front elements from the earlier models. All three still need a focusing unit to work (either the CU-1 or AU-1) and still lack meter coupling, but they now have ED glass.

Excellent before ED glass, they are now really sweet! The elements changed little from the original versions. The 600 lost 0.2 lbs. (91 g), the 800mm f/8 gained 1.3 lbs. (590 g), and the 1200mm f/11 gained 1.4 lbs. (635 g). The 600mm f/5.6 ED and the 800mm f/8 ED have just five elements. The 1200mm f/11 ED has six elements, with two being combined into one group in the new versions. Although extremely rare, these lenses make an excellent introduction to telephoto photography.

A slow year in new lens design was **1976,** with only four models introduced. They were:

13mm f/5.6 Ultra-Wide
135mm f/2
TC-1
TC-2

The **13mm f/5.6 Ultra-Wide.** Only one word can describe it—INCREDIBLE! The widest of wide-angle lenses, it covers 118°! This is not a small lens. It has a length of 4 inches (10.2 cm), an aperture range from f/5.6 to f/22, a filter size of 39mm (rear bayonet mount), meter coupling, an angle of view of 118°, and a weight of 43.7 oz. (1,239 g). Like the 15mm f/5.6, the 13mm has a built-in scalloped lens shade (the photographer's hand still works great for additional shading as long as it doesn't show up in the photograph), a floating rear element design (CRC), a rectilinear element design for straight line rendition, and it can focus down to one foot. A new feature of the 13mm is that it accepts 39mm bayonet filters. Rather than the turret system, the lens has a rear bayonet mount. A filter must always be attached because it is part of the lens' optical formula. It still cannot be polarized, but now there are more filter choices for different needs. It can focus down to 11.8 inches (30.0 cm), and with its tremendous angle of view and depth of field it can deliver an entire world in focus. This is a lens that must be seen and experienced to be believed!

The **135mm f/2** is a magnificent lens that became instantly popular with PJs because of its focal length and speed. It has a length of 4.1 inches (10.4 cm), an aperture range from f/2 to f/22, meter coupling, a filter size of 72mm, an angle of view of 18°, and a weight of 30.3 oz. (859 g). Its clean and simple design delivers outstanding performance. Over the years of production it has not even changed cosmetically. Nikon did it right the very first time.

The TC-1 and TC-2 teleconverters are discussed with the TC-200 and TC-300 later in this chapter.

The Next Generation

In **1977** Nikon introduced a whole new metering system for all their lenses and bodies. **Automatic Indexing (AI)** would be on every lens and body released from this time forward. This makes for rapid lens changing while shooting (refer to the *Bodies* chapter for specifics). All the lenses in production in 1977 were changed to the AI system and received cosmetic updates as well.

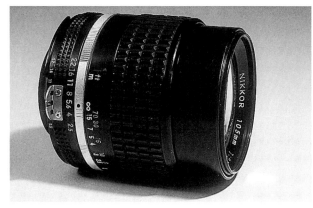

Nikkor 105mm f/2.5 AI

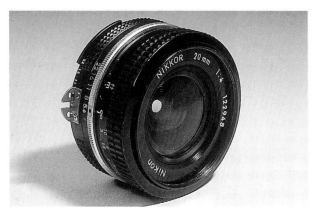

Nikkor 20mm f/4 AI

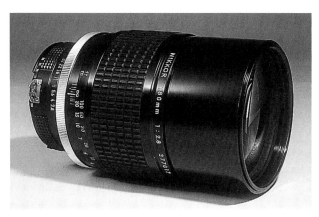

Nikkor 180mm f/2.8 AI

Some lenses' cosmetic changes were so slight that it is difficult to see the change. Others, such as the 135mm f/3.5, 135mm f/2.8, and 200mm f/4 changed radically, becoming much smaller and slimmer, in addition to losing their metal focusing ring. This smaller size made them attractive to users. All the lenses now had an all-black barrel, rubber focusing ring, and multicoated elements. Nikon was able to effect all this change without modifying the bayonet F mount. Also retained was the non-AI metering prong on the new AI lenses, affording owners of older bodies the use of the new optics while maintaining meter coupling. Lenses that had a fixed aperture or were pre-set in design remained the same since they are not capable of meter coupling.

The lenses still in production that became AI were:

6mm f/2.8 Fisheye
8mm f/2.8 Fisheye
13mm f/5.6 Ultra-Wide
15mm f/5.6 Ultra-Wide
18mm f/4
20mm f/4
24mm f/2.8
28mm f/2
28mm f/2.8

28mm f/3.5
35mm f/1.4
35mm f/2
35mm f/2.8
50mm f/1.4
50mm f/2
55mm f/3.5 Micro
105mm f/2.5
105mm f/4 Micro
135mm f/2
135mm f/2.8
135mm f/3.5
180mm f/2.8
200mm f/4
300mm f/4.5
400mm f/5.6 ED
43-86mm f/3.5
80-200mm f/4.5
50-300mm f/4.5
180-600mm f/8 ED
360-1200mm f/11 ED

These lenses, as well as the non-AI PC, Mirror, and Medical lenses, made up the entire lens line for Nikon in **1977**. In all the hoopla over the new meter coupling system, lenses were introduced that seemed to have been lost in the shuffle. They were:

85mm f/2
400mm f/3.5 EDIF
1000mm f/11
200-600mm f/9.5 ED
TC-200
TC-300

The **85mm f/2** never seemed to catch on with Nikon users. It was intended to fill the shoes of the discontinued 85mm f/1.8, which it couldn't do. It has a length of 2.4 inches (6.1 cm), an aperture range from f/2 to f/22, meter coupling, a filter size of 52mm, an angle of view of 28°, and a weight of 15.2 oz. (431 g). It came with a reversible shade, the HS-10, which mounts backwards for easy storing. The lens never changed in design or cosmetics during its production run. It is one of those Nikon lenses that no one would write home about.

The **400mm f/3.5 EDIF** was, at the time of its release, the fastest 400mm on the market. It was the first Nikon to be released with Internal Focusing (IF), which revolutionized telephoto lens design. It has a length of 10.4 inches (26.4 cm), an aperture range from f/3.5 to f/22, meter coupling, a front filter size of 122mm, an angle of view of 6.1°, and a weight of 5.7 lbs. (2.6 kg). The first and second elements are ED glass.

The 400mm f/3.5 EDIF has a built-in tripod collar with full 360° rotation as well as a built-in lens shade. The tripod collar has two lugs that accept a neck strap. This prevents the camera's lens flange from bearing the weight of the lens while being carried. The lens also has a filter drawer, accepting 39mm screw-in filters. These screw-in filters have a special mount, the glass actually being 37mm in diameter. A standard off-brand 39mm filter will not fit in this filter drawer because its mount does not taper to the correct proportions.

The Internal Focusing (IF) technology is an internal, mechanical focusing operation. Normal lens construction consists of a helicoid, a large, heavy, threaded assembly in which the elements are moved back and forth by the turning action of the focusing ring (like screwing a bolt into a nut). When focusing, the lens expands and contracts because of the helicoid. With an IF lens, the barrel does not expand or contract, as there is no helicoid. The elements move internally in relation to one another and the film plane. This means a smaller, quicker focusing lens that can actually focus closer than a non-IF lens. The 400mm f/3.5 EDIF is not small, but it is smaller than the 400mm f/4.5 lens. The IF design also permits it to focus 2 feet (0.6 m) closer than the older lens.

The EDIF lenses all have a unique feature in common, a focus pre-set. On a small ring just above the focusing ring is a silver locking knob. This is the focus pre-set, which works very simply. If photographing a baseball game and sitting behind home plate, focus can be pre-set on second base. This is performed by focusing on second base, turning the pre-set focus ring, and locking it into place. While photographing the game, the focus ring probably goes past the pre-set point a couple of times, the lens clicking past the spot. This is normal and will not affect the operation of the lens. When the steal happens at second base, turn the focusing ring until it clicks into place at the pre-set position. This enables a fast, tack-sharp capture of the play.

The **1000mm f/11** originally introduced in 1965 received a big remake, modernizing the cosmetics and sharpening the optics. It has a length of 9.5 inches (24.1 cm), an aperture of f/11, fixed meter coupling, a filter size of 39mm (screw-in), an angle of view of 2.3°, and a weight of 67.1 oz. (1,902 g). The filter turret is no longer present; the lens takes rear-mount 39mm screw-in filters instead. This makes the lens much sleeker. The shade is built in, pulling out into place for use, which is much more convenient than that on the original model. The lens also has a rapid focus handle that can be attached for quick focus. The tripod collar has a full 360° rotation for vertical and horizontal shooting. The sharpness is improved, delivering quality never before available in a mirror lens.

The **200-600mm f/9.5 ED** is an updated version of the earlier 200-600mm f/9.5, which was discontinued the previous year. The specs for the lens did not change, nor did its popularity grow. This lens is very rare; it is likely that few were manufactured.

The **TC-1** and **TC-200** were the first teleconverters ever produced by Nikon (after 19 years of SLR lens production). They both double the focal length (2x) of the lens as well as its effective f/stop. The TC-1 and TC-200 are the exact same teleconverter, the only difference is the meter coupling. The TC-1 couples with the non-AI system and the TC-200 couples with the AI system. Neither converter can be used on the other metering system. They are unable to mount on the lens because of the ridge needed to achieve metering coupling, which is specific to each system. They are small in size, at 1.8 inches (4.6 cm) long.

Note: When mounting the TC-1 to a metered body and a coupled lens, make sure the lens, converter, and body are all coupled together. It is not an automatic system. The coupling on the converter is spring-loaded at the junction with the lens, and can easily be uncoupled if bumped.

The front elements of the TC-1 and TC-200 are inset 15mm to accept the back of lenses with rear elements that protrude slightly. The optical formula of the converters is matched to that of the lens, so even illumination and sharpness are maintained when the proper converter and lens are combined. These converters do, however, suck up two stops of light. A lens with an f/stop of f/2 has an effective f/stop of f/4 when the converter is attached. The depth of field with the teleconverter attached, though, will be only 40% of that effective f/stop. The minimum focusing distance remains the same, but the image size is doubled.

The **TC-2** and **TC-300** complement the TC-1 and TC-200 as the 2x converters for longer lenses. As with the TC-1 and TC-200, the TC-2 meter couples with the non-AI system, and the TC-300 couples with the AI system. They are only 3.3 inches (8.4 cm) long. The TC-2 and TC-300's front element extends 23mm from the lens mounting flange where the converter and lens couple. These converters work on lenses whose rear element is set into the back (not flush with the back). The front element of the converter protudes into the lens when they are coupled. This delivers even illumination and sharpness. (A TC-200 connected to a 400mm lens, for example, vignettes in all four corners of the photograph because they are incorrectly matched and therefore cannot transmit light from the lens to the film plane.)

Nikon did not slack off after 1977's revisions. In **1978** eight new lenses came on the market. They were:

24mm f/2
50mm f/1.8
58mm f/1.2 Noct
300mm f/2.8 EDIF
400mm f/5.6 EDIF
600mm f/5.6 EDIF
35-70mm f/3.5
50-300mm f/4.5 ED

The **24mm f/2** is a perfect example of the increasing wave of "fast" lenses that were coming from manufacturers. Nikon was at the forefront in fast lens designs. The 24mm f/2 has a length of 2.4 inches (6.1 cm), an aperture range from f/2 to f/22, meter coupling, a filter size of 52mm, an angle of view of 84°, and a weight of 10.8 oz. (306 g). Its small size really lends itself to being handheld wide open in low light levels. It has the floating rear element design (CRC) for outstanding quality corner to corner, even when at its minimum focusing distance of 11.8 inches (30.0 cm). Not many know of or have experienced its excellence. This is probably due to its high price, which keeps many from owning it. The images of the 24mm f/2, though, have that magical Nikon snap!

The **50mm f/1.8** has had more design and cosmetic changes than any other Nikon lens. The original design had the look and feel of lenses of the day. It has a length of 1.8 inches (4.6 cm), an aperture range from f/1.8 to f/22, meter coupling, a filter size of 52mm, an angle of view of 46°, and a weight of 7.7 oz. (218 g). The original design was with an all-black barrel with a rubber focusing ring. When the AI model was introduced, it was slimmed down slightly. More is written about the 50mm f/1.8 and its various manifestations later on.

The **58mm f/1.2 Noct**—the name alone makes most photographers' mouths water. Its reputation for outstanding optics has made it a demigod. It has a length of 2.5 inches (6.4 cm), an aperture range from f/1.2 to f/16, meter coupling, a filter size of 52mm, an angle of view of 40.5°, and a weight of 17.1 oz. (485 g). The 58mm Noct has that famous aspherical lens surface and front element for producing outstanding results at f/1.2. (Its aspherical element was designed specifically to reduce coma or flare from bright pinpoint light sources against a dark background.) This is true even when shooting in darkness with point light sources in the scene. Are there many of these in use? Those I know of are used in the movie and theater industry. It is a highly specialized lens introduced in the days of slow ISO films. I can tell you that viewing through this very bright lens is an awesome experience!

The **300mm f/2.8 EDIF** is one of the most desired lenses Nikon has ever produced. Its remarkable sharpness crosses all disciplines of photography making it one of the most widely used lenses! This incredibly bright, sharp, and outstanding lens lends itself to nearly every photographic situation. It has a length of 9.8 inches (24.9 cm), an aperture range from f/2.8 to f/22, meter coupling, a front filter size of 122mm and a 39mm filter drawer, an angle of view of 8.1°, and a weight of 5.8 lbs. (2.6 kg). Only the front two elements are ED glass. Even shot wide open, the 300mm f/2.8 is tack sharp corner to corner!

The 300mm f/2.8 has the advantage of ED glass as well as IF for quick focusing. Its minimum focusing distance is 13 feet (4 m). It has a 360° tripod collar and a built-in lens shade. The f/2.8 is very conducive to working in low light without flash. Seen at every press conference, football game, court case, wildlife expedition, and every major event of our day, it owes its popularity to its ability to isolate the subject effectively. At f/2.8, the depth of field of the 300mm f/2.8 is so shallow that the football player on the field pops right out from the crowd. Fashion photographers utilize the depth of field and angle of view, because it enables them to selectively use only those background elements they want. Wildlife photographers like it because it faithfully renders the proportions of big game while still giving them some physical distance for safety. This is truly a lens for all seasons!

The **400mm f/5.6 EDIF** is a magnificent lens that's more than just an IF version of the earlier 400mm f/5.6. It is an amazingly sharp lens when used wide open. It has a length of 10.2 inches (25.9 cm), an aperture range from f/5.6 to f/32, meter coupling, a filter size of 72mm, an angle of view of 6.1°, and a weight of 42.3 oz. (1,199 g). The second element is the only ED glass element. This is a very handholdable lens, especially when used with a pistol grip or gunstock. Because of this small lens' light weight and remarkable balance, using it on a gunstock enables a photographer to work easily with shutter speeds as low as 1/30 second. This lens never received due credit from photographers because of its speed. The photographers who do own and use this lens know that it is one of Nikon's silent sleepers.

The **600mm f/5.6 EDIF** is designed with all the characteristic attributes of EDIF lenses. This is another "sleeper," ignored by most photographers because of its "slow" aperture. It has a length of 31.8 inches (80.8 cm), an aperture range from f/5.6 to f/22, meter coupling, a front filter size of 122mm and a 39mm filter drawer, an angle of view of 4.1°, and a weight of 5.3 lbs. (2.4 kg). The first and second elements are ED glass. The 600mm f/5.6 EDIF is an extremely sharp lens even wide open, and it focuses to 18 feet (5.5 m). For the photographer who wants to own an excellent telephoto for little money, this is a really good buy. There are many on the used market that can be purchased at a reasonable price compared to the price of a new lens.

The **35-70mm f/3.5** is a zoom intended for photojournalists, proving itself to be a vital tool in their work. It has a length of 4 inches (10.2 cm), an aperture range from f/3.5 to f/22, meter coupling, a filter size of 72mm, an angle of view of 62° to 34°, and a weight of 19.4 oz. (550 g). The 35-70mm f/3.5 is a two-ring zoom, one for focusing and one for zooming. It is a true zoom, so once focused, zooming does not change the focus. It has good corner-to-corner image quality but never really attained great popularity.

The **50-300mm f/4.5 ED** is more than an ED version of the 50-300mm f/4.5. It is a redesign, a smaller, sharper lens than its predecessor (the second element is ED glass). It lost only 2 oz. (57 g) in weight but lost 1.8 inches (4.6 cm) in length. It is still not suitable for handholding. All other specs are the same. The ED version received greater respect and acceptance from photographers. Finding a used ED version can be difficult, a testament to its popularity.

Nikon still did not slow down in lens design, coming out with ten new lenses in **1979.** They were:

16mm f/2.8 Fisheye
20mm f/3.5
50mm f/1.2
300mm f/4.5 EDIF
600mm f/4 EDIF
800mm f/8 EDIF
TC-14
35mm f/2.5 E
50mm f/1.8 E
100mm f/2.8 E

The **16mm f/2.8 Fisheye** is a completely new lens, not just a revision of the 16mm f/3.5. There are a number of changes between the two lenses, making the 16mm f/2.8 the better choice. It has a length of 2.6 inches (6.6 cm), an aperture range from f/2.8 to f/22, meter coupling, a filter size of 39mm (rear bayonet), an angle of view of 180°, and a weight of 11.6 oz. (329 g). The specs tell the story on the changes. The 16mm f/2.8 is a half-stop faster, has 180° coverage (compared to the 170° of the 16mm f/3.5), and accepts 39mm bayonet filters instead of having a filter turret. The lens is supplied with four filters in a CA-2 case when purchased new. These mount on the rear of the lens (one must be in place). It is still a full-frame fisheye with all the same characteristics of the 16mm f/3.5.

The **20mm f/3.5** is a completely new lens, not just a redesign of the 20mm f/4 (which was a redesign of the 20mm f/3.5, 72mm version). There are 11 elements in the 20mm f/3.5, whereas there are only 10 in the 20mm f/4. Even with this extra glass, the lens is 1/3 stop faster. It has a length of 2 inches (5.1 cm), an aperture range from f/3.5 to f/22, meter coupling, a filter size of 52mm, an angle of view of 94°, and a

weight of 8.3 oz. (235 g). This 20mm f/3.5 is considerably smaller than the original 20mm f/3.5 and is the sharpest 20mm yet. Unlike many of the other wide-angles, it lacks the advantage of CRC. Though it focuses to one foot (0.3 m), the corners are not quite as sharp as the center by a split hair.

The **50mm f/1.2** is a new lens design. It has always had loyal supporters, but has never been a big seller. It has a length of 2.3 inches (5.8 cm), an aperture range from f/1.2 to f/16, meter coupling, a filter size of 52mm, an angle of view of 46°, and a weight of 13.4 oz. (380 g). It is a sharp lens but lacks the snap, crackle, or pop of the 58mm f/1.2 Noct. The Noct design is superior because of its aspherical element, which eliminates flare. The price difference between the lenses (at least $1,000) usually persuades most to go with the 50mm f/1.2.

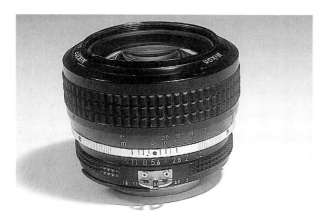

Nikkor 50mm f/1.2 AI

The **300mm f/4.5 EDIF** was an entirely new design utilizing ED glass and IF focusing. Long after its release and even after its discontinuation, this lens is outrageously popular! It has one more element then the conventional 300mm f/4.5, but weighs less. It has a length of 7.9 inches (20.0 cm), an aperture range from f/4.5 to f/32, meter coupling, a filter size of 72mm, an angle of view of 8.1°, and a weight of 2.3 lbs. (1 kg). The 7 oz. (198 g) weight loss and the much slimmer lens barrel are a direct result of the internal focusing design. By removing the helicoid unit for focusing, Nikon achieved a smaller lens. This is also a sharper lens and focuses 3 feet (1 m) closer. The second element is the only ED glass in the lens. This lens is easily handholdable. And for wildlife photographers, it is an outstanding, versatile photographic tool.

The **600mm f/4 EDIF,** simply put, is magnificent! It is probably the only lens Nikon has ever come out with that was never in stock because of its constant demand. Still the fastest 600mm lens produced by any manufacturer, its massive size has not decreased its popularity. It has a length of 18.1 inches (46.0 cm), an aperture range from f/4 to f/22, meter coupling, a front filter size of 160mm with a 39mm screw-type filter drawer, an angle of view of 4.1°, and a weight of 12.4 lbs. (5.6 kg)! The first and second elements are ED glass.

This remarkable lens provides extremely bright viewing. Considering its size, it is well balanced for tripod use (it is not handholdable) and focuses down to 26 feet (8 m)! It has a built-in lens shade that screws to lock into place for use or storage. It comes with a large tripod collar that has three separate sockets for screwing it to a tripod. The size of the front element is so large that no metal or plastic front cap is available. It comes with a leather slip-on cap. It originally came with the TC-14, another new lens released that year. The TC-14 converts the 600mm f/4 into a 840mm f/5.6 lens that still focuses to 26 feet (8 m). Its optics are so outstanding even with the converter attached that there is no loss of image quality.

The **800mm f/8 EDIF** is an outstanding sleeper that slipped by nearly everyone! It never caught on with photographers, probably because of its slow f/8 speed. Considering its power, it is a small package. It has a length of 18 inches (45.7 cm), an aperture range from f/8 to f/32, meter coupling, a front filter size of 122mm and a 39mm filter drawer, an angle of view of 3°, and a weight of 9.4 lbs. (4.3 kg). The first and second elements are ED glass. The 800mm is a long, skinny lens with only the front few inches being 122mm in diameter, so it is very well balanced. It is dark for viewing, but still manageable in low light. These lenses can be bought on the used market for relatively little money, making them an incredible buy. They are hard to find, though, because few were bought originally, and those who own them don't give them up.

The **TC-14** is a 1.4x teleconverter of outstanding quality! As mentioned earlier, it was originally released with the 600mm f/4. The TC-14 has a length of 1.9 inches (4.8 cm), a magnification of 1.4x, a one-stop light loss, a weight of 4 oz. (113 g), and meter coupling is maintained. The TC-14 can be used on lenses other than the 600mm f/4, and because of popular demand, Nikon released it as a separate unit. The TC-14 works on the same lenses as the TC-300. Its front element protrudes out, so it can be mounted only to lenses whose rear element is inset. When attached to a lens, it causes no reduction in quality, which is why it is in such great demand.

Also in 1979, Nikon came out with their **Series E** lenses, which were kind of an experiment by Nikon. They were testing the waters of the consumer market. The main differences between Nikon E lenses and standard Nikon F lenses were in the way they were manufactured. Rather than being hand-assembled like the standard Nikon F lenses, the Series E lenses were assembled by machine. This means that some assembly points were glued instead of screwed together, and more plastics were used in the barrel design to facilitate the process. Internal parts, such as the helicoid, were also made with lesser materials than those of the prime Nikon F lens. The optics, though, are still prime Nikon glass, with most lens designs having NIC coatings.

Series E lenses are AI meter coupled but do not come with the non-AI coupling prong. They will not meter couple with older bodies. However, the non-AI coupling can be retrofitted to the lens by some repair facilities at a nominal price. The E series came on the market about the same time as the EM body. It was an attempt to entice a mass-market audience to the Nikon system by offering lower priced equipment.

The **35mm f/2.5 Series E,** being very small in size, is typical of Series E design. It has a length of 1.5 inches (3.8 cm), an aperture range from f/2.5 to f/22, meter coupling, a filter size of 52mm, an angle of view of 62°, and a weight of 4.4 oz. (125 g). Optically this is a good lens, but ironically, it did not sell well until it was discontinued.

The **50mm f/1.8 Series E** turned out to be a big hit with no one, filling most "used-equipment" cases instantly. It has a length of 1.3 inches (3.3 cm), an aperture range from f/1.8 to f/22, meter coupling, a filter size of 52mm, an angle of view of 46°, and a weight of 4.4 oz. (125 g). This is probably one lens design that is better left unmentioned.

The **100mm f/2.8 Series E** was one of the best of the E-series line. It is very sharp and comes in a nice, compact package. It has a length of 2.1 inches (5.3 cm), an aperture range from f/2.5 to f/22, meter coupling, a filter size of 52mm, an angle of view of 24.2°, and a weight of 6 oz. (170 g). Though the entire barrel and focusing ring are plastic and have a very different feel to them than a normal Nikon F lens, they sold extremely well and are still quite popular.

In **1980** Nikon introduced five new lens designs. Three were Nikon F lenses, and two were Series E lenses that were to become the favorites of the series. They were:

15mm f/3.5 Ultra-Wide
200mm f/2 EDIF

25-50mm f/4
28mm f/2.8 E
75-150mm f/3.5 E

The **15mm f/3.5** is more than just a revision of the 15mm f/5.6! It is the most sought-after ultra-wide because of its amazing angle of coverage, straight line rendition, and outstanding sharpness. It is easy to handhold because of its relatively compact size. It has a length of 3.5 inches (8.9 cm), an aperture range from f/3.5 to f/22, meter coupling, no front filter mount (39mm bayonet in rear), an angle of view of 110°, and a weight of 22.2 oz. (629 g). It does have the same scalloped lens shade design as the 15mm f/5.6, but that is the only feature common between the two.

The biggest improvement of the 15mm f/3.5 is in the focusing ring, which is at the rear of the lens. This makes it smaller in diameter and wider for holding, which makes the lens much easier to focus. The 15mm f/3.5 uses 39mm bayonet filters at the rear of the lens (one must be in place) and does not accept front filters, which means that it cannot be polarized. The 15mm f/3.5 is standard equipment for thousands of photographers, keeping Nikon very busy trying to meet the demand. Since this lens was introduced, many have said that it flares more than the f/5.6, but both lenses actually flare to the same degree because of their wide degree of coverage. Using these lenses on cameras with 100% viewing is a must, insuring that UFOs (Unidentified Flaring Objects) will not be in the picture. This also facilitates the use of the photographer's hand to block out any flare.

The **200mm f/2 EDIF** is a beautiful lens, but it just never caught on with photographers. It has a length of 8.7 inches (22.1 cm), an aperture range from f/2 to f/22, meter coupling, a filter size of 122mm, an angle of view of 12.2°, and a weight of 3.8 lbs. (1.7 kg)! The first and second elements are ED glass. It has a built-in shade that is the same style as other long lenses but has no 39mm filter drawer. It has a tripod collar with full 360° rotation for vertical and horizontal shooting. With a TC-14, it makes a really excellent 280mm f/2.8! Even with its incredible sharpness, its size kept the 200mm f/2 from wide use. The 180mm f/2.8, which is extremely close in focal length and f/stop, is much smaller in size, contributing to the cool reception given the 200mm f/2.

The **25-50mm f/4** is an extremely sharp lens that attained popularity only after being discontinued. It has a length of 4.4 inches (11.2 cm), an aperture range from f/4 to f/22, meter coupling, a filter size of 72mm, an angle of view of 74° to 46°, and a weight

of 21.2 oz. (601 g). Its price when introduced was quite high compared to other lenses (as in, way up there). This prevented many from purchasing it. Those few who own the lens rave about its sharpness throughout its entire zoom range, but even this acclaim did not help initial sales. In 1982, the 25-50mm f/4 was closed out by Nikon at half the original price. It was not until then that the majority of photographers got to experience its qualities. Since that time, it has been hard to find because of its popularity and reputation.

The **28mm f/2.8 Series E** is one of the better designs and is still popular today. It has a length of 1.6 inches (4.1 cm), an aperture range from f/2.8 to f/22, meter coupling, a filter size of 52mm, an angle of view of 74°, and a weight of 5.3 oz. (150 g). It has the all-plastic barrel and focus ring common to the E series.

The **75-150mm f/3.5 Series E** was so popular that many wanted it to be redesigned as a Nikon F lens! This is an E-series lens that was to attain a mythical stature. It has a length of 4.9 inches (12.4 cm), an aperture range from f/3.5 to f/32, meter coupling, a filter size of 52mm, an angle of view of 31.4° to 17°, and a weight of 18.3 oz. (519 g). For a time, this lens was "the" lens in New York for fashion work, especially in the studio. It has a macro mode at the 150mm setting, providing 1:5 magnification. The first version has an all-black barrel and black lens attaching ring. This was not as strong mechanically as the second and final version, which was fitted with a chrome attaching ring. The box the lens came in had a green dot on the end to signify that it was the newer model. The 75-150 is still sought after and in wide use. It's that good!

Only four new lenses were introduced in **1981,** three being very specialized and exciting additions. They were:

28mm f/3.5 PC
120mm f/4 Medical
200mm f/4 Micro IF
135mm f/2.8 E

The **28mm f/3.5 PC** differs little from the 28mm f/4 PC, having the same angle of coverage and sharpness, but with a slight increase of coverage power when shifted. It has a length of 2.7 inches (6.9 cm), an aperture range from f/3.5 to f/22, pre-set meter coupling, a filter size of 72mm, an angle of view of 74°, and a weight of 13.4 oz. (380 g). The assembly and knob for the shifting movement have been improved and strengthened over those of the 28mm f/4

PC. Some other cosmetic changes reduced the weight. The aperture is still pre-set, working as all other pre-set lenses. Thus it is not good for general shooting, but is an excellent lens.

The **120mm f/4 Medical** is a rare lens even though it is still in production. Few photographers have the job requirements to justify owning this extremely specialized lens. It has a length of 5.9 inches (15.0 cm), an aperture range from f/4 to f/32, a filter size of 49mm, an angle of view of 18.5°, a weight of 31.4 oz. (890 g), and it is not meter coupled. The 120 Medical has a built-in ring-light providing approximately 60W of power and a focusing lamp circling the front element.

Power is provided by either an AC unit (**LA-2**) or DC unit (**LD-2**). The lens is capable of focusing 1:11 to 1:1 and with an additional close-up lens can reach 0.8x to 2x magnification. It is not capable of focusing to infinity because it is designed specifically for close-up photography. It does have IF focusing for easy operation but is not capable of TTL flash connections (a real drawback). For calculating flash exposure, it employs an automatic guide number system like the 45mm GN. It can imprint data (optional) at the time the photograph is made, imprinting information of the magnification in use. It is an extremely sharp lens with an extremely flat field, but it is dated by the lack of TTL technology. Better alternatives for close-up photography requiring a flash for lighting are now available.

The **200mm f/4 Micro IF** is a sleeper—a great lens many photographers have not had the opportunity to try. It is extremely sharp! With IF focusing it can focus from infinity to one-half life size (1:2) by itself and down to life size 1:1 with the TC-301 (the TC-201 also works). It has a length of 7.1 inches (18.0 cm), an aperture range from f/4 to f/32, meter coupling, a filter size of 52mm, an angle of view of 12.2°, and a weight of 28.3 oz. (802 g). It also has a tripod collar with 360° rotation, which is removable for handholding. When focused down to 1:2, the 200mm has a working distance of 20 inches (50.8 cm), which is excellent for introducing extra light with flash, reflectors, etc. The TC-14 is excellent with the 200 Micro, maintaining its flat-field quality. This makes the 200mm a 280mm f/5.6 that can focus to 1:9! When used for general photography, it is a straight 200mm lens that can be used like any other 200mm. Its quality is comparable to that of the 180mm f/2.8, but it lacks the fast f/stop.

A new addition to the E series, the **135mm f/2.8 Series E** was a popular lens with a well-earned reputation for quality. It has the nicer rubber focusing

ring, a built-in shade, and a compact size. It has a length of 3.5 inches (8.9 cm), an aperture range from f/2.8 to f/32, meter coupling, a filter size of 52mm, an angle of view of 18°, and a weight of 14.8 oz. (420 g). This is one of the few Series E lenses that became popular and remained so, making it hard to find. It is a good lens for anyone, but especially those starting out on a tight budget.

Jumping Out Ahead

By **1982** Nikon had modernized and updated the meter coupling system again, modifying the AI system to become AIS. The **AIS (Automatic Indexing-Shutter)** lenses have a small scoop removed from the mounting flange. This allows camera bodies to detect the focal length of the lens in use, providing information for Program and Shutter-Priority modes. All lenses that were in production at the time were converted to the AIS system. All new lenses introduced after this time had AIS coupling. Lenses that are not AIS cannot be converted to AIS.

To determine if a lens is AIS, look at the aperture ring. The minimum aperture number (the largest number) on *both* the ADR (Aperture Direct Readout) list and the main aperture number list will be bright orange. If the largest number is orange only on the main aperture list and not on the ADR, then chances are it is not an AIS lens. Early E-series lenses, which have a groove cut out of the back of the lens mounting ring, do not have the orange f/stop but are AIS. However, the groove cut out of the back of the lens' mounting ring alone does not necessarily mean a lens is AIS.

Lenses (not including E-series) that were retrofitted to AIS were:

6mm f/2.8 Fisheye
8mm f/2.8 Fisheye
13mm f/5.6
15mm f/3.5
20mm f/3.5
24mm f/2
24mm f/2.8
28mm f/2
28mm f/2.8
28mm f/3.5
35mm f/1.4
35mm f/2
35mm f/2.8
50mm f/1.2
50mm f/1.4

50mm f/1.8
58mm f/1.2 Noct
85mm f/2
105mm f/4 Micro
135mm f/2
135mm f/3.5
200mm f/2 EDIF
200mm f/4 Micro IF
300mm f/2.8 EDIF
300mm f/4.5
300mm f/4.5 EDIF
400mm f/3.5 EDIF
400mm f/5.6 EDIF
600mm f/4 EDIF
800mm f/8 EDIF
25-50mm f/4
50-300mm f/4.5 ED
180-600mm f/8 ED

With the AIS update, some lenses were discontinued from the line. Others received cosmetic and physical design changes. One change that runs true for all the redesigned lenses is the slimming down of the lens barrel diameter, the same basic change that was made when the lenses became AI. This was especially true for the 200mm f/4 and 300mm f/4.5, both of which were substantially reduced in size.

The wide-angles lost (or gained, however you want to look at it) the amount of throw required to focus the lens from infinity to its minimum focusing distance. For example, the AI version of the 24mm f/2.8 had a throw of 180°, but the AIS version had a throw of only 90°. This makes the lens much faster to focus and more responsive to the photographer. The 200mm f/4 Micro and 400mm f/5.6 EDIF received wider tripod collars and narrower aperture rings. (The AI versions of these lenses have wide aperture rings and narrower tripod collars. This makes using them much easier for folks with large hands or wearing gloves.) Many prefer the AI versions of these lenses for this reason.

Nikon did not stop there, adding nine more lenses to the line in **1982.** They were:

18mm f/3.5
55mm f/2.8 Micro
85mm f/1.4
105mm f/1.8
180mm f/2.8 ED
1200mm f/11 EDIF
80-200mm f/4
36-72mm f/3.5E
70-210mm f/4E

The **18mm f/3.5** is a magnificent lens! It is a completely new design, having only the focal length in common with the older 18mm f/4. It has a length of 2.9 inches (7.4 cm), an aperture range from f/3.5 to f/22, meter coupling, a filter size of 72mm, an angle of view of 100°, and a weight of 12.3 oz. (349 g). Two really nice features of the 18mm f/3.5 are its ability to focus down to 9.8 inches (24.9 cm) and the presence of CRC, which was missing in the 18mm f/4. This compact wide-angle is the favorite of many who want to get into ultra-wides at a budget price; it is one really sharp lens, corner to corner!

"The **55mm f/2.8,** the best of the 55 micros to date!" This claim has been the subject of many conversations since the lens was introduced. But shooting with the lens quickly illustrates the point— so much so that it is still in wide use today. It has a length of 2.8 inches (7.1 cm), an aperture range from f/2.8 to f/32, meter coupling, a filter size of 52mm, an angle of view of 43°, and a weight of 10.2 oz. (289 g). The 55mm f/2.8 focuses 1:2 to infinity, needing the PK-13 extension tube to go to 1:1. The element design has been modified, but retains the deeply inset front element. Whether used for general-purpose photography or macro work, the 55mm f/2.8 was a hit from day one and remains so today, despite its discontinuation.

Nikkor 55mm f/2.8 Micro AIS

The **85mm f/1.4**—it was "the" lens to own! This stubby powerhouse of optics is incredibly sharp. It is the lens with the huge, beautiful, sparkling front element! It has a length of 2.9 inches (7.4 cm), an aperture range from f/1.4 to f/16, meter coupling, a filter size of 72mm, an angle of view of 28.3°, and a weight of 21.9 oz. (621 g). Considered by most as the focal length of natural perspective, the exceptionally fast f/1.4 makes it a natural for PJs. It can be shot wide

open at f/1.4 and maintain its edge-to-edge, corner-to-corner performance like no other lens. This is because it is the first telephoto to employ CRC. Close Range Correction insures that no matter how close or far away the subject is, when using the lens at f/1.4 and employing selective focus the subject is tack sharp! If used with the TC-14A or TC-201 at f/11 and a fast shutter speed, uneven exposure is possible.

The **105mm f/1.8** is another "sleeper" lens that was overshadowed by the 85mm f/1.4. It is a tad bigger than the 85mm f/1.4. It has a length of 3.5 inches (8.9 cm), an aperture range from f/1.8 to f/22, meter coupling, a filter size of 62mm, an angle of view of 23.2°, and a weight of 20.5 oz. (581 g). It is very sharp corner to corner, but attains this quality without CRC. It never has caught on with photographers and is not widely owned.

The **180mm f/2.8 ED** is a remake of the earlier 180mm f/2.8 with the exception of the acknowledged ED glass front element and ED gold band around the barrel. The dimensions of the 180mm f/2.8 ED are the same as those of the original 180mm f/2.8. For the money, the original 180mm f/2.8 is just as good (it probably had ED glass) and is a better buy.

The **1200mm f/11 EDIF** is a beautiful lens that has been overlooked by the photographic community. It has a length of 22.7 inches (57.7 cm), an aperture range from f/11 to f/32, meter coupling, a filter size of 122mm (39mm filter drawer), an angle of view of 2°, and a weight of 8.1 lbs. (3.7 kg). The first and second elements are ED glass. Except for the front element assembly (5 inches [12.7 cm] long), which is 122mm in diameter, the remainder of the lens is just a long tube 70mm in diameter. It has a built-in shade and tripod collar with 360° rotation for vertical and horizontal shooting. Its slow f/stop discourages most photographers from taking it seriously. This is a great loss. There is one photographer who has become quite famous through the use of this lens, to which he credits much of his success. It only focuses down to 45 feet (13.7 m), but this can be easily cut to 30 feet (9.1 m) with an extension tube without causing loss in quality or light.

The **80-200mm f/4**—a mistake? The 80-200mm f/4.5 (with its demigod status) had been off the market for only a year when the 80-200mm f/4 was introduced. But no matter how long it had been off the market, the ghost of the 80-200mm f/4.5 would haunt the f/4. The gain of 0.5 f/stop in speed increased the size of the 80-200mm f/4 considerably. It has a length of 6.4 inches (16.3 cm), an aperture range from f/4 to f/32, meter coupling, a filter size of 62mm, an angle of view of 30.1° to 12.2°, and a weight of 28.6 oz.

(811 g). The 80-200mm f/4 never caught on with photographers. It is not that the 80-200mm f/4 is not sharp (though not as sharp as the f/4.5 by a split hair), but it is physically large. The 62mm front element size especially stopped many from even trying it. Today the 80-200mm f/4.5 still outsells the 80-200mm f/4, which says a lot for the quality of the f/4.5.

Nikkor 80-200mm f/4

The **36-72mm f/3.5 Series E** is a nice, compact zoom. It has a length of 2.8 inches (7.1 cm), an aperture range from f/3.5 to f/22, meter coupling, a filter size of 52mm, an angle of view of 62° to 33.3°, and a weight of 13.4 oz. (380 g). Though a popular lens, it is not sharp throughout its zoom range, and the corners are not as sharp as the center. For other than critical use, it is an excellent lens.

The **70-210mm f/4 Series E** falls into the same category as the 36-72 E in terms of quality but was never as popular. It has a length of 6.1 inches (15.5 cm), an aperture range from f/4 to f/32, meter coupling, a filter size of 62mm, an angle of view of 34.2° to 11.5°, and a weight of 25.7 oz. (729 g). It has a macro mode at the 70mm setting that allows 1:6 magnification.

Hint of a New Era

A new look in lens design was introduced in **1983,** with two of the four lenses offering autofocus. They were:

50mm f/1.8N
80mm f/2.8 AF
200mm f/3.5 EDIF AF
80-200mm f/2.8 ED

The **50mm f/1.8N** is a new look for the 50mm f/1.8, taking on the appearance and size of the 50mm f/1.8 E. It has a length of 1.4 inches (3.6 cm), an aperture range from f/1.8 to f/22, meter coupling, a filter size of 52mm, an angle of view of 46°, and a weight of 5.1 oz. (145 g). It went through three cosmetic changes before this final version, refining its cosmetic appearance and controls. Optically this is the best of the 50mm f/1.8 designs, but its small size, feel, and look were not well received by buyers. Several changes were implemented to correct these faults, leaving the optics the same. All of these models have a minimum focusing distance of 2 feet (0.6 m). A version of the 50mm f/1.8N made for the Japanese market focused to 1.5 feet (0.5 m) and is called the 50mm f/1.8 "S."

Nikkor 50mm f/1.8 S

The **80mm f/2.8 AF** is one of two special autofocus lenses designed to work with the F3 AF body. It is capable of working either autofocus or manually when attached to the F3 AF. On all other Nikon bodies it works manually. It has a length of 2.5 inches (6.4 cm), an aperture range from f/2.8 to f/32, meter coupling, a filter size of 52mm, an angle of view of 30.2°, and a weight of 13.4 oz. (380 g). The autofocus motor is built into the lens (this is interesting knowing what's to come). The finder on the F3 AF connects to the lens electronically, telling it which way to turn for correct focus. It is incredibly sharp! Like all Nikon lenses, it has a metal barrel and a wide focusing ring. The F3 AF did not do well, and the lenses for the camera were to share the same fate for a while. The quality of these lenses, however, soon made them very popular for strictly manual use and today they are hard to find on the used market.

The **200mm f/3.5 EDIF AF** is the second lens introduced with the F3 AF. It is an absolutely incredible

lens, redefining the meaning of sharp! It has a length of 5.9 inches (15.0 cm), an aperture range from f/3.5 to f/32, meter coupling, a filter size of 62mm, an angle of view of 12.2°, and a weight of 30.6 oz. (868 g). Like the 80mm f/2.8 AF, the 200mm f/3.5 AF works either autofocus or manual focus. The 200mm f/3.5 has ED glass (the first and second elements are ED glass) and IF focusing, which makes it an outstanding lens.

Both the 200mm f/3.5 and the 80mm f/2.8 receive the power as well as information needed for autofocus from the camera body. These lenses are scarce on the used-lens market and are a great buy for the price. If a fast aperture is not required, no better optics are available. (It should be noted that the motor that drives this lens is built into the lens. Long before the AF-I came on the market, Nikon had solved the problem of incorporating the motor into the lens. This was a feat that many thought would force Nikon to change their lens mounting system (something that never came to pass). The focusing speeds of these lenses do not match up with the speeds of current AF lenses.

The **80-200mm f/2.8 ED** is a massive lens for its focal length. It has a length of 9.2 inches (23.4 cm), an aperture range from f/2.8 to f/32, meter coupling, a filter size of 95mm, an angle of view of 30.1° to 12.2°, and a weight of 4.3 lbs. (2 kg). It is a sharp lens (the second and third elements being ED glass), but its size makes handholding difficult at best. It has a built-in tripod collar with a full 360° of rotation. The zoom-focus ring has a lock that enables the entire ring to be locked into place. For long exposures or for photographing a subject over a long period of time during which the focus needs to be maintained, the lock prevents the weight of the zoom from changing the focus. This lens was on the market for a relatively short period. It became popular again briefly when the AF version was introduced. This was because the AF version did not have a tripod collar and this manual version does.

The 80-200mm f/2.8 went through a number of design changes before the final version came on the market. Two years before this push-pull version was introduced, a two-ring zoom prototype was displayed at Photokina. This version was never produced nor was another version before that.

The factory doors burst open in **1984** with 13 new lens designs. It was the year of the zoom, with five new models coming out. They were:

105mm f/2.8 Micro
300mm f/2 EDIF with TC-14C

28-50mm f/3.5
35-105mm f/3.5-4.5
50-135mm f/3.5
100-300mm f/5.6
200-400mm f/4 ED
500mm f/8N Mirror
TC-14A
TC-14B
TC-16 AF
TC-201
TC-301

The **105mm f/2.8 Micro** is an incredible lens—the best of the 105s. The 105mm f/2.8 is more than a faster version of the 105mm f/4, it is a complete remake. It has a length of 3.5 inches (8.9 cm), an aperture range from f/2.8 to f/32, meter coupling, a filter size of 52mm, an angle of view of 23.2°, and a weight of 17.7 oz. (502 g). Its design departs from the tradition of having a built-in shade, coming instead with a reversible shade, the HS-14. It focuses from infinity to 1:2 by itself and 1:2 to 1:1 with the PN-11 extension tube. The outstanding optical design delivers edge-to-edge sharpness, but it is not "flat field." It does not employ CRC, but rather has flat-field characteristics as part of its optical design. It has a focus-lock screw on the barrel to prevent the focus from changing when a predetermined magnification ratio is required. Oddly, the lock comes from the factory inoperable, needing to be sent to Nikon for warranty repair. The focus is such that this feature is not really needed, and few photographers bother to have it fixed.

The **300mm f/2 EDIF** lens is not just fast, it is sharp! Its size qualifies it as a tank. With a suggested list price of over $21,000 at the time it was discontinued, a defense department budget is needed to justify its purchase. It has a length of 13.6 inches (34.5 cm), an aperture range from f/2 to f/16, a filter size of 160mm (52mm drop-in filter drawer), an angle of view of 8.1°, and a weight of 16.6 lbs! It is front-heavy, but this is where the majority of the glass is housed. An extension shade can be added to the built-in one to provide maximum protection from flare as well as damage to the front element.

It has a built-in tripod collar with full 360° rotation. There are also three holes to attach it to a tripod. The first, second, and forth elements are ED glass, one element more than the 300mm f/2.8 EDIF. The 300mm f/2 comes with a matched teleconverter, the TC-14C. When attached, it transforms the lens to a 420mm f/2.8. The TC-14B, TC-201, and TC-301 can be used with the 300mm f/2, but at smaller f/stops

with faster shutter speeds uneven exposure is possible. Introduced in time for use in the 1984 summer Olympic games in Los Angeles, NPS (Nikon Professional Services) made it available for loan. Many photographers took advantage of this and produced thousands of outstanding images with this lens.

The **28-50mm f/3.5** is a funky little lens that came and went in a matter of two years. It earned a loyal following during that brief time. Its small size was what attracted most to it. It has a length of 3 inches (7.6 cm), an aperture range from f/4 to f/22, meter coupling, a filter size of 52mm, an angle of view of 74° to 46°, and a weight of 13.9 oz. (394 g). Its zoom is a push-pull with not quite a 2x range. The f/stop is constant throughout the zoom range. It has a macro mode at the 50mm setting providing 1:5.2 magnification. The sharpness, too, remains constant throughout the entire range. This, combined with its compact design, makes it popular.

The **35-105mm f/3.5-4.5** is an extremely popular zoom, though it has been found not to be tack sharp at all focal lengths. Its small size is one of its biggest assets. It has a length of 3.9 inches (9.9 cm), an aperture range from f/3.5–4.5 to f/22, meter coupling, a filter size of 52mm, an angle of view of 62° to 23.2°, and a weight of 18 oz. (510 g). It has a macro mode at the 35mm setting that provides 1:3.8 magnification. This is the first of the new zoom designs for which Nikon incorporated a variable f/stop into the optical formula. As the lens is zoomed out, the f/stop changes. The 35-105 starts at f/3.5 and when zoomed to the 105mm focal length, the f/stop changes to f/4.5. The variable f/stop lens design has received a lot of flack from photographers, but the flexibility this gives lens designers allows for greater zoom focal lengths in smaller packages.

The **50-135mm f/3.5** was short lived, but its popularity grew once the lens was discontinued. It still has a loyal following today, keeping the lens hard to find. It has a length of 5.6 inches (14.2 cm), an aperture range from f/3.5 to f/32, meter coupling, a filter size of 62mm, an angle of view of 46° to 18°, and a weight of 24.7 oz. (700 g). Its optics are excellent, the f/stop is constant, and it has a push-pull design. It has a macro mode at the 50mm setting that provides 1:3.8 magnification. One feature that is quoted as being an asset in the 50-135 is that the front filter does not turn as the focus ring is turned. If a polarizing filter is in use, once the filter has been turned for the desired effect, the lens can be focused and it will not change the polarizing effect.

The **100-300mm f/5.6** is optically an excellent lens, but its size and slow f/stop kept it from being a

Nikkor 50-135mm f/3.5 AIS

popular lens. It has a length of 8.1 inches (20.6 cm), an aperture range from f/5.6 to f/32, meter coupling, a filter size of 62mm, an angle of view of 24.2° to 8.1°, and a weight of 31.7 oz. (899 g). It is a big lens, but is sharp throughout its entire zoom range. It has a macro mode at the 100mm setting that provides 1:4.4 magnification. Never a big seller, its optics are excellent and deserve more respect than they ever received.

The **200-400mm f/4 ED** is an amazing lens! The optical quality of the lens is outstanding throughout its entire zoom range. This holds true even when the TC-14B teleconverter is attached. It has a length of 13.6 inches (34.5 cm), an aperture range from f/4 to f/32, meter coupling, a filter size of 122mm, an angle of view of 12.2° to 6.1°, and a weight of 7.8 lbs. (3.5 kg). The second, third, eighth, and tenth elements are ED glass. Wow! It has a built-in tripod collar with 360° rotation and is designed to handle the shift in weight caused by zooming. It has a reversible shade for maximum protection and a zoom collar lock like the 80-200mm f/2.8. It has ED glass, providing outstanding results wide open, and it can focus down to 13 feet (4 m), which is excellent at the 400mm range. Its production life was short compared to most large ED lenses, because it was still considered slow at f/4, especially at the 200mm end. It was very hard to sell when first introduced, but that is not the case today. The original dealers' net of $2,400 seems like nothing when folks are standing in line for them today to buy them used for $10,000!

The **500mm f/8N Mirror** is a completely new design for the 500 mirror. It is still a catadioptric design with a fixed aperture of f/8, but the optical quality and versatility surpasses any earlier design. It has a length of 4.6 inches (11.7 cm), an aperture of f/8, fixed meter coupling, a filter size of 82mm (39mm

screw-in rear mount), an angle of view of 5°, and a weight of 28.7 oz. (814 g). The redesigned 500mm f/8N's (N = New) compact design makes the lens easily handheld even at slower shutter speeds. The new design's added benefit is that it can focus down to 5 feet (1.5 m), providing greater than 1:1 magnification. It has a built-in tripod collar with 360° rotation and click-stops for vertical and horizontal positions. The TC-14A and TC-201 teleconverters work with the 500mm f/8N when the rear filters are attached. The TC-14B can be used if the rear filter is removed.

The **TC-14A** was introduced in response to the overwhelming demand for a 1.4 teleconverter for "shorter focal length" lenses. It is small, 1 inch (2.54 cm) long, meter coupled, and weighs 5.1 oz. (145 g). The "A" on the converter signifies that it works on lenses whose rear element is flush in the back. The front element of the TC-14A is inset, so the rear element of the lens can fit into the converter, maintaining even illumination and the flat-field quality inherent in the lens. The TC-14A meter couples with the AI and AIS systems. There is one stop of light lost when used, but depth of field is as described for the TC-1. The optical quality is outstanding. This is a very viable tool. Do not hesitate to use it!

The **TC-14B** is the same as the TC-14 but has the AIS coupling, hence the "B." The lens specs and applications are the same as those of the TC-14. Refer to its description on page 88 for specifics.

TC-14B Teleconverter

The TC-200 and TC-300 were also updated to be compatible with the AIS system, reintroduced as the **TC-201** and **TC-301.** Refer to the descriptions of the earlier teleconverters on pages 85 and 86 for specific details.

The **TC-16 AF** is a curious teleconverter designed to work with the F3 AF. It allows non-AF lenses to work on the F3 AF in a semi-autofocus mode. It is compact in design, increasing the effective focal length by 1.6 and adding only 1-1/3 stops. The element in the converter moves to focus the image on the film plane, but its small degree of movement limits the range the converter can focus. Refer to the TC-16A AF's description on page 100 for methods of use.

After the incredible release of new optics the previous year, Nikon had only four new lenses to offer in **1985.** They were:

20mm f/2.8
35-70mm f/3.3-4.5
35-135mm f/3.5-4.5
400mm f/2.8 EDIF

The **20mm f/2.8** is the best 20mm made by Nikon to date and is the first to feature CRC technology. It has a length of 2.1 inches (5.3 cm), an aperture range from f/2.8 to f/22, meter coupling, a filter size of 62mm, an angle of view of 94°, and a weight of 9.2 oz. (261 g). This is a magnificent lens of legendary status and outstanding optical quality. The 20mm f/2.8's CRC technology and its ability to focus 0.85 foot (0.3 m) makes it an excellent lens for wide-angle work. Wide open at f/2.8, it isolates the subject while maintaining edge-to-edge quality.

The **35-70mm f/3.3-4.5** is a very short version of the earlier 35-70 that Nikon introduced to complement the smaller camera bodies. It has a length of 2.7 inches (6.9 cm), an aperture range from f/3.3–4.5 to f/22, meter coupling, a filter size of 52mm, an angle of view of 62° to 34.2°, and a weight of 9 oz. (255 g). Its variable f/stop design allowed Nikon to produce the lens in such a small package. The amazing thing about this lens is its incredible sharpness. Even when in macro mode at the 70mm setting with 1:4.4 magnification, the lens retains its sharp image quality. Many photographers did not give it much thought because of its low price, but those who use it swear by it.

The **35-135mm f/3.5-4.5** is a lens that has received mixed reviews since its introduction. It has a length of 4.5 inches (11.4 cm), an aperture range from f/3.5–4.5 to f/22, meter coupling, an angle of view of 62° to 18°, and a weight of 21.4 oz. (607 g). It is a variable f/stop model, changing from f/3.5 to f/4.5 as the lens is zoomed from 35mm to 135mm. The optical quality is good for a zoom lens, but this lens is not widely used for critical work. It has a macro mode at the 135mm setting that provides 1:3.8 magnification.

The **400mm f/2.8 EDIF** is a haunting ghost of speed and optics! This is a tank, only slightly smaller

than the 300mm f/2. It has a length of 15.2 inches (38.6 cm), an aperture range from f/2.8 to f/22, meter coupling, a filter size of 160mm (52mm filter drawer), an angle of view of 6.1°, and a weight of 10.1 lbs. (4.6 kg). The first and second elements are ED glass. The 400mm f/2.8 does not accept a filter in the front because it has a hardened, built-in, protective glass filter that can be replaced if damaged. The filter drawer accepts all 52mm filters except a polarizing filter. The edge-to-edge quality of the 400mm f/2.8 shot at f/2.8 can be matched against the best lenses on the market and will come out ahead. Its price tag and its weight keep the majority of photographers from owning this lens.

In **1986** Nikon introduced three more lenses to fill in their manual lens line. They were:

800mm f/5.6 EDIF
28-85mm f/3.5-4.5
35-200mm f/3.5-4.5

The **800mm f/5.6 EDIF** is one of the sharpest but least known telephoto lenses in production. It has a length of 21.8 inches (55.4 cm), an aperture range from f/5.6 to f/32, meter coupling, a filter size of 160mm (52mm filter drawer), an angle of view of 3°, and a weight of 10.6 lbs. (4.8 kg). The second, third, and eighth elements are ED glass. The 800mm has the same hardened front element as the 400mm f/2.8 and all current telephotos. The edge-to-edge quality of the 800mm at f/5.6 is superior even when focused down to its minimum focusing distance of 30 feet (9.1 m). Introduced at a time when fast f/stops were the main selling point of lenses, the lens' maximum aperture of f/5.6 discouraged many photographers from trying it.

Nikkor 800mm f/5.6 EDIF

The **28-85mm f/3.5-4.5** is a popular focal length lens that many enjoy using. It has a length of

3.9 inches (9.9 cm), an aperture range from f/3.5–4.5 to f/22, meter coupling, a filter size of 62mm, an angle of view of 74° to 28.3°, and a weight of 18.5 oz. (510 g). It has a macro mode providing 1:3.4 magnification. Its popularity had always been good, but it increased tremendously when the lens was discontinued.

The **35-200mm f/3.5-4.5** is an outstanding lens with excellent optics. There has been resistance to the lens from photographers because of its variable aperture, but that's what makes the lens design possible. It has a length of 5 inches (12.7 cm), an aperture range from f/3.5–4.5 to f/22, meter coupling, a filter size of 62mm, an angle of view of 62° to 12.2°, and a weight of 25.9 oz. (734 g). It has a push-pull operation. Like most of the variable zooms, it has a macro capability of 1:4 with the turn of a ring. The sharpness of the lens throughout its entire range is incredible. If you want just one lens, this would be it!

Nikkor 35-200mm f/3.5-4.5

The Autofocus Era

Nikon rattled their loyal lens users in **1986** with the introduction of a new autofocus (AF) lens line released with the N2020 camera. This new generation of autofocus lenses has a completely different feel and appearance than the first generation of AF lenses (introduced with the F3 AF) to which Nikon users had become accustomed. This created a lot of resistance to these lenses from the start. They were:

24mm f/2.8 AF
28mm f/2.8 AF
50mm f/1.8 AF
50mm f/1.4 AF
55mm f/2.8 Micro AF
180mm f/2.8 EDIF AF

28-85mm f/3.5-4.5 AF
35-70mm f/3.3-4.5 AF
35-105mm f/3.5-4.5 AF
35-135mm f/3.5-4.5 AF
70-210mm f/4 AF
TC-16A AF

The autofocus lenses are a radical departure from the Nikon lenses of the past. The first noticeable difference is their polycarbonate lens barrel. This replaced the metal barrel of Nikkors past. These barrels have a totally different feel to them—smooth and tinny. The original model autofocus lenses also had a very narrow focusing ring. Saying these were very unpopular would be an understatement. The feel of the focusing was even more disliked. When used manually, the focusing ring does not have the same drag (stiffness). This gives the impression of inferior quality in its construction. These perceptions are erroneous, and unfortunately they overshadow the quality of the construction and the performance of these autofocus lenses' optics.

There are benefits to the autofocus lens design that the manual lenses cannot touch. In most cases, this makes them superior. The non-metal lens barrel allows for a focusing mechanism to be used that is not a helicoid design. The weight and cost of producing a helicoid for an autofocus lens can be prohibitive. In place of the conventional helicoid, Nikon designed a new system for moving the elements through the lens barrel. The system consists basically of a plastic sleeve with vertical-diagonal slots cut in it (there are small differences in each lens). These are tracks in which the elements ride. As the lens barrel is turned, the elements move.

The drag of the conventional helicoid focusing system is too great for the autofocus motor in autofocus cameras. To move a conventional helicoid mechanism, the focusing motor would have required tremendous torque. This would require a bigger motor, adding greatly to the weight of the body and demanding more voltage to make it all work. This new focusing system allowed autofocus lenses to be developed, with lower production costs (the milling cost of the helicoid having been eliminated).

The changes that have been made in the design of the autofocus lenses are obvious. The zooms do not have depth-of-field engraving on the barrel. Rather, it is necessary to cut the depth-of-field chart out of the instruction sheet (then hold it on the barrel). Fixed focal length lenses have a depth-of-field engraving on the barrel, but the distance scale is enclosed under a plastic window and rotates as the lens is focused.

At the rear of the AF lens, near the lens mounting ring, are metal contacts connecting the lens' **CPU** (Central Processing Unit) to the computer in the body. The CPU is the latest in the evolving communications between the body and lens. These contacts transfer various lens data as well as commands regarding aperture control and focusing. Also at the rear lens mount is a small circle with a ditch through its middle. This is the autofocus coupling that the body connects to and turns to focus the lens.

The non-AI coupling prong is omitted from autofocus lenses preventing them from coupling with the older non-AI system. This prong can be retrofitted to the aperture ring by a number of repair facilities. The autofocus lenses' aperture rings have a lock on them. This is so they can be locked at their minimum f/stop (for use with Program and Shutter-Priority modes). The shade system has also been changed on the autofocus lenses. The recommended shades for many of the lenses have a bayonet mounting system, but they can still accept screw-in shades.

This second generation of autofocus lenses was not welcomed with open arms. But with time, their extremely fine optics and smaller, lighter design were accepted. It has gotten to the point that they have become hard to find at many retail outlets. As a general rule of thumb, autofocus lenses are as good if not better than their manual focus counterparts.

The **24mm f/2.8 AF** is an excellent lens. It is not a radical departure from the original 24mm f/2.8. It has a length of 1.8 inches (4.6 cm), an aperture range from f/2.8 to f/22, meter coupling, a filter size of 52mm, an angle of view of 84°, and a weight of 8.9 oz. (252 g). The 24mm f/2.8 has CRC, and its optical design is the same as its manual counterpart, though Nikon's written description omits this point. It maintains the same edge-to-edge performance as the manual lens' design, which speaks very well for its design.

The **28mm f/2.8 AF** is the most popular 28mm Nikon has ever produced. Its extremely small size and price tag combined with excellent quality is the difference. It has a length of 1.5 inches (3.8 cm), an aperture range from f/2.8 to f/22, meter coupling, a filter size of 52mm, an angle of view of 74°, and a weight of 6.8 oz. (193 g). It does not have CRC (of the 28s only the 28mm f/2.8 AIS has CRC), but has excellent edge-to-edge quality nonetheless.

The **50mm f/1.8 AF** is another very small lens with a very small price tag. Its performance is excellent. It has a length of 1.5 inches (3.8 cm), an aperture range from f/1.8 to f/22, meter coupling, a filter size of 52mm, an angle of view of 46°, and a weight

of 7.4 oz. (210 g). It is a simple lens, designed for beginning photographers. Performance and price have endeared it to a wide range of users. It works excellently reversed. It can be found rather inexpensive used, making it a great backup lens for low light levels.

The **50mm f/1.4 AF** is the best of the 50mm f/1.4 designs to date. Extremely bright and sharp, it is an excellent choice to include in any camera bag. It has a length of 1.6 inches (4.1 cm), an aperture range from f/1.4 to f/16, meter coupling, a filter size of 52mm, an angle of view of 46°, and a weight of 7.4 oz. (210 g). This is one of the more expensive autofocus lenses to be introduced, and it was hard to get at its release. Its optical quality is in keeping with Nikon's high standards.

The **55mm f/2.8 Micro AF** is outstanding, with a reintroduction of an old feature of the 55mm f/3.5 Micro Pre-set. It can focus to 1:1 magnification without extension tubes, a first since 1962. It has a length of 2.9 inches (7.4 cm), an aperture range from f/2.8 to f/32, meter coupling, a filter size of 62mm, an angle of view of 43°, and a weight of 14 oz. (397 g). It is bigger than the manual 55mm, both in length and filter size. The first reports of its being sharper than the manual version were dismissed by most photographers, but experience has converted many early skeptics.

Its gaudy appearance when focused out to 1:1 and the barrel's movement (but not the elements') when extended were very unpopular. On the front of the lens barrel is a moving ring that, when pushed down and turned, changes the lens from autofocus operation (A) to manual (M). Though it works in either mode when the ring is at either setting, having the lens set to "A" mode when using autofocus reduces the torque on the camera's autofocus motor.

The **180mm f/2.8 EDIF AF** is by far the best 180mm ever produced! This lens received a cold reception from photographers when introduced, probably because it was going up against a demigod, the manual version! It has a length of 5.6 inches (14.2 cm), an aperture range from f/2.8 to f/22, meter coupling, a filter size of 72mm, an angle of view of 13.4°, and a weight of 25.2 oz. (714 g). The second element is ED glass. It has a completely new element design over the manual version. The 180mm f/2.8 AF includes IF focusing. The rear element is placed farther up in the lens barrel instead of flush with the back as in manual versions. It was not until a very well-known and respected photographer wrote an article applauding the 180 AF that the photographic community took notice of it. The first version of the 180 AF had a plain focus ring 1/2-inch wide. This was replaced by a version with a rubberized focusing ring.

The **28-85mm f/3.5-4.5 AF** is a good enough lens, but it has received mixed reviews. It has a length of 3.5 inches (8.9 cm), an aperture range from f/3.5–4.5 to f/22, meter coupling, a filter size of 62mm, an angle of view of 74° to 28.3°, and a weight of 18.9 oz. (536 g). It is a two-ring zoom—the rear ring zooms and the front ring focuses. It has a macro feature providing 1:3.4 magnification. Its focal length is very popular. This is a fine lens for the traveling photographer who does not want to carry many lenses.

The **35-70mm f/3.3-4.5 AF** is an amazing little lens! It has a length of 2.4 inches (6.1 cm), an aperture range from f/3.5–4.5 to f/22, meter coupling, a filter size of 52mm, an angle of view of 62° to 34.2°, and a weight of 9.6 oz. (272 g). It is astonishingly sharp throughout its entire zoom range as well as edge to edge. Its small size and price tag kept it from being taken seriously for quite a while. It wasn't until a number of photographers had used it and written about its quality that it was given due credit.

The **35-105mm f/3.5-4.5 AF** has always been a very popular focal length. The autofocus 35-105 stepped into the manual version's niche of popularity, but it was not a better lens optically. It has a length of 3.4 inches (8.6 cm), an aperture range from f/3.5–4.5 to f/22, meter coupling, a filter size of 52mm, an angle of view of 62° to 23.2°, and a weight of 16.1 oz. (456 g). The autofocus version is superior to the manual version, however, in that it's more consistent throughout its zoom range. It has a macro mode, providing 1:3.5 magnification. It has a two-ring system, the rear ring for zooming, the front ring for focusing.

The **35-135mm f/3.5-4.5 AF** is a nice lens. One of the bigger autofocus lenses to be introduced, it was popular from the start. It has a length of 4.4 inches (11.2 cm), an aperture range from f/3.5–4.5 to f/22, meter coupling, a filter size of 62mm, an angle of view of 62° to 18°, and a weight of 21 oz. (595 g). It has a macro mode providing 1:3.5 magnification. Its two-ring design operates like the 28-85mm and the 35-105mm.

The **70-210mm f/4 AF** is optically an outstanding lens, though its mechanical design is unconventional. It has a length of 5.9 inches (15.0 cm), an aperture range from f/4 to f/32, meter coupling, a filter size of 62mm, an angle of view of 34.2° to 11.5°, and a weight of 25.9 oz. (734 g). It is a two-ring zoom, working as the others. Its optics are excellent but were not given much attention by photographers. That is, until it was discontinued. This lens now enjoys a very loyal following despite its narrow focusing ring and cosmetics.

The **TC-16A AF** is called an autofocus teleconverter, but this is misleading. It does magnify the image by 1.6x (losing 1-1/3 stops), but it is not a full-range autofocus converter. It must be used on an autofocus body. When attached to the body, the TC-16A AF provides critical focus only; it cannot focus the lens from infinity to its minimum focusing distance. To use the converter to its fullest, first focus the lens manually on the subject, then touch the shutter release to activate the camera's autofocus operation. The teleconverter now kicks in and critically focuses the photograph. There is a 1-1/3 stop loss of light, and with longer lenses (400mm or longer), vignetting occurs. This converter works extremely well within its limitations, delivering a sharp photograph matching the quality of the TC-14B.

And if that wasn't enough innovation for one year, Nikon introduced four remodeled EDIF lenses:

200mm f/2N EDIF
300mm f/2.8N EDIF
600mm f/5.6N EDIF
600mm f/4N EDIF

These lenses have the same optical formula and specs as the previous versions but now have a permanent front filter (which can be replaced if scratched) with no front auxiliary filter threads. In the optical formula this is not counted as an element or element group. The "N" lenses also have reversible lens shades in addition to the shades previously built into the lens, providing extra flare protection. The 200mm f/2N also gained a gel filter holder at the rear, in front of the aperture ring.

In **1987** Nikon added to its autofocus inventory by introducing three new lenses. Only two of these lenses ever saw the market. At the PMA (Photographic Marketing Association) show, Nikon had a **600mm f/4 EDIF AF** on display in a glass case. This lens was said to be coming on the market the following fall and was even pictured full-page in the N2020 brochure. For reasons unknown, the lens never made it to the production line. It is sorely missed in the product line (five years later the 600mm f/4 AF-I would come out). The two lenses that were released were:

300mm f/4 EDIF AF
300mm f/2.8 EDIF AF

Simply put, the **300mm f/4 EDIF AF** is a marvelous lens! The optical design provides better quality when matched with the TC-14B than a straight

400mm f/5.6 EDIF. It has a length of 10 inches (25.4 cm), an aperture range from f/4 to f/32, meter coupling, a front filter size of 82mm and a 39mm filter drawer, an angle of view of 8.1°, and a weight of 46.6 oz. (1,321 g). The second and seventh elements are ED glass. Unlike most autofocus lenses, the 300mm f/4 has an all-metal lens barrel construction (with the characteristic ED lens crinkle finish). The 300mm f/4 has outstanding edge-to-edge quality, even when used with a TC-14B teleconverter or an extension tube shot wide open at f/4.

Nikkor 300mm f/4 EDIF AF

The wide rubber focusing ring has a lever on it labeled "A" for autofocus and "M" for manual. If the body is in autofocus mode but the lens is in "M" mode, it will still work, but the focusing ring will turn and it cannot be held when shooting. If the lens is in "A" mode when shooting autofocus, the focus ring will not turn, allowing it to be held for better camera system balance. In front of the focusing ring is a focus range limiter. This can be selected so that the lens focuses only on subjects within a certain range, such as 25 to 50 feet (7.6 to 15 m), for instance. It can be set on a number of choices or left for complete operation when set at "Full." It has a built-in lens shade and a 360° rotating tripod collar. Its 82mm filter size is a bit big by Nikon's normal standards, but that has not stopped it from being a major lens for shooters.

The **300mm f/2.8 EDIF AF** is an amazing lens! Like the 180 AF when it was introduced, the 300mm f/2.8 EDIF AF was going up against a legend—the manual version. But 300mm f/2.8 AF has proved itself to be a better lens. It has a length of 9.8 inches (24.9 cm), an aperture range from f/2.8 to f/22, meter coupling, a front filter size of 122mm and a 39mm filter drawer, an angle of view of 8.1°, and a weight of 89 oz. (2,523 g). Its first and second elements are

ED glass. It has a built-in shade as well as a reversible shade for extra flare protection. It has a 360° rotating tripod collar for vertical and horizontal shooting and a ring that must be turned and set for either "M" or "A" mode shooting. It has the same focus range limiting system as the 300mm f/4 AF.

The 300mm f/2.8 EDIF AF was not accepted very well by photographers, even though its optical quality was superior to the manual version's. The main complaint was about its feel when focusing manually. Though normal for an autofocus lens, the drag is looser than on the manual version and it drove photographers crazy. Users have complained that the focus doesn't change instantly when the lens' focus ring is turned. Within 18 months a new version, the 300mm f/2.8N EDIF AF, came on the market. Cosmetic changes were made that addressed these complaints. No matter which version is used, it is a fantastic lens that is now preferred over the manual version, even at a higher price.

This was the last year that a manual lens would be introduced into the Nikon lens line for some time. Six new autofocus lenses, one new version of an autofocus lens, and one manual lens made up the new releases for **1988**. They were:

35mm f/2 AF
85mm f/1.8 AF
180mm f/2.8N EDIF AF
24-50mm f/3.3-4.5 AF
35-70mm f/2.8 AF
70-210mm f/4-5.6 AF
80-200mm f/2.8 ED AF
500mm f/4P EDIF

The **35mm f/2 AF** is an outstanding lens, surpassing its manual version. It has a length of 2.1 inches (5.3 cm), an aperture range from f/2 to f/22, meter

Nikkor 35mm f/2 AF

coupling, a filter size of 52mm, an angle of view of 62°, and a weight of 7.5 oz. (213 g). It has excellent edge-to-edge quality, rivaling that of the 35mm f/1.4. It focuses 6 inches (15.2 cm) closer than the manual version, retaining its edge-to-edge quality when focused close. Its size and sharpness make this lens extremely popular.

The **85mm f/1.8 AF's** optical quality equals that of the 85mm f/1.4. This small, compact lens is easily handholdable, taking full advantage of its f/1.8 for available-light photography. It features a new "rear focusing" design. It has a length of 2.7 inches (6.9 cm), an aperture range from f/1.8 to f/16, meter coupling, a filter size of 62mm, an angle of view of 28.3°, and a weight of 14.6 oz. (414 g). It is sharp edge to edge when shot wide open at f/1.8, gaining only slightly when closed down. This speaks well for its optical design. It has a wide rubberized focus ring. With the market's resistance to the narrow ring, all AF lenses from this time on would have that feature. The 85mm f/1.8 comes with the HN-23 shade when purchased new, and it can be kept on the lens at all times, covered with a 77mm snap cap for protection.

The **180mm f/2.8N EDIF AF** has the exact construction of the 180mm f/2.8 AF except for minor cosmetic changes. The lens barrel is now constructed of metal (rather than polycarbonate materials) and has the crinkle finish of the large EDIF lenses. The focus collar is twice as wide as that on the original model and now has a rubberized ring. The optical formula and performance remain the same but have been repackaged in a more traditional Nikon lens design.

The **24-50mm f/3.3-4.5 AF** is an excellent lens with outstanding optics. Its compact size makes it a great choice for travel photography. It has a length of 3.2 inches (8.1 cm), an aperture range from f/3.3–4.5 to f/22, meter coupling, a filter size of 62mm, an angle of view of 84° to 46°, and a weight of 13.2 oz. (374 g). It is a two-ring zoom, the rear ring working the zoom and the wide, front, rubberized ring operating the focus. It has a macro mode at all focal settings with a maximum magnification at the 50mm setting of 1:8.5. The edge-to-edge performance of the lens is excellent. It is at its best at f/5.6 to f/8.

The **35-70mm f/2.8 AF** is an incredibly sharp lens, shot wide open at any focal length! It has a length of 4.1 inches (10.4 cm), an aperture range from f/2.8 to f/22, meter coupling, a filter size of 62mm, an angle of view of 62° to 34.2°, and a weight of 23.5 oz. (666 g). It has a macro mode at the 35mm setting providing 1:4 magnification. This can be increased to almost 1:1 with the addition of a 6T filter without any

optical loss, even at the corners. It is a push-pull zoom design, but only the front focus ring turns; the main zoom barrel stays fixed. This is a true zoom that allows the focus to be set with the zooming action, not affecting the focus setting. Its zooming is the reverse of most Nikon zooms, starting at 70mm and pushing out to 35mm. The sharpness of this lens, even wide open, assures its place in the Nikon legend of optical designs.

The **70-210mm f/4-5.6 AF** is a completely new remake of the 70-210mm f/4 AF. It has a length of 4.3 inches (10.9 cm), an aperture range from f/4–5.6 to f/32, meter coupling, a filter size of 62mm, an angle of view of 34.2° to 11.5°, and a weight of 20.6 oz. (584 g). The first noticeable difference is its smaller size. The reduction in size comes from the use of a variable f/stop design, which was not present in the 70-210mm f/4. The second difference is that it's a push-pull zoom with the same zoom design as the 35-70mm f/2.8. It has a macro mode that provides 1:4.5 magnification. The optical quality of this new version is not as good as compared to the original version.

The **80-200mm f/2.8 ED AF** is a beautiful lens with an outstanding optical design. It has a length of 7.3 inches (18.5 cm), an aperture range from f/2.8 to f/22, meter coupling, a filter size of 77mm, an angle of view of 30.1° to 12.2°, and a weight of 42.3 oz. (1,199 g). The second, third, and thirteenth elements are ED glass. It has a macro mode providing 1:5.9 magnification at the 200mm setting. The lens barrel is of all-metal construction with a partial crinkle finish. It is a push-pull zoom with the same ring zooming and focusing. The 200mm setting is at the rear of the zoom, pushing out to the 80mm setting.

At the back of the zoom barrel are the "A" and "M" settings, which must be set for use in either autofocus or manual modes. The recommended 1.4x converter is the TC-14A, but the TC-14B can also be employed without mechanical problem or optical loss. The 80-200mm f/2.8 AF has been criticized for its lack of a tripod collar. But adding a collar would have made the lens even larger. Though large, this is a smaller and sharper zoom than the manual 80-200mm f/2.8. It should be noted that its autofocus speed is slower than that of any of the other autofocus lenses.

The **500mm f/4P EDIF** is the first new addition to Nikon's line of long glass in a decade. What an addition! It has a length of 15.5 inches (39.4 cm), an aperture range from f/4 to f/22, meter coupling, a front filter size of 122mm and a 39mm filter drawer, an angle of view of 5°, and a weight of 6.6 lbs. (3 kg). The first

and second elements are ED glass. The "P" in the nomenclature indicates that the lens has a CPU incorporated into its design. When used on the N8008, N90s, and F4s, it completely integrates with the cameras' matrix metering systems. It has a built-in tripod collar with a full 360° rotation. It has the deepest reversible shade available for any telephoto lens, providing maximum flare protection. It also incorporates the protective front filter design found in all large telephotos. The balance of the 500mm f/4P is excellent; some photographers use it on a gunstock with little effort. This has to be the most popular and widely owned telephoto Nikon has ever manufactured!

It is not uncommon to see folks using this lens with a TC-14B or TC-301. These teleconverters produce 700mm and 1000mm versions of this lens, which deliver outstanding quality. In fact, some never take their 1.4x teleconverter off the 500mm f/4. This makes this lens extremely economical and versatile. This is why it is probably the lens most widely owned by wildlife photographers!

In **1989** Nikon introduced three new lenses plus three new versions of older AF lenses. They were:

20mm f/2.8 AF
50mm f/1.8N AF
60mm f/2.8 Micro AF
300mm f/2.8N EDIF AF
35-70mm f/3.3-4.5N AF
75-300mm f/4.5-5.6 AF

The **20mm f/2.8 AF** is a beautiful lens! It has the exact same optical design as the manual version, except that it is an AF lens. It has a length of 1.7 inches (4.3 cm), an aperture range from f/2.8 to f/22, meter coupling, a filter size of 62mm, an angle of view of 94°, and a weight of 9.2 oz. (261 g). It incorporates all the same features of the manual 20mm including

Nikkor 20mm f/2.8 AF

the CRC. The 20mm AF's minimum focusing distance is 12 inches (30.5 cm) whereas the manual version's is 10 inches (25.4 cm). The 20mm AF has the new aperture locking switch, a small lever that is pushed in to lock the aperture at f/22. It is a sharp lens and is extremely popular with photographers.

Because of its angle of view, this is a difficult lens to polarize. The Nikon 62mm polarizer (even with its built-in step-up ring) cannot be used without causing vignetting if another filter is already attached. When using filters, be sure to check for vignetting by closing the lens down to f/22 and pressing the depth-of-field button on the camera body. Then look closely at the corners of the viewfinder for darkening.

The **50mm f/1.8N AF** is the same lens as the 50mm f/1.8 AF, except that it has a wide, rubberized focusing ring. It has a length of 1.9 inches (4.8 cm), an aperture range from f/1.8 to f/22, meter coupling, a filter size of 52mm, an angle of view of 46°, and a weight of 5.4 oz. (153 g). It is interesting that Nikon chose to give this lens a cosmetic update of the wide focus ring while ignoring the 50mm f/1.4 AF.

The **60mm f/2.8 Micro AF** is a radical new design that exceeds the optical quality of the 55mm micros of the past. It has a length of 3 inches (7.6 cm), an aperture range from f/2.8 to f/32, meter coupling, a filter size of 62mm, an angle of view of 39.4°, and a weight of 16 oz. (454 g). It focuses from infinity to 1:1 without extension tubes; the length of the lens grows only an additional 23mm when focused to 1:1.

Nikkor 60mm f/2.8 Micro AF

The way Nikon got around the physics of getting to 1:1 without adding 60mm of extension is through a radical new design. The elements realign themselves as the lens is focused closer. This permits magnification without a lens extension. At 1:1 magnification, the working distance between the lens and subject is

2.8 inches (70 mm). It is a flat-field lens, making it ideal for copy work.

The 60mm can work in either manual or autofocus mode. The lens must be set to the proper setting for correct operation. The 60mm f/2.8 AF has a limit switch that allows either full operation from infinity to 1:1 or just a partial range. This helps limit the range the lens searches to focus. The 60mm has the new aperture lock lever like the 20mm f/2.8 AF. The distance scale has a reproduction scale (as with the original 55mm micros), so setting the lens for a particular ratio is possible, requiring only that you move in physically to focus on the subject. Whether used at infinity, 1:1, or any spot in between, the 60mm f/2.8 Micro is sharp!

The **300mm f/2.8N EDIF AF** has the exact same optical formula and specifications as the 300mm f/2.8 AF. The biggest difference is that the lens, when focused manually, now has a stiffer drag. A few cosmetic changes were also made, such as the small knobs on the focus lock and focus range lock were made bigger and sturdier.

Nikkor 300mm f/2.8N EDIF AF

The **35-70mm f/3.3-4.5N AF** is a remake, with only cosmetic changes. It has a length of 2.2 inches (5.6 cm), an aperture range from f/3.3–4.5 to f/22, meter coupling, a filter size of 52mm, an angle of view of 62° to 34.2°, and a weight of 8.5 oz. (241 g). The lens is slimmer in diameter and has a wide, rubberized focus ring and zoom ring.

The **75-300mm f/4.5-5.6 AF** is the sleeper of the decade! It is beautifully sharp and handles extremely easily considering its focal length. It has a length of 6.8 inches (17.3 cm), an aperture range from f/4.5–5.6 to f/22, meter coupling, a filter size of 62mm, an angle of view of 31.4° to 8.1°, and a weight of 29.1 oz. (825 g). It remains at f/4.5 until the

200mm mark, then switches to f/5.6. It has a macro mode and a built-in tripod collar with full 360° rotation for vertical and horizontal shooting. It has a limit switch for the autofocusing range like the 60mm Micro. Its compact size can be attributed to the variable f/stop design, which aids in its being easy to handhold. An added feature of this remarkable lens is its "macro" capability. Active throughout its zoom range, it focuses down to just five feet (1.5 m)! No other 300mm lens is capable of this. Its popularity with photographers testifies as to the quality of the lens.

Nikkor 75-300mm f/4.5-5.6 AF

In **1990** there were only three new lenses added to the Nikon line, and they were exciting. They were:

105mm f/2.8 Micro AF
135mm f/2 AF DC
1200-1700mm f/5.6-8P EDIF

The **105mm f/2.8 Micro AF** seems destined to join the ranks of the great micros. It has a length of 4.2 inches (10.7 cm), an aperture range from f/2.8 to f/32, meter coupling, a filter size of 52mm, an angle of view of 23.2°, and a weight of 22.3 oz. (632 g). It is a big lens when compared to the manual 105mm f/2.8 Micro. But unlike the manual version, it can focus to 1:1 without extension tubes. It employs the same moving element system as the 60mm Micro, so its overall length barely changes. Be aware that the lens is not "flat field" through CRC. Its flat-field qualities are inherent in its optical design. The working distance between the lens and the subject at 1:1 magnification is 5.4 inches (13.6 cm), which is less than with the 105mm f/2.8 manual at the same magnification. The 105mm f/2.8 AF has the same "A" and "M" switch, aperture lock, and limit switch as the 60mm Micro. The popularity of the 105mm

seems to constantly grow, making it difficult to find on occasion.

The **135mm f/2 AF DC** is a radical new design in lens construction. It has a length of 5.2 inches (13.2 cm), an aperture range from f/2 to f/16, meter coupling, a filter size of 72mm, an angle of view of 18°, and a weight of 30.4 oz. (862 g). The "DC" stands for "De-focus Control." By turning a dial on the lens once the subject has been focused, the foreground or background will be "de-focused," or out of focus. The amount that it appears to be out of focus can be lessened or magnified by the amount selected with the "DC" ring (in combination with the aperture in use). The lens features a "round" diaphragm to assure an agreeable, soft blur at any f/stop. It also has a rear-focus (RF) design. The rear elements move internally to focus on the subject, thereby giving the lens IF focusing.

At Photokina 1990, Nikon displayed a working Prototype **1200-1700mm f/5.6-8P EDIF** lens to prove that such a lens could be manufactured. It has a length of 34.6 inches (87.9 cm), an aperture range from f/5.6 to f/22, meter coupling, a filter drawer accepting 52mm filters, an angle of view of 2° to 1.3°, a weight of 35.5 lbs. (16.1 kg), and a diameter of 9.1 inches (23.1 cm). It has a built-in handle for easy handling (who's kidding whom). It became a special-order item in 1993, but before you rush out to buy one to shoot your next track meet, you should know that its price tag is $75,000. Sorry, I've never shot with one, so I cannot report whether it's worth the couple of extra dollars to own it.

The spring of **1991** saw the long-awaited update of two of the original autofocus lenses. They were:

28-85mm f/3.5-4.5N AF
35-105mm f/3.5-4.5N AF

The **28-85mm f/3.5-4.5N AF** is a total remake of the original version, and it shows. It has a length of 3.5 inches (8.9 cm), an aperture range from f/3.5–4.5 to f/22, meter coupling, a filter size of 62mm, an angle of view of 74° to 28.3°, and a weight of 17.7 oz. (502 g). The cosmetics and the optical quality have been vastly improved over the original version (though official policy claims that no change was made in the optical formula). The zoom and focus rings are wider, rubberized, and stiffened. The lens is now a marvelous tool for the serious photographer.

The **35-105mm f/3.5-4.5N AF** received the same remake as the 28-85. Its cosmetics and optical quality were improved in the same fashion. It also became a push-pull zoom.

That spring also saw one odd addition to the Nikon lens line and three revisions. The new lens was:

28-70mm f/3.5-4.5 AF

The **28-70mm f/3.5-4.5 AF** is a curious little lens made specifically to work with the built-in flash of the N6006. It has a length of 2.8 inches (7.1 cm), an aperture range of f/3.5–4.5 to f/22, meter coupling, an angle of view of 74° to 34.2°, a filter size of 52mm, and a weight of 12 oz. (340 g). This lens' small physical size does not obstruct the flash of the N6006, whereas the 28-85 AF, because of its physical size, actually blocks light from the flash at 28mm.

The 28-70 has something in common with the 58mm f/1.2. The 28-70's second element is of an aspheric design just like the 58mm f/1.2's. The 28-70's element is manufactured by a new process, which reduces the cost dramatically. The addition of an aspheric element in the lens design allowed Nikon to make the lens very small while maintaining image quality. This lens has received mixed reviews. Some have produced good results, many are below par. Overall the vote would suggest this is not one of the strongest in the Nikon line.

Finally, the **24mm f/2.8N AF, 28mm f/2.8N AF,** and **50mm f/1.4N AF** were brought up to par with the addition of a rubberized focusing ring. No other changes were made in the lens' specs aside from this modification. Now all Nikon autofocus lenses have rubberized focusing rings.

In the spring of **1992** Nikon finally came out with lenses most said couldn't be manufactured with current technology. They were:

300mm f/2.8D EDIF AF-I
600mm f/4D EDIF AF-I

These revolutionary lenses have a focusing motor built into them while maintaining Nikon's traditional F bayonet mount. Autofocus operation is limited, though, to just the F4, N90, N90s, and N70 bodies. They can be used manually on any Nikon body while maintaining all meter coupling (although for cameras without AI meter coupling you will need to have the lens retrofitted with a meter coupling prong). The 300mm f/2.8D AF-I and 600mm f/4D AF-I incorporate a new optical design, a "Distance" encoder chip (what the "D" stands for), an "Integral" built-in focus-driving motor (what the "I" stands for in "AF-I"), instant manual focus override, a convenient focus range limiter, and four focus-lock buttons on the lens barrel all in a new housing.

The **300mm f/2.8D EDIF AF-I** is not a simple remake of earlier versions, but a completely new design. It has a length of 9.5 inches (24.1 cm), an aperture range from f/2.8 to f/22, meter coupling, a 39mm screw-in filter drawer, an angle of view of 8.1°, and a weight of 6.4 lbs. (2.9 kg). The front element is 122mm in size. But like current-generation long lenses, it has a built-in front dust filter (so there are no filter threads). Its minimum focusing distance is 10 feet (3 m).

The DC coreless focus-driving motor built into the lens provides virtually silent operation in the autofocus mode. A unique focusing feature on the new lens is the A-M (manual override) mode. When in the A-M mode, you can lock onto the subject in autofocus mode and then "fine tune" manually if required. A turn of the focus ring disengages the AF operation, providing a smooth transition to manual focusing instantly! The autofocus lock is much easier with the new models, as four buttons are placed around the barrel. The actual focusing speed is amazing! The lens can focus on a subject literally before your eye; this was never possible with previous AF long lenses.

The **600mm f/4D EDIF AF-I** is radically new from the first AF version originally shown years ago. It has a length of 16.4 inches (41.7 cm), an aperture range from f/4 to f/22, meter coupling, a 39mm screw-in filter drawer, an angle of view of 4.1°, and a weight of 13.3 lbs. (6 kg). It does not accept a front filter, is 160mm in diameter, and has a minimum focusing distance of 20 feet (6 m). It incorporates all the new features of the 300mm f/2.8D AF-I with one addition, a new streamlined look. The squared-off edges of previous models are gone, having been replaced with rounded edges and lines.

The first delivery of these lenses was made in late July, in time for sport shooters going to the Olympics. They were extremely pricey and limited to F4 users, so not many photographers rushed out to replace their older models. That all changed with the introduction of the N90 and N90s. The 600mm f/4 AF-I could be considered a common lens in some fields of photography. It is by far the most popular 600mm ever produced by Nikon!

In the fall of **1992** with the introduction of the N90 Nikon introduced three modified lenses that work with the camera's technology. They were:

28-70mm f/3.5-4.5D AF
35-70mm f/2.8D AF
80-200mm f/2.8D ED AF

All three lenses have the new "D" (distance encoder) technology on board. It is computer chip technology that communicates the actual focus distance of the subject to the N90 or N90s. This information is used in the N90's 3D matrix metering and Monitor Pre-Flash technology when the SB-25 is being used.

The **28-70mm f/3.5-4.5D AF** and **35-70mm f/2.8D AF** are the exact same lenses as the original models, the only difference being the addition of the computer chip. The **80-200mm f/2.8D ED AF** was changed so that the front element no longer turns when the lens is focused. Though the construction that makes this happen is not truly internal focusing, the result still feels and appears the same. The lens does not have a tripod collar. All three lenses operate exactly as the original models.

Nikkor 35-70mm f/2.8D AF

Nikkor 80-200mm f/2.8D ED AF

In the spring of **1993** Nikon continued their new releases of "D" technology lenses. They also introduced two new teleconverters. They were:

16mm f/2.8D AF
20-35mm f/2.8D AF
28mm f/1.4D AF
105mm f/2D AF DC
400mm f/2.8D EDIF AF-I
TC-14E
TC-20E

The **16mm f/2.8D AF** is nearly the same lens as the manual version. It has a length of 2.2 inches (5.6 cm), an aperture range from f/2.8 to f/22, meter coupling, a filter size of 39mm (bayonet), an angle of view of 180°, and a weight of 10.1 oz. (286 g). It has all the same properties of the manual version and works in the same manner. The AF version focuses closer (0.85 foot, or 25.9 cm) and weighs an ounce less. The most unique new feature of the 16mm AF has nothing to do with optics. This is the first non-telephoto to have the crinkle finish characteristic of the big ED lenses. This lens seems to have breathed some life back into the fisheye, which up to this point was in few camera bags. It delivers excellent results and opens up a fun aspect of photography.

The **20-35mm f/2.8D AF** is an amazing lens that delivers blistering images! There's no doubt as to why it's extremely hard to find even with its high price tag. It has a length of 3.7 inches (9.4 cm), an aperture range from f/2.8 to f/22, meter coupling, a filter size of 77mm, an angle of view of 94° to 62°, and a weight of 22.6 oz. (641 g). It is sharp throughout its entire range. It is a two-ring zoom, maintaining focus while being zoomed. It too has the crinkle finish typical of the big ED telephotos. Filtration is possible, but stacking filters causes vignetting. Those who are into using wide-angles will find using this lens a one-of-a-kind experience. It is not uncommon for photographers to trade in all their fixed focal length wide-angles to own this one lens. You cannot ask for better quality, edge to edge!

The **28mm f/1.4D AF** is a more esoteric lens. It has a loyal following, especially among PJs, but otherwise it is not widely owned. It has a length of 3.1 inches (7.9 cm), an aperture range from f/1.4 to f/16, meter coupling, a filter size of 72mm, an angle of view of 74°, and a weight of 18.3 oz. (519 g). This lens has brought the limelight back to the 28mm. It delivers beautiful images in a small package. It too has the characteristic crinkle finish of the big telephotos.

The **105mm f/2D AF DC** operates the same as the 135mm f/2 AF DC. It has a length of 4.1 inches (10.4 cm), an aperture range from f/2 to f/16, meter coupling, a filter size of 72mm, an angle of view of 23°, and a weight of 21.9 oz. (621 g). It has a built-in lens shade that pulls out and the crinkle finish.

Nikkor 400mm f/2.8D EDIF AF-I

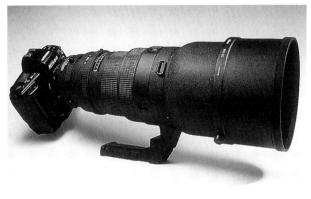

N90s with the Nikkor 400mm f/2.8D EDIF AF-I and MB-10 Multi-Power Vertical Grip

Refer to the 135mm f/2 AF DC description for operation specs.

The **400mm f/2.8D EDIF AF-I** is an incredible lens! The quality of its images is best described by saying they have the same "glow" as those taken with the 105mm f/2.5. It has a length of 14.8 inches (37.6 cm), an aperture range from f/2.8 to f/22, meter coupling, a filter drawer accepting 52mm filters, an angle of view of 6°, and a weight of 13.8 lbs. (6.3 kg). The AF-I technology and operation is the same as that of the 300mm f/2.8 and 600mm f/4. This is not a small lens, the front element assembly being 160mm in diameter. It is extremely well balanced, which makes it ideal for many applications. You will find its autofocus speed hard to comprehend, as it focuses as fast as your eye! But most of all, it is the beautiful, crisp images it delivers that make it a real standout in anyone's optical arsenal!

The **TC-14E** and **TC-20E** are the teleconverters made for the AF-I lenses. They are not meant for use with any other lens, as mounting these on any other lens will damage the teleconverter contacts. These teleconverters maintain full operation with the F4, N90, N90s, and N70 bodies and AF-I lenses.

The only exception is when the 600mm f/4 AF-I is used with the TC-20E, autofocus does not operate. The TC-14E (1.4x) sucks up one stop of light and the TC-20E (2x) sucks up two stops. Autofocus operation requires an effective f/stop of f/5.6 or faster. The 600mm f/4 AF-I on the TC-20E has an effective f/stop of f/8. This is beyond the range of the sensor, so it cannot work autofocus as a 1200mm.

These teleconverters do slow down autofocus speed. But the amount seems to vary. I've experienced very little while others complain it can be a problem.

In the fall of **1993** Nikon introduced four updates and three new lenses. Two of these new lenses are simply amazing. They were:

18mm f/2.8D AF
24mm f/2.8D AF
60mm f/2.8D AF Micro
105mm f/2.8D AF Micro
200mm f/4D EDIF AF Micro
35-80mm f/4-5.6D AF
70-210mm f/4-5.6D AF

The **18mm f/2.8D AF** is a beautiful lens! A total remake of the 18mm, this latest version receives the highest marks. It has a length of 2.3 inches (5.8 cm), an aperture range from f/2.8 to f/22, meter coupling, a filter size of 77mm, an angle of view of 100°, and a weight of 13.6 oz. (386 g). It has the crinkle finish of the ED telephotos and other newly designed "D" lenses. The 18mm has an aspherical element adding to the optical quality it delivers. This is the fastest ultra-wide in the Nikon lineup.

The **200mm f/4D EDIF AF Micro** is truly a gem of a lens! With its completely new design, this lens demonstrates that Nikon lens designers still deliver the best. It has a length of 7.7 inches (19.6 cm), an aperture range from f/4 to f/32, meter coupling, a filter size of 62mm, an angle of view of 12°, and a weight of 42.3 oz. (1,199 g). This amazing lens focuses down to 1:1 with a working distance (the distance between the front of the lens and the subject) of 10 inches (25.4 cm). It has an extremely sturdy built-in tripod collar, which provides 360° rotation. Its ED glass and overall optical design deliver blistering sharpness throughout its focusing range. It has IF focusing, which makes focusing quick while preventing

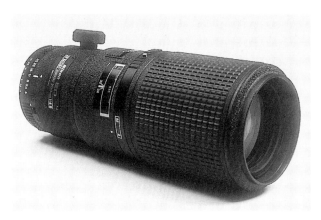

Nikkor 200mm f/4D EDIF AF Micro

the lens from expanding or contracting. The most amazing aspect of the lens is that it loses only 1-1/3 stop of light at 1:1! This lens quickly rocketed to the top of the charts with its performance and flexibility!

The **35-80mm f/4-5.6D AF** is a small lens designed to go with the N50 and N70. It has a length of 2.4 inches (6.1 cm), an aperture range from f/3.5 to f/22, meter coupling, a filter size of 52mm, an angle of view of 62° to 30°, and a weight of 9 oz. (255 g). It won't rock the world of photography, but it is a good little lens, especially for the travel photographer.

The **24mm f/2.8D AF, 60mm f/2.8D AF, 105mm f/2.8D AF,** and **70-210mm f/4-5.6D AF** were simple updates. They received only the "D" chip and no other additions. Refer to the previous descriptions of these focal lengths for specs. The 60D and 105D can be autofocused without changing the A-M switch, a new feature on these lenses.

In the fall of **1994** Nikon released three new lenses with "D" technology. They also brought out a long sought-after lens. They were:

20mm f/2.8D AF
28mm f/2.8D AF
85mm f/1.8D AF
500mm f/4D EDIF AF-I

The **500mm f/4D EDIF AF-I** was dreamed of ever since the release of the manual version. It has a length of 14.6 inches (37.1 cm), an aperture range from f/4 to f/22, meter coupling, a filter drawer accepting 39mm filters, an angle of view of 5°, and a weight of 9.2 lbs. (4.2 kg). This is another amazing lens like the 400mm f/2.8D EDIF AF-I. The images it delivers are blistering. Its tracking ability of moving subjects is lightning fast. Its balance is excellent, and its size makes it easy to use (as long

telephotos go). The only drawback is that it works with only the TC-14E and not the TC-20E. I have no doubt that this lens' popularity will be second only to the manual version 500mm f/4.

The **20mm f/2.8D, 28mm f/2.8D,** and **85mm f/1.8D** are like other "D" updates; these lenses just received the new chip. Refer to the previous lens descriptions for specs.

In the spring of **1995** Nikon brought out some new "D" updates with one total revision. They were:

35mm f/2D AF
180mm f/2.8D EDIF AF
35-105mm f/3.5-4.5D AF

The **35mm f/2D AF** and **180mm f/2.8D EDIF AF** are updates of the 35mm f/2 and 180mm f/2.8N AF, receiving only the "D" technology. Refer to the previous lens descriptions for specs.

The **35-105mm f/3.5-4.5D AF,** unlike other "D" updates, is a new lens. It features aspherical optics and IF focusing. It has a length of 2.7 inches (6.9 cm), an aperture range from f/3.5 to f/22, meter coupling, a filter size of 52mm, an angle of view of 62° to 23°, and a weight of 14 oz. (397 g). The new optics make it possible to have fewer elements while maintaining the same optical quality as the other 35-105mm lenses. It is smaller and lighter than the previous AF model.

In the summer of **1995** Nikon introduced its **50mm f/1.4D AF** lens. It is exactly like the 50mm f/1.4N AF, other than it now has "D" technology.

In the fall of **1995** Nikon brought out new technology in the introduction of two lenses:

28-80mm f/3.5-5.6D AF
80-200mm f/4.5-5.6D AF

The **28-80mm f/3.5-5.6D AF** was the start of a new line of ultra-compact, ultra-light lenses. It has a length of 2.7 inches (6.9 cm), an aperture range from f/3.5 to f/22, meter coupling, a filter size of 58mm (great, another oddball size), an angle of view of 71° to 30°, and a weight of 7.8 oz. (221 g). Its ultra-compact design is due to the aspherical elements incorporated into the lens, creating a very small package. This small lens is unique because it is one of the first to have a lens mounting ring constructed of a high-density plastic. It is also one of the first Nikkor lenses to be manufactured outside of Japan.

The **80-200mm f/4.5-5.6D AF** is meant to be a continuation of and companion to the 28-80. It has a length of 3.4 inches (8.6 cm), an aperture range from

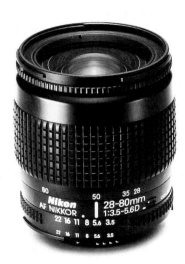

Nikkor 28-80mm f/3.5-5.6D AF

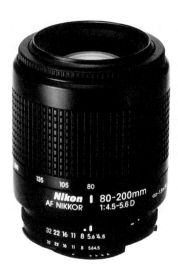

Nikkor 80-200mm f/4.5-5.6D AF

f/4.5 to f/32, meter coupling, a filter size of 52mm, an angle of view of 30° to 12°, and a weight of 11.6 oz. (329 g). All other aspects of this lens mirror those of the 28-80.

In the spring of **1996** Nikon introduced five new lenses. Two are updates of previous versions, but the three AF-S lenses are radical improvements over earlier models. They were:

85mm f/1.4D IF AF
300mm f/2.8D EDIF AF-S
500mm f/4D EDIF AF-S
600mm f/4D EDIF AF-S
24-50mm f/3.3-4.5D AF

The **85mm f/1.4D IF AF** is an update of the old tried-and-true manual 85mm f/1.4. It has more modern styling, and includes autofocus, internal focusing, and "D" technology. It has a length of 2.8 inches (7.1 cm), an aperture range from f/1.4 to f/16, meter coupling, a filter size of 77mm, an angle of view of 28.3°, and a weight of 19.6 oz. (556 g).

The 300, 500 and 600mm lenses have one thing in common, the Silent Wave Motor. The vast majority of the information concerning this new motor is proprietary. Nikon states that "Near silent operation is achieved with Nikon's new Silent Wave Motor Technology, which converts "traveling waves" into rotational energy to focus the optics." This internal lens motor is nearly silent, especially when compared to the AF-I motor. More importantly, its performance is faster. It is said that when used on the N90s these lenses are 15% faster than the AF-I lenses and 25% faster when used on the F5. To be honest with you, my eye cannot see the faster performance, but my images can!

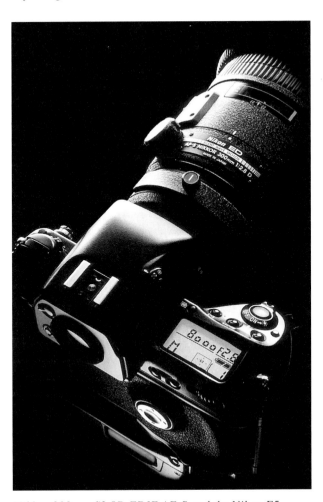

Nikkor 300mm f/2.8D EDIF AF-S and the Nikon F5

A note on cosmetics. The AF-S lenses have a very wide gold band near the end of the lens. While I think it's a bit much, it sure makes it easy to tell if someone is using one of these great lenses!

The **300mm f/2.8D EDIF AF-S** is one sexy lens. It has a length of 10 inches (25.4 cm), an aperture range from f/2.8 to f/22, meter coupling, a filter drawer accepting standard, threaded 52mm filters, an angle of view of 8.1°, and a weight of 6.6 lbs. (3 kg). While carrying on the same basic tradition of previous 300mm f/2.8 lenses, this lens really flies! Its smaller size and weight have endeared it to its users.

The **500mm f/4D EDIF AF-S** made a focal length already popular with wildlife photographers even more popular! It has a length of 14.6 inches (37.1 cm), an aperture range from f/4 to f/22, meter coupling, a filter drawer accepting standard, threaded 52mm filters, an angle of view of 5°, a weight of 8.125 lbs. (3.7 kg). While maintaining the same big, deep lens shade as the manual focus and AF-I versions, the 500mm AF-S is probably a tad sharper. You can see this best when using either the TC-14E or TC-20E. The TC-20E is technically not supposed to work with this lens, but in bright sun, I have found that it works just fine. However in marginal light, the light entering the lens and striking the sensor just doesn't have enough contrast to function correctly.

Nikkor 500mm f/4D EDIF AF-S

The **600mm f/4D EDIF AF-S** is the sweetest of all the 600s! It has a length of 17.5 inches (44.5 cm), an aperture range from f/4 to f/22, meter coupling, a filter drawer accepting standard, threaded 52mm filters, an angle of view of 4.10°, a weight of 12.8 lbs. (5.8 kg). The smaller size, better balance, and lightning-fast focusing speed really make this version the best of all. I don't know exactly how much faster the AF-S lens is compared to the AF-I model, but I can tell you that it locks on faster, allowing me to take a few more images than the AF-I lens. I am often asked

if one already owns an AF-I lens should one trade in and buy the AF-S version? In my opinion the extra little bit of speed you get is not worth the extra big bucks. But if you're buying your first big telephoto, go right to the top and buy the AF-S!

Nikkor 600mm f/4D EDIF AF-S

The **24-50mm f/3.3-4.5D AF** has the same specs as its original counterpart except it has "D" technology.

In the fall of **1996** Nikon introduced a lens that was radically new in appearance to any other Nikon lens. It was:

24-120mm f/3.5-5.6D AF

The **24-120mm f/3.5-5.6D AF** is an amazing lens, which took the photographic community by storm. It has a length of 3.14 inches (8 cm), an aperture range from f/3.5–5.6 to f/22, meter coupling, a filter size of 72mm, an angle of view of 84° to 20.3°, and a weight of 19.6 oz. (556 g). This pudgy lens, and I mean pudgy, is in reality a little dynamo of optics and performance. Its size, zoom range, and aperture range made buyers scratch their heads at first, but soon the lens was given glowing reports. Initially thought to be a Nikon "sleeper," the lens was soon bought up with such fury that it was quickly placed on the backorder list, and rightfully so. I find this lens to be an absolute delight to shoot. Its tremendous zoom range makes it a great "grab one lens that does it all" workhorse. I know a lot of shooters, from industrial to wildlife, who depend on this lens. It's perfect for when your big lens is too powerful, and when you do need to change to a bigger lens, its compact size makes it very easy to drop into a vest pocket. The only thing I've heard that folks don't like about this lens is its 72mm filter size, but that's required for the lens' construction. This is a two-ring zoom, one for focusing and the other for zooming. The zoom ring is

Nikkor 24-120mm f/3.5-5.6D AF

This lens is a true zoom. Once you focus the lens, it retains focus as you zoom. The 70-180 is a two-ring zoom, one for focus and the other for zooming. The zoom ring is nice and wide, easy to work when wearing gloves. This is great when shooting macro and you want to crop the subject just so. The working distance with this lens when at 180mm and focusing to its closest distance (providing just slightly less than 1:1) is about 5 inches. There is no "macro" setting like on other zooms, but it has a true macro focusing capability. And if you want to get even greater magnification, you can attach the 6T filter, which gives you nearly 2:1 magnification.

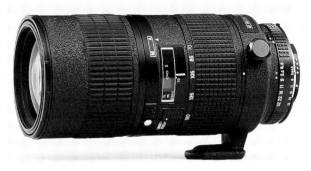

Nikkor 70-180mm f/4.5-5.6D ED AF Micro

nice and wide—easy to work when you're wearing gloves. If you're a traveler, serious shooter, or pro, you can't go wrong having this lens in your bag (that is, if you can find one)!

In the fall of **1997** Nikon introduced one new lens, and I'm glad they did. It was:

70-180mm f/4.5-5.6D ED AF Micro

From the first moment I mounted the **70-180mm f/4.5-5.6D ED AF Micro** on my F5, I had to own it. The reasons why, you'll soon see, are obvious. It has a length of 6.5 inches (16.5 cm), an aperture range from f/4.5–5.6 to f/32, meter coupling, a filter size of 62mm, an angle of view of 34.2° to 13.4°, and a weight of 34.9 oz. (989 g). Nikon introduced this lens as "the world's first autofocus zoom close-up lens." Nikon went on to say, "From Nikon's original idea of designing a new lens category—the zoom close-up lens—a lens has evolved that provides not just superb close focusing performance, but also a zoom range that is highly suitable for general photography." I have found this to be very true! This lens immediately replaced my 80-200mm f/2.8D AF in my bag for all of these reasons and more. The 70-180 is a small, seductive lens that fits easily in my vest pocket. It has a tripod collar, which makes it extremely easy to use in the field. The 62mm front element permits me to use my standardized filter size of 62mm. The ED glass delivers incredible image quality when shot wide open whether it's a macro subject or a big game animal shot from a distance.

Just as easily as going into macro mode with this lens, you can return to general shooting. This focal length is one of my favorites for shooting big game such as elk and mountain goats. The lens' performance when photographing such subjects is tremendous. It's for all of these reasons that the 70-180 instantly found a home in my camera bag. Having one lens that's so versatile, flexible, and of such incredible quality makes it a stand out in my book!

In the spring of **1998** Nikon introduced three new lenses. One was a complete makeover of an old classic, the other two are completely new to the Nikon lineup. They were:

400mm f/2.8D EDIF AF-S
28-200mm f/3.5-5.6D IF AF
70-300mm f/4-5.6D ED AF

The **400mm f/2.8D EDIF AF-S,** one of my favorite lenses was made a whole sweeter! It has a length of 13.9 inches (35.3 cm), an aperture range from f/2.8 to f/22, meter coupling, a filter drawer accepting standard, threaded 52mm filters, an angle of view of 6.1°, and a weight of 11 lbs. (5 kg). While I loved and once shot all the time with the manual version of the 400mm f/2.8, I never took the plunge to buy the

AF-I version, it was too front-heavy and just overall, too big. Well, Nikon went and pried some more money out of my already thin wallet when they came out with this latest, and to me best, version of the 400mm f/2.8.

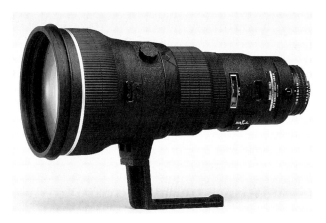

Nikkor 400mm f/2.8D EDIF AF-S

The first thing you'll notice with this lens is its size and weight reduction compared to the AF-I lens. Nikon actually has in one of their press releases "used hand-held," which gives you an idea of what we've got here. The lightweight design was achieved through the creation of a lighter optical system (less glass). The 400mm f/2.8 also uses advanced engineering resin and carbon fiber material for the lens' chassis (the parts that hold and move the glass). This construction, design, and material delivers the light weight we all like while maintaining the durable construction we demand from Nikon optics.

The 400mm f/2.8 is an AF-S lens. While the design of the Silent Wave Motor is still proprietary, we now have a measurement of its speed. This lens goes from infinity to 12.35 feet (3.8 m) (minimum focusing distance) in a mere 0.27 seconds! And if you plug an F5 onto this lens, boy does it fly!

I was fortunate enough to have both the AF-I and AF-S 400mm f/2.8 lenses at the same time to compare performance, but this is Nikon's slant on the subject: "The new lens incorporates a totally new optical design and upgraded construction. In brief, compared to the AF-I lens, the new AF-S lens has improved performance for correction of chromatic aberrations, improved flatness characteristics at the image-forming surface, improved picture blur characteristics with its rounder shaped 9-blade diaphragm, and improvements from its multi-layer Nikon Integrated Coating."

Building on the success of the 24-120, Nikon brought out another lens on nearly the exact same platform, the **28-200mm f/3.5-5.6D IF AF.** It has a length of 3.5 inches (8.9 cm), an aperture range from f/3.5–5.6 to f/22, meter coupling, a filter size of 72mm, an angle of view of 74° to 12.2°, and a weight of 19.6 oz. (556 g). A stubby giant like the 24-120, I have no doubt this lens will also be on the backorder list for some time to come.

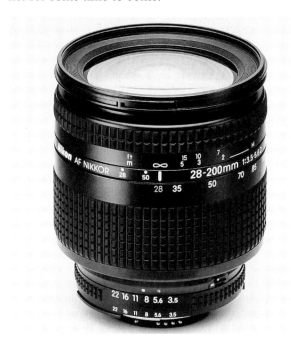

Nikkor 28-200mm f/3.5-5.6D IF AF

All the marvelous characteristics that the 24-120 has can be applied to the 28-200. However, this lens is slightly longer and not so wide as the 24-120, which suits many photographers who thought the 24-120 was too wide and not long enough. Being basically the same size and design as the 24-120, this lens fits easily into many vests and camera bags, and suits most any style of photography. This is a two-ring zoom, one for focusing (which is internal) and the other for zooming. The zoom ring is nice and wide, easy to work when wearing gloves. I have no doubt this lens will also be placed into that "sleeper" category of Nikon lenses.

An interesting addition to the Nikon lineup is the **70-300mm f/4-5.6D ED AF.** It has a length of 4.75 inches (12.1 cm), an aperture range from f/4–5.6 to f/32, meter coupling, a filter size of 62mm, an angle of view of 34.2° to 8.1°, and a weight of 18.7 oz. (530 g). It's really hard to say just where this lens

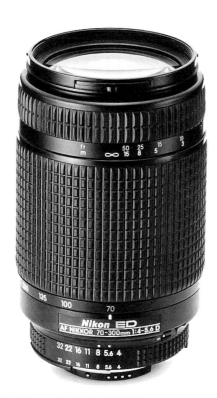

Nikkor 70-300mm f/4-5.6D ED AF

"lighter-weight" lens than the 75-300, the 70-300 has zoom and focus that are that good-old Nikon "stiff" that I like. The biggest thing to me, now that I've become an AF hog, is that the 70-300 focuses faster than the 75-300 when used on my F5!

Having a 62mm filter size means that all the filters I normally have in my vest pocket work with it, and I don't have to buy a new set. And its overall shorter length means that it's easy to carry around as a second lens in the vest pocket. I think that, for the price, this is a great lens you cannot go wrong with!

In the fall of **1998** Nikon introduced two lenses that are extremely exciting for the action photographer. They were:

28-70mm f/2.8D EDIF AF-S
80-200mm f/2.8D EDIF AF-S

The **28-70mm f/2.8D EDIF AF-S** is one truly magnificent lens! It has a length of 4.9 inches (12.45 cm), an aperture range from f/2.8 to f/22, meter coupling, a filter size of 77mm, an angle of view of 74° to 34.2°, and a weight of 33 oz. (935 g). Though announced in the fall of 1998, it was not placed on the market until spring of 1999.

This is a cool little lens. The first thing you'll notice is its focusing speed—it screams! That's

fits in. From the relatively low price and lighter feel of this lens, some might wonder about its quality. In terms of optics, I think it is a marvelous lens, delivering the quality we have come to expect from any lens bearing the Nikon name. I know many will be comparing this lens to the older 75-300. To be honest with you, my first impression when I saw this lens on the exhibition floor was not enthusiastic, to say the least. But after shooting with it and comparing it to the 75-300, I have to tell you I prefer this lens.

The 70-300 has ED glass, a feature that I think delivers better quality at the edges and wide open. The 70-300 is lighter, partly because of its design and partly because it does not have a tripod collar. I can see where some might not like that, but I have found the loss of the collar has caused me no operational problems. The biggest factor for me is that the 70-300 can focus approximately 5 inches closer than the 75-300. This doesn't sound like that big a deal, but when photographing a nesting bird, those 5 inches can make a world of difference. It has a two-ring zoom, one for focusing and the other for zooming. The zoom ring is nice and wide, easy to work when wearing gloves. This also means it won't slip back at 300mm like the 75-300 does, which is important if you're photographing flying birds. Though a

Nikkor 28-70mm f/2.8D EDIF AF-S

because it has the AF-S Silent Wave Motor. It focuses from infinity to its macro setting just about as fast as your eye can! Because of the lens' advanced technology, it has an M/A feature, which allows one to switch quickly from autofocus to manual, a feature I feel is very important in professional autofocus lenses.

The 28-70mm f/2.8 has one of the new generation of Nikon lens hoods. The HB-19 is a deep, scalloped shade that bayonets onto the front of the lens. This shade provides maximum protection for any focal length the lens is zoomed at. The one problem with the shade is that it is very deep; adjusting a filter such as a polarizer requires long, skinny fingers.

Along with speed, the 28-70 delivers outstanding image quality. The corner-to-corner, edge-to-edge performance of this lens is right up there with the best Nikkor lenses. You can use the TC-14E or TC-20E with this lens, but I'm not sure why you would. The only drawback to this lens is its steep price tag, and for that reason only I wouldn't recommend it to everyone. But if you want a tack-sharp, fast-focusing, wide-angle zoom that's sexy as heck, then this is a lens for you!

80-200mm f/2.8D EDIF AF-S

Probably one of the hottest lenses Nikon produced in the nineties is the **80-200mm f/2.8D EDIF AF-S.** It has a length of 8.1 inches (20.6 cm), an aperture range from f/2.8 to f/22, meter coupling, a filter size of 77mm, an angle of view of 30.1° to 12.2°, and a weight of 3.4 lbs. (1.56 kg). This lens sizzles in its box before you even open it up! In all honesty, I feel this is one of Nikon's finest optical designs, delivering images of incredible sharpness.

The 80-200mm f/2.8 AF-S incorporates Nikon's Silent Wave focusing motor technology. When this lens is attached to an F5 or F100, you'd best have your safety belt buckled, because it flies! With its

bright f/2.8 aperture and fast, quiet motor, the 80-200 locks on and stays locked on to the subject even in dim lighting situations. Of course, this is partly due to the camera it's attached to, but this performance is also enhanced by the lens design itself.

The 80-200 accepts the TC-14E 1.4x and TC-20E 2x teleconverters, giving it incredible versatility. While your depth of field isn't that great with the teleconverters attached, the optical quality is still outstanding. You might see a slow down of autofocus speed when using either teleconverter in lower light levels, but it's not serious.

The 80-200 has a removable tripod collar. Without the collar, the weight of the zoom is reduced by 4 oz. (113 g). When the collar is attached and the lens is mounted to a tripod, you will experience the only flaw this lens might have. When rotating the 80-200 in the tripod collar from vertical to horizontal or vice versa, you will notice a chatter. This is not the smoothest of actions, but since no one usually shoots while rotating the lens, I don't think it will matter much.

This lens has the same style deep, bayoneting lens shade as the 28-70mm f/2.8 AF-S. The HB-17 is one of the largest lens shades I've ever seen designed for a short lens. It provides great flare protection even when shooting towards the sun. You can shoot in the rain and not worry about the front element getting wet. But if you're using a polarizer and want to turn it, you'd best have chopsticks with you!

The original 80-200mm f/2.8 ED is bigger than this version of the 80-200. Anybody trading up will notice this. They will also notice the improved performance, especially in focusing speed. Will they see a difference in the optics? I think so, and even though it is very slight, there is a difference. Many people have asked me if it's worth trading up from the 80-200 f/2.8D ED AF to the 80-200mm f/2.8D EDIF AF-S. In my opinion, if you're depending on focusing speed to get the shot, you bet. But if you just want the AF-S because it's new, I wouldn't. I can tell you though, I wouldn't trade my 80-200 AF-S for anything!

In the spring of **1999,** along with the F100, a cool little lens was introduced. It was:

28-105mm f/3.5-4.5D IF AF

The **28-105mm f/3.5-4.5D IF AF** is another in a series of compact zooms ideally suited for the traveling photographer. It has a length of 3.3 inches (8.4 cm), an aperture range from f/3.5 to f/22, meter coupling, a filter size of 62mm, an angle of view of

74° to 23°, and a weight of 17 oz. (482 g). Its small, compact design along with its great zoom length makes it perfect for the one-lens traveler.

But what about its performance? I found that the lens delivers marvelously sharp, crisp images. In fact, the quality is surprising considering its zoom range, size, and reasonable price. I can see this lens being very popular with the average photographer who wants one lens for any situation.

In the fall of **1999** two lenses were released—one, long-anticipated, and the other, a totally new design for Nikon. They were:

17-35mm f/2.8D EDIF AF-S
85mm f/2.8D PC Micro

The **17-35mm f/2.8D EDIF AF-S** is a sweet lens! It has a length of 4.2 inches (10.7 cm), an aperture range from f/2.8 to f/22, meter coupling, a filter size of 77mm, an angle of view of 104°-62°, and a weight of 26.5 oz. (750 g). There's a lot packed into this small lens, which includes two glass mold aspherical, one compound aspherical, and two ED lens elements in its 13-element construction. I understand why the aspherical elements are part of the optical formula, but it's the ED glass that's puzzling to me. Whatever the reason, this lens delivers beautiful images!

The lens, though not technically rectilinear, does deliver straight line rendition throughout its entire zoom range. It is a true zoom, holding focus while you zoom as well as having IF (Internal Focusing). In other words, the lens does not lengthen or shorten when zooming or focusing. This is an AF-S lens, which means it has Nikon's lightning-fast motor. But even without that, the manual focus throw from infinity to the minimum focusing distance of 0.9 foot (27.4 cm) isn't even 90°! Unlike other AF-S lenses, the TC-14E or TC-20E cannot be used with the 17-35mm f/2.8, because when the lens is zoomed to 17mm, its rear element crashes into the teleconverter's front element.

This is not one of Nikon's sexiest lenses. It doesn't have the crinkle finish like the 28-70mm f/2.8 and 80-200mm f/2.8 AF-S. At best, its finish can be described as a muted crinkle finish. The only real drawback to the 17-35mm f/2.8 is that, when there is a light source in the frame, it flares just as easily as the 15mm f/3.5. But don't get me wrong, I added it to my camera bag. It's a gorgeous lens!

The **85mm f/2.8 PC Micro** is a lens that came from out of the blue! It has a length of 4.3 inches (10.9 cm), an aperture range from f/2.8 to f/45, no meter coupling, a filter size of 77mm, an angle of

85mm f/2.8 PC Micro

view of 28°30', and a weight of 27.3 oz. (775 g). The 85mm f/2.8 provides the photographer with the ability to tilt and shift the lens. The goal of these two capabilities is to permit the photographer to have the greatest control over depth of field possible. It can shift +/-0.49 inches (+/-12.4 mm) and tilt +/-8.3°.

This is a manual focus, not autofocus, lens. Because the lens barrel moves when it is tilted or shifted, autofocus is impossible. The lens provides 1:2 life-size magnification at a working distance of 1.3 feet (39.6 cm), and it incorporates CRC in its design. There is a CPU in the lens, which transmits effective aperture values to the camera body. This is useful for determining exposure when external exposure meters are used.

I have not personally seen the lens, so at this time I can't comment on its quality or provide functional hints on its operation.

Nikon Lens Production Dates

Lens	Introduced	Discontinued	Lens	Introduced	Discontinued
6mm f/2.8	1969	S.O.	50mm f/1.4N AF	1991	1995
6mm f/5.6	1972	1977	50mm f/1.4D AF	1995	S.I.P.
7.5mm f/5.6	1967	1971	50mm f/1.8	1978	1983
8mm f/2.8	1970	S.I.P.	50mm f/1.8N	1983	1990
8mm f/8	1963	1966	50mm f/1.8 E Series	1979	1986
10mm f/5.6 OP	1969	1976	50mm f/1.8 AF	1986	1989
13mm f/5.6	1976	1999	50mm f/1.8N AF	1989	S.I.P.
15mm f/3.5	1980	1999	50mm f/2	1959	1980
15mm f/5.6	1973	1979	55mm f/1.2	1965	1976
16mm f/2.8	1979	1998	55mm f/2.8 Micro	1982	1990
16mm f/2.8D AF	1993	S.I.P.	55mm f/2.8 Micro AF	1986	1989
16mm f/3.5	1973	1978	55mm f/3.5 Micro (pre-set)	1962	1963
18mm f/2.8D AF	1993	S.I.P.	55mm f/3.5 Micro		
18mm f/3.5	1982	S.I.P.	Compensating	1963	1964
18mm f/4	1974	1981	55mm f/3.5 Micro	1964	1978
20mm f/2.8	1985	1990	58mm f/1.2 Noct	1978	1998
20mm f/2.8 AF	1989	1994	58mm f/1.4	1959	1960
20mm f/2.8D AF	1994	S.I.P.	60mm f/2.8 Micro AF	1989	1994
20mm f/3.5 (72mm)	1969	1973	60mm f/2.8D Micro AF	1993	S.I.P.
20mm f/3.5 (52mm)	1979	1984	80mm f/2.8 AF	1983	1988
20mm f/4	1974	1978	85mm f/1.4	1982	S.I.P.
21mm f/4	1959	1967	85mm f/1.4D IF AF	1996	S.I.P.
24mm f/2	1978	S.I.P.	85mm f/1.8	1964	1977
24mm f/2.8	1967	1990	85mm f/1.8 AF	1988	1994
24mm f/2.8 AF	1986	1991	85mm f/1.8D AF	1994	S.I.P.
24mm f/2.8N AF	1991	1997	85mm f/2	1977	1988
24mm f/2.8D AF	1993	S.I.P.	85mm f/2.8D PC Micro	1999	S.I.P.
28mm f/1.4D AF	1993	S.I.P.	100mm f/2.8 E Series	1979	1981
28mm f/2	1971	S.I.P.	105mm f/1.8	1982	1999
28mm f/2.8	1974	1990	105mm f/2D AF DC	1993	S.I.P.
28mm f/2.8 E Series	1980	1986	105mm f/2.5	1959	S.I.P.
28mm f/2.8 AF	1986	1991	105mm f/2.8 Micro	1984	1990
28mm f/2.8N AF	1991	1994	105mm f/2.8 Micro AF	1990	S.I.P.
28mm f/2.8D AF	1994	S.I.P.	105mm f/2.8D Micro AF	1993	S.I.P.
28mm f/3.5	1959	1985	105mm f/4 Pre-set		
28mm f/3.5 PC	1981	S.I.P.	(Rangefinder)	1959	1961
28mm f/4 PC	1974	1980	105mm f/4 Bellows	1969	1976
35mm f/1.4	1970	S.I.P.	105mm f/4 Micro	1974	1984
35mm f/2	1965	1990	135mm f/2	1976	1997
35mm f/2 AF	1988	1995	135mm f/2 AF DC	1990	1997
35mm f/2D AF	1995	S.I.P.	135mm f/2D AF DC	1997	S.I.P.
35mm f/2.5 E Series	1979	1983	135mm f/2.8	1965	S.I.P.
35mm f/2.8	1959	1985	135mm f/2.8 E Series	1981	1984
35mm f/2.8 PC	1974	S.I.P.	135mm f/3.5	1959	1985
35mm f/3.5 PC	1961	1967	135mm f/4 Short Mount	1959	1967
45mm f/2.8 GN	1969	1977	180mm f/2.5 Short Mount	1955	1966
50mm f/1.2	1979	S.I.P.	180mm f/2.8	1970	1981
50mm f/1.4	1963	1990	180mm f/2.8 ED	1982	1989
50mm f/1.4 AF	1986	1991	180mm f/2.8 EDIF AF	1986	1988

Lens	Introduced	Discontinued
180mm f/2.8N EDIF AF	1988	1996
180mm f/2.8D EDIF AF	1995	S.I.P.
200mm f/2 EDIF	1980	1986
200mm f/2N EDIF	1986	S.I.P.
200mm f/3.5 EDIF AF	1983	1988
200mm f/4	1963	1990
200mm f/4 IF Micro	1981	S.I.P.
200mm f/4D EDIF Micro AF	1993	S.I.P.
250mm f/4 Short Mnt.	1955	1963
300mm f/2 EDIF	1984	1990
300mm f/2.8 ED	1975	1977
300mm f/2.8 EDIF	1978	1990
300mm f/2.8N EDIF	1986	1993
300mm f/2.8 EDIF AF	1987	1989
300mm f/2.8N EDIF AF	1989	S.I.P.
300mm f/2.8D EDIF AF-I	1992	1996
300mm f/2.8D EDIF AF-S	1996	S.I.P.
300mm f/4 EDIF AF	1987	S.I.P.
300mm f/4.5	1964	1990
300mm f/4.5 ED	1975	1978
300mm f/4.5 EDIF	1979	1989
350mm f/4.5 Short Mount	1958	1964
400mm f/2.8 EDIF	1985	S.I.P.
400mm f/2.8D EDIF AF-I	1994	1998
400mm f/2.8D EDIF AF-S	1998	S.I.P.
400mm f/3.5 EDIF	1977	S.I.P.
400mm f/4.5	1966	1979
400mm f/5.6	1973	1974
400mm f/5.6 ED	1975	1978
400mm f/5.6 EDIF	1978	S.I.P.
500mm f/4P EDIF	1988	S.I.P.
500mm f/4D EDIF AF-I	1994	1995
500mm f/4D EDIF AF-S	1996	S.I.P.
500mm f/5 Short Mount	1955	1961
600mm f/4 EDIF	1979	S.I.P.
600mm f/4D EDIF AF-I	1992	1996
600mm f/4D EDIF AF-S	1996	S.I.P.
600mm f/5.6	1964	1978
600mm f/5.6 ED	1975	1978
600mm f/5.6 EDIF	1978	1986
600mm f/5.6N EDIF	1986	S.I.P.
800mm f/5.6 EDIF	1986	1999
800mm f/8	1964	1978
800mm f/8 ED	1975	1978
800mm f/8 EDIF	1979	1989
1200mm f/11	1964	1978
1200mm f/11 ED	1975	1978
1200mm f/11 EDIF	1982	1988

Zooms

Lens	Introduced	Discontinued
17-35mm f/2.8D EDIF AF-S	1999	S.I.P.
20-35mm f/2.8D IF AF	1993	S.I.P.
24-50mm f/3.3-4.5 AF	1988	1996
24-50mm f/3.3-4.5D AF	1996	S.I.P.
24-120mm f/3.5-5.6D IF AF	1996	S.I.P.
25-50mm f/4	1980	1985
28-45mm f/4.5	1974	1977
28-50mm f/3.5	1984	1986
28-70mm f/2.8D EDIF AF-S	1998	S.I.P.
28-70mm f/3.5-4.5 AF	1991	1992
28-70mm f/3.5-4.5D AF	1992	S.I.P.
28-80mm f/3.5-5.6D AF	1995	S.I.P.
28-85mm f/3.5-4.5	1986	1990
28-85mm f/3.5-4.5 AF	1986	1990
28-85mm f/3.5-4.5N AF	1991	S.I.P.
28-105mm f/3.5-4.5D IF AF	1999	S.I.P.
28-200mm f/3.5-5.6DIF AF	1998	S.I.P.
35-70mm f/2.8 AF	1988	1992
35-70mm f/2.8D AF	1992	S.I.P.
35-70mm f/3.3-4.5	1985	1989
35-70mm f/3.3-4.5 AF	1986	1989
35-70mm f/3.3-4.5N AF	1989	1999
35-70mm f/3.5	1978	1984
35-70mm f/3.5-4.8	1996	S.I.P.
35-80mm f/4-5.6D AF	1993	S.I.P.
35-85mm f/2.8	1960	1961?
35-105mm f/3.5-4.5	1984	1990
35-105mm f/3.5-4.5 AF	1986	1991
35-105mm f/3.5-4.5N AF	1991	1995
35-105mm f/3.5-4.5D AF	1995	S.I.P.
35-135mm f/3.5-4.5	1985	1989
35-135mm f/3.5-4.5 AF	1986	1990
35-135mm f/3.5-4.5N AF	1990	1998
35-200mm f/3.5-4.5	1986	S.I.P.
36-72mm f/3.5 E Series	1982	1984
43-86mm f/3.5	1963	1981
50-135mm f/3.5	1984	1985
50-300mm f/4.5	1965	1980
50-300mm f/4.5 ED	1978	S.I.P.
70-180mm f/4.5-5.6D ED Micro AF	1997	S.I.P.
70-210mm f/4 E Series	1982	1986
70-210mm f/4 AF	1986	1988
70-210mm f/4-5.6 AF	1988	1993
70-210mm f/4-5.6D AF	1993	S.I.P.
70-300mm f/4-5.6D ED AF	1998	S.I.P.
75-150mm f/3.5 E Series	1980	1984

Lens	Introduced	Discontinued
75-300mm f/4.5-5.6 AF	1989	1998?
80-200mm f/2.8 ED	1983	1986
80-200mm f/2.8 ED AF	1988	1992
80-200mm f/2.8D ED AF	1992	1999
80-200mm f/2.8D EDIF AF-S	1998	S.I.P.
80-200mm f/4	1982	1990
80-200mm f/4.5	1970	1981
80-200mm f/4.5-5.6D AF	1995	S.I.P.
85-250mm f/4	1969	1973
85-250mm f/4-4.5	1959	1969
100-300mm f/5.6	1984	1990
180-600mm f/8 ED	1974	S.O.
200-400mm f/4 ED	1984	1988
200-600mm f/9.5 ED	1977	1981
200-600mm f/9.5-10.5	1963	1976
360-1200mm f/11 ED	1974	1981
1200-1700mm f/5.6-8P EDIF	1993	S.O.

Medical Nikkors

Lens	Introduced	Discontinued
120mm f/4 Medical	1981	S.I.P.
200mm f/5.6 Medical	1963	1984

Mirror Nikkors

Lens	Introduced	Discontinued
500mm f/5	1963	1969
500mm f/8	1969	1984
500mm f/8N	1984	S.I.P.
1000mm f/6.3 Short Mount	1958	1965
1000mm f/11	1965	1976
1000mm f/11	1977	S.I.P.
2000mm f/11	1969	S.O.

Teleconverters

Lens	Introduced	Discontinued
TC-1	1976	1981
TC-2	1976	1983
TC-14	1979	1983
TC-14A	1984	S.I.P.
TC-14B	1984	S.I.P.
TC-14C	1984	1990
TC-14E	1993	S.I.P.
TC-16 for F3 AF	1984	1987
TC-16A AF	1986	1991
TC-20E	1993	S.I.P.
TC-200	1977	1983
TC-201	1984	S.I.P.
TC-300	1977	1983
TC-301	1984	S.I.P.

These dates represent the years the lenses were introduced and discontinued in the U.S. market. Introductions in other parts of the world often pre-date these dates. In many cases, actual release dates were later than the introduction dates. Discontinuation dates are as accurate as the author can determine, since many lenses are discontinued without public knowledge.

S.I.P.: Still in Production
S.O.: Made by Special Order Only

Serial Numbers for Original and New (N) Versions of Nikkor Lenses

AF Lenses			AIS Lenses		
Lens	*Non-N*	*N*	*Lens*	*Non-N*	*N*
50mm f/1.8 AF	2000000	3000001	200mm f/2 EDIF	178501	200001
180mm f/2.8 EDIF AF	200001	250001	300mm f/2.8 EDIF	609001	620001
300mm f/2.8 EDIF AF	200001	300001	500mm f/8	501001	183201
35-70mm f/3.3-4.5 AF	2000001	3000001	600mm f/4 EDIF	178001	200001
35-70mm f/3.3-4.5			600mm f/5.6 EDIF	178501	200001
(Non-AF Model)	2000001		1000mm f/11	111001	142361
35-135mm f/3.5-4.5 AF	200501	300001			
70-210mm f/4 AF	200001	*			

* Became 70-210mm f/4.5-5.6 AF

Serial Numbers and Metering Coupling Updates for Nikkor Lenses

Fixed Focal Length Lenses

Lens	*Non-AI*	*AI*	*AIS*
6mm f/2.8	NA	628001	629001
6mm f/5.6	656001	NM	NM
7.5mm f/5.6	750011	NM	NM
8mm f/2.8	230011	242001	243001
8mm f/8	880101	NM	NM
10mm f/5.6 OP	180001	NM	NM
13mm f/5.6	175021	175055	175901
15mm f/3.5	NM	177051	180001
15mm f/5.6	321001	340001	NM
16mm f/2.8	NM	178051	185001
16mm f/3.5	272281	280001	NM
18mm f/3.5	NM	NM	180051
18mm f/4	173111	190001	NM
20mm f/2.8	NM	NM	200001
20mm f/3.5 (72mm)	421241	NM	NM
20mm f/3.5 (52mm)	NM	176121	210001
20mm f/4	103001	130001	NM
21mm f/4	220111	NM	NM
24mm f/2	NM	176021	200001
24mm f/2.8	242803	525001	700001
28mm f/2	280001	450001	575001
28mm f/2.8	382011	430001	635001
28mm f/2.8 E Series	NM	NM	1790601
28mm f/3.5	301011	1760201	2100001
28mm f/3.5 PC	179121 (NMC)		
28mm f/4 PC	174041 (NMC)		
35mm f/1.4	350001	385001	430001
35mm f/2	690101	880001	920001
35mm f/2.5 E Series	NM	NM	1780801
35mm f/2.8	255311	773111	521001
35mm f/2.8 PC	851001/1st version	900001/2d version	179091/ current

Lens	Non-AI	AI	AIS
35mm f/3.5 PC	102105	NM	NM
45mm f/2.8 GN	710101	NM	NM
50mm f/1.2	NM	177051	250001
50mm f/1.4	314101	3940001	5100001
50mm f/1.8	NM	1760801	2050001
50mm f/1.8N	NM	NM	3135001
50mm f/1.8 E Series	NM	NM	1055001
50mm f/2	520101	3500001	NM
55mm f/1.2	184711	400001	NM
55mm f/2.8 Micro	NM	NM	186211
55mm f/3.5 Micro (pre-set)	171529	NM	NM
55mm f/3.5 Compensating	171513	NM	NM
55mm f/3.5 Micro	211001	940001	NM
58mm f/1.2 Noct	NM	172011	185001
58mm f/1.4	140051	NM	NM
80mm f/2.8AF	NM	NM	182011
85mm f/1.4	NM	NM	179091
85mm f/1.8	188011	410001	NM
85mm f/2	NM	175111	270001
100mm f/2.8 E Series	NM	NM	1780701
105mm f/1.8	NM	NM	179091
105mm f/2.5	194011	740001	890001
105mm f/2.8 Micro	NM	NM	182061
105mm f/4 (pre-set)	NA (NMC)		
105mm f/4 Bellows	910001 (NMC)		
105mm f/4 Micro	174011	186956	232001
105mm f/4.5 UV	NA	NA	NA
120mm f/4 Medical	180041 (NMC)		
135mm f/2	175011	190001	201001
135mm f/2.8	163011	770001	900001
135mm f/2.8 E Series	NM	NM	180031
135mm f/3.5	720101	193501	290001
180mm f/2.8	312011	360001	NM
180mm f/2.8 ED	NM	NA	380001
200mm f/2 EDIF	NM	176111	178501
200mm f/3.5 EDIF AF	NM	NM	182501
200mm f/4	169211	710001	900001
200mm f/4 Micro IF	NM	178021	200001
300mm f/2 EDIF	NM	NM	182121
300mm f/2.8 ED (pre-set)	603011 & 604011 (NMC)		
300mm f/2.8 ED	NM	605101	609001
300mm f/4.5	304501	510001	550001
300mm f/4.5 ED	NM	190001	NM
300mm f/4.5 EDIF	NM	200001	210001
400mm f/2.8	NM	NM	NA
400mm f/3.5 EDIF	175121	176091	181501
400mm f/4.5	400111 (NMC)		
400mm f/5.6	256031	NM	NM
400mm f/5.6 ED	260001	261178	NM
400mm f/5.6 EDIF	NM	280001	287601
600mm f/4 EDIF	NM	176121	178001
600mm f/5.6	600111 (NMC)		

Lens	Non-AI	AI	AIS
600mm f/5.6 ED	650001 (NMC)		
600mm f/5.6 EDIF	176011	176091	178501
800mm f/5.6 EDIF	NM	NM	200001
800mm f/8	800111 (NMC)		
800mm f/8 ED	850001 (NMC)		
800mm f/8 EDIF	NM	178041	179001
1200mm f/11	120011 (NMC)		
1200mm f/11 ED	150001 (NMC)		
1200mm f/11 EDIF	NM	178051	179001

Zoom Lenses

Lens	Non-AI	AI	AIS
25-50mm f/4	NM	178041	201001
28-45mm f/4.5	174011	210001	NM
28-50mm f/3.5	NM	NM	183021
28-85mm f/3.5	NM	NM	NA
35-70mm f/3.5 (72mm)	NM	760701	821001
35-70mm f/3.5 (62mm)	NM	NA	NA
35-85mm f/2.8	352801	NM	NM
35-105mm f/3.5-4.5	NM	NM	1820869
35-135mm f/3.5-4.5	NM	NM	NA
35-200mm f/3.5-4.5	NM	NM	NA
36-72mm f/3.5 E Series	NM	NM	1800701
43-86mm f/3.5	438611	810001	NM
50-135mm f/3.5	NM	NM	811001
50-300mm f/4.5	740101	980001	NM
50-300mm f/4.5 ED	NM	175111	183001
70-210mm f/4 E Series	NM	NM	2000001
75-150mm f/3.5 E Series	NM	NM	1790801
80-200mm f/2.8 ED	NM	NM	181091
80-200mm f/4	NM	NM	180081
80-200mm f/4.5	101911	270001	NM
85-250mm f/4	184711	NM	NM
85-250mm f/4-4.5	157911	NM	NM
100-300mm f/5.6	NM	NM	183051
180-600mm f/8 ED	NM	174041	174701
200-400mm f/4 ED	NM	NM	182121
200-600mm f/9.5	170111	305001	NM
200-600mm f/9.5 ED	NM	NA	305001
360-1200mm f/11 ED	NM	170431	174701

AI: Automatic Indexing
AIS: Automatic Indexing-Shutter

NA: Not Available
NM: Never Manufactured
NMC: Never Meter Coupled

Nikon Accessories— The Evolution

As the rangefinder camera systems evolved, Nikon recognized the importance of having a complete system of accessories to complement their cameras and lenses. By developing a complete line of accessories to aid the photographer in solving photographic problems, Nikon created an almost limitless horizon of photographic possibilities. Starting with the F, the company spent as much time developing system accessories as lenses and bodies. This dedication has resulted in the extensive systems available today. The "pro" models have always had the widest assortment of accessories. They were designed to be "custom outfitted" with accessories, providing them with the flexibility and problem-solving capabilities required by pro photographers. At the same time, the other "non-pro" bodies have their own unique accessories, providing them with a greater depth to their functions.

F Accessories

The F, with its slide-down back design, utilized a motor drive very similar to that used on the rangefinder cameras. The motor drive for the F is the **F-36.** It can utilize two different portable power sources, the **Cord Pack** and the **Cordless Battery Pack.** The F-36 motor unit is the same in either case and was originally fitted to the body at the factory. It was later sold separately by dealers.

There is a special **Motor Drive Plate** required that is fitted to the base of the camera. If you look at the base of the camera when the back is off, you will see a three-inch long plate. This standard plate is solid with curved ends fitting around the film chambers. The Motor Drive Plate looks like the standard plate except that it has two holes at one end and a lever on the underside of the plate. These holes and lever function to synchronize the body's film transport and mirror box operation with that of the F-36 motor cocking mechanism. It is possible to add an F-36 to an F that was not factory mated, but there is only a 50-50 chance that it will sync properly. If the units fail to do so, a repair technician must be found to make the internal adjustments required to sync the F and F-36 (regardless of the power supply).

The **Standard Battery Case** (known by most as the Cord Pack with Connecting Cord) uses six C batteries and connects to the F-36 via a connecting cord (3-foot [0.9 m] or 30-foot [9.1 m] length available). The top of the battery pack has a firing button that operates as a remote cable release, with settings for "S" (single frame firing), "C" (continuous frame firing), or "L" (lock). The F-36 also has a firing button on its back at the center of the motor drive. The outside ring of the firing button sets the F-36 to either "S," "C," or "L" (the same as the settings on the battery pack). Directly to the right of the firing button on the motor drive is the frame counter, which counts down the number of frames left on the roll. When a fresh roll of film is inserted into the camera, the thumb dial must be turned manually in the direction of the arrow to reset the counter to "36." Once the counter hits "0," the drive stops firing and must be reset before it will fire again. This dial can also be set to another number if a limited burst of shooting is desired.

To the left of the firing button is the firing rate dial, which must be set to match the shutter speed in use. There is a chart printed on the back of the F-36 that provides the correct setting for the firing rate and relates it to the shutter speed. If not correctly synchronized, the firing speeds and shutter speeds may not be correct and there is a possibility of damaging the shutter mechanism itself. There is also the possibility of damage to the film transport system. The shutter speed range for each firing rate provides enough room so that constantly changing the firing rate is not required.

When the Cordless Battery Pack is added, the motor drive gains a number of features. An additional handle on the right side of the body makes for easy handling. There is a firing button on the top of the handle for easier firing operation. This button has a locking collar. There is a white "S/C" (single or continuous frame) toggle switch on the side of the handle that overrides the S/C function ring surrounding the firing button on the back of the drive. This switch is rather large and sticks out. It can be hit easily, changing the setting by accident. The camera can be fired by either

the F-36 rear firing button or the one on the Cordless Battery Pack. In either case you must still have the firing rate set on the back for proper operation.

The Cordless Battery Pack comes in two models. The second model has a feature that the first model lacks. It has a front locking rod located on the handle directly under the firing button, which screws in tightly against the camera body, providing greater strength in mating the two units.

Nikon made special film cassettes to be used with the motorized F. The **F Cassette** is a reloadable 36-exposure cassette that works only in the F body because its film gate is operated by the O/C key on the F's back.

The F-36's top speed is 4 fps (frames per second) with the mirror on the body locked up. In the early sixties, this was considered fast. To do any remote work, a **Relay Box** is needed, which boosts the power signal to the drive from the remote device. This same relay box is required when using the **Intervalometer (NC-1), Nikon Wireless Control (Model 2), Special AC Unit (MA-1),** or when doing extremely remote work using a number of connecting cables linked together. This same relay box is used when operating the F-250, 250-exposure film back.

The **F-250 Exposure Back** uses the same F-36 motor drive, but it is permanently mounted to the base of the F-250 chassis. The Cordless Pack cannot mount on the F-250, so the Standard Battery Case is the only portable power supply. The F-250 requires two **MZ-1 250-Exposure Cassettes** containing a maximum of 33 feet of film. One cassette contains the unexposed film, while the other is the take-up for the exposed film. The first approximately 12 inches (30.5 cm) of film are lost in loading the film from one cassette to the other. The loading process must be done in the daylight to feed the leader properly through the film gate into the take-up cassette. There are special gates on the MZ-1 that are operated by the control knobs on the F-250. These knobs open and close the cassette's film gates, preventing the film from fogging during the loading process (when the gates are closed).

Nikon makes a **Bulk Film Loader** (which can be used only in a darkroom) for loading the MZ-1 directly from bulk film. The Bulk Loader can be

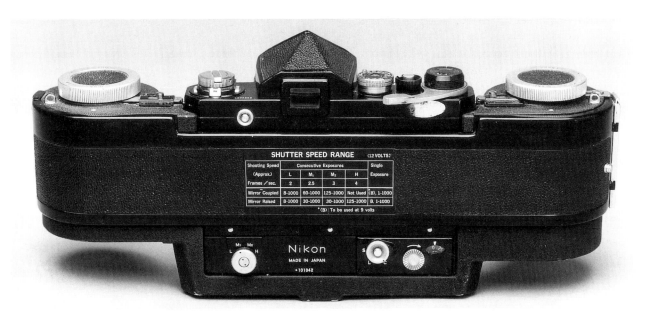

F-250 Exposure Back

pre-set to load 36 to 250 frames of film. Practice is required to use this loader before going into the dark. The Bulk Loader comes with an extra bulk film spool, which can be removed if the purchased bulk film comes on its own reel.

There are two **Pistol Grips** for the F, one model for firing a non-motorized body and a second for firing a motorized body. The first pistol grip has a cord that connects it directly to the camera's shutter release button. The motorized pistol grip can be set up in one of two ways: either with one cord going from the standard battery pack to the pistol grip and another cord to the motor, or with one cord going directly from the pistol grip to a cordless pack. The difference depends on the portable power source, the cordless battery offering the simplest system.

The **AR-2 Cable Release,** made for the F, is an extremely well-made 9-inch (22.9 cm) release with a locking plunger that fits the special Nikon cable release threads.

The Nikon F is also capable of doing large-format photography with the aid of the Speed Magny system. Depending on the model of Speed Magny, it can produce an image that's 3-1/4" x 4-1/4" or 4" x 5". The **Speed Magny Model 100** works only with Polaroid film types 107 and 108 (with a magnifying ratio of 3.2:1), while the **Speed Magny Model 45** has a Graflex back for 4" x 5" film holders (with a magnifying ratio of 4.1:1). Not all lenses work with this system; some focal lengths cause severe vignetting. The Speed Magny also changes the effective focal length of the lens in use by as much as 200%.

The Speed Magny is an awkward system at best. The slide-down back of the F is removed, and the F body is mounted directly to the Speed Magny (a large, bulky, and clumsy unit). When the picture is taken, the light passes through the camera lens, through the film gate, and bounces off an optical mirror set at an approximate 45° angle. This light then bounces down through a magnifying relay lens (an EL Nikkor 50mm f/2.8 enlarging lens). The enlarged light path hits another optical mirror at 45°, bouncing off and then striking the film. During this process, four stops of light are lost.

The F had 14 interchangeable viewing screens when it was first introduced, and more were added to the system later, bringing the total to 22 (see pages 141 to 143 for a listing, as the nomenclature has not changed). The F also has viewfinder aids, the **Right-Angle Finder** and the **Eyepiece Magnifier.** The Right-Angle Finder provides 90° of relief. The camera can be on the ground, for example, and with the Right-Angle Finder, it is possible to view through the camera. The Right-Angle Finder provides complete screen viewing, but the Eyepiece Magnifier does not. It only magnifies the center portion of the screen. It is a small tube that comes straight back from the finder, providing no angle of relief. It is a critical focuser, used in situations such as macro shooting when focusing can be difficult.

When these attachments are used with the original F **Eyelevel Finder,** an adapter is required to convert the rectangular shape of the prism to a round hole. This rectangular design was later dropped (just prior to the release of the F2) when all finder view ports were converted to round holes. The F has other interchangeable finders, which are described in the *Bodies* chapter. There are other prism accessories such as the **SF-1 Ready Light Adapter** and F **Hot Shoe Adapter.** They allow ISO flash units to be mounted to the body and sync without the use of a PC cord.

Eyecups are available for the F to aid in keeping extraneous light from hitting the eyepiece. And diopters were made for those who wear prescription eyeglasses but don't want to wear them when using the camera. However, the diopters and eyecup originally manufactured for the F have been discontinued. The replacement eyepiece for the FA and its **Eyecup DK-3** can be used on the F, as can the F3 eyepiece and **Eyecup DK-4.**

The F was probably the most custom-modified camera ever made by Nikon. Coming as it did early in the development of the modern photographic system, it was subject to much experimentation and modification. Many of these modifications were done at the factory as custom orders (rarely done today), some were done by independent technicians. Many of these modified cameras are available on the used market but are not mentioned in this book. This is one reason why the F camera is now becoming quite collectible.

Nikkormat Accessories

The Nikkormats do not have as many accessories as the F, since they were designed with simplicity in mind. They share with the F the same Right-Angle Finder, Eyepiece Magnifier, and the cable release AR-2. The Nikkormats also share eyecups and diopters with the F since the eyepiece diameter and eyepiece-to-camera-back distances are the same. The only accessory specifically for the Nikkormats (and it is for the FT and FTn only) is the **Accessory Shoe.** This allows a flash to be mounted to the camera above the eyepiece but doesn't provide for hot shoe connection.

The flash still must be plugged into the PC socket for operation. The Nikkormat accessory line did not change until the ELw and EL2 came on the market. Then a winder, the **AW-1,** was introduced. This is a simple winder that advances the film as fast as the shutter release button is depressed.

F2 Accessories

When the F2 came on the market, an exciting new array of accessories came with it. Nikon probably spent as much time designing the accessories for the F2 as they did the F2 itself. The most prized accessories for the F2 were the motor drives.

Three different motor drives were manufactured for the F2, the MD-1, MD-2, and MD-3. The **MD-1** was introduced first and is exactly the same as the **MD-2** except for two features: the MD-1 is missing two contacts on the back of the drive that mate with the MF-3 back, and its SC (single/continuous) firing button is a large, square lever. This was later changed on the MD-2 to a smaller, round firing button (the SC button of the MD-2 detaches and can be used on the MD-1). The MD-1 was replaced within two years by the MD-2.

The most common power source for the MD-1 and MD-2 is the **MB-1 Battery Pack.** It can accept either ten AA batteries (held in two **MS-1 Battery Clips**) or two optional **MN-1 NiCds** (nickel cadmium batteries), which require the **MH-2 Charger** to recharge. The MB-1 is the standard battery pack for the MD-2, because its greater voltage gives the MD-2 a faster firing rate. The MB-1 with AA batteries has a top speed of 4 fps. The MN-1 NiCd provides 5 fps.

MD-2 Motor Drive with MB-1 Battery Pack

The MB-1 can be attached directly to the MD-2 or via the **MC-7 Cord.** This permits the MB-1 to be kept warm in your pocket for cold-weather operation, for example. There is also an AC power source, the **MA-4,** and a cold-weather **Battery Pack Jacket MA-3** that connects to the motor drive via an **MC-2 Cord.**

The MD-1 and MD-2 can also be powered by the **MB-2 Battery Pack,** which uses eight AA batteries (held in two **MS-2 Battery Clips**). It provides only 2.7 fps. (The MB-2 is standard with the MD-3, in keeping with its physically lighter weight.)

Note: The battery holders for the MB-1, the MS-1, have long been discontinued and are hard to find. This also holds true for the MS-2 battery holders for the MB-2.

Attaching the MD-2 to the F2 body requires the removal of the O/C key on the base of the camera. A spot on the inside of the MD-2's handle accepts the O/C key so it can't get lost when the camera is attached to the motor drive. There are no other modifications required to attach the F2 body to the MD-2, a vast improvement over the F.

The MD-2 has a power film rewind. There is a lever with a button in its center located on the back right of the motor drive (next to the film counter). Depress the button in the middle of the lever, then push the lever up. This clears the film counter on the MD-2 while disengaging the film take-up spool. On the far left of the MD-2 is a button surrounded by two levers. To rewind the film, push the small button while cocking the right-hand lever to the right. The lever to the left of the button opens the camera back. Lift it up and slide it to the left.

Like the F-36, the MD-2's film counter dial can be set to fire off either the whole roll of film or a given number of frames. The MD-2 also has a firing rate dial on the back, which must be set (like that on the F-36) to match the shutter speed with the fps rate. The outer ring of the dial pulls out from the drive, enabling it to be turned and set.

The SC button (the firing button) on the top of the handle of the MD-2 controls the firing functions. The "S" (single frame), "C" (continuous), and "L" (lock) features are the same as those on all Nikons. The SC button can be removed by depressing the two little buttons on the side of the drive handle and pulling up. The SC button can then be attached to the 10-foot **MC-1 Cord** (or 33- and 66-foot SC Connecting Cords) for remote firing (one end of the MC-1 goes into the handle of the MD-2). There is also a terminal on the front of the drive that accepts the **MC-10**

Cord (10 feet [3 m] long with its own firing button) for remote firing.

The **MD-3 Motor Drive** is a simplified unit with a slower firing rate than the MD-2. It has no automatic film rewind, and because of this it has a smaller price tag than the MD-2. There is no need to remove the O/C key from the body when connecting the MD-3 with a body. The flange of the O/C key folds down and slips into a slot in a ring on the MD-3. This ring turns when released by a button, opening the camera back. There is no firing rate converter on the MD-3, which always provides a consistent sequential firing rate no matter what the power source. It provides 3.5 fps with the MB-1 powered by AA batteries, 4 fps with MN-1 NiCds, and 2.5 fps with the MB-2 attached. The MD-3 was sold with the MB-2 because it was meant to be a lighter outfit providing simple performance. The MD-3/MB-2 weighs 5.4 oz. less than the MD-2/MB-1. The MD-3 uses the same remote units as the MD-2, except it does not accept the MC-1 cord.

The MC-1 fires the drive in the mode set on the SC button, as does the MC-10 when it is in use. The **MC-3 Cable** and the **MR-1 Button** attach to the terminal on the front of the drive and provide a second firing button as well as a port for the AR-2 cable release. Later the **MR-2** would take the place of the MR-1, providing the same function.

Other remote firing devices are the ML-1 Infrared Remote, the MW-1 Radio Remote, the MT-1 Intervalometer, and the Pistol Grip II. The ML-1, MW-1, and MT-1 are unique remote triggering systems that only Nikon could have developed. The **ML-1 "Modulite"** is an infrared wireless remote with a transmitter and receiver unit. They work via modulated light signals and are powered by AA batteries, four in each unit. The receiver stays with the camera and is connected to the camera's motor drive via the **MC-8 Cord.** It has a range of 200 feet (61 m). This is a line-of-sight unit, limited by the requirement of keeping the transmitter and receiver within sight of one another.

The **MW-1** is a solid-state radio control remote firing system capable of firing up to three motorized cameras. It works on a CB band (no permits are required) at 80 megawatts, hence the name MW-1. The transmitter can operate from up to 2,300 feet (700 m) away from the receiver and does not have to be within sight of it. Powered by AA batteries, each unit requires eight. (Folks said using these units would set off garage door openers for blocks!)

The **MT-1 Intervalometer** can fire a motorized camera at precise intervals and is powered by eight AA batteries for remote use. The trick with this unit is to calculate and set the timing interval desired. It

has a pulse setting and a frame setting. The pulse setting regulates the number of frames fired and is related to the shutter speed and firing rate of the motor drive. The MT-1 cannot easily be set to fire three frames every five minutes. Rather, experimentation with the pulse and frame settings is required to achieve the desired firing rate. It can work in conjunction with the MW-1.

The F2 accepts a number of accessory backs. The **MF-3 Rewind Stop Back** attaches to the camera, and when used in conjunction with the MD-2 (not the MD-1), it stops the film rewinding process, leaving a two-inch leader of film sticking out of the cassette.

The **MF-1 250-Exposure Back** requires the MD-2/MB-1 to drive and power it. Unlike the F-250, it does not contain its own motor drive. The MF-1 can shoot up to 250 exposures (33 feet [10 m] of film) and uses the same MZ-1 cassettes as the F-250.

Mounting the MF-1 to the camera is a slow procedure. First, the camera back must be removed from the F2. Then the F2 and MD-2 (minus the battery pack), need to be connected and fitted into the base of the MF-1. This is locked into place via a lever on the side of the MF-1, which closes a flange onto the camera body. Next the power lead of the MF-1 is plugged into the base of the MD-2's handle. Finally, the MB-1 is attached to the base of the MF-1, which powers the whole assembly.

The **MF-2 750-Exposure Back** can expose as many as 750 exposures in three minutes. It requires the **MZ-2 750-Exposure Cassette** that accepts an entire 100-foot (30 m) roll of film. There is no need for a bulk loader, since the bulk film can be placed directly into the cassette. The MF-2 has a cutter built into the unit, which allows smaller amounts of film to be fired and removed from the back. It mounts in the same fashion as the MF-1. The MF-2 is a rare unit; very few have ever come into the country. The MF-1, on the other hand, seems rather common.

The **MF-10 Data Back** came with a matched F2 body, MD-2/MB-1 motor drive, and **AH-1 Hand Strap.** The combined setup is known as the **F2 Data.** The F2 body is not specially modified to accept the MF-10. It does come with an S screen, which shows where the data will be imprinted on the film. It has a small (removable) masking plate located on the right side of the shutter opening frame. It creates a shadow on the picture where info can be imprinted.

The MF-10 imprints the date (via the Dating Unit), the time (via the Timepiece Unit), and a hand-written message (via the Memo Plate). The Timepiece Unit is a little clock that slips into the side of the MF-10 right above the Dating Unit. The camera triggers the

MF-10 into action via a cord connected to the PC socket, firing the back in the same manner that it fires a flash. The **MF-11** is the data back for the MF-2 750-exposure back, performing the same functions as the MF-10. Both the MF-10 and MF-11 are rare units, very hard to find except in private collections.

The F2 has a Speed Magny system similar to that of the F. The **Speed Magny Model 100-2** is the same as the Speed Magny 100 for the F but accepts the F2 body. The **Speed Magny Model 45-2** accepts a 4 x 5 film holder.

DR-3 Right-Angle Finder

The F2 has interchangeable prisms (described in the *Bodies* chapter) and screens. The screens are the exact same as those for the F. It also accepts the Right-Angle Finder and Eyepiece Magnifier. During the production of the F2, the Right-Angle Finder was replaced by the **Right-Angle Finder DR-3,** a nicer unit with a lockable diopter correction. The F2 has the **DL-1 Illuminator** available for the **DP-1 and DP-11 Meter Heads.** It attaches to the eyepiece and goes over the prism to shine a small wheat lamp over the metering needle. This enables the photographer to see better in order to make meter readings when viewing through the prism in low light.

FM and FE Accessories

The FM was the first non-pro body to be "motor-ized." The **Motor Drive MD-11** has a clean design with the battery box incorporated into the entire drive (it was the first not to have a separate battery holder). The batteries are contained in the base of the drive,

and a well-formed handle extends up the right side. The firing button and mode selector switch (marked "S" and "C") are on top of the handle. At the base of the handle is a terminal socket that accepts the same remote firing devices used by the MD-2.

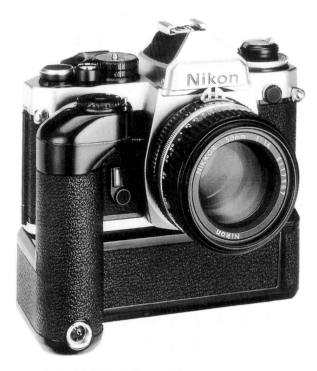

Nikon FM with MD-11 Motor Drive

The MD-11 screws into the tripod socket on the base of the FM. The MD-11 offers 3.5 fps advance but no automatic film rewind. It uses eight AA batteries and is turned on by a switch on the back of the motor. As long as the motor drive remains on, the camera's meter is on, so the camera's batteries can drain during operation if care is not taken.

It is advised that you turn the power off before removing the drive from the camera! If the camera is removed from the motor drive with the power switch on, it is possible to short out the drive and charge the winding mechanism, cocking it halfway through its cycle. This causes the motor to lock up and not function. However, if this does occur, the drive can be reset by using a quarter to short out the four brass contacts on the drive. When done properly, the motor makes a sound and the winding key turns, stopping when it is parallel to the length of the drive. Cock and fire the camera and place it back on the drive. They should both be in sync now. Test it by firing off one frame. Remember to set the collar surrounding the

FM's shutter release for motorized operation. This applies to early model FMs. Refer to the FM section of the *Bodies* chapter for more information.

The FE also accepts the MD-11, but it was replaced with the **MD-12** shortly after the FE came out. Some improvements were made to the MD-12, such as a strengthened hand grip and a microswitch that shuts the camera's meter off after 16 seconds. To turn the meter back on, depress the firing button on the drive. This is a battery-saving feature. Be sure to shut the MD-12 off when it is not in use. If the camera is placed in a camera bag with the drive left on, the firing button may be hit as the camera is jostled in the bag, which would keep the meter active and drain the batteries.

The FE accepts the **MF-12 Data Back** that imprints the date/time or a two-digit frame number. This is connected to the camera via a connecting cord plugged into the PC socket. The connecting cord is the weak link and is often lost or broken. It can still be obtained, but not without a lot of agony. The MF-12 has an external battery pack available, the **DB-3.**

EM, FG, FE2, FM2, and FA Accessories

The EM has its own winder, the **MD-E,** which advances the film at 2 fps with no film rewind. It is a small unit that fits under the EM. The EM can also utilize the **MD-14 Motor Drive** made for the FG. The FG's own specialized motor drive, the MD-14, delivers 3.2 fps on the "HI" setting and 2 fps on "LO" when attached to the FG, however the higher speed (3.2 fps) is not available to the EM. The handgrip on the FG must be removed to attach the MD-14, otherwise no other modifications are necessary. There is no firing button on the MD-14. The shutter release button on the body is used to fire the camera when this drive is attached. There is also no film rewind with the MD-14.

The FG has the **MF-15 Data Back**. The MF-15 can imprint the date/time or a sequential number up to 2,000. The MF-15 also has a quartz clock and an alarm feature. It does not require an auxiliary cord to make the connection between the back and body. It fires via contacts on the inside of the back and body, which mate when the back is closed.

The FM2 and FE2 use the same motor drive as the FE and FM, the MD-12. Neither body requires any special modification to accept the drive. Removing the body from the drive with the drive's power on can

cause problems. Refer to the section on the MD-11 for the cure for when the drive is out of cycle. The MD-12 accepts all the accessories that remotely fire the MD-2.

The FE2, FM2, and FA all accept the same data back, the **MF-16.** It can imprint the date and time or a sequential number up to 2,000. There is no cord required between the back and body because the contacts are built into the body. The FA can accept the MD-12 motor drive, but it only provides motorized operation and meter-off microswitch features.

MF-16 Data Back

The FA's special motor drive is the **MD-15.** Attaching the MD-15 requires that the handgrip and the small cap on the base of the FA be removed. There is a small hole on the MD-15 to hold the cap once it is removed from the body so it won't be lost. The MD-15 powers (with eight AA batteries) both the

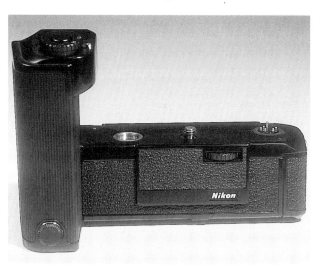

MD-15 Motor Drive

camera's as well as its own operations, so batteries do not need to be installed in the camera for operation.

The MD-15's design is different from previous small drives made by Nikon. The base portion (the built-in battery box) is slightly kicked out for better balance when handheld. It fires up to 3.2 fps and has an SC switch. The firing button has a microswitch like that of the MD-12 that turns off the camera's meter after 16 seconds to save batteries.

F3 Accessories

Nikon developed an assortment of accessories for the F3 to increase the versatility of this pro model camera. The **Motor Drive MD-4** was a masterful design that utilized many new advances in technology. It can deliver 5.5 fps in normal operation with eight AA batteries and 6 fps with the mirror locked up using the **MN-2** rechargeable NiCd (requiring the **MH-2** for charging). When the motor drive is attached, this source powers all functions of the F3 body.

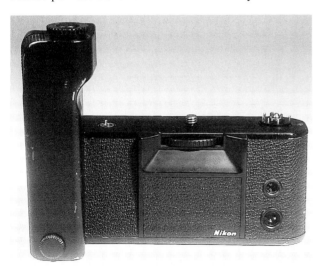

MD-4 Motor Drive

To attach the MD-4 to the F3, the small motor drive cap on the base of the F3 must be removed. The cap can then be stored in a small slot in the **MS-3** AA battery holder or MN-2 NiCd. The MD-4 has an "S," "C," and "L" collar around the firing button, which is at the top of the handle. These functions are the same as previously mentioned. The MD-4 does not need an additional battery pack, since one is built into the motor drive. The battery compartment is slanted out, giving the F3 incredible balance. The tripod socket was placed on the far right-hand side of the drive to prevent it from jamming into the battery. The camera-

motor drive assembly can be centered on a tripod, though, by attaching the **AH-2** or **AH-3** tripod adapter plate.

AH-3 Tripod Adapter Plate

The operation of the MD-4 is very clean and easy. The few controls it requires are on the back of the motor drive. The drive can rewind the film in a two-step operation. First, the lever near the center (on the back of the MD-4) marked "1" must be disengaged by pushing in a button; then push the lever. Next, push up the lever on the far left marked "2." This starts the film rewinding. This must be terminated manually by pushing the number "2" lever back to its original position when the film has been rewound. Two red LEDs on the back of the MD-4 serve as a battery check (two lights mean there is full power); one light lights up every time the cam-era is fired. When using the camera remotely, this light confirms visually that the camera has been fired.

There is also a subtractive frame counter like those on the MD-2, MD-3, and F-36. It operates similarly but has been improved with the ability to be neutralized. Simply turn the counter until the orange circle is aligned with the arrow and the counter is locked. This permits unlimited firing without the need to reset the counter. Otherwise, using the dial to set the counter to a certain number permits the camera to fire only that set number of frames.

The F3 has the **MF-4 250-Exposure Back.** Nikon never introduced a 750-exposure back for the F3. The MF-4 gets its power from the MD-4 via a connection at the base of the drive's handle. The MF-4 is a lot easier to attach to the camera than any previous 250-exposure back. Just remove the back from the camera and attach the MF-4. It slips into place with the MD-4 attached to the F3. It is held into place with a bar that swings into place after a lever is pressed. It uses the MZ-1 film cassette and has the same basic operation as the MF-1 250-Exposure Back.

The **MF-17** is the data back for the MF-4. This is a clone of the MF-11 data back system, which was

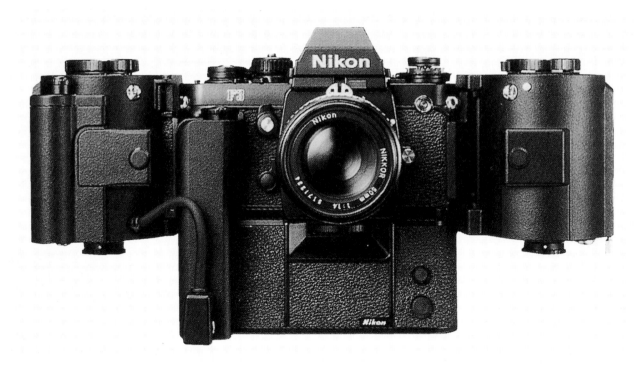

MF-4 250-Exposure Back

modified to fit the MF-4. There are three other backs for the F3, the MF-6 (and later the MF-6B with changes that are unknown), MF-14, and MF-18. The **MF-6B** (originally called the MF-6) if attached to the F3 with the MD-4, leaves the film leader sticking out of the cassette after the film has been rewound.

The **MF-14** is a data back that imprints date and time or sequential numbers up to 2,000 in the lower right-hand corner of the film frame. The **MF-18** does the exact same thing, but imprints between the frames rather than on the film frame. The MF-18 can also leave the leader out of the cassette once the film is rewound. On the MF-6B or MF-18, this leader control can be canceled by placing a small piece of electrical tape on the two gold contacts above the frame counter on the MD-4.

The MD-4 has one additional accessory, the **MK-1** Firing Rate Converter. The MD-4 does not have a firing rate button on the back of it like the F-36 or MD-2, because the MD-4's computer sets the firing rate automatically according to the shutter speed in use. For times when exact firing rates are required, the MK-1 is needed. It attaches to the base of the MD-4, plugging into the same terminal as the MF-4. The MK-1 can be set to fire the camera at either 1 fps (C1), 2 fps (C2), 3 fps (C3), or neutral (CS). It also centers the tripod socket like the AH-2 and AH-3.

One other accessory plugs into the terminal at the base of the handle, the **Connecting Cord MC-17** or **MC-17S.** When plugged into the MD-4, either allows two motorized cameras to be fired simultaneously. There is a slight delay of milliseconds in the firing, just enough to disallow the use of one flash for both cameras. The MC-17S is 15 inches (38 cm) long and the MC-17 is 10 feet (3 m) long.

In the mid-1980s, the accessory cord to fire the motor drives was changed. The **MC-12** is a 10-foot (3 m) remote release cord that plugs into the remote terminal of motor drives. It replaced the MC-10. It has a two-pole switch that activates the meter when pushed halfway down and when pushed all the way

MC-12A Remote Control Cord

down, fires the camera. This in turn, was replaced with the **MC-12A,** similar to the MC-12 but with a locking button to lock it in the firing position for time exposures and a 90° plug that goes into the motor drive. The AR-2 cable release was replaced with the **AR-3** (9 inches [23 cm] long). This is the standard cable release with a locking collar. The MR-2 was replaced by the **MR-3,** the only difference being that it accepts a standard cable release.

N2000 and N2020 Accessories

With the introduction of the N2000 and N2020 cameras, a number of accessories were changed slightly so that they could fit not only the cameras they were intended for, but also these two new models. All connecting cords for the accessories received an "A" after their name (e.g., MC-3A), signifying that they work with the automatic cameras. They all have a 90° plug that goes into the motor drive.

The **MW-2 Radio Remote** was introduced at this time. It is smaller and lighter in design than the MW-1. The transmitter and receiver are powered by four AA batteries, reducing their weight and operating range. The operating range is also reduced by the single-action, two-pole switch. Partially depressing this switch focuses an autofocus camera; fully depressing it fires the camera. It can still fire up to three cameras and retains the other features of the MW-1.

MF-19 Multi-Function Data Back

The **MF-19 Multi-Data Back** is a new style of data back introduced with the N2000 and N2020. The MF-19 has five possible imprint fields. It can print a sequential number from 1 to 99,999 or year/month/day/hour/minute. It has a built-in intervalometer that

can be set to take a specific number of frames at a specific interval. It can be set to take a picture at the same time each day for up to 99 days. Though apparently desirable, this feature has one drawback, which is a function of the camera itself. Although the N2000 and N2020 are excellent cameras, there is some slack in the transport of film across the film plane. They cannot deliver exact film registration of the same image from frame to frame.

N8008 and N8008s Accessories

With its internal computers the N8008 changed everything, and accessories would never be the same again! The basics, such as the MW-2, MT-2, and other units and cords did not change, but the camera backs revolutionized the capabilities of the photographer. The **MF-20 Data Back** is pretty basic with simple date/time/year imprinting.

The **MF-21 Multi-Control Back**, however, excited the photographic community with its remarkable capabilities. It has data imprinting, an interval timer, long time exposure, autoexposure bracketing, freeze focus, and the option of combining these functions.

Nikon N8008 with MF-21 Multi-Control Back

The key to successful use of any data back, especially a multi-control back such as the MF-21, is setting the original data correctly. The display should show the correct day/month/year (or a combination of these) or day/hour/minute. This is accomplished by first pushing the MOD button until a date setting appears on the display. Then push the SEL button until the desired digits are reached. The field blinks to indicate that it has been selected. Next push the ADJ

button to adjust to the correct number. This same method is used to reset any of the available functions.

Two important symbols are found on the LCD of the MF-21, a solid bar and a triangle. If the solid bar appears beside a function, it means that that particular function has been selected; if the bar appears with the triangle beside a function, that function has been activated. By pressing the PRN button, the "PRINT" message appears on the MF-21's LCD, and the current data imprints on the film. Be aware of that message; it can be set by accident and ruin a good photograph. This text is not meant to replace the instruction book (which should be read for a complete explanation of all functions), but is designed to clarify some points and suggest others.

The Interval Timer (known by some as an intervalometer) on the MF-21 is an excellent tool that can be applied to many photographic problems. The MF-21 can be set to take a specific number of frames at specific intervals. For example, it can be set to take two frames every five minutes to photograph a sunrise, or one frame every two hours to document the construction of a building. Access the interval timer by pressing the FNC button until the solid bar appears to the right of the "INTERVAL" message on the LCD panel. Then press the MOD button so the message "INT TIME" appears. The SEL and ADJ buttons are then pressed to set the desired settings. There are specific parameters in which the interval timer will not function. Such things as setting frames per shooting to "00" and setting the shutter speed dial to "bulb" prevent the interval timer from functioning. Once all the information is set and the cam-era is ready to take the photograph, press the S/S button to activate the camera and start the interval timer. Press the S/R button to cancel the function. It is very important to read Nikon's instruction book for correct operation of the interval timer.

Long Exposure is used to make timed exposures longer than 30 seconds (which is the longest shutter speed that can be set on the camera itself). Setting a long exposure is similiar to setting the interval timer. The same parameters apply for correct operation.

If operating the camera remotely or when using the long exposure mode with the MF-21, remember to attach the Eyepiece Cover DK-8. This prevents light from entering through the eyepiece and altering the meter reading, which could cause exposure errors.

Autoexposure Bracketing on the MF-21 is an excellent feature (but is not meant to make up for bad photographic technique). The MF-21's autoexposure bracketing can be set to fire 3 to 19 frames (in odd numbers) at increments of 0.3, 0.5, 0.7, 1.0, 1.3, 1.7, and 2.0 stops of compensation. The number of frames the camera can take is directly related to the bracketing compensation desired. If the number of frames or amount of compensation are dialed in improperly as they relate to each other, the camera defaults to firing three frames. When the back is set to "AUTO BKT" and the S/R button is pressed, the triangle blinks in the LCD. This indicates it is ready to go. When the film advance of the N8008 or N8008s is set to "CH" or "CL," the camera fires off the set number of frames. It counts down on the MF-21's LCD the number of frames left to be exposed through autoexposure bracketing. Once finished, the autoexposure bracketing triangle stops blinking to indicate it has completed the bracketing. If the N8008 or N8008s's film advance is set to "S," each frame will be exposed one frame at a time until the set number of frames has been fired.

The Freeze Focus function (Focus Priority) on the MF-21 first appeared on the MF-19. Freeze focus is directly connected to the autofocus function in the N8008 and N8008s. Without one there cannot be the other. Once the Freeze Focus function is selected on the MF-21, select either the "C," "S," or "M" focus mode ("M" is recommended) on the camera and focus on the subject. Remember, the camera is working off the two small autofocus brackets at the center of the viewing screen. The subject must break the plane of focus set at that point in order for the camera to fire. The subject cannot just be in the frame, but actually must pass through the sensor indicated by the small bracket box in the viewfinder. Press the shutter release to activate the system.

Here are a few recommendations for operating the MF-21. When a number of exposures over a long period of time are desired, use the MC-12A cord to activate the system, using the lock on the MC-12A to keep the system activated for the entire time (otherwise a finger must be used to trigger the shutter over the entire exposure period). The camera's film advance needs to be set at either "CH or "CL" for this to work. With the MC-12A cord in use and set on "lock," the camera's electronic system is activated and drawing battery power. A word of warning, though: If the camera is left for eight hours or more in this mode, the batteries in the body could be drained, closing the shutter, and canceling all functions.

F4, F4s, and F4e Accessories

The F4 pro body has a host of sophisticated, problem-solving accessories never before manufactured

for a camera. There are three accessory backs for the F4, the MF-22 Data Back, MF-23 Multi-Control Back, and MF-24 250-Exposure Back. The **MF-22** is a basic data back with features similar to those of other units.

The **MF-23 Multi-Control Back** is a real jewel, with many of the same basic features as the MF-21. The MF-23 has the following functions: data imprinting, an interval timer, exposure delay, long time exposure, daily alarm, freeze focus, film alarm, film stop, autoexposure bracketing, and any combination of these features. These functions are operated by a small control panel on the back of the MF-23. Setting the main system date starts here. As on the MF-21, you must set the date and time properly to ensure correct operation of all other features. This description does not try to replace the instructions supplied with the MF-23. However, it does try to clarify and add to those instructions for ease of operation.

The MF-23 has an indicator "bar" that travels around its LCD display as functions are selected. The bar resides beside the function that has been selected. As with the MF-21, the MF-23 has a triangle that appears opposite the function that is currently in use.

Auto bracketing is activated by pressing the "BKT" button on the back of the MF-23. This calls up a long, two-section bar with a "+" and "-" sign (a "+/-" compensation signal lights up inside the finder when it is activated). The left bar with the "+" sign indicates overexposure and the right bar with a "-" sign indicates underexposure. The center, "main" value of compensation and the amount of over- or under-compensation on either side of that "main" value can be set to match your needs.

The number of frames taken at either over- or underexposure can be set as well—two under or three over, for example, or any other combination that meets your needs. As with the MF-21, the number of frames that can be exposed relates directly to the amount of compensation set. With the MF-23 a compensation range of from -7.7 to +7.7 in third-stop intervals is available. Once the desired compensation is set (see pages 92 to 96 of the MF-23's instruction book), the bar displays the number of frames to be fired. A number is indicated for both the over- and under-compensation values (to either side of the "main" compensation value). Also, the amount of compensation for the first frame and the amount of compensation for the entire range are displayed. With the camera set to either "CH" or "CL," all the exposures are fired off in one burst for quick action.

Using autoexposure bracketing can be confusing the first time. Test runs are recommended before using it in the field. Many photographers set up the bracketed exposure values that they use most often and leave them set in the back. Then when it's needed, they simply select autoexposure bracketing, activate it, and fire. Afterwards, they turn off the function and continue on with their shooting. The most common setting is: one frame 1/3 stop overexposed, one right on, and one 1/3 stop underexposed.

The MF-23 can imprint data during any of these various functions, but careful reading of the instruction book is required to activate data imprinting while a function is in use. The MF-23 has the ability to imprint the data on either the film frame itself or between the frames. Like all other functions, data imprinting must be selected and activated to operate. It is possible to have the shutter speed and aperture in use imprinted between the frames. This can be an extremely valuable tool, but remember if shooting slide film, the printed data is hidden inside the slide mount. There is a variety of data that can be imprinted in the same manner. Consult the instruction book for the numerous data sets that can be imprinted.

The Interval Timer function on the MF-23 operates basically the same as that on the MF-21. The specific interval between camera firings and the number of frames shot can be set to the photographer's requirements. There are a number of parameters that must be met for proper operation of the interval timer. See the instruction manual to avert pilot error (a nice way of saying photographer screw-up). The Exposure Delay function works like that of the MF-21, taking the exact same number of frames at the exact same time each day. With either of these functions, make sure the eyepiece curtain is closed to avoid incorrect exposures.

Long Time Exposure permits extremely long exposures to be made by an unattended camera. This function can be used for photographing things such as star trails in which hours of exposure are required. The shutter speed must be set manually to "B" in the manual mode for this function to work. Exposures can be set for periods as long as 999 hours. With the **MB-20** battery compartment there are only four hours of battery life, and only six hours with the MB-21. I've had the MN-20 NiCd battery unit last as long as eleven hours used in long time exposure. Remember, since the camera's in "bulb" and not "T," the batteries are being drained during the entire exposure.

The Freeze Focus function (Focus Priority) on the MF-23 operates along the same lines as that on the MF-21. Press the FNC button until the bar is to the right of "FCS PRIOR" on the LCD panel. Next, make sure the focus mode is set to "M" on the body (and

the lens as well if using a lens with an A or M switch). Now press the S/R button activating the Freeze Focus function, which causes the triangle to come up on the LCD. Next, focus the lens manually (remembering that the plane of focus must be broken for the camera to fire). Finally, all that is needed is to depress the shutter release button and the system will be activated. As with the MF-21, the MC-12A has a locking button that can be used to operate the F4s (or any of the F4 series cameras) and MF-23 combination unattended for long periods of time. The camera will be in this mode until the S/R button is pressed and the triangle on the LCD disappears. (This is required to change film.) As long as the triangle is on, the camera cannot be fired manually.

The Freeze Focus function is touchy, working off information from the electronic rangefinder of the F4. Once the system is in place and operating, it should be checked through focusing to see that it will fire at the point selected. Use something with contrast, such as the MF-23 instruction book with its white cover and black letters (which should be carried for emergency review). Place it where the camera is focused to fire. If the camera fires when this is done, it has been set correctly. If it does not, start the whole procedure over. When the subject is seen going in front of an unresponsive camera, remember that the subject must pass through the detection area exactly to make the camera fire.

Trying to capture a moving subject can be very frustrating! The subject has to pass precisely through the center brackets seen through the viewfinder in order for the camera to fire. If the subject's size is not adequate, even passing through the brackets does not guarantee that the camera will fire. And if the subject should be low in contrast or have lines the camera's AF sensor cannot detect, the camera will not fire. Though this function has some exciting potential, a lot of experimentation is required to get it to perform on cue. With the F4s/MF-23 set up in this fashion and left unattended, approximately seven hours of battery life are possible with the MB-21 (with fresh batteries) or ten hours with the MN-20. If an entire roll of 36 exposures won't be exposed during that period of time and more exposures are needed, using a long-life NiCd hooked up to the camera via the MB-22 and MC-11A is advised.

The Film Alarm can audibly warn the photographer when a pre-set number of frames is left in a roll to be shot. The number at which the warning sounds is set by the photographer. For example, an audible warning can be set at 34 frames. This informs the photographer that there are only two frames of film remaining. The Film Stop is a related function, letting the photographer set the number of frames to be fired during one burst of shooting. Once the camera has fired that set burst, the shutter locks and an audible alarm notifies the photographer.

The LCD display on the MF-23 provides a lot of information when activated. When the shutter release button has been pressed, the back displays all its information for 16 seconds. It shuts off when the F4 shuts off, either by the internal 16-second clock or turning the camera off manually. If the display on the MF-23 goes off sooner than that (especially within seconds), it means the batteries in the F4 and not

MF-24 250-Exposure Multi-Control Back

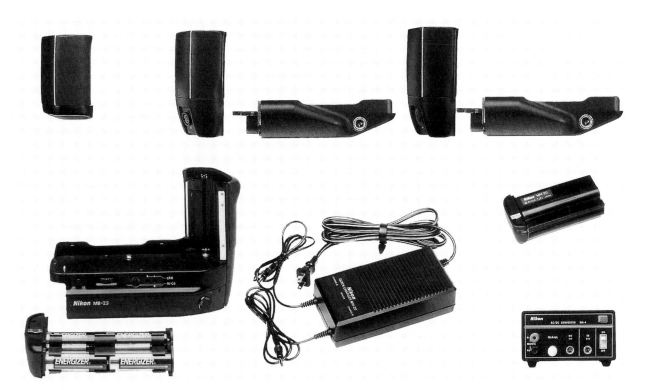

Some of the power accessories for the Nikon F4 are (clockwise, from top left) MB-20 Reserve Battery Pack, MB-21 High Speed Battery Pack, MB-22 Battery Pack, MN-20 NiCd Battery Pack, MA-4 AC/DC Converter, MH-20 NiCd Battery Charger, and MB-23 Multi-Power High Speed Battery Pack.

those in the MF-23 are going dead. If that is the case, pressing the battery check on the MB-21 can easily determine if it's the camera.

When activated, the MF-23 displays: 1) the shutter speed in use, 2) the f/stop selected if using a lens that has a CPU connected *directly* to the body (an extension tube or teleconverter breaks this connection, so when they are in use, two dashes replace the f/stop readout), 3) the number of frames fired, 4) the date, and 5) the time. It also displays the functions that are in operation. Functions can be combined so that multiple functions can be done at once, but careful reading of the instruction book is required. It is strongly suggested that the photographer study the function(s) before putting the back into use in the field.

The **MF-24 250-Exposure Multi-Control Back** is the epitome of 250-exposure backs. It has all the multi-control functions of the MF-23 plus it incorporates a 250-exposure magazine. (It uses the same MZ-1 250-exposure cassettes originally introduced with the F-250.) This makes it an incredible tool for many applications. The one drawback is that it is very expensive and relatively hard to find. Its applications, though, are many, mostly centering around

remote camera work. It is powered by the **MB-23 Battery Pack,** which accepts the **MN-20 NiCd Battery Unit.**

All the remote firing devices (MC-12A, MW-2, and MT-2) work with the F4s and F4e, but not with the F4 with its MB-20 battery compartment attached. That is because only the MB-21 and MB-23 have the socket necessary to connect the cords. The F4 does not have the electrical remote socket that is part of the MB-21 and MB-23 unit.

F4 Power Accessories

The **MB-22** is a power system unique to the F4. It is made up of the grip portion of the MB-21 (**MB-21G**) and its own bottom portion (**MB-22B**). The terminals in the base enable it to be connected to the MA-4 AC/DC converter power source, which converts 120v AC to 15v DC. This is ideal for use on the F4 in the studio or in scientific situations when the camera is stationary.

In 1990 Nikon introduced the **MB-23 Battery Pack** and MN-20 NiCd to power the F4. The MB-23 is a one-piece unit with a battery clip (**MS-23**) that holds six 1.5v AA batteries. There is a button on the MB-23 that releases the MS-23 clip from the MB-23.

There is a detent to prevent the battery tray from dropping out when removed from the MB-23. This detent seems to weaken within a short period, so be cautious when changing the MS-23 or MN-20 so that the tray does not fall out prematurely. This single battery tray feature does make replacing batteries quick and easy.

The MB-23 gives the F4 a higher profile and adds 4.1 oz. of weight compared to the F4/MB-21. The battery pack portion of the MB-23 is metal; the handgrip is rubberized. Both have an anatomical design for horizontal and vertical firing. The MB-23 has a vertical firing button on its lower right corner. There is a lever around the firing button, which functions as a lock. When pushed and the red dot is exposed, the firing button is active. It attaches as a single unit to the F4 via a thumb wheel on the MB-23. The MB-23 also has a terminal for the MF-24, MC-12A, and other remote firing devices. It has a centered 1/4"-20 tripod socket.

The **MN-20 NiCd** is for use in the MB-23. The MN-20 NiCd takes the place of the MS-23 (and its AA batteries), providing greater power and performance at low temperatures. A single charge should last long enough to expose 150 rolls (this is a conservative number). You can expect the MN-20 to accept at least 100 recharges during its life (I've found this to be pretty accurate). You'll be able to tell when it is time to buy a new one when the current NiCd runs down after firing just a few rolls of film.

MH-20 NiCd Battery Charger, MN-20 NiCd Battery Pack

The **MH-20 Charger** is a high-tech charger for the MN-20. It is capable of charging two MN-20s at a time. It first charges the MN-20 connected to lead "A," and when finished, charges the second on lead "B." Both MN-20s are charged within three hours. After fully charging the NiCds, the MH-20 goes into a trickle mode so the batteries can be left connected to the MH-20 without damaging the cells. When first introduced, the MH-20 was said to "discharge" the NiCd before recharging. This has been found to be incorrect. The MH-20 has no facility for discharging the NiCd.

The MB-23 can also be powered via the **DB-6 External Battery Pack** and **MC-28 Connecting Cord.** One end of the MC-28 inserts into the MB-23 while the other plugs into the DB-6. The DB-6 runs off six D-size batteries, providing power for cold conditions or extended shooting times.

The newest addition in remote firing devices came in 1990, the **ML-2.** It is basically an autofocus version of the ML-1—an infrared-emitting, light-triggered remote control for motorized, compatible cameras. Both transmitter and receiver run on four AA batteries. The transmitter can have as many as 4,500 flashes with alkaline batteries (the flashes being what triggers the receiver to fire the camera). The receiver can run up to 200 hours on standby (waiting to be triggered by the transmitter). The recycling time of the transmitter is 1/2 second once fired. Unlike the ML-1, the ML-2 has three channels, making it capable of firing three cameras individually. Its range is 100 meters (109 yards), and it is possible to bounce its beam in operation. Shutter release lag time is one millisecond after triggering the transmitter. Light burst duration is ten milliseconds.

N90 and N90s Accessories

With the introduction of the N90 in 1992 and the N90s in 1994 came a new assortment of accessories. The N90 and N90s were designed with a ten-pin terminal (three- and two-pin terminals having been common previously), making new advances in the transfer of information between cameras and accessories. Besides using the conventional camera controls, the N90 and N90s can be set and fired via an MC-20, MF-26, Sharp® Wizard Electronic Organizer, Photo Secretary, or a combination of these devices.

The introduction of the N90 brought with it a new multi-control back, the **MF-26.** The features this back boasts are quite extensive, especially when coupled to the Sharp Wizard EO. The **MF-25** was also introduced, which is a world time data back like the MF-22 (but not quite as exciting).

The MF-26 Multi-Control Back is a powerful tool,

MF-26 Multi-Control Back

opening up a world of tremendous photographic possibilities. Its capabilities include data imprinting, world clock, interval timer, long exposures, auto-sequence shooting, all-mode exposure bracketing, flash exposure bracketing, multiple exposures, focus priority, AE and AF lock override, custom reset, and flash output, just to name a few. Reading the N90 instruction book, the photographer is constantly reminded of what the MF-26 can do to enhance the performance and capabilities of the N90 and N90s.

Some separate functions can be combined to operate simultaneously. Data Imprint, Interval Timer, Focus Priority, AE/AF-Lock, Custom Reset, and Flash Output can be paired with any of the following:

Auto Sequence Shooting, All Mode Exposure Bracketing, Flash Exposure Bracketing, Multiple Exposure, and Long Time Exposure. Limitations to this are that only two functions can operate together and the Long Time Exposure and Interval Timer functions cannot be combined.

Caution: *Any time the word "PRINT" is present on the LCD panel, be warned that data is printing onto the film!*

Data Link AC-1E/2E System

As if understanding and applying all the functions offered by Nikon's sophisticated N90 and N90s weren't enough, here comes the magic of the Sharp® Wizard Electronic Organizer. This is a tool that is probably before its time for most photographers, but the potential it holds for the future of photography is staggering.

Operating the N90 or N90s through the Data Link System requires a **Sharp® Wizard Electronic Organizer** (made by the Sharp Electronic Corporation. USA: #OZ-8000 or 9000 series; in other countries: IQ-8000 or 9000 series), a Nikon **AC-1E** or **AC-2E Card,** and the **MC-27 Connecting Cord.** The AC-2E works with the N90 and N90s, and the AC-1E works only with the N90. With either, most of the camera programs of the N90 and N90s' computer system can be modified or enhanced according to your own personal photographic needs. This is the only camera system on the market that can be

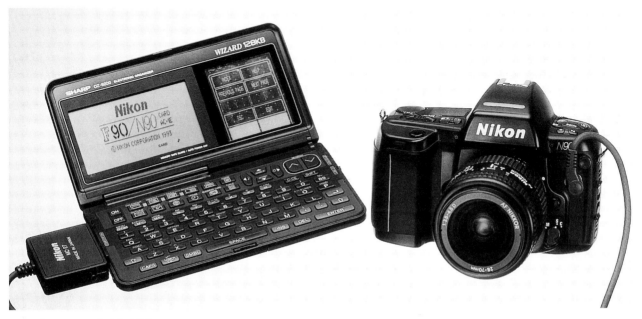

Nikon's Data Link AC-1E System

completely and totally personalized to one's own shooting requirements without having to go to the repair shop to have the modifications performed.

Caution: The data on the AC-1E/2E card can be modified, damaged, or lost if care is not taken. To avoid losing altered data, the following precautions should be observed. The battery for the AC-1E/2E card should be replaced every two years. When replacing the battery, make sure the AC-1E/2E card is installed in the Sharp EO. When inserting or removing the AC-1E/2E card from the Sharp Wizard Electronic Organizer, make sure the Organizer is turned off. A backup should be made of important data by either writing it down or making a printout from the Organizer. And most important, read the instruction manual and understand the operations of the Sharp Wizard Electronic Organizer completely!

"Directly changing the setting(s) on the camera body while operating the AC-1E/2E card is not recommended. Doing so does not update the data in the AC-1E/2E card and may result in improper operation." This instruction manual warning should end with "if you don't press the COMMUNICATE key." Operation of many functions of the AC-1E/2E requires manual settings to be made on the camera. If this is done, be sure to press the COMMUNICATE key to update all data in the AC-1E/2E!

Two modes, On-Line and Off-Line, are available with the AC-1E/2E. On-Line mode is used for communicating directly between the Sharp Wizard Electronic Organizer (EO) and your N90 series camera. Your camera must be linked to the EO with the MC-27. On-Line mode has five menus: 1) Camera Operation, 2) Customized Settings, 3) Memo Holder, 4) Photo Technique Selection, and 5) Control of MF-26 Settings. On-Line mode offers a tremendous amount of programmability to the N90 or N90s user. It is the On-Line functions that are of the most use, as they are used to customize the N90-series cameras.

Off-Line mode can be used with or without the N90 or N90s being attached to the Sharp Wizard EO. There are three menus under this: 1) Operations Guide, 2) Photo Hand-Book, and 3) Utilities. The first two are what you would expect: electronic guides that replace printed instruction books. Utilities, on the other hand, works directly with files created in On-Line mode and can be used to modify those files. It is important to note that certain procedures must be followed in the operation of the Sharp Wizard EO to avoid any errors. It is also important to be aware of any messages or delays in operation.

Consult the Sharp Wizard and Data Link IC Card owner's manual for more information.

Other N90 and N90s Accessories
In 1997 Nikon introduced **Photo Secretary for the N90s/N90,** written for a Windows-based computer system. There is no Macintosh version. The software comes with an **MC-31 Connecting Cord,** which links the camera to your computer. With it you can alter up to 18 camera functions, write your own custom programs, take exposure notes, and fire the camera remotely. This system is covered extensively in the *Magic Lantern Guide to Nikon N90s/N90.*

The **MC-20** is a two-foot long electronic cable release. It has built into its handle an electronic timer that can control an exposure for up to 9 hours and 59 minutes. It runs off the batteries in the N90/N90s or F5 (provided they are fresh), or a battery can be installed in the MC-20 itself. In that case, it runs off its internal battery and not that of the camera. The display on the MC-20 dims when the battery becomes exhausted (whichever power source is used).

The MC-20 takes on a life of its own. Be sure to connect the cord with due care, making sure the "D" symbol on the plug is pointed the correct way when inserting it into the remote terminal. To use the MC-20 just as an electronic cable release, press the MODE button, making sure the LCD displays a "- - - -" symbol. Then depress the firing button on the MC-20 to fire (lightly pressing the button activates the metering and focusing systems without firing the camera). Setting the functions takes a little more programming.

For setting the Long Time Exposure mode, the camera must first be set to "bulb" in Manual mode. Press the MODE button to select the long time exposure. Press it again to select long time exposure with beeper. The LCD of the MC-20 displays either "LONG EXP" or "•))) LONG EXP" respectively. Press "H," "M," or "S" to set the appropriate hours, minutes, and seconds for your exposure. The maximum time that can be set is 9 hours, 59 minutes, and 59 seconds. This time can be cut short if the batteries in either the MC-20 or N90 (or N90s) should give out. Remember that the camera batteries are active during the entire exposure time. (Any previous exposure setting is erased when a new one is programmed in). To make the exposure, lightly press the MC-20 firing button to activate the camera, and then fully depress it to start the exposure (or just fully depress it and start the exposure). "LONG EXP" blinks during the entire exposure and the audible signal beeps if it has been set.

Setting the Time Mode first starts with setting the camera to "bulb" in Manual exposure mode. Press the MC-20's MODE button to select Time Mode and press again to select Time Mode with Beeper. The LCD displays "TIME" or "•))) TIME" respectively. Then press the MC-20's firing button to start the exposure. The LCD counts the length of time the shutter has been opened through the entire length of the exposure. If the beeper is activated, it beeps every second of the exposure. To stop the exposure, depress the firing button; the length of time the shutter was open remains on the LCD display. To clear it, simply press the firing button (no picture will be taken).

And if you are working in dark situations, the MC-20 comes equipped with its own light. Press the light button and the LCD panel lights up. It remains lit as long as the button is depressed.

The **MC-21** is a ten-foot (3 m) extension cable for ten-pin cables. The **MC-22** is a ten-pin to three-prong banana plug cord. The **MC-23** is a 16-inch (0.4 m) long cord for simultaneous or synchronized firing of two N90/N90s or F5 cameras (the Data Link or Photo Secretary system is required for synchronized firing). The **MC-25** permits using two- or three-pin accessories with the N90/N90s or F5's ten-pin socket. The **MC-26** cord is needed to use the MC-20 with two- or three-pin sockets on other bodies. The MC-20 functions just the same once connected with other camera bodies via the MC-26 as it does with the N90/N90s. The **Remote Cord MC-30** electronic cable release is similar to the MC-12A but is just 32 inches (81 cm) long and has a ten-pin male end for plugging into the N90s or F5 remote terminal.

Nikon also introduced the **ML-3** around the same time as the N90. The newest in Modulites still works

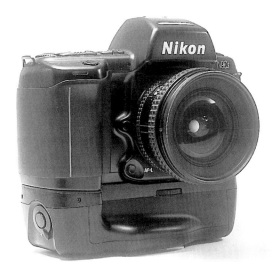

N90s with the MB-10 Multi-Power Vertical Grip

off an infrared LED beam that remotely fires two cameras equipped with receivers from up to 25 feet (7.6 m). What makes this Modulite unique is that it is smaller than a 50mm lens and can be used as a beam splitter. The transmitter and receiver can be set up so that if something breaks the beam, the camera will fire. The unit also has a delay mode, which postpones the camera from firing once the shutter is tripped. This, coupled with the technology of the N90s and SB-25, makes it one of the best remote firing systems on the market.

The firing range of the ML-3 is less than that of any other Nikon Modulite unit. But it can be boosted by using the ML-2 transmitter with the ML-3 receiver. The delay and beam splitter functions are not retained, but the distance is increased to that of the ML-2 (100 meters or 109 yards). And using the ML-3 with cameras other than the N90 and N90s requires the MC-26 and a separate 6v DC power supply for the ML-3 receiver.

The N90 and N90s can take advantage of the **External Battery Pack DB-6** via the **MC-29 External Power Cord.** The DB-6 uses six D-size batteries. It is a unit designed to be used during extended shooting or in cold conditions. It provides greater battery life than the standard four AA batteries. Possibly a good solution for long exposures when used with the MC-20.

The **AH-4 Handstrap** is also available for the N90 and N90s and it also works on the F4, N8008, and N8008s. It is like the original AH-1 handstrap, with a metal base and leather strap that attaches to a strap ring on the shutter release side of the camera, providing great security when handholding the camera.

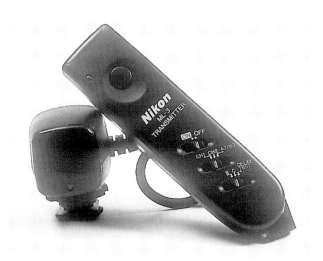

ML-3 Modulite Remote Control Set

Nikon introduced an exciting new accessory with the N90s, the **MB-10 Multi-Power Vertical Grip.** The grip adds greater "holdability" to the N90s in the vertical position by incorporating a molded finger hold into the base. On the right of the MB-10 is a vertical firing button like that on the F4. (The MB-10 also works with the N90, but the vertical firing button does not function.) The other great feature of this grip is its quick-change battery holder. The battery holder **MS-10** accepts four AAs while the **MS-11** accepts two 3v lithium batteries for cold-weather photography. The MB-10 grip can also be powered by a NiCd battery, the **NB-100.** This unit can power the exposure of approximately 60 rolls of 36-exposure film. It has the life expectancy of approximately 500 charges. The NB-100 can provide you with better cold-weather performance than standard AA batteries. It is charged using the **NC-100 Quick Charger,** which is capable of charging two NB-100 units, one before the other, not simultaneously. Charging time for one unit is approximately one hour.

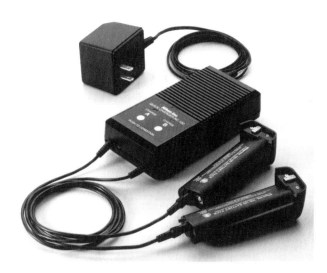

NB-100 NiCd Battery and NC-100 Quick Charger

F5 Accessories

With the F5 came two optional camera backs, the **MF-27** and **MF-28.** The MF-27 is a basic data back providing the same features as the MF-22. The MF-28 is basically the same as the MF-23 except that it can imprint a copyright symbol and your name and date in between the frames. Both of these backs for the F5 have a thumb control to select the AF sensor.

The F5 has a number of remote control accessories, the Modulite ML-3, MC-20 cord, MC-21, MC-23, MC-25 and MC-30. The MC-12A was finally replaced with a shorter electronic cable release, the **MC-12B Motor Remote Trigger Cord.** It is exactly the same as the MC-12A and compatible with the same cameras but just 30 inches (76.2 cm) long.

Other accessories for the F5 include five diopter correction lenses, the DK-2 eyecup, **DR-3** right-angle finder **DG-2** eyepiece magnifier, the eyepiece adapter **DK-7,** and the **PK-11A, 12,** and **13** extension rings.

Photo Secretary

Nikon makes Photo Secretary software for the N90s/N90 and the F5 cameras. These programs allow you to customize your camera to suit your particular needs. With Photo Secretary you can write a number of custom programs (a set of Custom Settings grouped together), store them, and load them into your camera whenever you need to use their particular parameters. The following discussion applies to the F5 version.

Nikon has developed Photo Secretary software for the F5 for both Macintosh and PC platforms. If you use a Macintosh, you will need an **AC-1ME,** a **Connecting Cord MC-34,** and Macintosh System 7.0 to 7.6. You will also need the following:

> 680x0 Mac: 16 MB of memory (32 or more recommended for best performance)
> Power Mac: 24 MB of memory (40 MB or more recommended for best performance)
> Floppy disk drive
> External serial port
> Approx. 16 MB free disk space for program files
> CD-ROM drive

If you use a PC, you'll need the **AC-1WE,** a **Connecting Cord MC-33,** and the Windows 95 operating system. (The appropriate cord comes with the software you buy.) The software comes on two diskettes. A serial port is required to connect the cord to your computer.

Minimum PC system requirements (in order to take advantage of everything):

> 80386 processor (or higher)
> 8 MB of memory (16 MB or higher recommended for best performance)
> Windows-supported display adapter
> Mouse or other Windows-supported pointing device
> Floppy disk drive

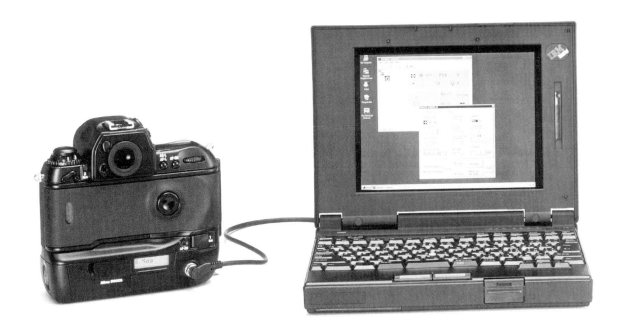

Nikon Photo Secretary for the F5

Available external RS-232C serial port (COM1 - COM2)
Approx. 4 MB free disk space for program files
Windows-supported printer
SCSI interface
CD-ROM drive
Scanner with TWAIN support
Photo CD

Before you start the fun, it is recommended that you turn both the F5 and your computer off when connecting the MC-33. Then connect the MC-33 to the serial port of your computer and connect the other end to the F5. Remember that the F5 is a computer too!

Once you've loaded the software, click on Start and then Program, and you'll see seven "modules" to choose from:

Camera ID Setup
Camera Operation
Film Manager
Nikon Photo Secretary for F5 Help
Nikon Photo Secretary for F5 Uninstall
Photo Finder
ReadMe

Once you're connected, head for Camera ID Setup. Here's where you give your camera an ID number between 1 to 255 (it does not accept numbers preceded by zeros, such as 001). Photo Secretary searches these numbers sequentially, so the lower the number you select, the faster it finds your camera. This number resides in the F5's memory, and each time the camera is connected to the computer, a camera icon is displayed with the camera's ID number. The Photo Secretary for PC can operate up to three F5s at a time (the Mac version supports only one at a time). An additional cord is required for this.

With your camera ID in place, head for Camera Operation. This is where the vast majority of users spend most of their time at first. While I could rewrite the entire instruction book here, that's not my desire. The following list is only a selection of features that are possible with Photo Secretary.

In the Camera Operation box, many of the treasures of this software are found: Check Connected Camera, Remote, Custom Settings Menu, Custom Reset, Program, Metering Status, Location Check, Loading Shooting Data, and Function Settings.

The Custom Settings Menu (CSM) is where you can modify the camera's Custom Settings. Much of this menu duplicates the Custom Settings options that you can control on the camera without the aid of Photo Secretary, but with Photo Secretary, the options for customizing the settings are greater.

One interesting file/button in CSM is AF. This lets you work with Custom Settings 1, 2, and 4. I prefer to set this at Continuous Servo AF with Focus-Priority. This means the camera fires only when the subject is in focus. Another item on the AF list is Priority for

Dynamic AF Mode. This is one function you can't do without Photo Secretary! The options are: Normal, Horizontal Area, and Vertical Area. In Normal Dynamic AF mode, the sensors pass through a specific sequence when tracking focus. However, if you know your subject is only going to travel horizontally (such as speeding race cars), you can select Horizontal Area, and only the three horizontal sensors are used to track focus. This increases focusing speed because the camera doesn't have to hunt through all five sensors while tracking focus. It's great for shooting anything moving horizontally through your frame. The same principle holds true for Vertical Area Dynamic AF and vertically traveling subjects.

Another function on the AF list is Focus Area Selection. The options here are Diagonal Shift and Disable Diagonal Shift. This changes the way the focus area selector pad reacts to your touch, allowing you to shift diagonally from sensor to sensor or not, as desired.

There are two other options that I like in the AF file. The first is the ability to disable Front and Rear Focus Indication in AF. This allows you to turn off the red arrows in the viewfinder indicating the direction to turn the lens to focus. When shooting nocturnal subjects, reducing the number of lights in the viewfinder makes it easier to see through the lens. The second is Imprinting Focus Area between the Frames. This allows you to turn off the yellowish arrows in the viewfinder that point out which AF sensor is active.

The next file/button in CSM is Exposure/SB. The only thing I use in this file is Slowest Shutter Speed of Speedlight in Normal Mode. This lets you set a limit on the slowest allowable speed in Normal sync flash mode, which saves a few seconds in shifting between Rear and Normal sync mode. You can further "customize" Custom Settings 3, 5, 7, 11, 14, 17, 18, 19, 20, and 24 through this file.

The next file/button in CSM is Shooting Data. This can be great for those who want to store tons of shooting data, such as shutter speed, aperture, exposure mode, metering mode, flash sync mode, exposure compensation, focal length, and flash exposure compensation values. The Custom Settings Menu is just the beginning of what you can do in the Camera Operation menu!

The first button on the Camera Operation tool bar is Check Connected Camera. This function simply verifies that the computer and the F5 are talking to each other.

The next button on the tool bar is Remote. This function allows you to operate the F5 remotely via the computer (and MC-33 cord). You have control over basic settings. These include metering system (pattern), shutter speed, aperture, exposure mode, focus area, flash sync mode, exposure compensation, film advance mode, ISO, AF mode, and firing the camera remotely from the keyboard. None of these settings change the Custom Settings you have programmed, however they do override them. With Remote operation, you have two ways of firing the camera, Command Release and Line Release.

The next button on the tool bar is CSM, which I have already discussed.

The next button on the tool bar is RST, or Custom Reset. With this feature, you can change the F5's default settings. For example, I have set my Custom Reset so that Aperture Priority and Dynamic Focus are the new default.

The next button on the tool bar is Program. This has been described to me as the world's most sophisticated intervalometer. This lets you control things such as camera ID, start time, delay time between operations, number of shots, metering system, shutter speed, aperture, exposure mode, exposure compensation, flash sync mode, flash exposure compensation, and multiple exposure. All these things can be programmed and controlled from one picture to the next. It is especially valuable for special shooting situations such as scientific research, because you can use it to set programs containing up to 100 steps.

The next button on the tool bar is Display Metering Status Data. This is great for helping you understand how the 3D color matrix metering system reads a scene. It displays a static image, like a video snapshot, which is broken down into a 12 x 20-cell, 256-color color/brightness pattern display. It does not provide a clear picture like one you would see if you were actually viewing through the viewfinder, though.

The second to last button is Check Camera Location. This simply causes the Alert LED to the left of the prism to blink when depressed so you can locate the camera when doing remote work or firing more than one camera at a time.

The last file/button in Camera Operation is Function Settings. This file allows you to activate or disable certain camera functions such as exposure mode, exposure compensation, multiple exposure, autoexposure bracketing, flash sync mode, focus area selection, AF mode, and the lock button. For example, I have my F5 programmed so that Program mode is not an option. I have disabled autoexposure bracketing because I never use it, and Single Area AF mode and the lock button have also been disabled.

Of the other modules offered by Photo Secretary, Film Manager controls how you store your photos in the computer, Photo Finder is a filing system for the photos you've stored, and the other modules (Help, Uninstall, and ReadMe) are self-explanatory.

F100 Accessories

The F100 is able to accept multiple power supplies. As it stands on the shelf, the F100 uses four AA batteries. To reduce the weight of using four batteries, however, you can use the **MS-13 Battery Holder,** which accepts just two CR-123A batteries. The **MB-15 Power Pack** can also be used with the F100. This unit accepts six AA batteries, providing the camera with its fastest operation and slightly longer battery life. The **MN-15** NiMH battery can be used instead of AA batteries in the MB-15. The **MD-15 Motor Drive** can be used with the F100, increasing film advance from 4.5 fps to 5 fps. The **MF-29 Data Back** allows you to imprint the date or time on your photographs. The F100 takes many of the accessories designed for the F5, including the DK-2, DK-7, and DG-2. It also accepts the **DR-4 Right Angle** attachment. Shooting data can be downloaded to a PC using the **AC-2WE Photo Secretary II** with the MC-31 or MC-33 connecting cords.

Focusing Screens

Starting with the F, many of Nikon's camera bodies had interchangeable screens. The pro bodies have the greatest number, while the other bodies have only one or two, if they allow the screen to be changed at all. Also, not all the screen types are available for every Nikon camera. But no matter what camera body a screen is made for, the nomenclature for a type of screen is the same. An E screen for the N2020 has the same pattern as an E screen for the F4, even though each is designed to fit a specific camera model. Screens for the pro bodies are made of a thick, ground glass and are retained by a frame. Those for other bodies are made of thinner, etched plastic.

The F4 made use of new technology in the manufacture of viewing screens, making BrightView screens part of its system. Only 13 screens are available for the F4 and F5, whereas previous pro bodies had 22. One of these is the reintroduction of an older screen, the F screen. The F4 comes standard with the B screen, as do the other cameras with electronic rangefinders. The F5 comes standard with the EC-B screen. Earlier pro bodies came with a screen with a split-image rangefinder.

The F3, F4, and F5 were designed to make screen changes easier. It requires first removing the prism. With this accomplished, placing a thumbnail under the flange at the rear of the screen pops it right out. Replacing the screen is just the opposite. First, slide the front of the screen into the front of the mirror box opening. Next, just press the screen into place and replace the prism.

What follows is a generalized description of each screen and its possible application. Not all screens provide autofocus brackets. They still work with the autofocus system, but just don't aid in showing you where exactly to look in the finder in order to autofocus. Generally though, if the subject is dead center, you'll be in the ballpark.

The A screen is a matte/Fresnel field with a 12 mm reference circle around a split-image rangefinder in the center of the screen.

The B screen is a matte/Fresnel field with a 5 mm and 12 mm circle around the autofocus bracket in the center of the screen. This screen is bright and easy to view through. A great all-around, general-use screen; few ever replace it, which is smart.

The C screen is a fine-ground matte field screen with a 5 mm center spot with cross-hairs in the center. It is a very bright screen that provides no focusing aid if the electronic rangefinder isn't working. This screen is great in applications of high-magnification or astrophotography where focusing on a matte/Fresnel is not required but bright viewing is.

The D screen is a fine-ground matte field screen that is not Fresnel ground. It has no markings or focusing aids and is used mostly with telephoto lenses and for close-up photography.

The E screen is exactly the same as the B screen except it has five vertical and three horizontal lines. Often referred to as the "architectural screen," the lines etched on the screen can aid in lining up vertical lines. For those who have a hard time keeping the horizon line from sloping across the frame, this screen is ideal as it provides quick reference. The grid on the screen also aids in composition by suggesting areas to place the subject by following the "Rule of Thirds." This is by far the most popular replacement screen.

The EC-B screen is a matte BriteView field with a 12 mm circle. It also has five focusing area brackets, and the selected focusing bracket appears darker than the rest.

The EC-E screen is identical to the EC-B screen,

Nikon Focusing Screens

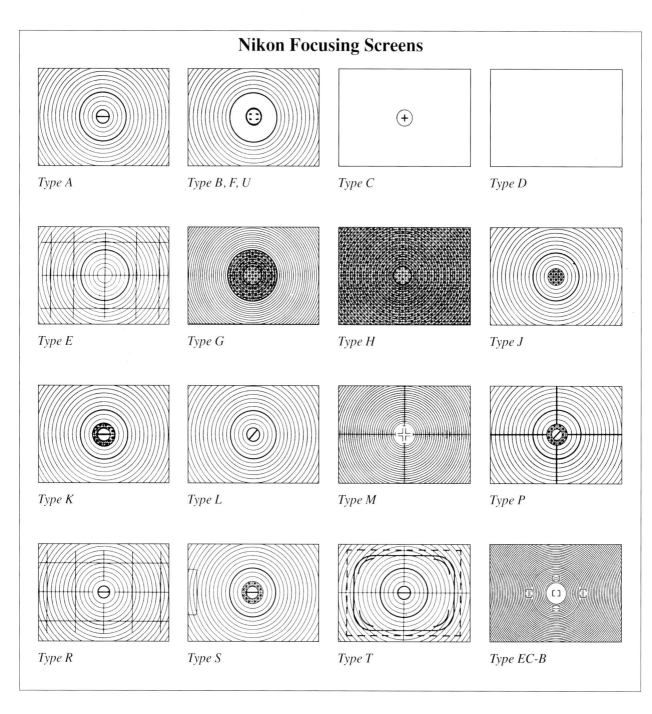

Type A

Type B, F, U

Type C

Type D

Type E

Type G

Type H

Type J

Type K

Type L

Type M

Type P

Type R

Type S

Type T

Type EC-B

however it has "architectural" grid lines on it like the standard E screen.

The F screen is matte/Fresnel with 5 mm and 12 mm center circles and centered autofocus brackets. Although the descriptions are similar, the F matte is best described as "brighter" than the B screen, which is why it is recommended for use with mirror lenses. Mirror lenses tend to produce vignetting in the viewfinder, which the F screen helps even out.

The G screen series has a clear Fresnel field with a 12 mm extra-bright microprism. There are four G screens, G1, G2, G3, and G4, each of which works with different focal length lenses. These screens are very dated, and the focusing aid they provide is, well, quite useless. With the technology provided by the F4's autofocus system, why spend money to have four screens to help you focus?

The H screen has a clear Fresnel field with microprisms over the entire screen. The microprism is a focusing aid that goes clear when the subject is in

focus. If the subject is not in focus, it looks like it is shimmering. It is recommended for photographing in low-light conditions. The are four H screens, H1, H2, H3, and H4, each corresponding to a different maximum lens aperture.

The J screen is a matte/Fresnel with a 12 mm circle surrounding a 5 mm microprism in the center of the screen. The uses for this screen are very limited.

The K screen is a matte/Fresnel screen with a 3 mm BrightView split-image rangefinder surrounded by a 1 mm-wide microprism. This was the standard pro body issue prior to the F4. This screen has two focusing aids to help focus faster on the subject. With the technology available in the F4, this screen seems a little outdated.

The L screen is similar to the A screen except the split-image rangefinder is at a 45° angle. This aids in focusing on horizontal lines.

The M screen is a very specialized fine-ground Fresnel field with a 5 mm clear spot in the center with double cross-hairs. This screen requires using a finder such as the DW-21 with its built-in diopter adjustment. When viewed through the M screen, the image focused by the lens can "float" and be out of focus on the film depending on the position of the eye. This is called an aerial image and requires diopter focusing on the screen before focusing on the subject. The screen is extremely bright and is marvelous for microphotography.

The P screen is exactly the same as the K screen, except the split-image rangefinder is at a 45° slant and the screen is split vertically and horizontally by etched lines.

The R screen is a matte/Fresnel screen with horizontal and vertical lines etched into it. At the center is a split-image rangefinder that does not darken, even with slow lenses. The grid pattern makes it an excellent choice for architectural photography.

The S screen is the same as the K screen except it provides an area on the left side of the frame for imprinting data when used with the MF-17 Data Back and MF-4 250-Exposure Back on the F3.

The T screen has a matte/Fresnel field with a vertical and horizontal line and TV screen frame lines. It is used for preparing slides for TV broadcasts.

The U screen is a matte/Fresnel screen with 5 mm and 12 mm circles around the autofocus brackets. Like the B and F in description, it is slightly brighter than the F. Recommended for long telephotos, it can be hard to use because it borders on being fine-ground. In really dim situations, defining what is in and out of focus is easier with the U screen, but in general work it is very difficult to use.

Some of these screens have very soft components. These softer components can scratch easily, so take care. The standard B and commonly used E screens can tolerate cleaning on their top surface, but the bottom surface can be easily scratched. The M screen is notorious for scratching easily. Using just air instead of lens tissue is recommended to remove dust. If a fingerprint should appear on the lower surface, a tissue with lens cleaning fluid can be used. Try to make circles in the direction of the surface pattern when cleaning screens to avoid scratches that will appear in the finder.

Lens Shades

Probably the one accessory that every Nikon owner buys is a lens shade. Nikon makes a wide variety of shades. Custom fitting the lens' angle of view and its filter thread size to the maximum depth the shade can be without vignetting is a challenge. Nikon is unique in that it manufactures metal lens shades for its lenses (except for its autofocus lenses). They are attached by screwing in (**HN**), snapping on (**HS**), or by slipping onto (**HK**) the outside rim of the filter ring. They also make a limited line of rubber (**HR**) shades. With the introduction of autofocus lenses, Nikon broke with tradition and introduced all-plastic, bayonet-style lens shades (**HB**).

Other than certain exceptions, most shades must be used with the correct lens to get the maximum shading without vignetting. There are other lens-shade combinations than those recommended by Nikon, providing greater protection for the front element. There are many reasons you might not want to use the recommended shade. One reason could be that you desire a screw-in model over a snap-on model. Often retail stores do not have in stock the exact shade that Nikon recommends, and a substitution must be made. The list on the following page is of lens-shade combinations the author has tried and found to work without vignetting.

Lens Shades HN-3 and HN-7

Lens	Shade	w/ Filter	w/o Filter
24mm f/2.8	HN-2	X	X
24mm f/2.8	HN-3	X	X
24mm f/2	HN-1	X	X
24mm f/2	HN-2	X	X
28mm f/2.8	HN-3	X	X
28mm f/2	HN-3	–	X
35mm f/2	HS-12	X	X
50mm f/1.2	HS-9	X	X
50mm f/1.4	HS-12	X	X
60mm f/2.8 AF	HN-23	X	X
35-70mm f/2.8 AF	HN-22	X	X

There are other possibilities that can be tried with wide-angle lenses. Because of their wide angle of view, finding a shade that does not vignette can be a challenge. Telephoto lenses do not have as much of a problem with vignetting because of their narrow angle of view.

When selecting a shade that is not recommended, a simple procedure can insure that you do not make a mistake in your selection. Using a body with 100% viewing (F, F2, F3, F4), attach the lens to be tested, making sure a filter is attached. Then attach the candidate shade. Close down the lens to its smallest aperture and look at an even, bright light source (such as a light table). Now press in the depth-of-field button to close down the aperture, and look at the four corners of the screen. If the shade attached vignettes, the corners will have dark shading. This means the shade itself is cutting into the picture. If this occurs, then that shade will not work with that particular lens. If you are working with a zoom, remember to try the shade at all focal lengths to guard against vignetting at its widest focal length.

Many of the Nikon snap caps attach to the shade so the lens and shade can be stored or used together protected by a cap. Some examples are the 77mm snap (which fits many shades) on the HN-23, or the 72mm snap on the HN-1, -2, or -3. The slip-on cap for the 500mm f/8N fits the shade for the 35-200 perfectly. Just give a cap a try on the shade to see if it fits.

Connecting Cords

The electrical cords that connect so many of the Nikon's funnier accessories remain a mystery to most. Often, photographers make their own cords starting with the Nikon cords as their base. Many of Nikon's cords must be "customized" to work with other manufacturers' equipment. Whatever the case,

knowing the correct nomenclature is important. Up until the N90 and N90s, all of Nikon's cords listed in the accompanying chart (page 153) contained the three basic leads (+, -, and a ground). With the introduction of the N90 and N90s, that number jumped up to ten. This has frustrated many home electricians. Before ever performing your own custom modifications, consult with a repair person or Nikon to avoid any unwanted modifications.

Eyepiece Accessories

The one frustration I hear most often is that people lose eyecups and eyepieces. This is especially true with the older eyecups, which did not have the retaining ring found on the DK-2. It is to your equipment's benefit that the eyepiece always be attached. It prevents unwanted dust, grit, and moisture from entering the prism area around the eyepiece. It also prevents the eyepiece element in the prism from becoming scratched.

There is another very good reason to use an eyecup. Modern Nikons with TTL meters in the prism can be affected by light entering through the prism. If you are like me, the camera does not fit perfectly to your face. Without an eyecup, light can bounce in off your skin through the eyepiece. If this happens, the meter will give bad advice, leading to bad exposures.

Another good reason for using an eyecup is sharper photographs. The eyecup acts like a shock absorber between your face and the camera itself. With an eyecup, you can press the camera back against your face to better hold the camera, especially at slower shutter speeds.

There is no one recommended way to prevent eyepieces and eyecups from falling off. Some like to glue them on, but this is not a great idea because of the possibility of damage. If a camera should fall or get knocked, the eyepiece or eyecup, instead of popping off as it should, will stay attached, causing greater damage to the prism.

The most common cause for losing an eyecup or eyepiece is carrying a camera over the shoulder. The camera naturally rubs and bounces, slowly loosening the eyepiece. The only suggestion I have is to constantly check the eyepiece. I always check it before and after use each day. And you best keep a spare around, for two reasons. One is that you are going to lose one sometime. The other reason is that they are often hard to find. If you find two, buy both!

Lens Shade Compatibility

Screw-in

Shade	Lenses
HN-1	24mm f/2.8, 24mm f/2.8 AF, 28mm f/2, 35mm f/2.8 PC
HN-2	28mm f/2.8, 28mm f/2.8 AF, 28mm f/3.5, 35-70mm f/3.3-4.5, 35-70mm f/3.3-4.5 AF, 35-80mm f/4-5.6D AF
HN-3	35mm f/1.4, 35mm f/2.8, 35mm f/2, 35mm f/2 AF, 43-86mm f/3.5, 55mm f/2.8, 55mm f/3.5
HN-4*	45mm f/2.8 GN
HN-6*	55mm f/1.2
HN-7*	85mm f/1.8, 85mm f/2, 80-200mm f/4.5
HN-8*	105mm f/2.5, 135mm f/3.5
HN-9	28mm f/3.5 PC
HN-10*	200-600mm f/9.5
HN-11*	all 50-300mm
HN-12	52mm Polarizing Filter
HN-13	72mm Polarizing Filter
HN-14*	20mm f/4
HN-15*	18mm f/4
HN-20	85mm f/1.4
HN-21*	75-150mm f/3.5 E
HN-22	35-70mm f/3.5 (62mm)
HN-23	85mm f/1.8 AF, 80-200mm f/4
HN-24	70-210mm f/4 E, 70-210mm f/4-5.6 AF, 75-300mm f/4.5-5.6 AF, 70-210mm f/4-5.6D AF
HN-25*	80-200mm f/2.8 ED
HN-26	62mm Polarizing Filter
HN-27	500mm f/8N
HN-28	80-200mm f/2.8 ED AF
HN-30	200mm f/4D EDIF AF Micro

Bayonet

Shade	Lenses
HB-1	28-85mm f/3.5-4.5 AF, 35-70mm f/2.8 AF, 35-135mm f/3.5-4.5, 35-70mm f/2.8D AF
HB-2	35-105mm f/3.5-4.5 AF
HB-3	24-50mm f/3.3-4.5 AF
HB-4	20mm f/2.8 AF
HB-5	35-105mm 3.5-4.5 AF
HB-6	28-70mm f/3.5-4.5 AF, 28-70mm f/3.5-4.5D AF
HB-7	80-200mm f/2.8D ED AF
HB-8	18mm f/2.8D AF, 20-35mm f/2.8D AF
HB-10	28-80mm f/3.5-5.6D AF
HB-11	24-120mm f/3.5-5.6D AF
HB-12	28-200mm f/3.5-5.6D IF AF
HB-14	70-180mm f/4.5-5.6D ED Micro AF
HB-15	70-300mm f/4-5.6D ED AF
HB-17	80-200mm f/2.8D EDIF AF-S
HB-18	28-105mm f/3.5-4.5D IF AF
HB-19	28-70mm f/2.8D EDIF AF-S
HB-23	17-35mm f/2.8D EDIF AF-S

EDIF "N" Replacement Lens Shades

Shade	EDIF Lenses
HE-1	300mm f/2
HE-3	400mm f/2.8, 800mm f/5.6
HE-4	200mm f/2, 300mm f/2.8N, 600mm f/5.6N

Shade	*EDIF Lenses*
HE-5	600mm f/4N
HE-6	300mm f/2.8 AF

Slip-on

Shade	*Lenses*
HK-1*	28-45mm f/4.5
HK-2	24mm f/2
HK-3*	20mm f/4
HK-4*	35-70mm f/3.5 (72mm)
HK-5	50-300mm f/4.5, 50-300mm f/4.5 ED
HK-6*	20mm f/3.5 (52mm)
HK-7	25-50mm f/4, 28mm f/1.4D AF
HK-8*	36-72mm f/3.5 E
HK-9	18mm f/3.5
HK-10*	50-135mm f/3.5
HK-11*	35-105mm f/3.5-4.5
HK-12*	28-50mm f/3.5
HK-14	20mm f/2.8
HK-15	35-200mm f/3.5-4.5
HK-16*	28-85mm f/3.5-4.5
HK-17	500mm f/4P EDIF
HK-18	600mm f/4D EDIF AF-I
HK-19	300mm f/2.8D EDIF AF-I
HK-20*	400mm f/2.8D EDIF AF-I
HK-21	400mm f/2.8D EDIF AF-I
HK-22	300mm f/2.8D EDIF AF-S
HK-23	600mm f/4D EDIF AF-S
HK-24	500mm f/4 EDIF AF-S
HK-25	400mm f/2.8D EDIF AF-S

Snap-on

Shade	*Lenses*
HS-1*	50mm f/1.4 (prod. #1037)
HS-2*	50mm f/2
HS-5*	50mm f/1.4 (prod. #1037)
HS-6*	50mm f/2
HS-7*	55mm f/1.2
HS-8*	105mm f/2.5
HS-9	50mm f/1.4
HS-10	85mm f/2
HS-11*	50mm f/1.8
HS-12	50mm f/1.2
HS-14	105mm f/2.8, 100-300mm f/5.6

Rubber Screw-in

Shade	*Lenses*
HR-1	50mm f/1.4, 50mm f/1.8, 50mm f/2
HR-2	55mm f/1.2, 50mm f/1.2
HR-3*	R-10 Movie Camera
HR-4*	50mm f/1.8 E, 35mm f/2.5 E
HR-5*	100mm f/2.8 E
HR-6*	28mm f/2.8 E

*Discontinued

Connecting Cords Nomenclature

Product No.	Item	Description
26*	—	Connecting Cord F-36, 3'
27*	—	Connecting Cord F-36, 30'
20*	ME-3	Basic Cord 3', AC/AC
21*	ME-6	Basic Cord 6', AC/AC
22*	ME-15	Basic Cord 15', AC/AC
23*	ME-30	Basic Cord 30', AC/AC
90*	AE-1	Tripping Button
91*	AE-2	Alligator Clips
92*	AE-3	Twin Lugs
94*	AE-4	Mini Plugs
95*	AE-5	Banana Plugs
41*	—	Pistol Grip w/ Microswitch (Cord to F-36)
24*	MC-1, 10'	SC Remote Cord, 10' long
88*	—	SC Remote Cord, 33' long
89*	—	SC Remote Cord, 66' long
25*	MC-2	Connecting Cord, 8' MD-2 or MD-3 to MA-4
28*	MC-3	Coiled Cord Pistol Grip II to Motor
4582	MC-3A	Coiled Cord for Pistol Grip II
29*	MC-4	Remote Cord, 3' with Banana Plugs
4583	MC-4A	Remote Cord with Banana Plugs
77*	MC-5	Connecting Cord, Motor to Intervalometer
95*	MC-7	Connecting Cord, Battery Pack to MD-2 and MD-3
75*	MC-8	Connecting Cord, Modulite to Motor
4585	MC-8A	Connecting Cord, ML-1 to Motor
NA*	MC-9	Battery Grip Cord, MA-3 to Motor
131	MC-10	Remote Cord with Button Release
132*	MC-11	External Power Cord
133*	MC-12	Remote Cord for MD-4, MD-12, N8008, F4
4586	MC-12A	Remote Firing Cord
4654	MC-12B	Motor Remote Cord
135	MC-14	Signal Cord MF-4
130*	MC-16	Connecting Cord, MT-2
4587	MC-16A	Connecting Cord, MT-2
138	MC-17S	Cord for Firing Two F3s Simultaneously
139	MC-18	Connecting Cord, MW-2
4650	MC-20	Remote Cord for N90/N90s, F5, F100
4651	MC-21	Ten-Pin Extension Cord
4652	MC-22	Banana Plug Cord for N90
4653	MC-23	Connects Two N90, F5, or F100 Cameras for Concert Firing
4655	MC-25	Two-Pin Accessory to 10-Pin Terminal
4656	MC-26	Ten-Pin Accessory to 2-Pin Terminal
4657	MC-27	Electronic Organizer Connecting Cord
4658	MC-28	External Power Cord F4 MB-23 to DB-6
4659	MC-29	External Power Cord for N90
4660	MC-30	Ten-Pin Remote Cord for N90s, F5, F100
—	MC-31	Connecting Cord for Photo Secretary for N90s/N90, F100
4664	MC-32	External Power Cord for F5
—	MC-33	Connecting Cord for Photo Secretary for F5 (PC), F100
—	MC-34	Connecting Cord for Photo Secretary for F5 (Mac)

*Discontinued NA: Not Available

Eyepiece Accessories

Product No.	Item	Description
2313*	—	Rubber Eyecup, F/F2
2316*	DL-1	Photomic FTn Illuminator
2320*	DR-2	Right-Angle Finder
2388	DK-1	Converts HP Finder Threads to Standard Thread
2406	DK-2	Rubber Eyecup, F3HP/F4/F5/F100
2362	DK-3	Rubber Eyecup, FE/FM/FE2/FM2/FA
2379	DK-4	Rubber Eyecup, F/F2/F3
2380	DK-5	Eyepiece Shield, N2000/N2020/N4004s
2393	DK-6	Rubber Eyecup, N8008/N8008s/N90/N90s/F100
2394	DK-7	Converts HP Finder Thread to Standard Thread
2395	DK-8	Eyepiece Shield, N8008/N8008s
2939	—	Rubber Eyecup, N2000/N2020/N4004s/N50
2355	DG-2	Eyepiece Magnifier
2326	DR-3	Right-Angle Finder
2329	DR-4	Right-Angle Finder

Cable Releases/Soft Releases

Product No.	Item	Description
661	AR-1	Soft Shutter Release, F/F2/Nikkormats
660	AR-2	9" Cable Release, F/F2/Nikkormats
664	AR-3	9" Cable Release, F3/FE2/FA/F4
2636	AR-4	Double Cable Release, F/F2/Nikkormats
46	—	Pistol Grip to F/F2/Nikkormats Cable
667	AR-6	Pistol Grip to F3/FE2/FA/F4 Cable
668	AR-7	Double Cable Release, F3/FE2/FA/F4
669*	AR-8	Converts F Cable to Fit Standard Socket
4417	AR-9	Soft Shutter Release, FE2/FA/F3
2670	AR-10	Double Cable Release, N8008/N8008s/F4s/F3-MD-4

Miscellaneous Accessories

Product No.	Item	Description
45	Pistol Grip II	Pistol Grip for Nikon Equipment
635	AN-1	Leather Neck Strap
638	AN-4Y	Yellow Nylon 1" Wide Neck Strap
639	AN-4B	Black Nylon 1" Wide Neck Strap
4507	AN-6Y	Yellow Nylon 2" Wide Neck Strap
4508	AN-6W	Wine Nylon 2" Wide Neck Strap
2028	AP-2	Panaroma Head with Level and Click Stops
3062	DB-2	Anti-Cold Pack, F3/FE/FE2/FA
3068	DB-5	Anti-Cold Pack, N8008/N8008s
3069	DB-6	External Battery Pack
2360	F-C	Adapts Nikon Bayonet F to C-Type Thread
2628	EL-F	Adapts Nikon Bayonet F to 39 mm Screw Thread
3068	DB-5	Anti-Cold Pack, N8008/N8008s

*Discontinued

Filters

Type	Item	Filter Size	Bayonet
Skylight	L1BC	39mm, 52mm, 62mm, 72mm	yes
Ultraviolet, non-multicoated	L37*	46mm, 52mm, 72mm	
Ultraviolet	L37C	39mm, 52mm, 62mm, 72mm, 77mm, 82mm, 95mm, 122mm, 160mm*	yes
Ultraviolet, non-multicoated	L39*	52mm, 72mm, 95mm, 122mm, Series 9†*	
Yellow, light	Y44	52mm, 72mm*, 95mm*, Series 9†*	
Yellow, medium	Y48	39mm, 52mm, 62mm, 72mm, 77mm, 95mm, 122mm, Series 9†*	yes*
Yellow, dark	Y52	39mm, 52mm, Series 9†*	yes
Orange	O56	39mm, 52mm, 62mm, 72mm, 77mm, 95mm, 122mm, Series 9†*	yes*
Red	R60	39mm, 52mm, 62mm, 72mm, 77mm, 95mm, 122mm, Series 9†*	yes
Green, light	X0	52mm	yes
Green, dark	X1	52mm	
Polarizer	Circular	39mm, 52mm, 62mm, 72mm, 77mm	
Polarizer	Linear*	52mm, 62mm, 72mm	
Neutral Density	ND2	39mm	
Neutral Density	ND4	39mm, 52mm, 72mm	
Neutral Density	ND8	39mm, 52mm	
Neutral Density	ND400	52mm	
Amber, light (81A)	A2	39mm, 52mm, 62mm, 72mm, 77mm	yes
Amber, dark	A12	39mm, 52mm, 62mm	
Blue, light	B2	39mm, 52mm, 62mm, 72mm, 77mm	yes
Blue, medium	B8	39mm, 52mm	
Blue, dark	B12	39mm, 52mm, 62mm	
Soft Focus	No. 1	46mm*, 52mm, 62mm, 72mm	
Soft Focus	No. 2	46mm*, 52mm, 62mm, 72mm	
Color Compensating	CC30R	52mm	

*Discontinued
†Series 9 filters fit an approximate range of sizes from 62mm to 85mm

Circular Polarizing Drop-in Filters

Type	Item	Compatible Lenses
Polarizer	CPL1L	300mm f/2.8D EDIF AF-S, 400mm f/2.8 EDIF, 400mm f/2.8D EDIF AF-S, 500mm f/4D EDIF AF-S, 600mm f/4D EDIF AF-S, 800mm f/5.6 EDIF
Polarizer	CPL1S	300mm f/2.8 EDIF AF, 300mm f/2.8 EDIF AI-S, 300mm f/4 EDIF AF, 400mm f/3.5 EDIF, 500mm f/4P EDIF, 600mm f/4 EDIF, 600mm f/5.6 EDIF, 800mm f/8 EDIF, 1200mm f/11 EDIF
Polarizer	CPL2L	400mm f/2.8D EDIF AF-I
Polarizer	CPL2S	300mm f/2.8D EDIF AF-I, 500mm f/4D EDIF AF-I, 600mm f/4D EDIF AF-I

Nikon Flash—The Evolution

Nikon's flashes have evolved radically over their nearly 40 years of manufacture. The tremendous technological leaps in electronics are best illustrated in the growth of flash photography. The design of electronic flash has been so influential, that flash operation has been integrated into camera body design. Its tremendous increase in use by photographers since 1959 directly affected the evolution of camera designs, which now incorporate major features and new technologies just to accommodate flash.

The photographers of the sixties who used flash were true technicians of light. Old flash equipment had to be manipulated manually to deliver the lighting that photographers' imaginations and jobs required. In the beginning (it sounds like so long ago), the flash bulb ruled supreme. Special pouches full of flash bulbs hung from the waists of photojournalists pushing to get in close to take their photo. Figuring out exposure was strictly a matter of figuring flash-to-subject distance, which in this situation was constantly changing.

When the F was introduced, it inherited the flash bulb unit originally designed for rangefinder Nikons. The **BC-7 Flash Unit** uses glass flash bulbs and requires the camera's controls to be set for their use (refer to the "F" section in the *Bodies* chapter for setting to bulb use). This technology, though simplistic by today's standards, was a workable system that produced many photographs still admired today. The BC-7 employs features that relate directly to current designs such as the tilting flash head and the angle of illuminance. The flash bulb was replaced when the SB-1 "electronic" flash came on the market in 1969.

The **SB-1 Speedlight** is a handle-mount unit designed to deliver maximum power with a short recycling time. It can be powered by the D-cell **SD-2 Battery Pack,** the 510v **SD-3 Battery Pack,** the **SN-1 NiCd** charged by the **SA-1 Charger** (or the quick charger **SH-1**), or you can use the SA-1 as an AC unit. It is simple in design and operation. The flash reflector has a 65° angle of coverage, enough for a 35mm lens. Recycle time is 4 seconds with the SN-1 and 1.5 seconds with the SD-3. The bracket can tilt for bounce flash. Flash duration is 1/2000 second, color temperature is 6000°K, and it has a guide number of 125 in feet (38 in meters) with ISO 125 film. It was advertised with a flash bulb life of 30,000 flashes.

The power of the SB-1 is minimal by today's standards, but it performed well for its day. It has an on/off switch and an open flash button, an exposure-calculator disc, an extension socket, a ringlight socket and an AC socket. The SB-1 can power the **SR-1 Ringlight** (designed for magnifications less than 1:1) or the **SM-1 Ringlight** (designed for magnifications greater than 1:1 with a reversed lens). The SB-1 can be linked to fire as many as three SB-1s simultaneously with the **SE-2** cord. An **SF-1 Ready Light** provides the F cameras with a ready light when used with the SB-1, and the **SC-4** connects to the

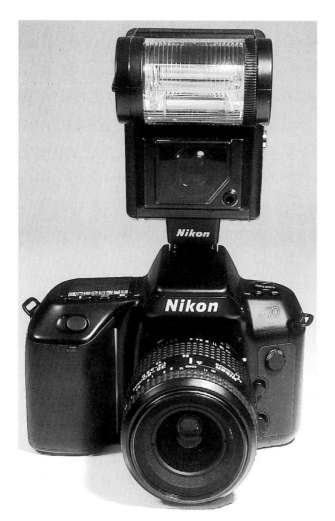

Speedlight SB-20 with N70 camera

ready light in the F2 prisms. The SB-1 was the only electronic flash available from Nikon until 1977, when a number of units, the SB-2, SB-3, SB-4, and SB-5 were introduced.

The **SM-2** and **SR-2 Ringlights** were introduced in 1975 and are the same as the SM-1 (52mm mount) and SR-1 (reversed lens mount), but can be powered by the **LA-1** AC or the **LD-1** DC power sources. The flashtube is circular, providing "shadowless" lighting. Exposure is figured by using charts that calculate subject-to-flash distance.

The SB-2, SB-3, SB-4, and SB-5 electronic flashes were all introduced at the same time (1977), each with slightly different features and power. The **SB-2 Speedlight** and **SB-3 Speedlight** are basically the same unit. The SB-2 foot connects to the F2 hot shoe and activates the ready light in the F2 prism. The SB-3 has a standard ISO foot for use on the Nikkormats' standard hot shoe. The units were advertised with a state-of-the-art SCR (Silicon-Controlled Rectifier), which shuts off the flash when the correct amount of light has reached the subject (the same as the Automatic settings on today's flash units).

This provides accurate automatic control from 2 to 20 feet (0.6 m to 6 m). The SB-2 and SB-3 also have the energy-saving thyristor system, which conserves its limited power. Four AA batteries power the unit, providing a guide number of 80 in feet (25 in meters) with ISO 100 film. They recycle in 1 to 8 seconds, depending on whether manual or automatic is in use. The units can be positioned for vertical or horizontal photography, and their angle of illuminance covers a 35mm lens. With the **SW-1 Wide-Angle Adapter,** they can cover a 28mm lens. They also feature direct-reading calculator dials for manual operation and an open flash button. The **PC Cord SC-7** has a standard PC connection on one end and a parallel blade plug on the other. The SB-2 and SB-3 also accept the SF-1 ready light and SC-4 cord.

The **SB-4** is Nikon's first compact flash. It has an ISO foot for use on Nikkormats (but can work on the F2 with the **AS-1 Adapter**). It is powered by two AA batteries providing a guide number of 52 in feet (16 in meters) with ISO 100 film for up to 1,000 flashes. It has single aperture automatic operation for reliable performance up to 13.1 feet (4 m). Its recycle time is 1 to 13 seconds in relation to the flash-to-subject distance. It provides hot shoe connection with ISO flash shoes and has a built-in PC cord for cameras that don't have a hot shoe.

The **SB-5 Speedlight** is a handle-mount unit with some remarkable features. Its main selling point is its versatile thyristor flash, ideally suited for motor drive photography. It has variable power control. A selector switch permits operation at full power, at 1/4 power, or at the special "MD" (Motor Drive) setting equivalent to 1/8 power. In "MD" mode, the SB-5 recycles in 0.25 second, allowing motorized photography at speeds of 3.8 fps (frames per second) at sequential bursts of up to 40 frames.

It has a guide number of 105 in feet (32 in meters) with ISO 100 film and a guide number of 36 in feet (11 in meters) when in the MD mode. With the accessory **SU-1 Sensor,** accurate automatic operation with three f/stops at distances of up to 26.2 feet (8 m) is possible. The sensor plugs into the flash for direct lighting or, with the **SC-9 Cord,** can be mounted on the camera accessory shoe for bounce flash. It can be angled in 30° increments for bounce photography (via the mounting bracket). It is powered by the **SN-2 NiCd** (charged by the **SH-2 Charger**) for up to 420 flashes, or by the heavy-duty power **SD-4 Battery Pack,** which uses two 240v batteries providing up to 4,000 flashes. The SB-5 has coverage for a 28mm lens and a direct-reading exposure calculator with automatic guide number readout and open flash control.

In 1976, Nikon introduced the **SB-6 Repeating Flash.** This is a very specialized flash unit designed to deliver up to 40 flashes per second. The SB-6 has ratio capabilities providing a guide number of 147 in feet (45 in meters) with ISO 100 film on full power, 104 (32 in meters) at 1/2, 72 (22 in meters) at 1/4, 52 (16 in meters) at 1/8, 36 (11 in meters) at 1/16, and 26 (8 in meters) at 1/32 power setting. The SB-6 is powered by the **SA-3 AC Unit,** which is connected via the **MC-9 Cord.** The **SD-5 DC Unit** with the **SN-3 NiCd** provides a portable power source. The stroboscopic capability of the SB-6 allows 5 to 40 flashes per second and can sync with a motorized camera firing as many as 3.8 fps. The SB-6 flash foot allows the unit to be attached to the F2 shoe.

In 1978 the **SB-7E** and **SB-8E Speedlights** were introduced. They are identical units except that the

SB-7E fits the F2 accessory shoe, lighting up the ready light in the F2 prisms, and the SB-8E has the standard ISO foot for Nikkormats. These units have a 2-f/stop Automatic and a Manual setting. On the top of the flash is the exposure calculator for manual use. They use four AA batteries providing a recycle time of 1 to 8 seconds with a guide number of 82 in feet (25 in meters) with ISO 100 film. The angle of illuminance covers a 35mm lens, and with the **SW-2 Wide-Angle Adapter** in place it covers a 28mm lens. The unit can be turned for vertical or horizontal shooting. These were the first electronic flashes to use special high-efficiency flashtubes. They provided power in a compact design.

The **SB-9 Speedlight,** introduced in 1977, was designed to be a carry-along compact flash. It weighs 3 oz. (85 g) without its two AA batteries and is only 24mm (just short of an inch) thick. It has an ISO shoe and was designed to work with the compact cameras of the day. It has automatic operation with two f/stops and a guide number of 46 in feet (14 in meters) with ISO 100 film. The SB-9 also uses the special high-efficiency flashtube.

The **SB-10 Speedlight** was introduced in 1978 primarily for use with the recently introduced FE. It has an ISO shoe and connects with the ready light in the FE viewfinder. It is basically the same design as the SB-8E. It has the same guide number (82 in feet, 25 in meters) and uses four AA batteries with the same vertical and horizontal shooting positions. It lights the ready light in the camera's finder and sets the sync speed when the camera is in Auto mode. When attached, the SW-2 increases the angle of coverage but reduces the guide number to 59 (18 in meters).

In 1980 the **SB-11 Speedlight** was Nikon's most powerful flash unit. It is a handlemount unit weighing 30.3 oz. (859 g). It has a guide number of 118 in feet (36 in meters) with ISO 100 film and a guide number of 82 (25 in meters) when the **SW-3 Wide-Angle Adapter** is in place. It is powered by eight AA batteries or the **SD-7 Battery Pack,** which uses six C batteries. Recycle time is up to 8 seconds, and it can provide up to 150 flashes. Though at the time the unit was the latest thing for Nikon, this flash leaves a lot to be desired.

It works TTL with the F3 via the **SC-12 Cord,** plugging into the SU-1 socket and attaching to the F3's flash shoe (or normal PC connection with the **SC-11 Sync Cord**). The **SC-23 Cord** attaches the SB-11 to ISO-shoe cameras and provides TTL coupling. The **SU-2 Sensor** (which is normally attached to the SB-11) can be mounted on an ISO shoe with the **SC-13 Extension Cord.** This cord maintains dedicated, but not TTL exposure control. The SU-2 also provides a modulated burst of light to trigger a second flash attached to the Nikon ML-1 remote control unit.

The SB-11 hooks into the F3's TTL system, lighting the ready light inside the F3 prism when the SC-12 is in use. At the same time, the ready light on the SB-11 indicates the correct exposure. If there is insufficient light for correct exposure or the cord is improperly connected, the ready light blinks rapidly. The head tilts incrementally to 120° for bounce flash photography. The light quality from the SB-11 is quite harsh because of the reflector and Fresnel design, requiring some type of diffusion to produce a more pleasant light source. The technology, size, guide number, and lack of features, especially in the 1990s, make the SB-11 basically worthless.

Note: The terms "TTL" and "dedicated flash" are not interchangeable (dedicated being another word for automatic). TTL, or Through-the-Lens technology relies on metering in the camera body for correct exposure. Dedicated flash relies on a sensor in the flash for correct exposure. TTL is a more accurate system currently used by many manufacturers. A more complete explanation of TTL metering can be found in the *Bodies* chapter.

The **SB-12 Speedlight,** also introduced in 1980, works on the F3 only. It is the first compact flash Nikon designed and manufactured to work TTL with a camera's metering system. The SB-12 has quite some power considering its compact size. It has a guide number of 82 in feet (25 in meters) with ISO 100 (59 in feet, 18 in meters with the **SW-4 Wide-Angle Adapter**) and coverage for a 35mm lens (28mm with SW-4). It is powered by four AA batteries providing up to 160 flashes. The entire flash head swivels for vertical and horizontal shooting. The SB-12's flash foot fits only the F3 and operates with only the F3's TTL system. When the flash is attached to the F3, it automatically sets the shutter speed to 1/80 second for flash photography. It also activates the ready light in the finder, indicating proper or improper flash, improper flash connection, or that the flash is charged and ready for the next photograph. The F3's exposure compensation dial can be utilized to change the exposure by plus or minus 2 stops (this affects the ambient light meter at the same time).

If the ready light goes out right after the exposure and then relights, the exposure was sufficient. If it blinks rapidly after the exposure, improper exposure probably occurred. Proper exposure is a function of

flash-to-subject distance and f/stop. If the flash indicates improper exposure, change the flash-to-subject distance, the f/stop, or a combination of both, to achieve the correct exposure.

The **SC-14 Cord** takes the SB-12 off camera a maximum of three feet (0.9 m) while maintaining TTL/flash sync. It has a 1/4"-20 threaded socket for attaching to a bracket or tripod. The ISO dial on the SC-14 overrides the ISO dial on the camera body and must be set for correct exposure. The **AS-6** can convert the F3 foot of the SB-12 to work with an ISO mount. The hot shoe connection remains, but all TTL functions are lost. In the days of the F3 and SB-12, there were no multiple TTL flash cords. Two SC-14 cords could be spliced together to operate two SB-12s TTL, but the ISO setting on the cord had to be doubled for correct exposure. For example, if using ISO 100 film, the setting on the cord would have to be 200. Thank goodness flash photography has progressed!

In 1982 Nikon introduced the **SB-14,** a "compact" handlemount flash unit. It has a guide number of 105 in feet (32 in meters) with ISO 100 film and 72 (22 in meters) with the **SW-5 Wide-Angle Adapter** installed. With the SW-5, it has the coverage for a 24mm lens. It is powered by the SD-7 battery pack (connected via the **SC-16 Cord**), which uses six C batteries. It provides a recycle time of up to 9.5 seconds and provides 270 flashes. It can work TTL with the F3 via the SC-12 cord or as a dedicated unit with ISO shoes and the SC-13 cord. The **SC-23** lets the SB-14 work TTL with ISO shoe cameras. Like the SB-11, the SB-14 also utilizes the SU-2 sensor, providing the same functions and features. The SB-14 is a harsh light source requiring some type of diffusion to make it a quality light source. This was a popular unit because of its size and guide number, but within a couple of years flash technology changed drastically, making it obsolete.

In 1986, Nikon introduced a more sophisticated version of the SB-14, the **SB-140.** The SB-140 is for ultraviolet, visible, and infrared photography. This is the same basic unit as the SB-14 with slightly different features. The SB-140 can work TTL (visible light only) with the F3 via the SC-12 cord or with an ISO shoe via the SC-23 cord. It comes with three special filters that are placed over the flash head, the **SW-5V Filter** for visible light at 400–1100nm, the **SW-5UV** for UV light at 300–400nm and the **SW-5IR** for infrared light at 750–1100nm. Its guide number is rather low and changes depending on the filter in use: with ISO 100 film, a guide number of 32 in feet (10 in meters) with filter SW-5V, 22 (7 in meters) with filter SW-5IR, and 16 (5 in meters) with filter SW-5UV. Like the SB-14, the SB-140 is powered by the SD-7 battery pack.

During this time Nikon released a newer pocket flash with an ISO foot, the **SB-E.** Primarily designed for the EM camera, it's powered by four AAA batteries delivering a guide number of 56 in feet (17 in meters) with ISO 100 film. It has one mode—automatic. The photographer sets the f/stop for the desired flash-to-subject distance according to the scale on the back of the flash. The flash does the rest.

Speedlight SB-15

In 1982 Nikon also introduced the **SB-15 Speedlight.** It's a compact flash that works TTL with ISO-shoe cameras. The SB-15 is an excellent unit with more flexibility than any other Nikon flash up to this time. It has a guide number of 82 in feet (25 in meters) with ISO 100 film and 59 (18 in meters) with the **SW-6 Wide-Angle Adapter** attached. It has coverage for a 35mm lens and, with the SW-6, for a 28mm lens. It is powered by four AA batteries, providing a recycle time of up to 8 seconds and delivering 160 flashes. The entire unit can be tilted for vertical or horizontal shooting. The flashtube module tilts 15°, 30°, 60°, and 90°. It has a ready light on the back of the flash and activates the ready light in the finder. This provides TTL information as with the SB-11 and SB-14. It also sets the sync speed on automatic cameras.

The SB-15 has two Automatic functions and a Manual mode for use on older cameras without TTL technology. It also has a motor drive setting that provides sync with a motorized camera capable of syncing up to 3.8 fps. This quick firing can be maintained for only short bursts. The number of bursts is determined by the flash-to-subject distance and f/stop in use. With its compact size, swiveling flashtube

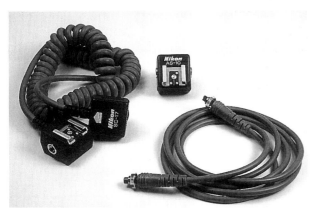

SC-17 Multi-Flash Connecting Cord, AS-10 Multi-Flash Connector, and the SC-18 Multi-Flash Connecting Cord

Speedlight SB-16B

module, and TTL function, the SB-15 is an outstanding unit for close-up photography. Up to five units can be linked to work TTL with the **SC-17, SC-18,** and/or **SC-19 Cords** and the **AS-10.**

In 1983 Nikon came out with its state-of-the-art flash, the **SB-16 Speedlight.** This flash can work TTL with both the F3 and ISO-shoe cameras by just changing the lower module. The **AS-8 Module** (the **SB-16A**) works with the F3 and the **AS-9 Module** (the **SB-16B**) works with an ISO shoe. The SB-16 has a manual zoom head that changes the angle of coverage of the light. It zooms from 28mm to 85mm with coverage for a 24mm lens with the **SW-7 Wide-Angle Adapter.**

The guide number changes depending on where the zoom head is set. It ranges from 105 in feet (32 in meters) at the 28mm setting to 138 (42 in meters) at the 85mm setting with ISO 100 film. That's more power than the SB-11, and in a much smaller package! The flash head can also be tilted and rotated 270° for bounce photography. It is powered by four AA batteries providing 100+ flashes. (It is a battery eater!)

The SB-16 has a built-in wink light that always points straight ahead. Its role is to place a catch light in the eye of the subject when using the flash in the bounce mode. The SB-16 hooks up to the ready light in the F3 and in ISO cameras just as the SB-15 (with the same exposure indicators). It also has two Automatic settings, a Motor Drive setting, and a Manual mode.

The dials on Nikon flash units are not connected to the camera or flash computers. The big dial on the back of the SB-16 is strictly for manual flash operation. It serves as a calculator to facilitate figuring correct manual flash exposure. The SB-16 has two

sockets on the lower module. One is for standard, PC, off-camera sync, and the other is for TTL sync (via the SC-18 or SC-19). At the time of its introduction, it was one of the top flash units on the market. But that did not last long. Many off-brand companies specializing in just flash manufacture came out with more powerful smaller units that worked TTL with Nikon bodies.

The **SB-17 Speedlight** was introduced in 1983, replacing the old SB-12. The SB-17 is the exact same unit as the SB-15 but offers TTL metering with the F3 only. It is a vast improvement over the SB-12 and was a big hit with photographers at the time. It has a TTL socket for use with the SC-18 or SC-19 cords.

The **SB-18 Speedlight** is a small pocket flash that was sold as part of a promotional package, but not separately. It is not a powerful flash. Powered by four AA batteries delivering up to 250 flashes, it has a guide number of only 66 in feet (20 in meters) with ISO 100 film. It has only two settings, Manual and TTL, working with ISO flash shoes.

The **SB-19 Speedlight** is along the same lines as the SB-18, but even smaller in size. It was designed to be a companion to the FG-20 and EM. It works with any ISO flash shoe and, when used with an FG-20 or EM and an AIS or AI lens, provides six automatic settings. On any other camera body there is only one setting. It is powered by four AA batteries, delivering up to 250 flashes with a guide number of 66 (20 in meters) with ISO 100 film.

In 1986, the **SB-20 Speedlight** was the first Nikon flash with autofocus assist. Many photographers have not taken full advantage of this flash and its

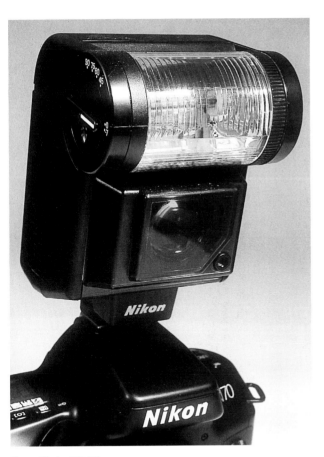

Speedlight SB-20

camera is depressed. This is still a marvelous unit to use as a second flash. Whenever using any Nikon flash as a secondary TTL flash, including the SB-20, the "STBY" function cannot be used.

In the Manual mode the SB-20 has ratios of 1/16, 1/8, 1/4, 1/2, and full available. With the proper body connection, the ready light works the same as on all Nikon TTL flash units. On the SB-20 next to the "READY" light is a "BOUNCE" light. The "BOUNCE" light comes on when the flash head is in the bounce position, whether set to bounce up or at the 7° down bounce. The SB-20 has one external sync plug for PC connection only. To use off-camera TTL, an SC-17 cord is required. And as a second flash unit, an SC-18 or SC-19 and AS-10 are required.

The SB-20 was introduced with the N2020, Nikon's first autofocus camera, to work in conjunction with the N2020's autofocus system. The SB-20 has an AF illuminator that, in dark situations, comes on and emits a red beam of light so the camera's autofocus sensor can focus. This illuminator functions only when the camera's autofocus selector switch is set to "S." It doesn't work at all with the "C" function. As with any beam of light, the illuminator's beam widens the farther it travels from the flash. Because of this, the photographer must look through the finder and make sure the illuminator beam and the autofocus bracket in the camera's viewfinder line up.

The **SB-21 Macro Speedlight** is an incredibly well-designed macro flash. It is not a ringlight, but a macro flash that utilizes two parallel flashtubes for its light source. It is a two-part unit. The flash head consists of the two flashtubes and focusing bulbs that attach to the front element of a lens (via the lens' filter thread). The Controller Unit attaches to the camera's flash shoe and delivers power to the flash. The **SB-21A** is for the F3 (the **AS-12 Controller**) system, and the **SB-21B** (the **AS-14 Controller**) is for ISO flash shoes. The controller mounts to the camera's flash shoe where the TTL connection is made. A power cord is used to get the power and computer-TTL connections from the controller unit to the flash head.

On the bottom of the flash assembly are two focusing bulbs (between the two flashtubes) that illuminate the subject. These operate according to the power source in use. The controller can use four AA batteries lighting up one focusing bulb for up to 200 flashes. Or the **LD-2 Battery Pack** can be used, lighting both focusing bulbs and providing up to 300 flashes. By using an alternative power source (which is not recommended by Nikon), there is a big

outstanding features. It is powered by four AA batteries providing up to 150 flashes with a recycle time of up to 6 seconds. It has a high-voltage plug for use with the Nikon **SD-7** or **SD-8 Battery Packs** with the **SC-16 Cord,** delivering a recycle time of up to 4 seconds. This same socket accepts Quantum's Turbo® Battery (not recommended by Nikon), providing instant recycle time with up to 240 flashes. The SB-20 has a rotating screen around the flashtube that changes the angle of light to cover 28mm to 85mm lenses. When set at 28mm ("W" setting) it delivers a guide number of 72 (22 in meters), and at the 85mm ("T" setting) it delivers a guide number of 118 (36 in meters)! The flashtube module can also be turned for bounce photography, still making use of the rotating flash screen.

It had a number of new features for a Nikon flash of its day. The power switch has "OFF," "STBY," (standby) and "ON" positions. The "ON" and "OFF" settings are self-explanatory, but "STBY" is new. When on this setting, the flash turns itself off when hooked up to cameras that turn themselves off. It then powers up the moment the shutter release on the

increase in the number of flashes, but only one focusing bulb lights up.

The controller manages the operation of the flash. On the rear panel there is the "OFF," "M," and "TTL" switch. The "M" is for manual operation, requiring the use of the calculator dial on top of the controller to figure out proper exposure. There is an "OVER EXP" and "FLASH/UNDER EXP" ready light on the back panel. When the controller is set to the TTL mode, they blink to indicate under- or over-exposure problems occurring during the exposure. The standard ready light for the SB-21 is the upper or "FLASH/UNDER EXP" light. It comes on when the flash is 90% charged for the next exposure and stays on until the unit has been fired.

The flashtube assembly clips onto a ring (52 and 62mm rings come with the unit) that is screwed into the lens' filter thread. On the back of the flash assembly there are two more control switches. One switch selects either the left tube, the right tube, or both tubes so that the photographer has control over the lighting pattern. The other switch operates the "M," "1/16," or "TTL" setting. These switches must be set to the proper mode for correct operation.

The SB-21 is not a powerful, general-purpose flash. It provides a guide number of 39 in feet (12 in meters) with ISO 100 film. This is plenty for its design as a macro flash, delivering power for f/22 at 1:1 magnification. For greater magnification, the SB-21 comes with a plastic adapter that increases the angle of illumination to properly light a subject that is close to the front element. When using the 60mm f/2.8 Micro AF, the **UR-3 Adapter Ring** is required to attach the flash to the lens. The UR-3 fits on the barrel of the lens rather than attaching to the filter ring. This prevents the autofocus motor in the camera from dealing with the weight of the flash when being focused. The SB-21 can be used with other flash units TTL via the SC-18 and SC-19 cords. It is possible to use a second flash to backlight a subject while using the SB-21 in this manner.

When the DP-20 prism is removed from the F4, and the DW-20 or DW-21 finders are attached (common practice in close-up photography), the ISO hot shoe on the DP-20 is lost. The DW-20 and DW-21 do not have an ISO shoe as part of their design, so Nikon provides a socket on the back of the DW-20 and DW-21 finders to plug in the **SC-24 Cord.** It accepts the controller unit (or an ISO shoe) providing all TTL connections. One drawback is that there is no place to solidly attach the controller unit because it now dangles at the end of a three-foot coiled cord. Attaching the body to the Controller/SC-24 cord (via

Speedlight SB-22

1/4"-20 thread on the SC-24) with a bracket (many are available, though none are manufactured by Nikon) is recommended when doing close-up work. This keeps the controller out of the way.

The **SB-22 Speedlight,** introduced in 1987, is an inexpensive autofocus flash. Using four AA batteries, it can deliver a guide number of 82 in feet (25 in meters), and with the wide-angle diffuser (built into the unit and pulled into place), 59 (18 in meters) with ISO 100 film. It delivers 200 flashes per set of batteries with a recycle time of up to 4 seconds. It has an autofocus illuminator and a high-voltage socket operating the same as that on the SB-20. The ready light also operates the same as those on all Nikon TTL flash units. The flashtube module pivots for bounce flash capability, up 90° and down 7°. It has "M," "MD," "A," and "TTL" settings that work as on other units. It has the "OFF," "ON," and "STBY" power switch that is incorporated into the SB-20.

In 1988 a unique little flash unit was introduced, the **SB-23 Speedlight.** This is a very compact autofocus flash powered by four AA batteries and delivering a guide number of 66 in feet (20 in meters) with ISO 100 film. What is amazing about this unit is its recycle time of up to 1 second. This, along with up to 400 flashes, is possible on just one set of batteries. The electronic technology of the SB-23 is quite sophisticated for such a small unit. The one drawback of the SB-23 is that it cannot easily be used as a secondary flash unit. Nikon states that it cannot be used synced to other flash units at all because it has only an "OFF" and a "STBY" setting. The flash does not

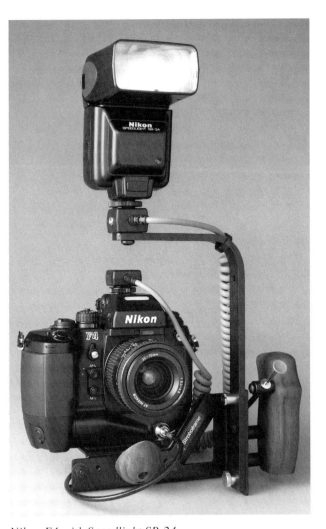

Nikon F4 with Speedlight SB-24

cameras were the first to make full use of all the SB-24's features.

This text on the SB-24 is not meant to replace the instruction book, but to explain or expand on functions of the SB-24 to facilitate its use by the photographer. Many terms in the instruction book do not coincide with common logic. These terms are explained but are used throughout the text to avoid confusion when referring back to the instruction book. Though the SB-24 works with later bodies (such as the N70 and N90s), the following text relates to its use with the N8008 and F4. These were the bodies the flash was originally built to work with and were released at the same time as the flash.

The SB-24 is a high-power flash with autofocus technology. It is powered by four AA batteries or with the SD-7 or SD-8 battery packs via the high-voltage socket. It can also be powered by Quantum® power sources via the high-voltage socket (not recommended by Nikon). The guide number with ISO 100 film is 98 to 164 in feet (30 to 50 in meters) depending on where the automatic zoom head is set.

The SB-24 zoom head automatically sets the correct angle of coverage when a lens with a CPU is attached to the N8008 or F4. When a zoom lens with a CPU is attached, the SB-24 zoom head operates in concert with the lens, zooming for the correct angle of coverage (covering from 24mm to 85mm) automatically. It can be set manually when using a non-CPU lens or when you need to override the automatic feature when using a CPU lens.

One setting must be made before using the SB-24: the distance scale. Inside the battery compartment is a small sliding switch that sets the distance scale to either feet or meters (factory default is meters). Select the method desired for distance readout on the LCD panel. The distance scale changes automatically when a lens with a CPU is attached. The f/stop in use appears on the LCD, and as it is changed (by turning the lens' aperture ring), the distance scale changes. This information, though, is only a guide and does not affect the exposure. The flash head itself tilts up or sideways for bounce photography. It does this while simultaneously maintaining the automatic zoom. If the flash head is tilted up, the distance scale in the LCD disappears. And if it is tilted down, the distance scale blinks.

The SB-24 has an "OFF," "STBY," and "ON" switch that operates like that on the SB-20. When the flash is switched to "ON," the LCD displays a number of features. The LCD of the flash is the heart of its operation. The SB-24 can do all, part, or none of

receive the signal from the camera when the shutter release button is touched. It can be used, however, but only if the flash is turned on and off manually prior to the exposure. This is the reason for operating the power feature manually.

In 1988 the introduction of the **SB-24 Speedlight** took Nikon's flash technology a quantum leap forward. Its smaller, streamlined shape and power were what attracted many to it at first. But it is its linkage with first the N8008 and then the F4 that really launched the SB-24 to stardom. Its many features based around TTL and matrix fill flash, especially rear-curtain sync and exposure compensation, opened the doors of flash photography to every photographer, which before had been open only to the most experienced photographers. This flash was specifically designed to interface with the N8008 and N8008s and the F4, F4s, and F4e. These

the exposure calculations for the photographer, depending on how the photographer initializes the settings. At the top of the flash are two switches that need to be set, the first is the Flash Sync Mode.

The SB-24 provides "REAR" curtain sync and "NORMAL" curtain sync. In "REAR" sync mode, the flash fires as the shutter is closing. This is opposite from "NORMAL," which fires the flash when the shutter is first opened. Rear-curtain sync permits the photographer to take the exposure and freeze the subject after the movement has been recorded. But there is a more important use of rear-curtain sync. With the N8008, N8008s, F4, F4s, or F4e in any exposure mode (except "M"), rear-curtain sync enables the camera to accurately expose ambient light from 30 seconds to 1/250 second while maintaining accurate TTL flash exposure. (This shutter speed range is limited to 1/60 to 1/250 second in "NORMAL.")

In "NORMAL" mode, the flash is fired as soon as the shutter is opened. Most flash units are used this way 99% of the time. In "NORMAL" mode, the flash instantly records the action present as the shutter is opened. The N8008's and F4's ambient exposure range includes only shutter speeds between 1/60 and 1/250 second when the flash is set in "NORMAL." Even if the ambient light requires a shutter speed slower than 1/60 second, the camera will not set one and will underexpose the ambient light.

Note: The viewfinders in the N8008 and F4 display the shutter speed when working with flash. When in the "NORMAL" mode, the shutter speed displayed ranges from 1/60 to 1/250 second. Many see the 1/60 and forget that it is as slow as the camera goes in the "NORMAL" mode. Instead, they think that it is the correct shutter speed for the ambient light. For that reason, many just have their flash set to "REAR" all the time to avoid underexposure of the ambient light. The drawback to that is that you could be caught shooting at a slow shutter speed when photographing a moving subject. The moral is simply to beware of what the camera is telling you.

The second switch is the Flash Mode Selector. This provides four options designated by "A," "M," three lightning bolts, and "TTL." "A" is an automatic mode in which the small port below the autofocus illuminator reads the light bouncing off the subject and turns off the flash when the correct exposure is reached. To select the f/stop, press the adjustment buttons (the two arrows) on the flash to change the setting on the LCD. The f/stop selected must be within the range that the flash's distance scale prescribes.

For correct exposure, the aperture on the lens must be set to the same f/stop that has been selected on the flash panel. This feature is useful only when the SB-24 is used on a non-TTL body. Otherwise, TTL mode should be utilized.

"M" (Manual) mode puts the photographer in complete control of the exposure, providing ratio options of 1/16, 1/8, 1/4, 1/2, and 1/1 (full) power. Exposure is calculated by the photographer according to flash-to-subject distance. When the SB-24 is attached to an N8008 or F4s with a lens with a CPU in use, the flash's LCD relays the f/stop at which the aperture has been set to facilitate manual operation. The distance scale right above the selected f/stop indicates the correct flash-to-subject distance for proper exposure. The scale changes as the f/stop changes.

The three lightning bolt symbol is the repeating flash function, which permits the subject to be exposed with the flash up to eight times consecutively on the same frame of film. This feature works only in the camera's M (Manual) mode. The camera should be set to "bulb" or a shutter speed long enough to allow all the flashes to be recorded. For example, if the flash is set to 6 pulses (the number of flashes) at 8Hz (the speed of the flashes) then it will take 6/8 second, or 0.75 second, for correct exposure. The fastest possible shutter speed for this situation is 1 second.

Depending on the effect desired by the photographer, the number of flashes is selected via the adjustment arrow. The M button selects the power setting between 1/8 and 1/16. Choosing 1/8 or 1/16 allows the photographer to vary the subject's distance, which is reflected on the distance scale on the LCD. Correct exposure is determined by the same method as in Manual mode, according to the flash-to-subject distance. The lower power setting of 1/16 allows more flashes per firing. This is a feature of the SB-24 that must be experimented with to completely understand and use it. Reading the instruction book twenty times minimum also helps!

The "TTL" mode is what really makes the SB-24 sing! All that is required to activate this wonderland of power is to switch the button to "TTL." With this accomplished, a "TTL" readout appears at the top of the LCD. Next to it is a graphic of a man and sun. This is the "AUTO/COMP" indicator. When this indicator is displayed (not blinking) and the F4's or N8008's metering system is on either matrix or center-weighted, the flash exposure is automatically balanced with the ambient light. This is what Nikon calls "Automatic" fill flash in the instruction book. In this mode, the camera's and flash's computers automatically set the fill-flash ratio. The ratio that is set

can range from 1:1 to 1-2/3 stops underexposed, depending on what the camera and flash computers calculate. I suggest using another mode for fill flash. (When the flash is the key light [the main lighting], Automatic TTL is recommended.)

What I recommend for fill flash is what Nikon calls "Standard TTL" in the instruction book. This is accomplished by first depressing the M button. This makes the man-and-sun symbol start blinking (technically, it sets the "MANUAL/COMP"). Next, press the SEL button, which calls up an analog scale in the top right corner. By pressing the arrows, either up or down, the flash exposure compensation is set. With this, the photographer is in control of the fill-flash ratio. With the man-and-sun symbol blinking, the exposure compensation set by the photographer is the same for each exposure.

Normally, fill flash is a function of balancing the flash and ambient light. Often photographers underexpose the flash compared to the ambient light. A good starting point for this is minus 2/3 stop. This means the flash exposure is 2/3 of a stop less than the ambient light. Now if the M button is depressed, either by accident or on purpose (the man-and-sun symbol stops blinking), then the compensation dialed in is added to the amount the camera's computer calculates (accidentally hitting the M button is easy, be forewarned). This means the automatic range adds to it the amount dialed into the flash. If any compensation has been set, the "+/-" compensation warning symbol lights in the camera's viewfinder to inform the photographer.

This procedure combined with rear-curtain sync basically guarantees correct flash/ambient light exposure in any situation. Lighting interiors with this method is quick and simple. Just remember, the shutter speed goes down to only 30 seconds in rear curtain sync. Remember to look at the shutter speed setting to see if a tripod is required for a long shutter speed. This all works whether one or up to five flash units are linked in TTL mode.

The SB-24 works in concert with the N8008 and F4 for matrix balanced and center-weighted fill flash. When in TTL mode, whether the camera is set to "P," "PH," "PD," or "S," the camera's computer (in concert with the flash) determines the correct exposure for the f/stop selected. The camera goes as far as setting the correct shutter speed for correct exposure of the ambient light. The ready light in the viewfinder indicates the correct exposure for TTL exposures just as with all other Nikon flash units.

The distance scale, aperture, and focal length information on the LCD panel go off after 16 seconds to conserve power. They come back on once the shutter release button is depressed. Next to the ready light on the back panel there is a button with a light symbol. When pressed, it illuminates the LCD panel for 7 seconds or shuts off when the camera is fired. If the lens in use does not have a CPU (or a lens with a CPU is used and the contacts are broken by an extension tube or teleconverter), the LCD panel no longer displays the f/stop.

The SB-24 can be taken off-camera via the SC-17 cord, maintaining full TTL and computer connections. The SB-24 has two connections on the side of the unit, one for a standard PC connection and one for TTL connection via the SC-18 and SC-19 cords. When the SB-24 is used as a second unit via an SC-18 or SC-19 cord, all functions on the SB-24 are lost except TTL exposure. Zoom, ISO, and TTL are the only functions to be set on the second unit. All other features of the master SB-24 are transferred to the second unit. The second unit cannot be on "STBY" either, as it does not receive the signal from the camera to switch on. It must be left in the "ON" position.

Any custom settings dialed in remain in memory if the flash is turned off (either directly or via the SC-17 cord) while connected to the camera's TTL shoe. The dialed functions are erased, though, if the flash is powered while not connected to the camera's flash shoe. The SB-24 has a microcomputer, and since the unit is not grounded, static electricity can cause the flash to stop functioning. This can be fixed by removing and reinserting the batteries, thus breaking the static charge. If the power is interrupted, all functions are reset to factory settings and custom settings must be reset.

The SB-24 operates with each camera body differently. A thorough reading of the instruction book is required to operate the SB-24 accurately with bodies other than those for which it was made. When used with the N6000 or N6006, all the above functions are no longer applicable. There has been a revision of the instruction book since the first SB-24s were released. On page 24, the current and most accurate instruction book shows a three-part system for use with different camera systems.

In the summer of 1990 Nikon introduced the **SD-8 High-Performance Battery Pack** for use with the SB-24. It can also work with the SB-11, SB-20, SB-22, and SB-24, all of which have the high-voltage power socket. The SD-8 requires six AA batteries; the four batteries in the flash must still be in place for proper operation. The purpose behind the SD-8 is that it offers a faster recycle time and a greater number of flashes. The SD-8 has two cords, a power lead

and a PC cord. It is important to plug in or unplug the PC cord before the power cord. The PC cord is plugged into the PC socket on the flash and not the one on the camera body.

As mentioned before, there are alternative power sources for the flash units with high-voltage sockets that can work quite effectively. These units are not recommended by Nikon, and using them voids the flashes' warranties. Thousands of photographers use alternative power sources on their Nikon flash units successfully and safely day in and day out, especially the SB-24, so some discussion is warranted.

The SB-24 can use the Quantum Turbo Battery via its high-voltage socket with the Quantum cord. When using the Turbo with the SB-24, there must still be four AA batteries in the flash (that holds true for any high-voltage Nikon flash) for proper operation. The AA batteries operate the LCD panel on the flash while the external pack charges the flash's capacitor, the power that runs the flashtube. Quantum offers a "battery saver," a dummy battery that replaces one of the four AA batteries. I have found this works best when it is in the battery slot closest to the flash foot. It does promote longer life of the AA batteries. But if you are going to be using the AF illuminator, use four AA batteries and not the battery saver. It works with the battery saver, but the illuminator flashes rather than staying on as a constant light source for the camera to focus on. (It must be pointed out, though, that Nikon has found most of the SB-24s and SB-25s that have required electronic system repairs were used with non-Nikon power packs.)

In September 1992, with the introduction of the N90 came a new flash, the **SB-25.** Though it is similar in appearance and in operation, the SB-25 obsoletes the SB-24 and carries on the sophisticated flash tradition it started. The SB-25 might share the same guide number and basic features as the SB-24, but a new array of features that Nikon has stuffed into its shell makes it a very powerful flash tool. Anyone familiar with the SB-24's controls will have no problem operating or manipulating the SB-25, as their operation remains identical in nearly all operations.

The main features of the SB-25 are fully automatic fill flash, standard TTL flash, FP high-speed sync flash, rear-curtain sync flash, red-eye reduction, and repeating flash. When these are used in conjunction with the N90 and D lenses, they make the SB-25 the most advanced flash on the market.

The first big change in the SB-25 is in the instruction book. It thoroughly and clearly goes through each and every flash operation, feature, mode, and possible use. A vast improvement on the SB-24's manual, this book takes a serious look at flash photography and will be an important tool in using flash successfully.

At first glance the SB-25 looks like the SB-24, but looks are deceiving. The flash head is no longer rectangular but slightly curved on the lower edge. It has the automated zoom head with manual override as in the SB-24, but also has a pull-out diffuser that increases the coverage for a 20mm lens. (Using a 20mm lens on the N90/N90s in normal curtain sync, the shutter speed range can go as low as 1/20 second. This is not true for the N8008 or F4.) When it is pulled out and in place, the zoom indicator on the LCD panel reads 20mm and the automatic zoom head is disengaged. Along with the extra diffuser is a small white card that pulls out. This is for use when you are bouncing the flash and want to direct some of the light at a 90° angle.

Other cosmetic advances include a rubberized cap for the TTL/PC terminal on the side of the flash. The flash head now locks at 90° and at 0°. The back LCD panel looks the same, and much of the information is displayed the same as on the SB-24. As with the SB-24, the meter/foot switch is still located in the battery chamber and must be changed to feet (if desired). The function buttons have been improved on the SB-25. They are recessed so the lettering won't be rubbed off easily or hit accidentally and changed. The selection arrows are now positioned such that the plus arrow points up and the minus arrow points down.

A new advance in cosmetics is the flash foot. As the knob is turned to secure the flash to the N90, a small pin is forced down. This safety lock goes into a small hole in the flash shoe of the N90 for extra security and snugness. For cameras that have no hole, such as the older F4s, the N8008, or N8008s, the pin is spring-loaded, so it stays up and out of the way. The HV socket is still right above the flash foot.

Since the instruction book for the SB-25 is so complete, only certain fuzzy areas will be discussed here to clear them up. Unless otherwise noted, discussion of use pertains to the N90, which is fully compatible with the SB-25, allowing all of its features to function. Where applicable, the shortcomings of using other camera bodies with the SB-25 are noted.

With the SB-25 set in Automatic Balanced Fill Flash and connected to the N90 or N90s, the following options are available: 3D Multi-Sensor Balanced, Multi-Sensor Balanced, Center-Weighted, and Spot Fill Flash. Pressing the M button on the SB-25 cancels the Automatic Balanced Fill Flash and activates Standard TTL flash as with the SB-24.

The first terms that might confuse the newcomer are Automatic Balanced Fill Flash and Standard TTL Flash. These terms are the same as with the SB-24. In Automatic TTL, the camera's and flash's computers set the fill flash ratio from 1:1 to minus 1-2/3 stops. In Standard TTL, the photographer has complete control over fill-flash exposure compensation (refer to the "SB-24" section for more info on this). The symbols for these features vary according to the camera in use.

When the SB-25 is connected to the N90 or N90s, the following symbols appear. In 3D Multi-Sensor Automatic Fill Flash, "TTL" and the matrix symbol appear. In Center-Weighted Automatic Fill Flash, "TTL" and the man-and-sun symbol appear (when using a manual lens on an N90 or any lens on the F4 or N8008). In any exposure mode, when the flash is set to Standard mode only the TTL symbol appears. These symbols change slightly when the SB-25 is attached to an F4 or an N8008. In Automatic mode, "TTL" and the man-and-sun symbol appear. In Standard mode, only the TTL symbol appears.

No matter what mode, underexposure from the flash is indicated just as with all prior Nikon Speedlights. The ready light blinks rapidly on the flash and in the viewfinder after the exposure to indicate underexposure. New on the N90, though, is the ability to determine just how much underexposure occurred. By pressing the "light" button on the flash, underexposure is indicated by stops in the top right of the flash's LCD panel. This information is available thanks to the monitor pre-flash function, which operates only when the flash is mounted to an N90 or N90s.

The Repeating Flash mode of the SB-25 was updated from that of the SB-24. Use of this high-tech function was made easier with the SB-25 mainly because of the excellent instructions. Start by turning Repeating Flash mode on as with the SB-24, sliding the switch to the three lightning bolts, and making sure the flash sync is set to "NORMAL." Set the zoom head to the desired coverage. Next press the M button to select the desired light output, the options are m1/8, m1/16, m1/32, and m1/64. Now press the SEL button to select the number of flashes per second. The SB-25's range of flashes per second was increased to 50HZ. The distance scale indicates the proper exposure for the f/stop in use. Exposure in this mode must be calculated the old-fashioned way, by subject-to-flash distance. The shutter speed is also set manually and is determined by the number of flashes per second. Press the shutter release and go.

The FP High-Speed Sync Flash option is possible with the N90/N90s and F5. In this mode, exposure can be made at 1/4000 second because the flash puts out a pulsed series of flashes rather than one big burst. Operation begins by selecting "M" and "NORMAL." Next press the M button until "FP" appears next to the "M" on the LCD panel. It may take a number of pushes on the M button to get the "FP" to appear. The distance bar should be watched as it counts down feet until the "FP" appears. If you go too far, the distance bar starts over on the 60-foot distance. Pressing the button ("M") that brings up "FP" also brings up a "1" in the lower right-hand corner of the LCD. Another press of "M" brings up a "2." The "1" is for FP1 operation and the "2" is for FP2 operation.

FP1 and FP2 refer to a complicated system that determines the correct guide number for calculating subject distance, f/stop, etc. The shutter speed can be set at any number between 1/250 to 1/4000 second. The aperture can also be selected as desired, but it might not necessarily work. Once the f/stop is selected, check the distance scales on the lens and on the flash's LCD panel. If they match, then the subject will be properly exposed. If they don't match, then you will have to go through the calculations and select either FP1 or FP2. The M button can be pressed, changing FP1 to FP2 or vice versa, to see if the distance will be correct. The alternative is to move to the correct distance from the subject as indicated on the LCD panel.

The ready-light button can be used to pre-test a non-TTL exposure on the SB-25. Set the flash to A mode. This engages the reflective sensor on the front of the SB-25. Press the ready-light button and fire the flash. If it blinks, then either get closer to the subject or open up the aperture. When you're ready to actually take the picture, switch the camera back to TTL.

The AF illuminator on the SB-25 is physically smaller than that of the SB-24 (or other flash units, for that matter). This, in conjunction with the camera's focus detection being able to be set to Spot automatically when the flash is attached, leads one to believe the AF illuminator is more precise than its predecessors. The "S" AF mode and "S" film advance mode are required to use the AF illuminator.

An important upgrade with the SB-25 has to do with saving any programmed settings. Unlike the SB-24, which loses any programming when turned on while not directly connected to a camera, the SB-25 retains its programming. So programming can occur and be saved if the SB-25 is turned on while not directly connected to a body.

Nikon has an updated way of powering the SB-25 (or any Nikon TTL flash). The **SK-6 Power Bracket** is an external power unit and handgrip built in one. It

Speedlight SB-26

uses four AA batteries while also utilizing the four in the flash. This reduces the flash's normal recycle time of 7 seconds to 3.5 seconds. If the SD-8 is used in conjunction with the SK-6, the recycle time is a mere 0.5 second (using six AA NiCd batteries). Recycle times can vary anywhere within these ranges depending on power source and battery conditions.

The SK-6's bracket design is unique. It attaches to the base of the camera (it's designed to work with modern TTL bodies). A short cord with a TTL foot slips into the camera's ISO shoe connecting the TTL system. The bracket then sits to the left of the camera with the flash attaching directly to it. There are no cords to plug in upon attaching the flash; slipping it into place makes all the necessary connections. This places the flash unit lower than if mounted on the camera's flash shoe. This is not optimal placement for horizontal flash photography. It is ideal though for vertical shooting, placing the flash in the perfect locale above the lens. If you want to take advantage of the vertical firing button on the F4 though, the flash is in the wrong place. Since the flash is on the left of the camera, it is below the camera when using the vertical firing button.

In 1994, Nikon introduced their new flash, the **SB-26.** This flash is only a slight upgrade of the SB-25 (I'm not sure it was worth the effort). There are two innovations, an 18mm pull-out diffuser for wide-angle flash photography and the wireless photo slave. This is the world's first sync-adjustable photo slave flash system.

While the SB-26 works with the TTL system when connected to the camera either directly or via the SC-17, it can sync off-camera with any flash. When disconnected from the body, the flash is no longer working TTL (a step back, if you ask me). Any number of SB-26 units can be used in this manner. Flash exposure calculations for all of these slaved units must be done manually or with a flash meter (or with the A mode on remote flashes). The SB-26 has a built in Delay mode for wireless operation (select "D" on the wireless slave flash selector on the front of the flash). In the S mode (select "S") the flash fires at the same time as the main flash. In the D mode, the flash delays firing until after the main flash goes off. This prevents its light from affecting exposure accuracy when the main light is set for TTL. When activated, a wave/lightning bolt symbol appears on the left of the LCD panel.

The only other new symbol on the SB-26 is for red-eye reduction. The symbol is an eyeball and two lightning bolts. All other symbols including those for automatic and standard TTL are the same as on the SB-25.

In the fall of 1995, Nikon introduced the **SB-27.** This is a real cool little flash! Old-timers will see a real resemblance to the old SB-15 in the SB-27. It has the same style pivotal head, allowing for horizontal and vertical placement. But the resemblance ends there.

The SB-27 has an automatic zoom flash head, covering 24 to 50mm in the horizontal position and 35 to 70mm in the vertical position. Coverage can also be set manually. The flash unit has both Manual and Auto (TTL) exposure modes available. It is powered by four AA batteries providing up to 140 flashes with

Nikon F4 with Speedlight SB-27

The SB-27 has a built-in diffuser card.

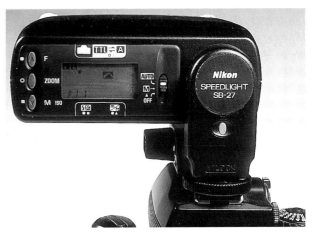

The back view of the SB-27 shows the flash unit's controls.

a recycle time of up to 5 seconds. It has a high-voltage socket for external battery sources. It has an AF illuminator and red-eye reduction capabilities. Rear-curtain sync is also possible with this flash. The guide number changes depending on where the zoom head is set, ranging from 82 in feet (25 in meters) at the 24mm setting to 112 in feet (34 in meters) at the 50mm setting (with ISO 100 film). One nice, new addition to the SB-27 is the built-in diffuser card.

This card pulls out from the front of the flash and can be used as a bounce card or for close-up work. It is capable of bouncing light down, right in front of the flash. Flash duration can be as fast as 1/6700 second or as slow as 1/1000 second.

In the fall of 1997 Nikon introduced their newest top-of-the-line flash, the **SB-28.** In my opinion, while the SB-28 is an improvement over the SB-26, it still retained the good features of that unit. In fact, my discussion of the SB-28 is brief because there isn't really all that much new about the flash other than that it is about 30% smaller than the SB-24, 25, and 26.

The SB-28 weighs only 11.8 oz. (335 g) and is 2.7 x 5 x 3.6 inches (6.9 x 12.7 x 9.1 cm), which makes it a nice, small package. It has the same power as the SB-26, with a maximum GN of 164 in feet (50 in meters). It is powered by the same sources as the previous, larger Speedlights with the same basic recycle time. With its built-in adapter, it has a coverage of 18 to 85mm. It differs from the SB-26 in that is lacks wireless remote capability, and it has no Normal/Rear flash control switch so rear-curtain sync is possible only with cameras that offer it.

The really new thing about the SB-28 is its look. Besides being smaller and trimmer, it has an entirely new control panel and LCD display. Its buttons are rubber-coated and recessed; there are no longer any sliding switches. Even the on/off switch is a button so you can no longer change a function or turn on the flash by hitting it accidentally. In fact, you must depress and hold down the on/off button for a few seconds in order for the flash to turn on. And the SB-28 automatically goes into Standby mode after approximately 80 seconds. The unit has a cool new feature—a little bounce card that pulls out like the built-in adapter and has some of the flash unit's important operating instructions printed on its back.

The SB-28 offers five basic modes: A (Non-TTL Auto Flash mode), TTL Auto Flash mode, M (Manual Flash mode), FP High-Speed Flash, and Repeating Flash mode. Access to these varies depending on the camera in use. There are no real surprises here, the instruction book pretty well lays things out.

There might be two drawbacks to the SB-28, depending on your point of view. The first is that although the flash unit has a red-eye reduction feature, it can be used only with the N90, N90s, and N70 cameras. (As this is a feature I have never used, I don't find this to be a drawback.) The second drawback is more important to my own photography, and that is that the SB-28's AF illuminator is smaller and dimmer than the SB-25. I don't have a way of measuring how much dimmer it is, but it's dim enough to have made me use the SB-25 as my main flash for nocturnal shooting so I can take advantage of its brighter AF illuminator.

In 1998 the **SD-8A High-Performance Battery Pack** was introduced for use with the SB-11, SB-22, SB-24, SB-25, SB-26, and SB-27. It is exactly the

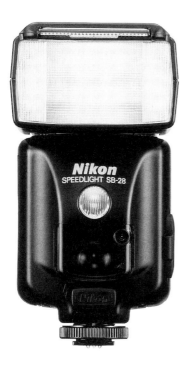

SU-4

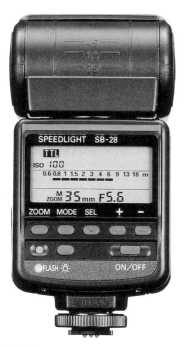

Speedlight SB-28

books stacked on top of one another, this little gizmo can make using flash a whole lot easier!

This is a true TTL flash slave, permitting full TTL exposure control with as many flash units as you want within 23 feet of the main flash! You heard me right, complete TTL control with a slaved flash within 23 feet! I just think this is the coolest thing, not only because of its size, but also the thought process that went into its design.

The flash slips into any ISO TTL hot shoe. Its shoe rotates within a range of 120°, making flash placement easy. The sensor that actually picks up the light from the main flash rotates 120°, which makes it simple to fine tune the sensor. There is a switch on the side of the SU-4 that, when turned on, makes a sound so you know when the flash has recycled and is ready to fire or when it expends all of its flash with an exposure. The SU-4 has a 1/4"-20 thread on its base to attach it to stands or flash brackets. This is a really well-thought-out unit.

Does it work? Brother, it just blasts away! Nikon recommends that you take some test shots before taking important flash photographs to determine that the sensor unit is working properly. This is a good idea and is just plain common sense. I attached it to my flash and shot without a problem. I varied my aperture, closing down each exposure, and sure enough, the flash kept putting out more light with each change of aperture. Perfect!

Working TTL

All of Nikon's TTL camera bodies can work with as many as five flash units at one time while maintaining TTL capabilities. The master flash either resides on the hot shoe or is connected to it via the SC-17 cord. The other four units are connected with the

same as the SD-8, but it's been approved by Underwriters' Laboratories.

I like cool gadgets, and Nikon came out with a honey in 1999! The **SU-4** is the Wireless Slave Flash Controller. A little smaller than the size of two match

SC-18 Multi-Flash Connecting Cord and the AS-10 Connector

SC-18 or SC-19 cords. Though this is the best system currently on the market, there are still some holes in the technology that photographers should be aware of in order to make the most of their system.

Nikon's TTL multiple flash system starts with one "Master" flash attached to the camera's hot shoe and additional units being triggered from it via the SC-18 or SC-19 cords. Usually the "Master" flash is taken off the camera, maintaining TTL connection with the SC-17 cord. The SC-17 cord is the heart of off-camera TTL work. It is the only cord with five wire leads built into the cord, relaying all information between the computers of the camera and the flash. When using the SC-17, all features available when the flash is attached directly to the camera are still present and available.

When attaching the SC-17, it is recommended that you attach it to the camera body first, then to the flash. The shoe on the SC-17 to which the flash is attached must have a flash attached to complete the circuit. On the bottom of the flash shoe at the end of the SC-17 is a 1/4"-20 threaded socket. This permits the shoe assembly to be attached to a bracket or stand. As many as three SC-17 cords can be connected to create 9 to 15 feet (2.7 to 4.6 m) of extension and still have proper TTL operation. Any more might cause resistance in the line, possibly resulting in improper exposure. Some folks, though, constantly use five SC-17 cords together. Be forewarned, this is not recommended!

There are two sockets on the flash shoe of the SC-17 cord. These are for connecting either the SC-18 or SC-19 cords for adding TTL flash units. These additional TTL flash units work only TTL, losing all other functions. They inherit the settings of the "Master" flash. That's because the SC-18 and

SC-19 are three-lead wire cords, carrying only the TTL "on/off" signal. (If a flash is plugged into the socket of the SC-17 without a master flash being present, the flash will not fire in the TTL mode.) All flash units connected with an SC-18 or SC-19 must be set to "ON" and not "STBY" in order to receive the impulse from the shutter release when it is pressed. If set to "STBY," they will not be activated when the exposure is made. (These units can be set to "STBY," but they must be reactivated manually before firing. This seems silly in some situations when the flashes are not within easy reach, but if you are shooting multiple flashes on a bracket, it can save batteries.)

It is advisable to have all TTL sockets on flashes, cords, and couplers covered with a PC cap (not done at the factory) when they are not in use to avoid foreign material getting in and shorting out the TTL system. This holds true especially for the flash units themselves.

It is recommended that you use the TTL sockets on the flash units when tying more than one together TTL. If you're in a pinch, use the sockets on the SC-17 or AS-10. The AS-10 has three sockets that accept the SC-18 or SC-19 cords and a 1/4"-20 thread on the base permitting attachment to a bracket or stand. Technically you don't need to use an AS-10 since you are connecting TTL info via the flash's TTL socket. But if you want to attach the flash to a bracket or stand, the AS-10 with its 1/4"-20 thread is really handy.

Since the SC-18 and SC-19 are only three-lead cords, as many as three SC-19s (a total of 30 feet [9.1 m] of extension) or six SC-18s (also totaling 30 feet) can be coupled together for TTL operation. These cords are joined by the AS-10. It has a TTL socket to accept a flash but does not need a flash in the socket to close the circuit. The SC-17 and SC-18 can be cut down in length (not recommended by Nikon) to accommodate special brackets so that the excess cord is not in the way.

Flash Accessories

Item	Description
AS-1	F2 to ISO Flash Shoe—Provides hot shoe use of ISO flash on an F2 body.
AS-2	ISO to F2 Flash Foot—Converts F2 flash foot to work on ISO shoe.
AS-3	F3 to F2 Flash Foot—Converts F3 hot shoe to work on F2 shoe.
AS-4	F3 to ISO Flash Shoe—Provides hot shoe use of ISO flash on F3 body.
AS-5	F2 to F3 Flash Shoe—Converts F2 shoe to work on F3 shoe.
AS-6	Converts F3 foot to ISO shoe.
AS-7	Allows flash to be moved out from F3 body, maintaining TTL connection and allowing the film rewind lever to be lifted to open back. Also has ISO foot, non-TTL.
AS-8	SB-16 Foot for F3 Body
AS-9	SB-16 Foot for ISO Shoe
AS-10	TTL Multi-Flash Adapter—Allows two TTL cords to be connected, has 1/4"-20 thread for tripod mounting.
AS-11	Permits F3 foot flash to be mounted to a 1/4"-20 thread.
AS-12	SB-21 Controller Unit for F3 Shoe
AS-14	SB-21 Controller Unit for ISO Shoe
AS-15	PC Sync Terminal Adapter for ISO Shoe
AS-17	F3 to ISO TTL Flash Shoe

Flash Wide-Angle Adapters

Item	Description
SW-1	For SB-2, SB-3
SW-2	For SB-7E, SB-8E, SB-10
SW-3	For SB-11
SW-4	For SB-12
SW-5	For SB-14
SW-6	For SB-15, SB-17
SW-7	For SB-16A or B

Flash Cords

Item	Description
MC-9	Connecting Cord F-36 to SB-6
SC-4*	Ready Light Adapter for F2 with Nikon Flash
SC-5*	Sync Cord for SB-5
SC-6	Screw-on Coiled Cord
SC-7*	Sync Cord, SB-2, SB-3, SB-7E, SB-8E, SB-10
SC-8*	Sync Cord SB-4
SC-9	Extension Cord for SU-1
SC-10*	Sync Cord for SB-9
SC-11	Sync Cord for SB-11
SC-12	TTL Cord for F3 and SB-11, SB-14, SB-140
SC-13	Extension Cord for SU-2 and ISO Foot
SC-14	TTL Off-Camera Cord for F3
SC-15	Coiled PC to PC Cord
SC-16	Power Cord for SD-7
SC-17	ISO TTL Remote Cord to Flash, 3' long

SC-18	TTL to TTL Connecting Cord, 5' long
SC-19	TTL to TTL Connecting Cord, 10' long
SC-20	Sync Cord for 120 Medical
SC-21	Power Connecting Cord for 120 Medical
SC-22	Sync Cord for 120 Medical
SC-23	TTL to ISO Connecting Cord for SB-11, SB-14, SB-140
SC-24	Off-Camera TTL Cord for F4 DW-20 and 21 Waist-Level Finders
SF-1	Eyepiece Pilot Lamp

Flash Power Sources

Item	*Description*
LA-1*	AC Battery Pack for 200 Medical, SM-2, SR-2
LA-2	AC Battery Pack for 120 Medical, SB-21
LD-1*	DC Battery Pack for 200 Medical, SM-2, SR-2
LD-2	DC Battery Pack for 120 Medical
MS-2*	AA Battery Holder for SB-7E, SB-8E, SB-10
MS-5	AA Battery Holder for SB-16
MS-6	AA Battery Holder for SB-15, SB-17
SA-2*	AC Adapter for SB-2, SB-3
SA-3	AC Power Unit for SB-6
SD-4*	480v Battery Pack for SB-5
SD-7	C-Cell Power Source for SB-11, SB-14, SB-140, SB-20, SB-22, SB-24
SD-8	Power Source for SB-24
SD-8A	Power Source for SB-11, SB-22, SB-24, SB-25, SB-26, SB-27
SH-1*	Charger for SN-1
SH-2*	Charger for SN-2
SH-3	Charger for SN-3
SN-1*	NiCd for SB-1
SN-2*	NiCd for SB-5
SN-3	NiCd for SD-5

Flash Sensor Units

Item	*Description*
SU-1*	Sensor Unit for SB-5, SB-6
SU-2	Sensor Unit for SB-11, SB-14, SB-140
SU-4	TTL Slave for SB-16B, SB-22s, SB-23, SB-27, SB-28

*Discontinued

Nikon Close-Up—
The Evolution

Before Nikon ever ventured into the camera business, they were manufacturing microscopes (and still produce the best on the market). It didn't take them long to combine their two fields of expertise, becoming the industry's major innovator in close-up photography. Nikon's rangefinders were the company's first forum for close-up photography. Nikon manufactured a number of accessories including the Bellows 1 to capture minuscule subjects. It was not until the SLR came on the market though, that the world of close-up photography became a "common man's" adventure. Only then was it explored by the everyday photographer. The appetite that this new breed of photographic adventurer had for equipment grew. Nikon did not hesitate to meet the challenge and go beyond what was expected.

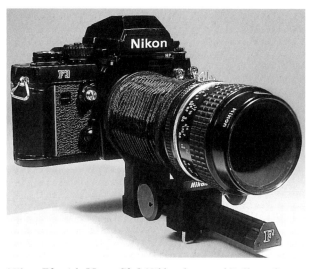

Nikon F3 with 55mm f/2.8 Nikkor lens and Bellows 3

Photography in its raw form uses physics to capture light. The optics of our lenses manipulate light, bending it so it hits the film at a set distance to create a sharp image. Close-up or macro photography takes this to the extreme, moving the lens away from the film plane and creating an air gap, altering the physics of a lens. This is why there are more mathematical formulas, exposure calculations, and rules of thumb in close-up photography than in your basic photography. Two factors must be understood to grasp the basics of close-up technology: the amount of extension required in order to reach a given magnification, and the amount of exposure compensation required for that amount of extension.

Two terms in close-up photography relate directly to extension: macro and micro. Macro is working at magnifications up to 1:1. Micro is working at magnifications greater then 1:1. The ratio of 1:1 is the formula signifying "life-size" magnification. At 1:1 the actual physical size of an object is exactly the same as the size of the image on the 35mm film frame. For example, a penny photographed with 35mm film at 1:1 is the same physical size as if it were actually laid on top of the film.

To reach 1:1 magnification, the amount of extension that must be added is equal to the focal length of the lens. For example, a 50mm lens requires that 50mm of extension be added to reach 1:1 magnification. (This is for a lens set at infinity. Determining extension for a lens that has been focused to its minimum focusing distance can be a challenge. This amount is subtracted from the formula to determine the required extra amount needed to reach 1:1.) One-to-one magnification can easily be calculated for any lens by this rule of thumb. When extension is added to a lens, there is a light loss that must be compensated for in the exposure.

The rule of thumb is, for every 1x magnification there is a loss of two stops of light. Working with a 50mm lens, if 25mm of extension is added (1/2x), one stop of light is lost. With the same lens, adding a total of 50mm, two stops of light are lost. Since most current cameras are meter coupled to the lens, this loss is read by the camera's meter. But if the lens is removed from the body by such devices as a bellows, then the meter coupling are lost. But with every rule, there are exceptions. Thank goodness!

When using special lenses such as the 60mm f/2.8 AF Micro, 105mm f/2.8 AF Micro, or 200mm f/4D EDIF AF Micro, theories of physics go out the window. The amount of extension required to go to 1:1

is not equal to the focal length of the lens (for more, see the appropriate lens in the *Lens* chapter). And adding extension tubes is not limited just to short focal length lenses. By adding a PK-13 to a 400mm f/5.6 the minimum focusing distance is drastically reduced, but the exposure is barely affected. So with each situation in close-up photography, considerations of the equipment and methods employed must be factored in to achieve the perfect photograph.

Bellows

Nikon equipment provides many options for getting "close-up"; the best known is the bellows. The first bellows introduced for the F was the **Bellows 2.** There are actually two models of the Bellows 2. Both use a single twin-rail system, meaning that the standards ride on one pair of rails. With the first model, the Photomic and Photomic T finders had to be removed before the F could be mounted to the bellows. That was fixed on the second version by simply extending the mounting flange by 3 mm. The Bellows 2 is the only bellows to receive serial numbers, which is good, because the only way the two models can be distinguished is by serial number. The modified Bellows 2 starts with a serial number of #106700.

With a 50mm lens, the magnification range of the Bellows 2 is 1x to 3.6x. With the bellows completely closed up, there is still 51.6mm of extension, which is why it starts at 1:1. There are engraved steps on the Bellows 2 corresponding to a 50mm f/2 and the 135mm f/4 Bellows lens. The markings provide guidance for setting accurate magnification when the bellows' lens standard is set appropriately. With the 50mm lens reversed (requiring the BR-2 reversing ring), the magnification range increases to 1.7x to 5.1x.

The Bellows 2 tripod socket is at the end of the bellows (to where the lens standard fully extends). Both the rear standard (where the body attaches to the bellows) and the front standard can be moved. This provides a means of setting a specific

magnification. If working at a set magnification, focus is achieved by moving the entire bellows, body, and lens assembly closer or farther away from the subject. With the tripod socket permanently mounted to the front of the bellows, the Bellows 2 doesn't lend itself to this requirement very easily.

The body standard allows you to shoot vertically and horizontally. By depressing a lever on the side of the bellows body mount, the mount is able to pivot 90°. The Bellows 2 accepts the **Slide Copier,** which attaches to the front standard and holds a 35mm slide. It has two trays, one on each side of the holder. This is for use in duplicating an uncut roll of film. The Slide Copier will work only on the Bellows 2 and the Bellows 2 accepts only the Slide Copier. All other copiers have the wrong rail and height for proper operation.

The **PB-3 Bellows** (also known as the Bellows 3) is a marvelous little bellows for field work. It is a dovetail-grooved, single-rail bellows with a range of extension from 35 to 142mm. It is physically the smallest of the Nikon bellows and is the only one with an octagonal shape. Magnification of 0.6x to 2.8x can be attained with a 50mm lens and 1.4x to 3.5x with the 50mm reversed. The rear standard of the bellows is locked in place. The tripod socket is

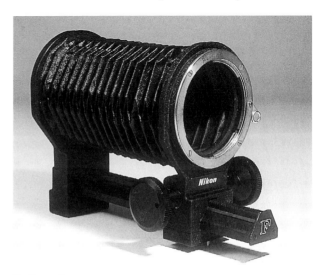

Bellows 3

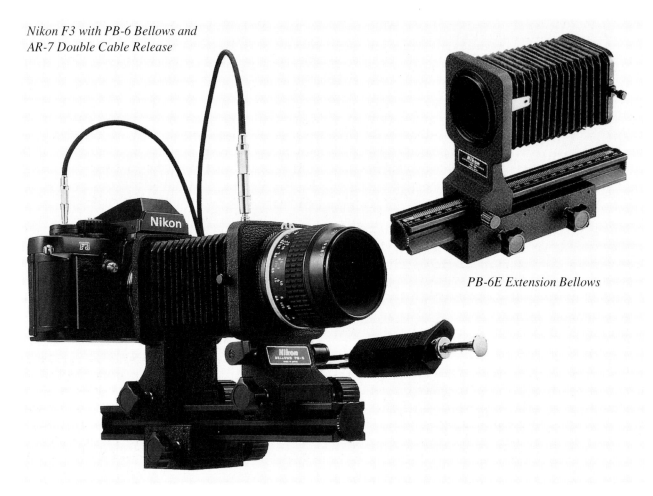

*Nikon F3 with PB-6 Bellows and
AR-7 Double Cable Release*

PB-6E Extension Bellows

located here. This supports the bellows and body quite well when attached to a tripod. Because the construction of the rear standard doesn't allow the body mount to turn horizontally or vertically, the F4 and N8008 cannot mount to this bellows. There are millimeter markings on the rail, which, when divided by the millimeters of the lens in use, provide the magnification. The PB-3 Bellows does not accept any slide copying attachment. These bellows are popular with many because of their small size, which makes finding them difficult.

The **PB-4 Bellows** was the most sophisticated bellows unit manufactured by Nikon. Its standards ride on a dual twin-rail system, allowing independent movement of the body and lens standards and of the entire assembly. It has 43mm to 185mm of extension. With a 50mm lens, magnification of 0.83x to 3.6x is possible. With the 50mm reversed, 0.6x to 4.4x is possible. The upper rail has millimeter markings like all bellows, from 0 to 192, and figuring magnification is the same.

The lens and body standards as well as the tripod head assembly have geared movement. This pro-

vides for extreme accuracy in magnification and focusing. The geared tripod head makes it possible to set up the body and lens at a specific magnification and focus the entire assembly while it's attached to a tripod. Focusing the entire bellows assembly is done by a simple turn of the knob. The two standards and the tripod head can be locked into place to prevent slippage or accidental changes.

What distinguishes the PB-4 from all other bellows is its lens standard. It has 25° of swing and 10mm of lateral shift. This aids in controlling the depth of field. There are two levers on the lens standard that, when released, permit these movements. When the lens standard is swung to control depth of field, the subject can be swung off the frame. The lateral shift corrects this by moving the subject back into the picture, like raising the front of a 4 x 5 camera. Though a unique feature in a bellows, its effect on the 35mm film format is limited and its problem-solving possibilities slim.

The body standard permits the camera to be rotated for horizontal and vertical shooting. The PB-4 accepts the **PS-4** slide copying attachment, which

works on the same principle as the Slide Copier. The one difference is that the PS-4 has 9mm of horizontal shift and 6mm of vertical shift. The PS-4 has an accordion leather bellows that attaches to the front of the lens. This prevents stray light from hitting the front of the lens and causing flare. The PB-4 also accepts the PS-5 slide copier (discussed below).

The **PB-5 Bellows** is a simplified version of the PB-4 with single, twin-rail construction. It has the exact same extension and magnification ranges as the PB-4. Its lens standard does not have the swings or shifts and it does not have an independent tripod socket. There is a tripod socket on the front and rear standard, but no means of mounting it in the center for stability. As with the Bellows 2, it does allow the body to be rotated for horizontal and vertical shooting by pressing a lever. It accepts the PS-4 or **PS-5 Slide Copier,** the PS-5 being the same as the PS-4 but without the slide trays.

Introduced in 1977, the **PB-6 Bellows** is still the state-of-the-art bellows for Nikon. It is part of a modular system, making it one of the most flexible bellows on the market. The PB-6 is a double-dovetail rail design, which allows independent operation of the body and lens standards and the entire assembly. The rail has a variable extension of 48mm to 208mm for magnification of 1.1x to 4x with a 50mm lens. The top rail has two scales for accurate measurement. The body and lens standards each have a geared focusing knob for precision work and can be locked in place.

The tripod head of the PB-6 is like that of the PB-4. The assembly is on the bottom section of the rail by itself. It has full use of the bottom rail's length, thereby affording the unit exact balance and stability. The body mount can be turned for vertical and horizontal photography. The PB-6 Bellows has a number of built-in accessories that are add-ons to other bellows. The lens standard has a built-in semi-automatic diaphragm (BR-4 on other bellows). Depressing a lever on the lens standard closes down the diaphragm manually. A double cable release is required to activate it automatically when taking a photograph. The lens standard can also be reversed to reverse the lens for greater magnification. This eliminates the need for a **BR-2/2A Reversing Ring,** which performs the same function on other bellows.

The **PB-6E Extension Bellows** can be added to the PB-6 for a maximum extension of 438mm. When the PB-6E is attached, the tripod mount's mobility is lost and with it the ability to focus by moving the entire assembly. The PB-6E comes with a large connecting plate to which the rails of the two units are joined. This plate has a tripod mount. It also comes with a bellows and standard that connect with the actual bellows of the PB-6. The lens standard must be removed from the PB-6 when assembling the two units. It is then reattached to the bellows section of the PB-6E. With a 20mm lens reversed, a magnification of 23x is possible, requiring 46 stops of compensation to record an image!

The **PB-6M Macro Copy Stand** is a small stand that attaches to the end of the PB-6. It is 90mm x 144mm in size with a white opaque acrylic disc at the center, which allows direct or trans-illumination of the subject. It also comes with a gray painted aluminum disc that can be used as an 18% gray card. If working with a small object that could be enhanced by backlighting, this is excellent.

The **PS-6 Slide Copier** attaches to the PB-6, allowing slide duplication. It is an updated PS-4.

Bellows Accessories

Making these bellows easier, simpler, and quicker to use is possible with the addition of specialized accessories. When the lens is attached to a bellows' front standard, its automatic diaphragm and meter coupling are lost. The meter coupling cannot be recoupled, but semi-automatic diaphragm operation can be regained by using the **BR-4** ring. The camera body keeps the aperture wide open for bright viewing when focusing, then closes it down to the selected f/stop when the camera is fired. If it did not operate this way, viewing through the lens would be extremely dark. The same thing holds true when using a bellows without the aid of the BR-4. It keeps the diaphragm wide open for bright viewing but closes down to the selected f/stop when the camera is fired.

The BR-4 requires a double cable release to trigger it when the camera is fired. Nikon makes three such releases: the **AR-4** double cable release for the old release sockets of the F and Nikkormat, the **AR-7** for standard cable release sockets, and the **AR-10** for motorized cameras such as the N8008 or F4s. When the plunger is depressed on the double cable release, it fires the camera, simultaneously stopping down the lens.

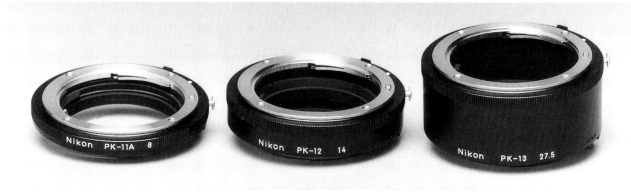

Extension Tubes PK-11A, PK-12, and PK-13

Extension Tubes

Bellows are not the only equipment Nikon has for close-up work. The first extension tubes were non-meter coupling. They were referred to as manual extension tubes because exposure had to be figured out manually. The **K Tubes** are a set of tubes that can be mixed and matched for various amounts of extension (stacked together for a total of 46.6mm of extension). These tubes are quite dated and are more trouble than they are worth. When the 55mm f/3.5 Micro was sold originally (1963 version), it came with a 27.5mm extension tube permitting the lens to focus to 1:1. The first tube was the **M Ring,** which was later replaced by the **M2 Ring.** Neither were capable of meter coupling.

The first meter-coupled extension tubes were the **PK-1, PK-2,** and the **PK-3.** They worked with the non-AI coupling system. Each tube has a different amount of extension: the PK-1 = 8mm, PK-2 = 14mm, and the PK-3 = 27.5mm. These can be mixed and matched to achieve the amount of extension needed to do the job. There is no limit to the number that can be stacked. Since they all maintain meter coupling between the body and lens, exposure compensation is easier to figure out.

The PK-1 and PK-2 are odd amounts of extension not related to any one lens. The PK-3 is the exact amount of extension required by the 55mm Micro for 1:1 magnification. Nikon offers one other meter-coupled extension tube, the **PN-1.** Its 52.5mm of extension couples with the 105mm f/2.8 Micro for 1:1 magnification. When the AI meter-coupling system was introduced, the extension tubes were updated to permit meter coupling with the new system. The exact same extension tubes were produced, except this time fitted with the AI coupling. They are the **PK-11, PK-12,** and **PK-13.** The PN-1 was also updated to an AI version, the **PN-11.**

As of yet there are no autofocus extension tubes. The only option remains the AI extension tubes. They all work fine on the autofocus equipment except the PK-11, so Nikon made a small modification and came out with the **PK-11A.** It has the same amount of extension as the PK-1 and PK-11, but a small part of the mounting flange was removed to prevent interference with the autofocus contacts in the body. None of the other tubes have this problem, so no other new versions were necessary.

Close-up photography can be achieved through the use of micro lenses such as the 55mm f/2.8, 60mm f/2.8 AF, 105mm f/2.8 AF, 200mm f/4 IF Micro, and the 200mm f/4D EDIF AF. The new generation of micro lenses 60mm, 105mm, and 200mm can achieve 1:1 without extension tubes. But any Nikon lens can be used with an extension tube, altering the minimum focusing distance and permitting close focusing. An example would be the use of the 300mm f/4 AF with the PN-11, which changes the minimum focusing distance from 9 feet (2.7 m) to 4.7 feet (1.4 m) with a magnification of 0.18x with 1/4-stop light loss.

Long telephotos lend themselves to the application of extension tubes quite readily to shorten their minimum focusing distance. For example, the 500mm f/4P has a minimum focusing distance of 20 feet (6.1 m). This changes to 17.5 feet (5.3 m) by adding the PK-11A with no light loss. This option allows for tighter cropping and greater image size while decreasing the depth of field. Infinity focus is no longer present because the lens has been moved away from the film plane, but this is no handicap since the lens is being used for close-up focusing.

Close-Up Attachments Nos. 0–6T

Close-Up Attachment Lenses

There are other options to modify a lens for close-up photography. Nikon makes the **Close-Up Attachment No. 0, No. 1,** and **No. 2.** These are basically filters designed to work with lenses up to 55mm. They can be stacked together for greater magnification, but this causes a loss in overall quality. The refractive power of the No. 0 is 0.7, the No. 1 is 1.5, and the No. 2 is 3.0. These are an inexpensive investment for a first venture into close-up photography, testing the waters before getting heavily into the very expensive lenses and attachments.

Nikon makes four other close-up attachments that are on a totally different level of quality without a big price. The **Close-Up Attachments Nos. 3T, 4T, 5T,** and **6T** are two-element, achromatic attachments (they attach like filters). This means they are corrected pieces of optical magnifying glass, which deliver outstanding quality. The 3T and 4T are 52mm and the 5T and 6T are 62mm. The 3T and 5T have a refractive power of 1.5, the 4T and 6T have a power of 2.9. The greater the refractive value, the closer the camera can be to the subject, and hence, the greater the image size.

The "T" after the numbers signifies that these attachments are designed to work with telephoto lenses (85mm to 200mm range) to increase their magnification, which they do quite handily. For example, the 4T on a 200mm lens provides 1.7 to 1.2x, the 6T on the 35-70mm f/2.8 AF (a great combo) provides 1.7 to 2.1x. Any of these attachments can be used in multiples for greater magnification without light loss. These can be excellent problem-solving tools for working in close when nothing else will.

BR-2A, BR-5, BR-3, BR-4 Reversing Attachments

Other Close-Up Accessories

A very popular method of working close up is by reversing a lens. Nikon makes the **BR-2A** (originally the BR-2) and **BR-5** for just this application. The BR-2 and BR-2A attach to 52mm threads, the BR-5 attaches to 62mm threads. Autofocus bodies require the BR-2A (it works just fine with other bodies, too). It has a small notch removed from its mounting flange so it won't harm the autofocus contacts in the body.

These rings permit 52mm and 62mm lenses to be mounted reversed onto a camera body, extension tube, or bellows for greater magnification. The most popular lenses to be reversed are the 20mm f/3.5, 20mm f/2.8, 35mm f/2, and 50mm f/2 because of their excellent edge-to-edge quality. When a lens is reversed, its optical formula is completely altered (light travels in reverse of its designed path). Some lenses can be excellent when used normally but perform poorly when reversed. Trial and error is necessary to test the performance of a reversed lens.

When the lens is reversed, all meter and automatic diaphragm connections are lost. As with a bellows, automatic diaphragm control can be gained with the **BR-4** or with the new **BR-6,** which is used in conjunction with the BR-2A ring. With the lenses reversed, the filter threads are lost. The rear element is also extremely exposed. The **BR-3** ring attaches to the lens mounting flange and has 52mm threads for attaching a protective filter (including close-up filters) to a reversed lens. The BR-3 can work on any reversed lens without vignetting because of the inherent magnification of the setup.

Working close to a subject at a fixed magnification, focusing can be difficult at best without some type of aid. When working with extension tubes, micro lenses, or another set system, photography is a lot easier with the aid of the **PG-2 Focusing Stage.** The PG-2 permits a motorized camera setup to be used vertically or horizontally, moving the whole camera assembly to fine focus. It works on the same double-dovetail rail as the PB-6. The top rail works the camera assembly; the bottom rail is the track for moving the whole stage. The **PG-1** is a version that works with a body only, no motor drive. When cameras with built-in motor drives came on the market, it was discontinued. These units provide 360mm (14.2 inches) of tracking, which accommodates almost any close-up setup requirement.

Nikon Service Facilities

Argentina
Eduardo Udenio y Cia.
S.A.C.I.F.I.
P. O. Box 410
Ayacucho 1235
Buenos Aires
Phone: +54 1 425538

Australia
Maxwell Optical Industries Pty. Ltd.
Unit 4, Northbank Industrial Park
20-36 Nancarrow Ave.
Meadowbank
New South Wales
Phone: +61 2 390-0200

Austria
Nikon Österreich GmbH
Modecenterstrasse 14
A-1030 Wien
Phone: +43 1 796 6100

Bahrain
Ashraf Brothers w.I.I.
P. O. Box 62
Manama
Bahrain, Arab. Golf
Phone: +973 534439, 730113, or
730894

Belgium
H. De Beukelaer & Co.
Peter Beniotstraat 7–9
B-2018 Antwerpen
Phone: +32 3 216 0060

Brazil
T. Tanaka & Cia., Ltda.
Rua Martim Francisco
438 (Sta. Cecilia) São Paulo
Phone: +55 11 825 2255

Canada
Nikon Canada, Inc. (Toronto)
1366 Aerowood Drive
Mississauga, Ontario L4W 1C1
Phone: +1 905 625 9910

Nikon Canada, Inc. (Montreal)
3300 Chemin Côtè-Vertu
Montreal, Quebec H4R 2B7
Phone: +1 514 332 5681

Nikon Canada, Inc. (Vancouver)
No. 5, 13511 Crestwood Place
Richmond, B.C. V6V 2E9
Phone: +1 604 276 0531

Canary Islands
Maya S.A.
Canoelaria 31
P. O. Box 757
38003 Santa Cruz de Tenerife
Phone: +34 22 24 5096

Chile
Reifschneider Foto S. A. C. I.
Jose Manuel Infante 1639
Casilla 4216 Santiago
Phone: +56 2 204 9030

Cyprus
K. H. Papasian Ltd.
240 Ledra Street
P. O. Box 1607
Nicosia
Phone: +357 2 463795

Czech Republic
Nikon s.r.o.
Stepánská 45/640
111 21 Praha 1
P. O. Box 431
Phone: +42 2 242 27590

Denmark
Dansk Fotoagentur A/S
Lerso Parkalle 101
DK-Kopenhagen 0
Phone: +45 39 162020

Finland
Suomen Interfoto Oy
Halsuantie 4
P. O. Box 79
SF-00401 Helsinki
Phone: +358 0 566 0060

France
Nikon France S.A.
191, rue de Marché Rollay
94504 Champigny-sur-Marne
Cedex
Phone: +33 1 4516 4516

Germany
Nikon GmbH
Tiefenbroicher Weg 25
40472 Düsseldorf
Phone: +49 211 94140

Greece
D. & J. Damkalidis S.A.
44 Zefyrou St.
175 64 Paleo Faliro
Athens
Phone: +30 1 941 0888

Hong Kong
Shriro (H.K.) Ltd.
2nd Floor, Hutchison House
10 Harcourt Road
G. P. O. Box 181
Hong Kong
Phone: +852 2 524 5031

Hungary
Nikon Kft
Devai u. 26-28. I. em.
1134 Budapest
Phone: +36 1 270 5525

India
Mazda Camera Centre
306,Veena Killedar Bldg.
Pais Street
K. Khadye Marg, Jacob Circle
Bombay 400 011
Phone: +91 22 307 9284

Photo Vision
223, Okhla Industrial Estate
New Delhi 110 020
Phone: +91 11 683 1936

Israel
Hadar Photo Supply Agencies
Ltd.
36-38 Achad Haam Street
Tel-Aviv 65817
Phone: +972 3 560 3947

Italy
Nital S.p.A.
Via Tabacchi 33
10132 Torino
Phone: +39 11 310 2151

Japan
Nikon Corporation
Fukuoka Service Center
Tenjin Bldg.
2-12-1 Tenjin
Chuo-ku
Fukuoka 810
Phone: +81 92 721 3561

Nikon Corporation
Nagoya Service Center
Dai-Nagoya Bldg.
3-28-12 Meieki
Nakamura-ku
Nagoya 450
Phone: +81 52 563 2881

Nikon Corporation
Osaka Umeda Service Station
Shinsankei Bldg.
2-5-2 Umeda
Kita-ku
Osaka 530
Phone: +81 6 348 9730

Nikon Corporation
Osaka Camera Service Dept.
Koukoku Bldg.
2-11-20 Minamisenba
Chuo-ku
Osaka 542
Phone: +81 6 251 7024

Nikon Corporation
Sapporo Service Center
Ohdori Bldg.
1-13 Ohdorinishi
Chuo-ku
Sapporo 060
Phone: +81 11 231 7896

Nikon Corporation
Nihonbashi First Bldg.
2-19 Nihonbashi
1-Chome, Chuo-ku
Tokyo 104
Phone: +81 3 3281 6810

Nikon Corporation
Ohmori Service Department
6-19-22 Omorikita
Ohta-ku
Tokyo 143
Phone: +81 3 3764 2605

Nikon Corporation
Shinjuku Service Center
Shinjuku NS Bldg.
2-4-1 Nishi-Shinjuku
Shinjuku-ku
Tokyo 163-08
Phone: +81 3 5321 4466

Nikon Corporation
Yokohama Service Station
TS Plaza Bldg.
2-23-2 Tsuroya-cho
Kanagawa-ku
Yokohama 221
Phone: +81 45 312 1101

Kuwait
Ashraf & Co., Ltd.
P. O. Box 3555
Safat
P. Code 13036-Safat
Phone: +965 531 2960,
531 2961, or 531 2962

Lebanon
Gulbenk Trading Co.
Hamra-Makdessi St.
P. O. Box 113-6645
Beirut
Phone: +961 1 353742

Malaysia
Shriro (Malaysia) Sdn. Bhd.
Lots 22 & 24, Jalan 225
Section 51A
46100 Petaling Jaya
Selangor
(P. O. Box 10571, 50718 Kuala
Lumpur)
Phone: +60 3 774 9842

Mexico
Mayoristas Fotograficos, S.A.
Dr. Jiminez 159
Mexico 7, D.F.
Phone: +52 5 588 7011

Netherlands
Inca B.V.
Rutherfordstraat 7
2014 Ka Haarlem
Phone: +31 23 249181

New Caledonia
Phocidis
B. P. 2359
Nouméa
Phone: +687 28 6670

New Zealand
T.A. Macalister Ltd.
Private Bag 92146
65-73 Parnell Rise
Auckland
Phone: +64 9 303 4334

Norway
Interfoto A.S.
O. H. Bangs Vei 51
1322 Hovik
Phone: +47 67 534990

Panama
Telefoto Internacional Zonalibre
S.A.
P. O. Box 31051
Colon Free Zone
Panama
Phone: +507 441 1598

Poland
Camera Sp. Z.O.O.
uL. Marszaikowaska B4/92
00514 Warszawa
Phone: +48 22 291180

Portugal
Sifoto-Soc. Import. de Fotogra-
fia, S.A.
Praca Afonso do Paco, 11-A
1300 Lisboa
Phone: +351 1 690 342,
388 6584, or 659 820

Réunion
Dimaciphot S.A.
5–7, rue Amiral Lacaze
B.P. 288
97467 Saint-Denis Cedex
Phone: +262 21 78 51

Saudi Arabia
(Postal Address)
Ahmed Abdulwahed
Abdullah Trading Establishment
P. O. Box 3611
Jeddah 21481

Hail Commercial Centre,
3rd Floor
Hail Road, beside Caravan Centre
Jeddah 21481
Phone: +966 2 642 5333 or
642 5777

Singapore
Shriro (Singapore) Pte. Ltd.
11 Chang Charn Road
Singapore 0315
Phone: +65 472 7777

Spain
Finicon S.A.
Calle Laforja, 95
Pral., 3
08021-Barcelona
Phone: +34 3 200 1521 or
200 1132

Calle Reina Mercedes, 7
20-Madrid
Phone: +34 1 553 9392

Sweden
Nikon Svenska AB
Anton Tamms Väg 3
Box 84
194 22 Upplands-Väsby
Phone: +46 8 5941 0090

Switzerland
Nikon Schweiz AG
Kaspar-Fenner-Strasse 6
8700 Küsnacht
Phone: +41 1 913 6111

Taiwan
Yang Tai Trading Corp. Ltd.
6F, 90 Huai-Ning Street
Taipei 10037
Phone: +886 2 311 7975,
331 3480, or 371 2128

Thailand
Niks (Thailand) Co., Ltd.
166 Silom Road 12
Bangkok 10500
Phone: +66 2 235 2929

Turkey
Nur Fotografcilik Pazarlama ve
Ticaret A.S.
Meclisi Mebusan Cad. No. 33
Findikli
80040 Istanbul
Phone: +90 212 293 3619

United Arab Emirates
Grand Store, w.I.I.
Saleh Mohammed Bin Lahej
Bldg.
Al Garhood, P. O. Box 2144
Deira, Dubai
Phone: +971 4 823700

United Kingdom
Nikon U.K. Ltd.
380 Richmond Road
Kingston-upon-Thames
Surrey KT2 5PR
Phone: +44 181 541 4440

Uruguay
Micro S.C.
Avda. 18 de Julio 1202
Montevideo
Phone: +598 2 915516 or
982639

U.S.A.
Nikon Inc.
1300 Walt Whitman Rd.
Melville, NY 11747-3064
Phone: 1 516 547-4200

Note: This list is current as of
the date of publication and is
subject to change.

Index

Notes